# NAVAJO AND PUEBLO JEWELRY DESIGN

## 1870–1945

# NAVAJO AND PUEBLO JEWELRY DESIGN

## 1870–1945

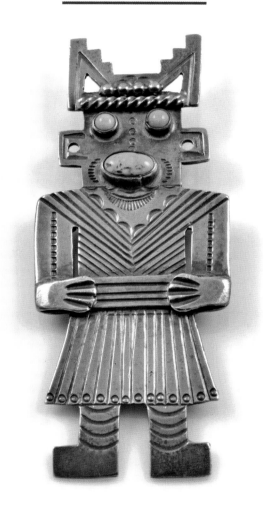

**PAULA A. BAXTER**

*Photography by Barry Katzen* | *Foreword by Robert Bauver*

4880 Lower Valley Road • Atglen, PA 19310

Other Schiffer Books by the Author:

Pueblo Bead Jewelry, ISBN 978-0-7643-5585-1
Southwestern Indian Bracelets, ISBN 978-0-7643-4868-6
Southwest Silver Jewelry, ISBN 978-0-7643-1244-1

Schiffer Books on Related Subjects:

A Study of Navajo Concha Belts, Donald Richards, ISBN 978-0-7643-5964-4
Indian Silver Jewelry of the Southwest, Larry Frank, ISBN 978-0-8874-0226-5

Designed by Chris Bower
Cover design by Ashley Millhouse

Type set in Le Havre/Arboria/Minion Pro

ISBN: 978-0-7643-6408-2

Printed in Serbia

Published by Schiffer Publishing, Ltd.
4880 Lower Valley Road, Atglen, PA 19310
Phone: (610) 593-1777; Fax: (610) 593-2002
Email: Info@schifferbooks.com | www.schifferbooks.com

For our complete selection of books on this and related subjects, please visit www.schifferbooks.com. You may also write for a free catalog.

Schiffer Publishing's titles are available at special discounts for bulk purchases for sales promotions or premiums. Special editions, including personalized covers, corporate imprints, and excerpts, can be created in large quantities for special needs. For more information, contact the publisher.

*Front cover:* Squash blossom necklace by Etcitty-Tsosie, 1920s. Courtesy of Karen Sires

*Title page:* Brooch by Awa Tsireh, 1930s–40s. Author's collection

*Page 3:* Large multistone butterfly brooch, Navajo, 1940s. Courtesy of Hoel's Indian Shop

*Back cover:* Decorative headstall ornament with *naja* form, late 19th century. Courtesy of White Collection

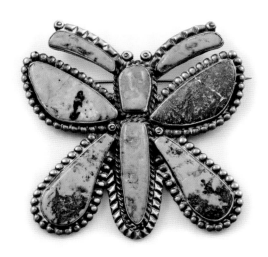

To all Navajo and Pueblo jewelers, past and present
*Ahéhee'. Kunda. Elahkwa.*
Thank you

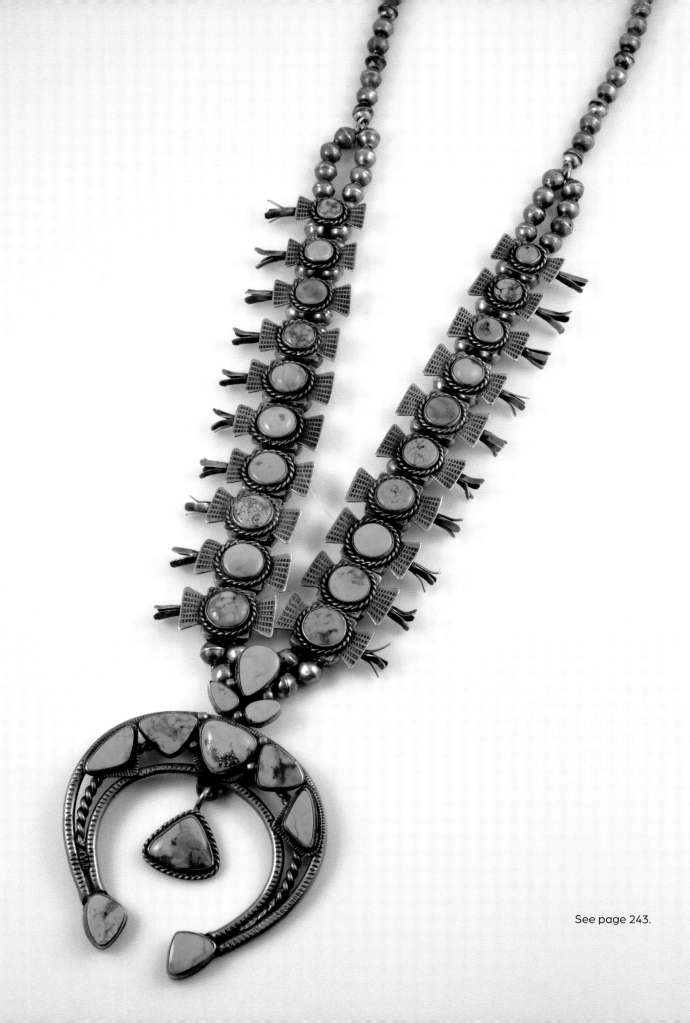

See page 243.

# CONTENTS

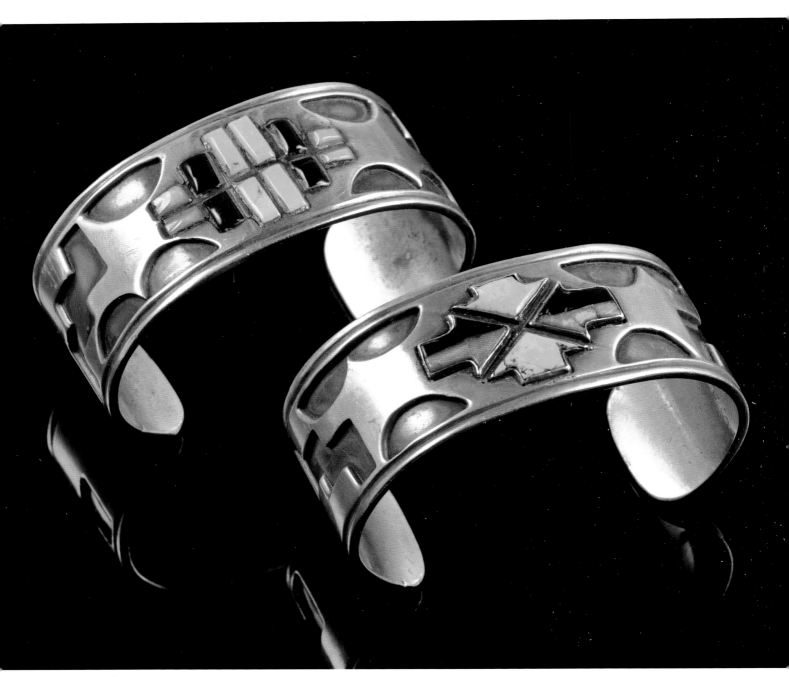

See page 244.

# Foreword

Over the past twenty years, Paula Baxter's books and articles on Native American jewelry of the Southwest have been filling the bookshelves and libraries of collectors, scholars, and those interested in the subject. Her publications are profusely illustrated with examples of jewelry held not only in museums throughout the country but with many fine pieces from private collections not previously available to the viewing public.

Writing in the foreword to John Adair's 1944 landmark volume *Navajo and Pueblo Silversmiths*, Dr. Clyde Kluckhohn, the highly respected authority on Navajo culture, stated: "American Indians have created their own imperishable achievement of beauty." This sentiment had been shared three years earlier by the Museum of Modern Art in New York when it included examples of Southwestern silver jewelry in a major exhibition introducing the world to the concept that works by Native artists are indeed a fine art.

This culmination of Paula's previous work traces a personal voyage and passage of discovery through the history of a truly American art form. In the following pages, the reader can follow the technical and stylistic evolution of the craft—from its formative years of simple buttons and bangles, through the explosive years of plentiful silver fashioned into the great turquoise set showpieces of belts, bridles and all forms of personal adornment to the later lapidary refinements of mosaic and channel inlay.

The well-chosen images of jewelry throughout the book will impart to the scholarly and the curious insights into the intrinsic sense of beauty and aesthetic of the people and the times of their creation.

ROBERT BAUVER
*New Salem, Massachusetts*

# Acknowledgments

I owe thanks to many, many individuals for their assistance over the years. Everything that I have learned has been poured into this design history. The people who helped me are legion, while any mistakes are mine alone. My research began in the late 1980s, and sadly a large number of those who contributed to this and earlier books have passed on. Some remain stalwart friends over the years, and many others, whether longtime or new acquaintances, have provided invaluable support along the way.

Three scholars in particular deserve heartfelt thanks. I had the good fortune to study under two of the finest art historians of the twentieth century: the late Dr. Albert Boime (1933–2008) and Dr. Kenneth Lindsay (1919–2009). They taught me to look out for new, more helpful methodologies and to focus on the big picture and its illuminating details. Anyone who investigates Southwestern Native metalwork owes much to another great twentieth-century scholar, anthropologist John Adair (1913–1997); his pioneering research has set a bar for examination and reflection.

Those who contributed images to this work must be mentioned. These individuals munificently shared their collections and expertise on a living art, since the economics of producing a work like this requires such generosity. They are: Laura Anderson, Robert Bauver, R. B. Burnham & Co., Joan Caballero, Eason Eige, Cyndy and Bob Gallegos, Michael Haskell, Frank Hill, John C. Hill, Hoel's Indian Arts, the Hoolie Collection, Suzette Jones, Janie Kasarjian, Michael Kvietkauskas, Bill and Minnie Malone, Pat and Kim Messier, Andrew Munaña, Paul and Valerie Piazza, Dr. Elisabeth Simpson, Karen Sires, Peter Szego, Territorial Indian Arts (Alston and Deborah Neal), Julia White, Ken Wolf, and four private collectors.

Those who assisted my education since the 1980s and helped create the genesis of this work are Robert Ashton, Phil Bacon, Mark Bahti, Jonathan Batkin, Bill Beaver, Harvey Begay, Allison and Mike Bird-Romero, Marjorie Bloss, John Bonnell, Ernie Bulow, Laura Cardinal, Merlin Carlson, Fred Chase, Dexter Cirillo, Jim Conley, Lane Coulter, Charles Dailey, Steve and Mary Delzio, Gloria Dollar, Carl Druckman, Lois Dubin, Barbara Duree, Jim Enote, Tony Eriacho, Jay Evetts, William Faust III, Octavia Fellin, Warren Fischbach, Abby Kent Flythe, Bronwyn Fox, Dan and Tricia Garland, Mary E. Graham, Ruby Hamilton, Jim Harrison, Russell Hartman, John C. Hill, Greg Hoffman, Robert Mac Eustace Jones, Hiroyuki Kawakami, Charles King, Liz and Tim King, Takayuki Kitaura, Yasutomo Kodera, John Krena, Deb Krol, Ingrid Levine, Dr. Henrietta Lidchi, Martin Link, David McFadden, Jennifer McLerran, David McNeece, Dr. Richard Martin, Pat and Kim Messier, Ernie Montoya, Steve Nelson, Perry Null, Lovena Ohl, Myron Panteah, Richard Pearce-Moses, Lauris Phillips, Susan Pourian, James T. Reynolds, Marian Rodee, Ruth Ellen Saarinen, Ruth and Sid Schultz, Doug Sill and Kristi Onken, Steve and Barry Simpson, Georgia Kennedy Simpson, Deborah Slaney, Martha Hopkins Struever, Ellis Tanner, Herbert Taylor, Lynn Trusdell, Orville and Darlene Tsinnie, Vicki Turbeville, Drs. William and Sarah Turnbaugh, Eric Van Italie, Robert Vandenberg, Mickey and Dolly Vanderwagen, Gene, Mike, and Lisa Waddell, Piki Wadsworth, Carol Watters, Kenneth Williams Jr.

Research conducted in the Navajo Nation, Four Corners, Gallup, and Zuni, and along the Rio Grande has imbued me with a strong sense of place and purpose.

Specific institutions of learning and their staff rendered essential research assistance. Foremost, the Heard Museum and its Collections Curator Diana Pardue, as well as the library staff of the Billie Jane Baguley Library and Archives. Nathan Sowry, Reference Archivist, Smithsonian Institution, National Museum of the American Indian, Cultural Resources Center; Caitlyn Carl, Digital Imaging Archivist, Photo Archives, New Mexico History Museum / Palace of the Governors; and Melissa Lawton, Archivist, Museum of Northern Arizona. In previous years, the registrar's office at the School of American Research was very helpful. Although not visited, the Wheelwright Museum holds John Adair's personal papers. Other places used for personal research: the resources of the New York Public Library's General Research Division; Goldwater Library at the Metropolitan Museum of Art, New York; Westchester (New York) Library System; Berkeley College (New York and New Jersey) databases; Octavia Fellin Public Library in Gallup (New Mexico); and the Scottsdale (Arizona) Public Library.

As always, my appreciation, recognition, and obligation must be expressed to those who merit them most: the artists. These individuals, including those departed but still deeply missed, are the great critical audience for my efforts. I would also like to particularly acknowledge my many Indian friends on Facebook who share their lives and artistry online. Their candor and willingness to tell it like it is gives meaning to my work.

I deeply appreciate the support of Peter Schiffer and his fine staff at Schiffer Publishing, Ltd.

I have also been fortunate in my supportive friends: Sandra Carpenter, Judith Kornberg, Sara Piazza, and Miki Safadi. Special regards to Daniel Fermon and Daniel Starr, who act like the brothers I wish I'd had. Perpetual thanks to Dr. Mark Kupersmith—I wouldn't be here today without his professional vigilance.

As someone who has little family left, I treasure my cousin, Dr. Pamela Doty, a true role model. When one lacks family, friends are a wonderful substitute and some become real, extended family. Orville Tsinnie and his wife, Darlene, taught me how wonderful a loving, close family can be. And most of all, my partner in this and everything else, Barry Katzen—and the bunnies.

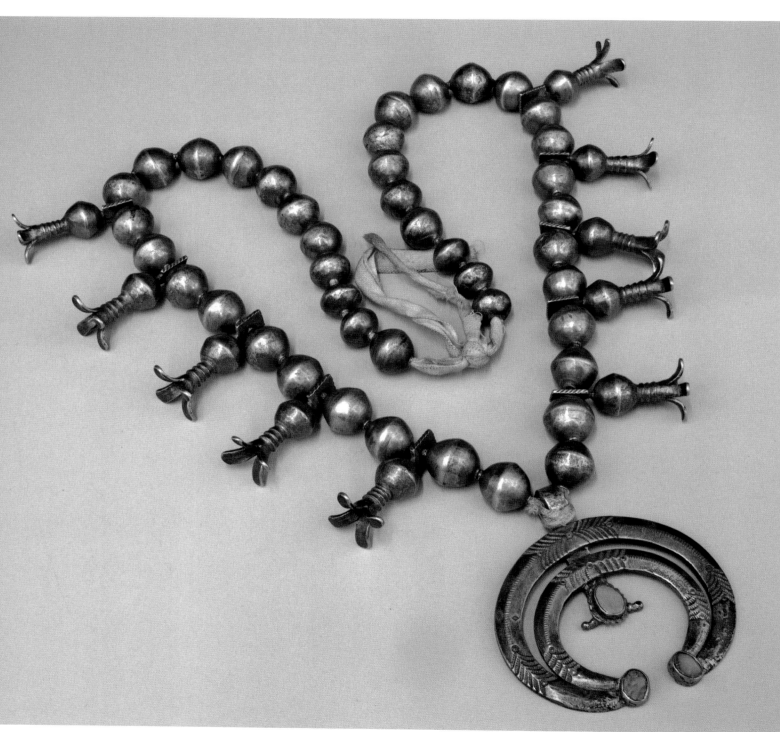

Early silver squash blossom necklace, possibly Pueblo in its organic design, strung on original flour sack strips, last quarter of the 19th century. Photograph courtesy of Cyndy and Bob Gallegos

# Introduction

When I wrote *Southwest Silver Jewelry* more than twenty years ago, I produced a work with more enthusiasm than expertise. Trained in both art history and anthropology, I wanted to improve the inconsistent literature on the subject of Southwestern American Indian jewelry; I knew that such a vital, living art was not being documented as well as it could be, and that new enthusiasts like myself, along with other students of the art, needed more reliable guidelines for understanding the character of this jewelry. What I was missing was a methodology, a means of explaining how Navajo and Pueblo jewelry design moved from ethnographic craft to a vehicle for internationally recognized artistry.

In the years after the publication of *Southwest Silver Jewelry*, I curated numerous exhibitions drawn from the art research materials (book, print, and photograph) at the large cultural institution in New York where I was employed. After that I worked for an East Coast business college for almost eight years, where I taught American art history and liberal arts courses related to critical thinking. As an independent scholar I finally chose to use the design history methodology I had relied on for my exhibitions work. Design history places a critical focus on how specific objects are created and consumed. Design historians attempt to understand design thinking based on three concepts: cultural context, technical abilities, and personal aesthetic vision. These three tenets were a better fit for the story I needed to tell.

Over these last twenty years I began to see the historical development of Southwestern Indian jewelry as a uniquely American success story. The kind of story in which two Indigenous peoples moved past conflict, colonization, and

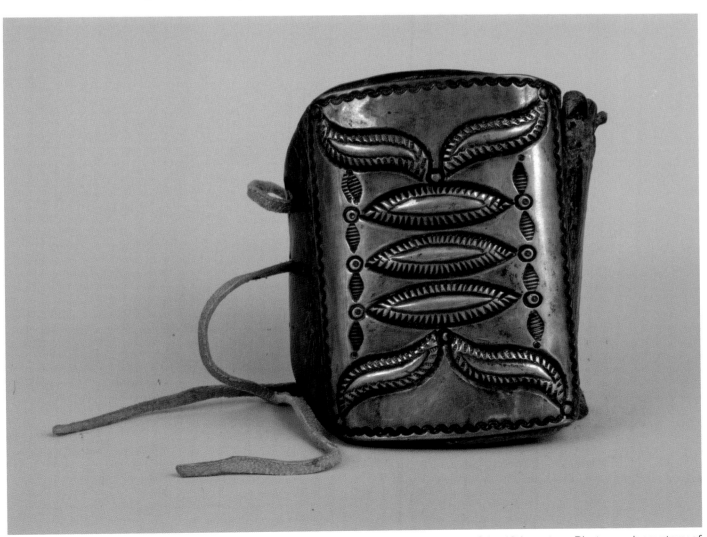

*Ketoh*, its silver plate marked with strong stamping and repoussé lozenges, last quarter of the 19th century. Photograph courtesy of Cyndy and Bob Gallegos

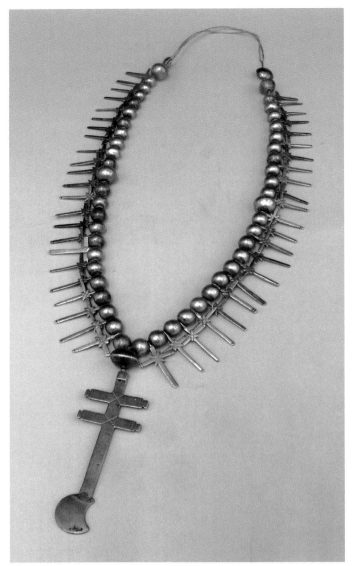

Cross necklace from Acoma or Isleta Pueblos, ingot or coin silver, ca. 1880–85. Photograph courtesy of Cyndy and Bob Gallegos

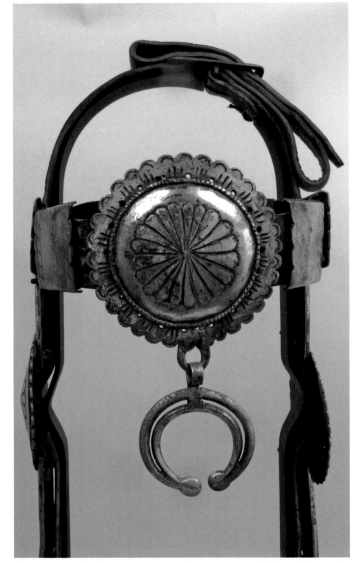

Navajo bridle, ca. 1875–80, with rocker–engraved silver side panels and Navajo–made bit. Horse bridles were the source of key silver jewelry forms. Photograph courtesy of Cyndy and Bob Gallegos

slow recovery from near annihilation to make products desirable around the world. Cast against that background, the labors of Navajo and Pueblo jewelry makers stand out because of their perseverance and devotion to creating beauty in the face of great disadvantages.

Narratives about Southwestern Indian jewelry making are scattered and highly incomplete. Until the late 1970s, this literature was largely dependent on local sources who based their writing more on opinion and sentiment than fact; many of these publications were authored by individuals in the Indian arts business who chose to focus on their own perceptions. The exception to this narrow perspective was the groundbreaking work of anthropologist John Adair, *The Navajo and Pueblo Silversmiths* (1944), based on research conducted on the Navajo reservation. At last there was a study in which the subjects themselves were interviewed and given a voice. Adair took a keen

look at design issues; his work signposted what direction future investigations should take.

Research into America's Indigenous peoples means encountering the rules established by the dominant, controlling class of European Americans. Non-Native museum curators and educators, Indian traders, dealers, and wealthy collectors of high social standing were the creators of such rules. These rule makers insisted on ethnographic evaluation when they considered Indian artistic production. They determined that Native-made works such as pottery and jewelry better fit the category of "material culture" since they were intended to have functional purpose. This bias ran deep. Exhibitions about arts produced by Native peoples invariably appeared in natural-history museums, not museums devoted to fine arts.

After certain kinds of Indigenous arts became objects for sale in the national marketplace, however, their makers

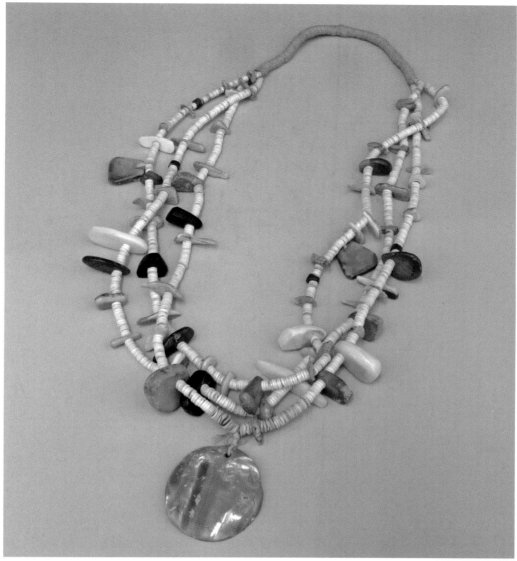

Traditional Pueblo necklace with pump-drilled tabs, late 19th century. Photograph courtesy of Cyndy and Bob Gallegos

started to work in a different mode. Outsiders from the dominant culture began to ask for various changes. Whether consciously or not, Navajo and Pueblo jewelry makers now exercised their critical judgment in order to retain control over their inventive impulses and design directions. Once we understand this fundamental truth, the history of Navajo and Pueblo jewelry making is less about outsider patronage and more about thoughtful adaptation and personal awareness of developing artistry.

Between 1890 and 1945, Navajo and Pueblo jewelry and its design assumed three distinct identities: tribal adornment, tourist commodity, and unique American craftwork. All of these identities entailed increasingly navigating through marketplace demands and the dominant popular culture. Doing so involved such activities as makers demonstrating their craft to outsiders, submitting work for judging in fairs, and working with Indian traders and non-Native collectors. Changes in jewelry fabrication and

design left a trail of significant social markers over the years. By the 1940s, this Native jewelry was winning national attention and praise.

In the precontact era, Indigenous peoples in South and Central America practiced metallurgy; they used the smelting process and worked with multiple types of metal, including gold and silver. The case was much different, however, in North America. Archeological evidence indicates that Indigenous peoples there found and used natural deposits of copper only and shaped them by heat and cold-hammering techniques alone. No other precontact metallurgical practices have been discovered in Native North America—especially the smelting and shaping of silver or gold.

When we assess how extraordinarily well Navajo and Pueblo peoples handled what was a new craft, this success needs to be set into historical context. Rapid, confident changes in the development of metalwork adornment can be noted and tracked. Pueblo lapidary creation is also

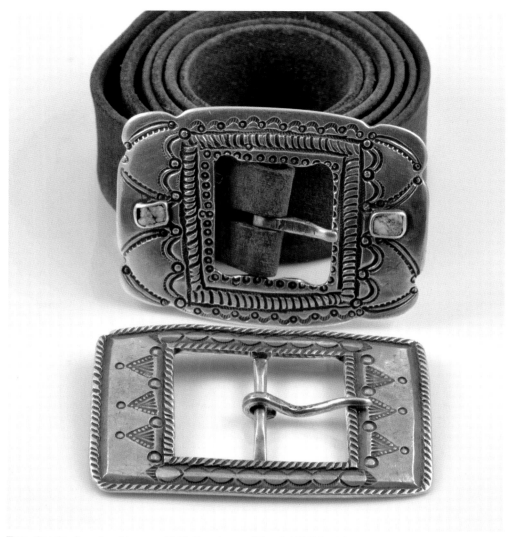

Two classic silver buckles, ca. 1915. Courtesy of Frank Hill Tribal Arts

documented, especially when traditional lapidary work becomes paired with silver. One of the most remarkable, unusual, and ironic aspects of this seventy-five-year span is that nineteenth-century Navajo and Pueblo silverwork was being called "traditional" by the 1930s!

The construction of traditional beadwork was a laborious task, requiring painstaking assembly and attention to detail. When Navajo and Pueblo silversmithing first began, this process was equally painstaking because of the very rough tools and limited techniques these blacksmiths had at hand. Their initial jewelry forms nevertheless emerged endowed with powerful aesthetic appeal to all who viewed them.

These peoples' skillfully created jewelry was intended to fulfill essential cultural needs. Navajos and Pueblos wore jewelry for everyday activities and dressed up for ceremonies and special events. Jewelry—and its design— was personally important for sacred, social, and (most important during the last quarter of the nineteenth century) economic reasons. A piece of jewelry itself, such as a silver button or manta pin, could also be used as currency in barter and trade.

Economic need helped drive the early decades of jewelry production. The arrival of non-Native Indian traders brought an American frontier business mode that helped Navajos get back on their feet after their incarceration and permitted Pueblos to enlarge their local commerce. Traders who went to live on or near the Navajo reservation proved to be financial lifelines at this time. So began the first genuine cross-cultural transactions that would lead to the increased importance of Indian jewelry making.

The great majority of images shown in this book do not come from museums, which are usually the ultimate authoritative source for other types of art. Navajo and Pueblo jewelry making is an active art with a market established relatively early in its historical progress. The collecting of Southwestern Indian arts by non-Natives allows us to view many valuable works that are instructive in their construction and design. Regional museum curators began gathering this sort of jewelry not long after the Smithsonian Institution's nineteenth-century expeditions left the field. Both of the region's two most active Indian arts fairs began in the early 1920s. Personal collecting was well underway by then.

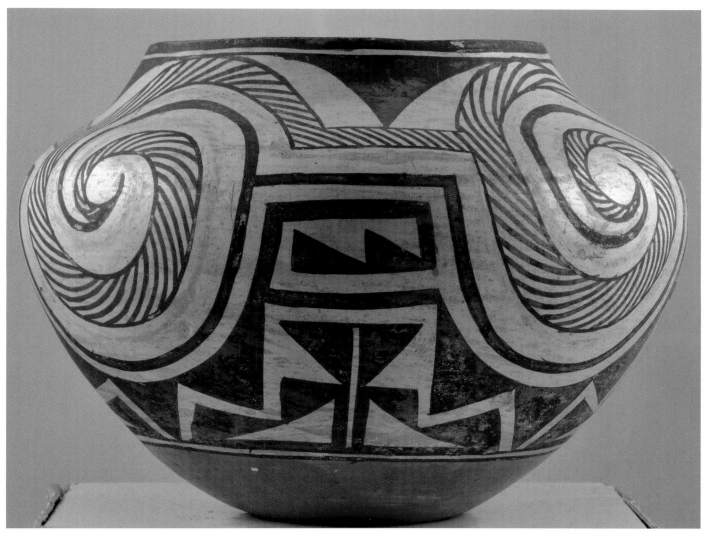

Spiral designs, as on this Acoma pot (ca. 1900–1910), resemble design choices for jewelry. *Courtesy of Paul and Valerie Piazza*

Since jewelry was an essential part of Native dress, photographs and postcard photos of Navajos and Pueblos between 1870 and 1945 show the historically significant jewelry forms they wore. Some of these images can be found in this book. However, it's important to note that these images were created by non-Native observers, largely for the tourist trade. Some of photographer Edward Curtis's artful portraits also appear here. (Curtis's role as a documenter of Indigenous peoples remains somewhat controversial. Indians today point to his controlling need to present his subjects in posed and often inaccurate attire.)

Curtis's photos tell us about his times—the period between the end of the nineteenth century and the first decade of the twentieth century. Curtis's great, multivolume work *The North American Indian* (1907) brought new attention to the plight of Indigenous peoples of the United States. By 1900, many non-Natives like Curtis sincerely believed that the Indians would either become wholly assimilated or go extinct. The devastating Indian wars and subsequent reservation era, when children were forced into boarding schools, left a frighteningly small and battered Native population.

Curtis photographed many western tribes, but his portraits of Southwestern Natives possess a special feature. He pictured Hopi, Zuni, and Navajo individuals wearing obviously personal adornment. Although he certainly staged many of his subjects and some wear historically inaccurate accessories, he managed to capture Navajos and Pueblos in the process of making jewelry or wearing their new jewelry forms. In fact, many of his portraits, including the ones shown in this book, seem to feature specific jewelry as part of the nature of his subjects. We see how lovingly masses of jewelry were bestowed upon children and how even one piece of jewelry, such as an earring or a shining *naja*, helps illuminate the essential humanity of the individuals he portrayed.

As the nineteenth century passed, the American Southwest began to draw new settlers and visitors, and from these people arose non-Native art patrons and artists ready to visualize and celebrate (even romanticize) Navajo and Pueblo culture in print and on canvas. Indian arts such as pottery, weaving, and basketry were already popular. This new wave of Indian arts advocates showed their appreciation of Navajo and Pueblo jewelry by collecting, wearing, and

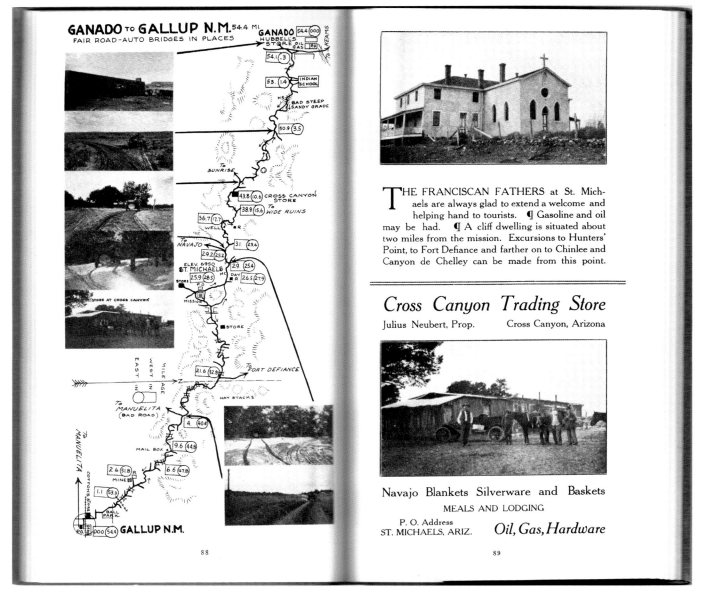

A 1913 tour book to Arizona roads, with an ad showing a trading post offering Navajo silverware, among other goods, for sale. Author's collection

promoting its beauty. These promoters prevailed upon the US government to aid Native jewelry-making growth and development during the Great Depression.

This cultural accommodation, however, did not yet include the voices of the makers themselves. Before 1945, we mostly learn how non-Native advocates perceived Navajo and Pueblo jewelry creation. In many cases, the reasons for this are obvious. Not all Natives could speak English well, and they possessed a cultural modesty that precluded the kind of "boasting" that non-Natives seemed to want from them. Instead, Indian traders and curio dealers such as the Fred Harvey Company sought to speak for them. Opportunities for gathering information were lost.

John Adair emerges as a groundbreaking figure with the 1944 publication of his study The Navajo and Pueblo Silversmiths. Without Adair's research, the history of the

first seventy-five years of jewelry making would have no foundation beyond speculation. Adair's broader anthropological assessment in the late 1930s focused on far-from-diminished peoples. Native jewelry making, among other things, was definitely artistic creation, even if it was not recognized as fine art in 1945.

*Navajo and Pueblo Jewelry Design: 1870–1945* is organized in a linear, chronological order. The text progresses in terms of decades or fifteen-year periods. Each chapter opens with a historical timeline and ends with a review of key features in jewelry during that period. There are dangers in such arrangements: developments in 1929 may spill over into the 1930s, but the emphasis is on when construction and design elements mature and change. Therefore, chapter 1 reviews and explains what characteristics constitute design, and sets out the design terminology that will appear

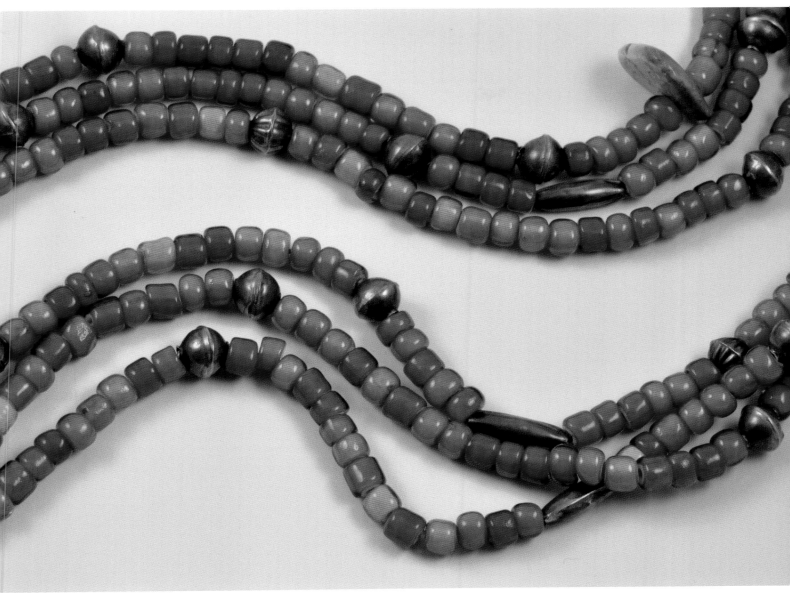

Red glass trade beads necklace with round and melon silver beads, ca. 1910s; imported glass trade beads were an influential cross-cultural adoption by Navajo and Pueblo bead makers. *Courtesy of Karen Sires*

throughout the book. Chapter 2 treats the historical era before 1870, including those activities that helped shape the direction of Navajo and Pueblo jewelry design.

In chapter 3, we see the first two decades of dedicated silversmithing in process, wherein jewelry forms and shapes are quickly established, and surface patterning serves as unique decoration. Chapter 4 shows how the last decade of the nineteenth century consists of constant experimentation and more expressive use of surface patterning.

Chapter 5 describes how technical innovations bloom between 1900 and 1915. In chapter 6, we begin to see how the next fifteen years of Navajo and Pueblo jewelry design mesh with new interest in modernist approaches to line, space, and abstract motifs. Chapter 7 examines how 1930s jewelry finishing becomes more assured and polished. Navajo and Pueblo fabrication and design take on a

maturity that can be labeled "classic." In chapter 8, jewelry design begins to point toward postwar developments, with figural design motifs and greater attention to detail. Chapter 9 summarizes the achievements of seventy-five years.

There are many things that may never be known about this period in Native jewelry history. Yet, the twenty-first century will be the time when underrepresented Native scholars come into their own with valuable insights into the historical movement from craft into art. I'd like to offer this particular narrative as a means to wrap up, correct, and discard outworn and dated perceptions, leaving the field free for future Native American study and erudition. In the meantime, I hope to demonstrate how our lives are all the richer for the artistic accomplishment recorded on these pages.

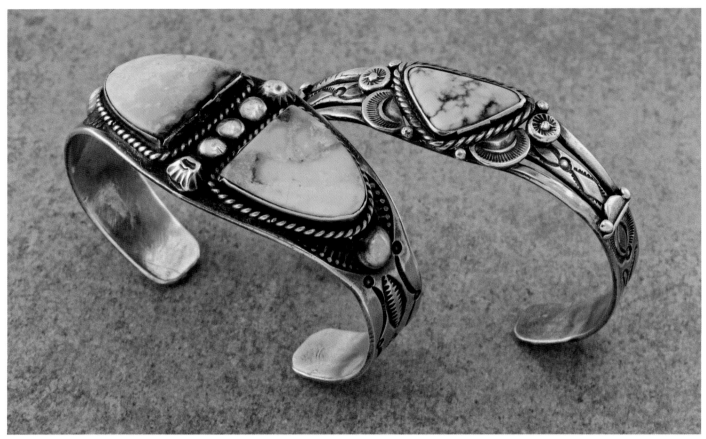

Two fine silver and turquoise bracelets by Hopi silversmiths: (*left*) Grant Jenkins, ca. 1930; (*right*) Homer Vance, c. 1935. Photograph courtesy of Pat & Kim Messier

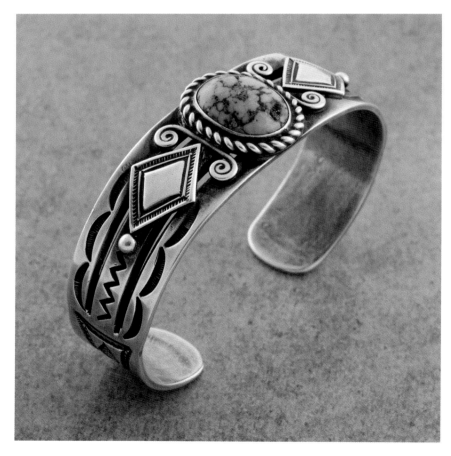

A striking Fred Harvey Company commissioned bracelet stamped "Fred Harvey Navajo," in lieu of artist's hallmark, ca. 1940. Photograph courtesy of Pat & Kim Messier

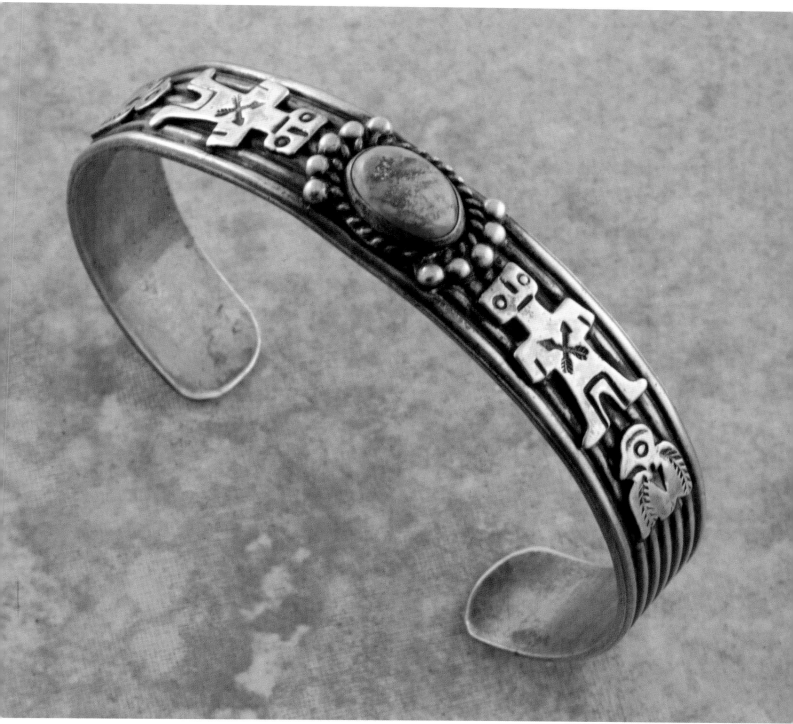

A bracelet with typical commercial design motifs, made in Maisel's Albuquerque shop; it has a sticker on the verso explaining that the piece was made in a process using mechanized tools, ca. 1936–40. Photograph courtesy of Pat & Kim Messier

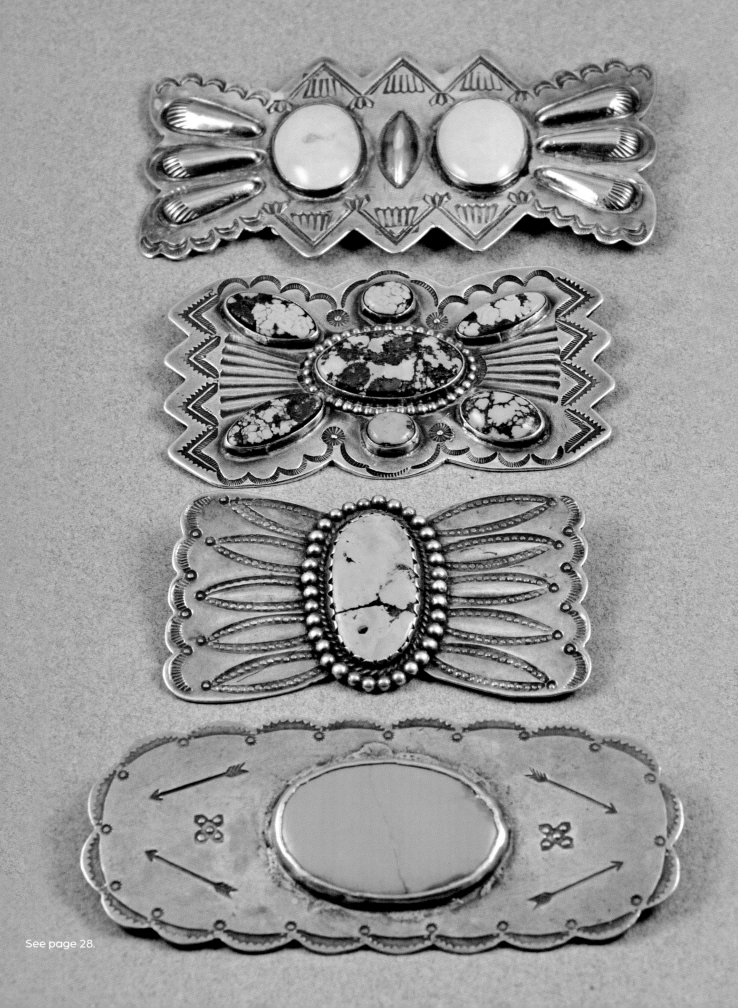

See page 28.

# Design Origins

The history of Navajo and Pueblo jewelry making in the American Southwest after the Civil War is a remarkable story of rapid aesthetic achievement. Over the course of seventy-five years, from 1870 to 1945, their tribal adornment moved from local and souvenir status to artful ornamentation with worldwide appeal. This is a triumphant story indeed, in which Native creators worked with, for, and against non-Native business norms in order to shape a product with great charm based on ethnic tradition, fine construction, and personal vision. The reason that Navajo and Pueblo jewelry expanded beyond its regional identity has everything to do with its dynamic design.

The development of this appealing design sustained families through hard times and helped generate a profession that allowed its makers to support themselves in a harsh—but inspiring—geographical landscape. Over the decades, these two peoples became the backbone of a Southwestern Indian arts market that would make the region a good place for Indigenous artists to work, exhibit, and sell. This achievement, wonderfully cross-cultural in nature, deserves serious study, but the literature on this subject has not always been as objective as it could be.[1]

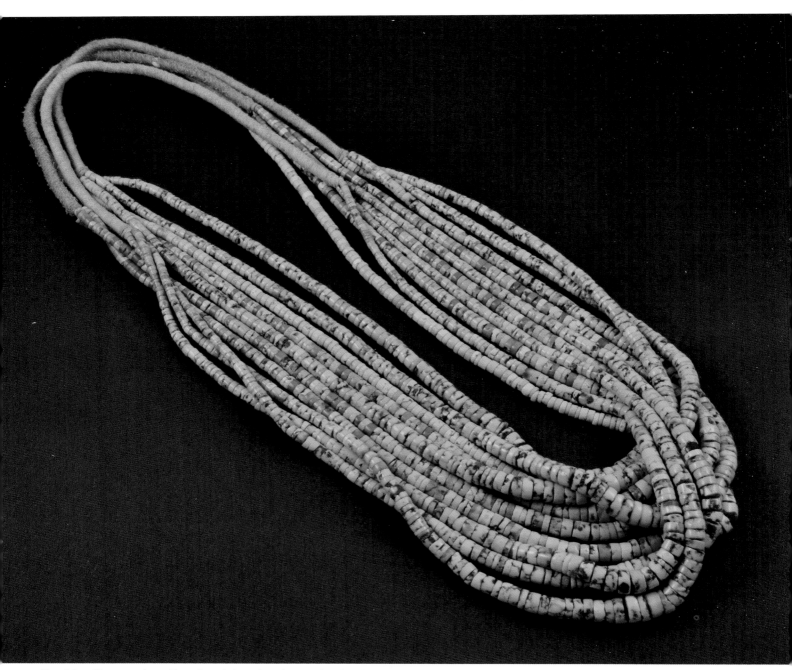

*Tradition:* The creation of handmade beadwork stretches back to the Ancestral Puebloans and other ancient cultures of the American Southwest. Private collection

The development of Navajo and Pueblo jewelry design illustrates how its makers chose to face acculturation: they implemented an initially unconscious form of **survivance**, a means whereby they kept their work aesthetically vibrant.[2] Survivance helps explain the ways in which artistic decision-making was used to make a popular product bridge cultures while staying true to core values and economic requirements. Navajos and Pueblos made sure that they always put something of their original ethnicity into their creations going forward. This allowed them to look back even as they moved ahead into the future.

Although non-Natives clearly helped them prosper in the ethnic-art marketplace, Native American jewelry makers controlled their objectives, accepting suggestions and amendments when financial gain was necessary. The product, however, always needed to be centered on design elements that the creators alone could provide. This essential originality is one of the keys to the popularity of Native-made adornment over the decades.

Publications about this jewelry first appeared when non-Native patronage was deemed a major factor in its success. Early Navajo and Pueblo jewelry production was labeled "primitive art." This description was especially relevant at a time when non-Native writers and critics were celebrating primitivism in art for the primacy of its design, spurred by a growing age of modernist aesthetics. Because Native jewelry creation remains a living art, museum permanent collections and exhibitions tell an excellent but not comprehensive story. As social conditions changed for Native jewelry makers, so did their aspirations. For them, forming jewelry was a journey that eventually transformed these makers into recognizably full-fledged artists.

Telling this story requires employing a methodology that does not rely solely on the anthropological or art historical. Historical investigation is essential, but our study also needs to embrace economic, object-creation, societal, and technological considerations. This examination calls for a design history approach, whereby we look at the record

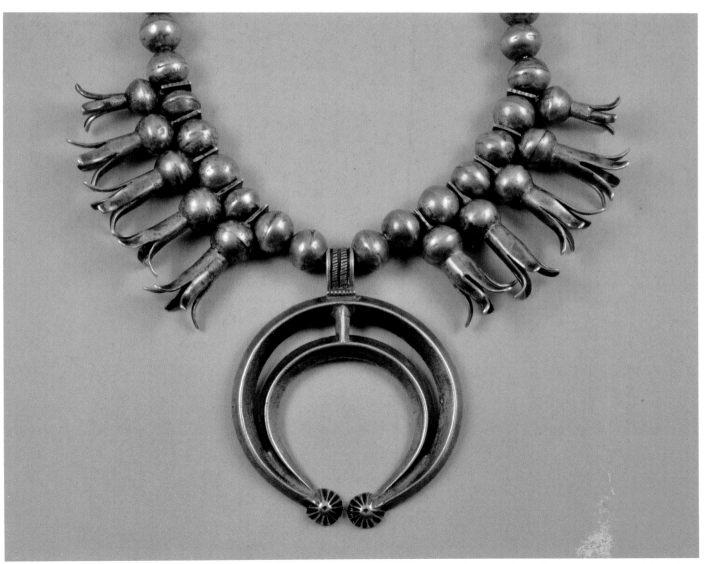

*Craft (Construction):* The squash blossom necklace is the oldest and most unique jewelry form fashioned by Navajo and Pueblo smiths. Courtesy of Michael Haskell Collection

of Navajo and Pueblo Indigenous-inspired design and note when the narrative history changes due to **tradition**, **craft (construction)**, and **personal insight**. In terms of tradition, there were two influences. The first tradition was ancient, derived from precontact bead working. The second was newly adopted skilled metalworking. These traditions take in historical cultural practices related to adornment and dress, including popular-culture influences current when an ornament was made. Craft, in the context of this narrative, is meant to indicate the changing use and development of various jewelry-making techniques, tools, and materials. Personal insight denotes the inner vision of the maker, influenced by past and present tradition and craft, and includes the maker's artistic motivation.

Before we study the origins of Navajo and Pueblo jewelry design, we need to look at the basic units of design itself. These features derive from that mix of tradition, craft, and personal vision. In the decades that make up the period from 1870 to 1945, design elements appear, change, are enhanced, or receive modification, based on tools, construction, materials, and artistic intentions. There are discrete differences between Navajo and Pueblo aesthetic preferences, although they become comingled over time, based on intermarriage, reciprocal agreements, and shared values. During the first decades of their metalworking phase, however, it remains difficult to distinguish between these peoples' design choices.

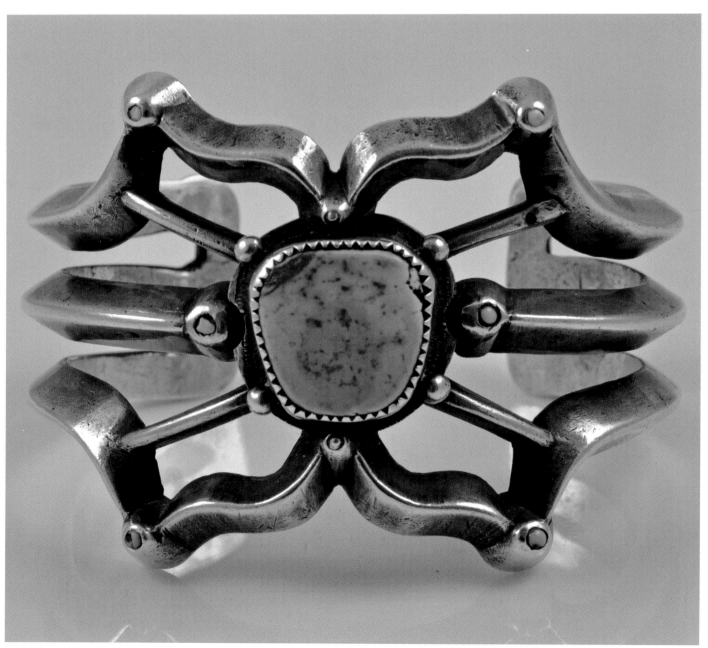

*Personal Insight:* The skillful creation and decoration of bracelet forms was dictated by the maker's personal aesthetic vision. Courtesy of Karen Sires

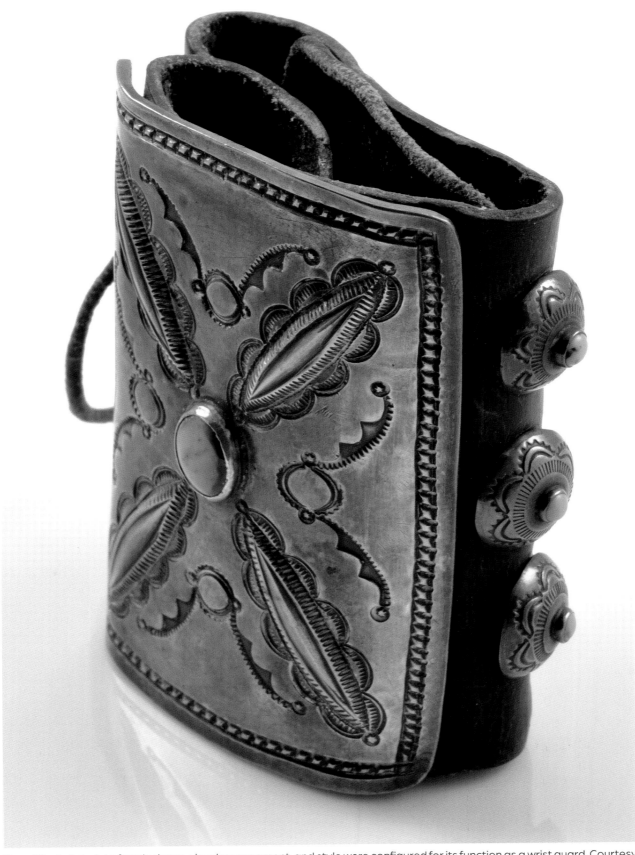

*Form:* The *ketoh* plate form's shape, visual arrangement, and style were configured for its function as a wrist guard. Courtesy of Paul and Valerie Piazza

## Defining Design and Its Elements

Design elements possess visual messages. These basic units of design compose the features belonging to a three-dimensional form of adornment. From the very start, cast silver openwork and hammered silver beads and bands had a sculptural appearance. Therefore, *form*, *shape*, *size*, and *texture* are primary design elements. Changes in these

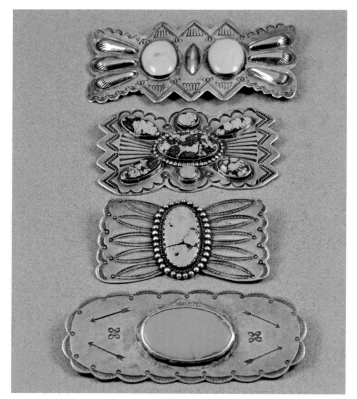

*Shape:* These early pins possess shape through the lines and texture of their enclosed areas, which in turn affect their three-dimensional composition. Courtesy of Joan Caballero

four characteristics were deeply influenced by social and personal demand. Pre-1870 metal jewelry shows borrowings from Northeast and Plains Indigenous ornament, knowledge of Spanish colonial decoration, and a primal taste for heavy pieces.

When we separate shapes and forms from surface decoration, we also see an aesthetic attachment to strong *lines*, *tone*, *contrast*, and *color*. These terms will appear again and again in each chapter's appraisal. Subtle changes in these vital design units are indicators of social acceptance and eventual social change. It is much too simplistic to say that Navajo design favored straight geometrical lines whereas Pueblo lines were more organic and rounded. We need to understand that early dies and stamps were handmade from metal scraps and more easily created straight line incising and engraving. Choices related to color, however, belong firmly to Navajo and Pueblo spiritual beliefs and aesthetics.

We must also consider elements that relate to bringing form and decoration together. These include

- *balance* and *hierarchy of arrangement*
- *dominance* and *emphasis*
- *scale* and *proportion*
- Tones and color are affected by *gradation* and *repetition*.
- Lines and contrast can possess *unity* and *harmony*.

In general, most tastes run to symmetry in design, but even asymmetry can be aesthetically appealing. Design motifs and patterns for jewelry began as perceived abstraction, which gradually moved to realistic representations; motifs created before 1945 may or may not have a tendency to dominate or emphasize a composition, while patterns regularly offer balance and/or repetition.

## Design Elements

Design elements with physical characteristics:
**Form*, *Shape*, *Size*, *Texture***
These terms refer to three-dimensional heft, weight, and object appearance.

**Design elements that relate to surface decoration:**
***Color*, *Contrast*, *Line*, *Tone***
These terms refer to the patterns and visual nature of an object's surface.

Design elements that reveal the creator's intentions and activate the viewer's aesthetic judgment:
***Balance*, *Hierarchy of Arrangement*, *Dominance*, *Emphasis*, *Scale*, *Proportion*, *Gradation*, *Repetition*, *Unity*, *Harmony***
These elements affect the appearance of motifs and patterns.

*Size:* Early Navajo and Pueblo jewelry tended to be large in size, perhaps reflecting the vastness of the landscape around them.

Changes in design elements signal the introduction of new tools and techniques or the maker's reaction to social and marketplace forces. The first years of Navajo and Pueblo metal jewelry creation were devoted to making adornment for Native consumption only. Since there was no real tradition of metalwork among the Indigenous peoples of the Southwest, they were free to adopt from other cultures through geographical contact and define their own taste. As a result, they invented forms, shapes, and surface decorations for jewelry that were exceptional in their originality.

It is important to understand also that these peoples' relationships with nature and the sacred are reflected in such design elements as stepped lines, loops, circles, contours, and texture. Imagine that the lines and curves represent the course of rivers, the contours of the mesas, textures of canyon walls, and doorways and ladders to buildings. Repoussé and raised appliqué, used early and often, added a dimensional character of contrast and tone. From the start, colors were deeply meaningful, whether they represented consecrated directional boundaries or the raw materials of the world as they saw it, especially gemstones.

The earliest silversmiths were in fact blacksmiths, and their facility with iron, brass, and copper served them well with the adoption of silver from the coins they were paid with. Post–Civil War Native jewelry makers impressed all viewers by how strongly they created and manipulated design elements. Their design vision was powerful from the start, shaped by individual experimentation with the bounds of conventional forms.[3] In particular, the first three decades of silversmithing show a growing confidence in rendering surface decoration.

When more and better tools became available, improved construction allowed design expression to thrive. With the progression of craft techniques, Native smiths readily pursued personal design innovations. Nor were they afraid to pair this new silverwork with age-old natural materials. Engravings and photographs from the late nineteenth century show Navajos and Pueblos wearing separate strands of both organic and metal beads. The next step would be adornment combining stone and silver.

The intrusion of outsider marketplace concerns voiced by incoming non-Native Indian traders and curio store suppliers brought change. The design elements immediately influenced by commercialization were size, scale or proportion, and a hierarchy of arrangement of surface decoration. The first experiments in metalwork tended to be large scale and have strong contours and contrast. Casting, done with local tufa rock, created robust texture on openwork. More refined designs appeared after Native smiths abandoned chisel filing and rough dies for handmade or manufactured tools that aided punching and stamping. They also gained access to cut and shaped cabs of turquoise and other stones.

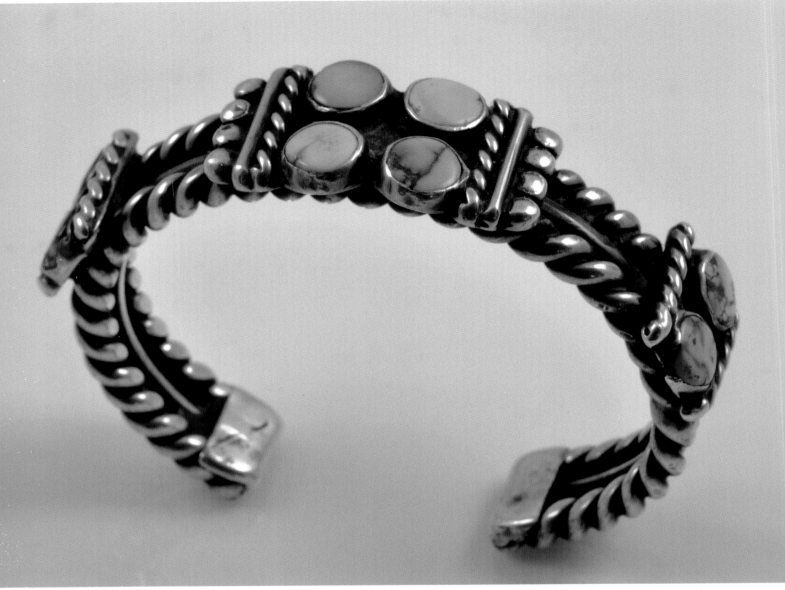

*Texture:* The surface quality, or the way a piece of jewelry looks and feels, reveals how important an element texture could be in its creation. Courtesy of Suzette Jones

## Cultural Jewelry Design Origins

Human design springs from the head and the heart. This means we must turn to look at the inherent qualities of Navajo and Pueblo beliefs and aesthetic appreciation. It also requires understanding the role of jewelry in their cultural contexts. These peoples' adornment could be washed and blessed, danced, bartered and traded, even buried in graves with its owners—all activities related to material and spiritual needs. They wore jewelry for ceremonies, social dances, family events, and occasions when they wished to look their best. Turquoise, in particular, held a deep cultural meaning for Indigenous peoples.

The core values of the peoples are rooted in a common desire for order and harmony and a deep appreciation for beauty in nature as well as in handmade endeavors. For the Pueblos, survival depends on the sacred forces of cooperation, harmony, and balance, but Pueblo rites are not for the uninitiated or outsiders. The Pueblo people are deeply aware of evil in the world, and materials like jewelry (especially shell and turquoise) have sacred properties that serve as a bulwark against malign forces. The Hopi have specific terms to indicate such powers: *suyanisqatsi* is the condition that brings harmony and balance, whereas *koyaanisqatsi* denotes chaos and social disorder.

The Navajo share their own vision of living in beauty, goodness, and harmony in all things as being the state of *hózhó*. To have *hózhó* ensures that the people, the Diné of Dinétah, live in health and well-being, protected by the *Diyin Dineʼé*, or "Holy Ones." Like the Pueblo, the Navajo share the concept of interconnections between human life and the natural world. The Navajo Beauty Way calls upon

30

*Color:* Navajo and Pueblo jewelry was constructed in colors drawn from the earth and the sky.

*nizhoni* as a means of walking in harmony through all aspects of life. The beauty of jewelry, its materials and design, serves as a means of confirming both beauty and *hózhó*. For example, jewelry plays a role in the Navajo *kinaaldá* ceremony, a coming-of-age ritual for young girls.

The visible world around these Indigenous peoples was informed by a rich cultural knowledge based on origin stories, sacred landscapes, cosmologies drawn from emergence tales, and objects important to prayer and ritual. As expected for those who lived in an unforgiving terrain where water is life, all the natural phenomena associated with this precious resource had visual and spiritual power: rivers, streams, lakes, clouds, lightning, thunder, and rain. Rain was sacred, as a gift offered by spirits of the ancestors, invoked by necessary prayers and rituals and not to be taken for granted.

The peoples' legends and lore were oral wisdom to be taught to the young. Often this would be done communally through dances and ceremonies. Jewelry was as much a part of this process as is the European American rituals of dressing for church attendance, although Navajo and Pueblo adornment could also be worn as part of everyday life. The design of such jewelry resided not in explicit patterns but in the physical characteristics of the material from which it was made. Shell had to do with life and death, and turquoise possessed various sacred properties. It is also extremely important to note that over the years, many Pueblos and Navajos chose the Jesus Road, adding their Christian belief to their cultural inheritance.

The Native acceptance of silver as a powerful source for ornament had to be linked to their own world of perception, and over time both Navajos and Pueblos identified this gleaming material as the "metal of the moon." The northern Rio Grande Pueblos obtained metal adornment in trade with Plains cultures because they liked the Plains ornaments. By the early 1800s such objects were observed on Navajos who obtained them through raiding or trade.

A taste for bead and metal adornment was shared by both Navajos and Pueblos in the mid-nineteenth century. This jewelry was also a potent social representation of much-desired material prosperity. The early silversmiths created jewelry forms rapidly. Some configurations reflect

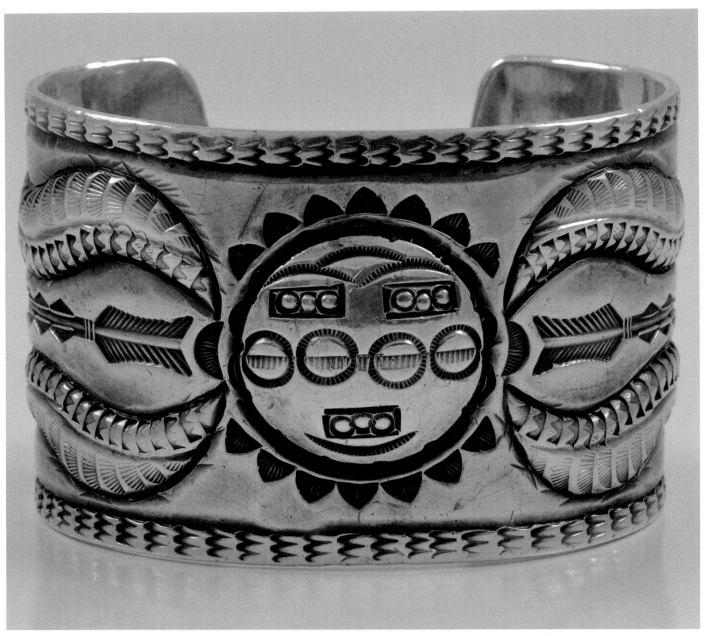

*Contrast:* A piece of adornment could be made in a way that highlighted the difference between design elements, making one or more elements more visually powerful in appearance. Courtesy of the Hoolie Collection

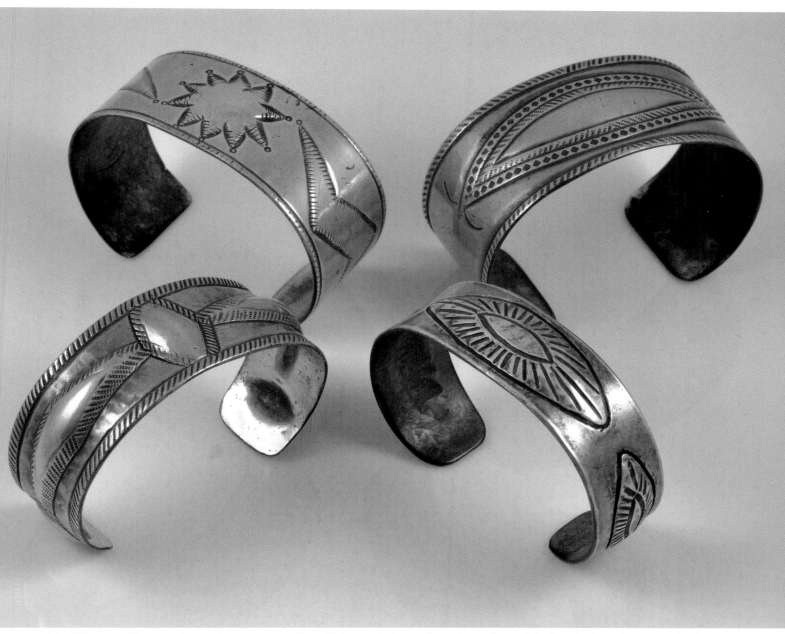

*Line:* The use of lines for decoration creates an identifiable path that defines the surface of the jewelry form. Private collection

basic dress needs: manta pins, band bracelets and rings, silver beads, and concha (or concho) belts. Nor is it any surprise that they first concerned themselves with the primary design elements of form, shape, size, and texture. The sources for this adornment reflect keen observation of both Native and non-Native people around them.

Pre-1945 Southwestern Indigenous design motifs, such as rain birds, deer, and water serpents, were drawn from ancient and contemporaneous pottery. Plains Indian ornaments obtained through trade, especially bangles, were copied. Later, designs from Mesoamerica, conveyed by the ancestral Puebloans, Hohokam, and Sinagua peoples, provided patterns and motif sources—especially after non-Native archeologists began excavating sites throughout the Southwest.

As silversmithing was transmitted to others, a primary interest in additional elements emerged, using color and the need to create pleasing surface decoration. Filing and rough punchwork gave way to indelibly incised stamps. The results were remarkable. And by the time that the earliest

elements were strong and distinctive, Native smiths sought to embellish them for the purposes of aesthetic gratification: hierarchy of arrangement, emphasis, and the repetition of fledgling patterns or motifs. The greatest goal, however, was a constant striving to create pieces displaying balance and harmony. Surface decoration was enriched through a combination of repoussé, attractive stamping, and appliqué. Contemporaneous Native cultural pursuits, like embroidery and weaving, offered examples of design borders.

Lines, both straight and curved, make up the most powerful border and central designs. Combined, the most direct patterns are crosses, chevrons, simple and serrated diamonds, triangles, zigzags, and terraced boxes. Curved shapes resemble seashell scallops, wavy hill and mountain silhouettes, half-moon clouds, and crescents. Rows of straight or bent short lines accompany contoured surface decoration, often mimicking organic outlines that may be seedlike in appearance. When mixed with repoussé and appliqué, these lines enhance contrast and tonal values.

*Tone:* This optical impression, which can be seen in nature, shows how light or dark an object can be, thereby creating a different visual effect.

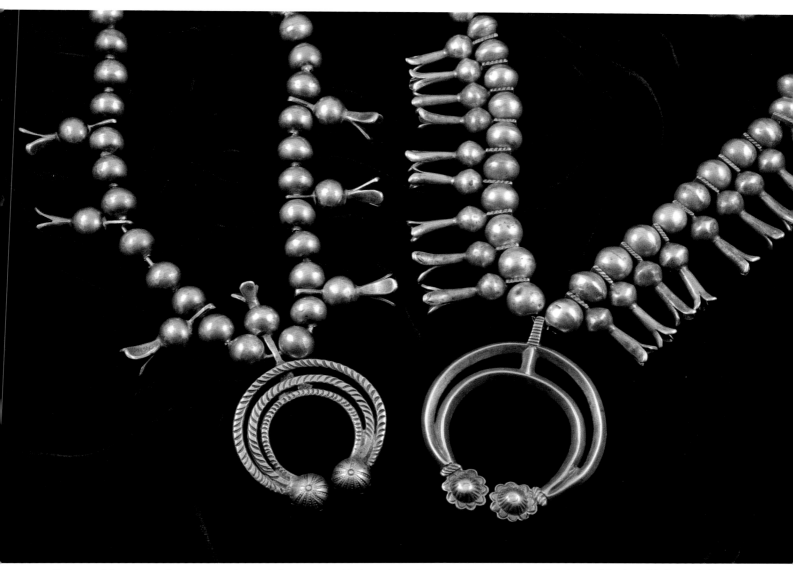

*Balance:* A jewelry maker can use elements in a manner that renders visual stability to a piece. Courtesy of Andrew Muñana Collection

Exposure to adornment worn by Spanish colonial, Mexican, and American settlers provided outsider design fodder for jewelry forms and aesthetic preferences. Spanish filigree and horse bridles, Mexican leatherwork decoration, and key shapes from American settlers, such as the cigar band and signet ring forms, were absorbed, amended, and recast to suit Navajo and Pueblo tastes. The three most influential jewelry forms brought by outsiders meshed with Native adoption and adaptation choices: the circle, or bead; the inverted horseshoe, or curved pendant; and the cross.[4]

A few points should be made about design motifs. Realistic depictions of animals and humans on jewelry developed slowly and infrequently between 1870 and 1945. In the 1920s and 1930s, certain animals, birds, and insects appeared in stylized forms, including thunderbirds, butterflies, and dragonflies. Designs featuring human figures largely show images of dancers impersonating sacred spirits wearing masks and ceremonial garments, much like those on early-to-mid-twentieth-century Navajo weavings. The exception comes with commercial tourist jewelry, for which stylized human figures on flatware and stereotyped animals, among other designs, were invented and offered for outsider consumption well before they carried over into hand-wrought design.

Once non-Natives began developing an early Indian curio arts industry, they attempted to establish metalwork as a long-standing craft "tradition" such as existed for weaving, pottery, and basketry. The commercial Indian arts industry's vision of these arts, however, was generic in nature and covered tribal design across the continent. Historical circumstances would make the Navajos and Pueblos the most prodigious and prolific of Indian adornment metalworkers. Their highly recognizable jewelry forms would soon become the standard for commercial manufacturing of "typical" Indian jewelry. In truth, however, there was nothing typical to be found in these peoples' hand-wrought designs.

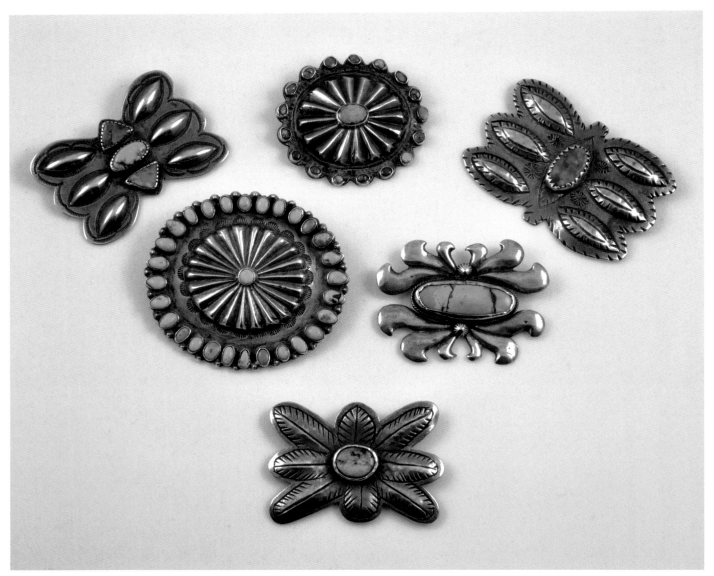

*Hierarchy of Arrangement:* Jewelry can be made through the control of visual information, whereby elements are presented in a way that signals their importance. Courtesy of Suzette Jones

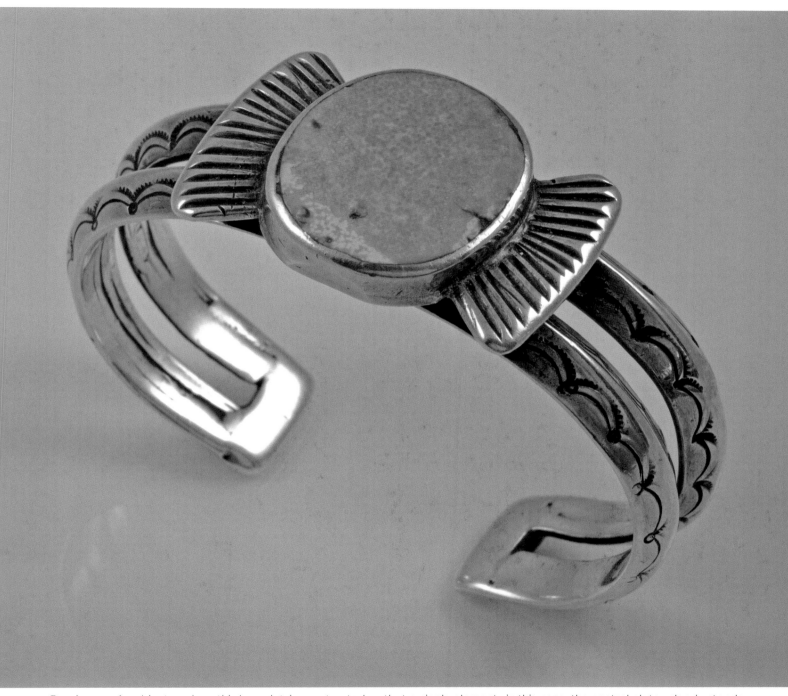

*Dominance:* An object, such as this bracelet, is constructed so that a single element—in this case, the central plate—clearly stands out in the overall design. Courtesy of Suzette Jones

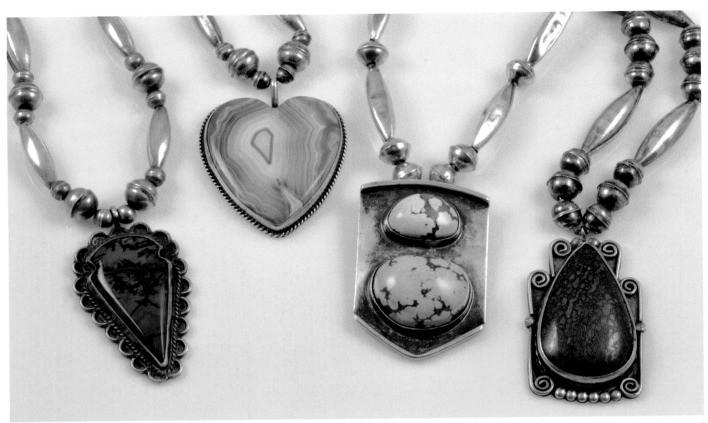

*Emphasis:* The focal point in these pendants are the stones, and they thereby serve to attract the viewer's attention. Courtesy of Elizabeth Simpson

*Scale:* This element puts the size of one object in relation to other objects, as in a human's size within nature.

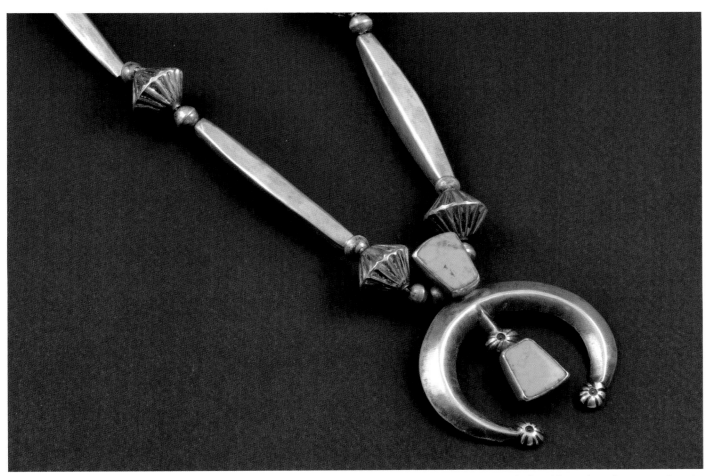

*Proportion:* An important element in jewelry making, the size of the parts in this necklace have a relationship to the other parts therein, creating a positive visual effect. Courtesy of Suzette Jones

*Gradation:* This element shows how objects in nature or human-made form can gradually transition from one color, shade, or texture to another.

*Repetition:* The recurrence of a pattern within an object can create a sort of rhythm or sense of movement. Courtesy of R. B. Burnham & Co. Collection

*Unity and Harmony:* These elements can be found in a well-finished piece of jewelry, tying its composition together to produce a sense of coherence. Courtesy of Elizabeth Simpson

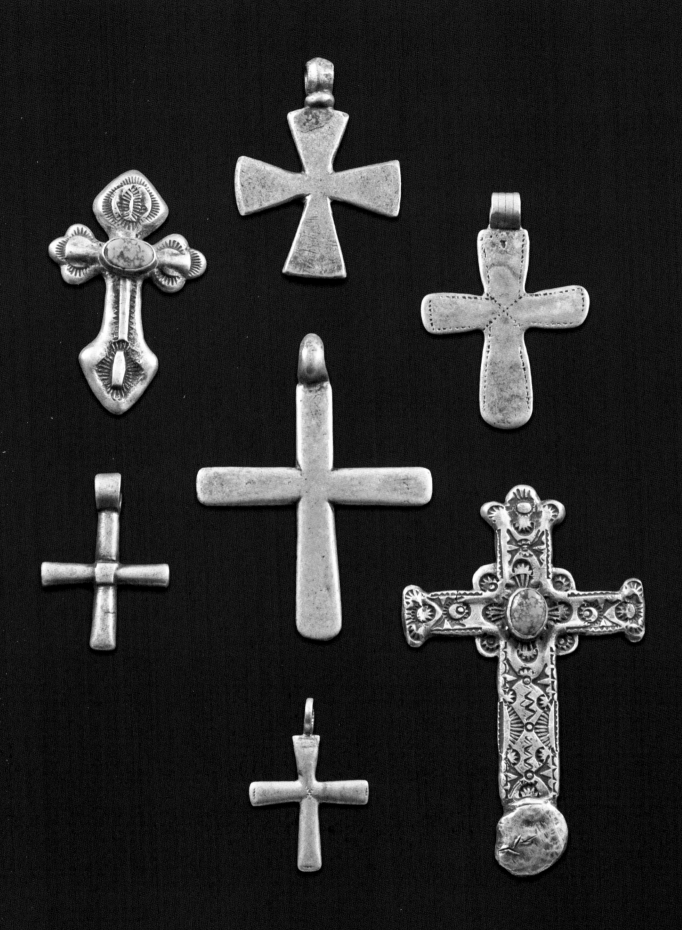

See page 59.

# Design up to 1870

"The business of America is business" is a famously misquoted statement used to summarize national ambition.[1] In this historical account, the process of Indigenous artistic transformation has been affected by changing American business development. The success of Navajo and Pueblo jewelry making was based on a unique design visualization shaped by cross-cultural marketplace factors. From 1870 to 1945—a period marked by great social change and Native reaction—tradition, construction, and personal vision combined to build a design vocabulary that ensured economic success for its Indian creators.

This story, however, should start at its beginning. Therefore, let us look at the American Southwest in the era before 1870. Two different cultures, arriving in the region at different times, faced war, upheaval, and a long period of colonization. Once under the control of the US government, they made critical choices that would preserve their lifeways in the decades to come.

# TIMELINE

| | |
|---|---|
| **1541** | Francisco Vásquez de Coronado arrives in the region looking for gold |
| **1598** | Juan de Oñate arrives with first colonists |
| **1680** | Organized Pueblo Revolt drives Spanish from the Southwest |
| **1693–94** | Reconquest by Diego De Vargas; mission churches restored |
| **1700** | Reports of Pueblo people wearing Spanish-made beads and crosses |
| **1780s** | Reports of silver-trimmed bridles and ornaments acquired by Navajos |
| **1820s** | Navajo work iron first, moving on to copper |
| **1821** | Mexico takes over from Spain |
| **1830s** | Reports of Southwestern Indians acquiring German silver from Plains and Northeast Natives |
| **1840s** | Navajos and Zunis make simple brass and copper bracelets and earrings from wire |
| **1848–50** | United States acquires Southwestern territories from Mexico |
| **1850** | New Mexico becomes a US territory |
| **1852** | Capt. Henry Dodge brings blacksmith and silversmith to Fort Defiance |
| **1853** | Gadsen Purchase from Mexico nets the United States land in Arizona, California, and New Mexico, including Indian lands |
| **1853** | Report that Zuni pueblo has a working forge |
| **1853–58** | Atsidi Sani reportedly exposed to iron- and silversmithing |
| **1857** | New settlers to region identify precontact turquoise workings at Cerrillos, New Mexico |
| **1860s** | Acoma individuals seen wearing copper and brass adornment |
| **1863** | President Lincoln sends silver-topped canes to Pueblo governors to thank them for their loyalty to US government |
| **1863** | Arizona becomes a US territory |
| **1863–69** | First transcontinental railway built |
| **1864–68** | Navajos forced to make Long Walk to Bosque Redondo, captivity, and release |
| **1868** | Navajo Indian reservation is created |
| **1868–69** | Atsidi Sani, trained by a Mexican smith, may have made first silver belt and headstall |

## Enemies and Then Allies

The Southwest was invaded in the 1500s by conquering and exploitive Europeans. Spanish soldiers and colonists rode up the Rio Grande valley, battling and enslaving the Pueblo peoples they encountered. There was a briefly successful rout led by PoPé of Ohkay Owingeh (formerly San Juan Pueblo) in 1680, but the Spanish returned for good a decade later. Despite the warlike nature of the Puebloans, they were no match for steel guns and foreign germs. Many pueblos were abandoned, and many peoples relocated or integrated into other groups. Throughout the 1700s, the enslaved Pueblo peoples learned to live side by side with their foreign conquerors while slowly regaining a measure of autonomy.

The Puebloans inherited from their ancestors a rich vocabulary of jewelry and ornament made from natural materials. Pueblo beads and figurines were admired and traded among other Native cultures well before the Spanish arrived. To the great disappointment of the newcomers, gold was not worked by these northern Indigenous peoples. Historical records for this period are sparse, but the Spanish did find silver and copper workings, along with turquoise that Pueblo groups mined in north-central New Mexico.[2] Early Spanish settlers possessed decorative metalwork in the form of tableware or equestrian gear. This Spanish, and subsequently Mexican, design left an indelible impression on future Pueblo metalworkers.

In the 1800s, itinerant Mexican blacksmiths and silver workers (*plateros*) plied their trade through the Southwest territory. Indian blacksmiths had worked iron as early as the 1820s, and basic utilitarian items such as buttons, dress sew-ons, and bridle bits were made from this material. By the 1830s, trade with Plains tribes to the north and east brought German silver (a lesser-grade metal made from an alloy of copper, nickel, and zinc) to the area, but it never gained much popularity in the Southwest. Some brass and copper ornaments were made in the 1830s and 1840s, and a few Navajo and Zuni blacksmiths created simple earrings and bracelets from hammered brass and copper wire.

When the United States took over the region in 1848, its government had the same needs for metalworkers. Army documents record that Captain Henry L. Dodge brought a blacksmith and a silversmith to Fort Defiance, Arizona, in 1853. Some Native men undoubtedly learned these crafts by observing *plateros*, although many *plateros* carefully guarded their skills. The first reports of Native silversmithing date to the mid-1850s. Oral tradition has it that Atsidi Sani was the first Navajo exposed to iron- and silversmithing around this time.[3]

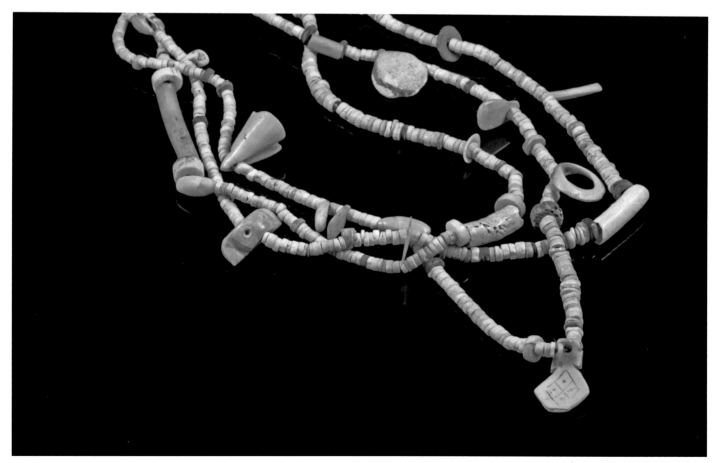

Ancestral Puebloan clamshell beads with natural shell and turquoise tabs, restrung on modern cordage, ca. 900–1200 CE. Courtesy of the Hoolie Collection

This Ancestral Pueblo necklace, created between 1300 and 1540 CE, is made of argillite or shale. Courtesy of the Heard Museum, Phoenix, Arizona. NA–SW–AZ–J–30

The remaining captives made poor farmers, but during these difficult years their jailers noted that the Navajo possessed one notable talent: they were able to perpetuate a clever mass counterfeiting of metal food-ration tickets. More than 3,000 excess tickets were forged before the commanding officer, General James Henry Carleton, had to send to Washington for more intricately designed tokens.[4] When the Navajo were released in June 1868, they returned to their homes with new resolve; they knew that in the years ahead, the material upkeep of their people would mean learning what was necessary for economic survival. As they began to rebuild, their facility with metalworking was not forgotten. The Navajo people (or Diné) may have been martially checked, but after their return to Dinétah their creative adaptability was as strong as ever.

In contrast, the Pueblo peoples, the Navajos' neighbors, had learned to tread more carefully with the US government. They had frequently sided with the European and American settlers against Navajo raids. Proximity to established towns made the Pueblos particularly careful about retaining their ever-threatened land holdings. Their peaceful cooperation prompted President Abraham Lincoln to present silver-headed canes to the Pueblo governors, which were brought to New Mexico in May 1864.

When the Civil War ended in 1865, the US government was free to dispatch troops to the western frontier. The troops were ordered to deal with tribes whose hostile behavior still endangered incoming settlers ready to claim Indian lands.[5] By this time, the Navajo had been resettled and the Pueblo people were not a threat. As a consequence, the Indian Wars of the 1870s and 1880s bypassed the Navajos and Pueblos, leaving them free to fashion their own social and economic revival at a time when the rest of the region was filled with conflict. Subsequently, we can consider 1870 as an effective starting date for the active transmission of metalworking and beadmaking among these two Indigenous peoples, although there likely was occasional Native silversmithing prior to that date.

The Navajos and Pueblos began cooperating, and this new peace between the formerly sworn enemies permitted the development of a practical craft intended to improve Native lives. For better or worse, these peoples had become neighbors with shared interests, and intermarriage followed in the decades ahead. Both groups had learned farrier work and ironmongery from their colonial overlords. Inevitably, decorative forms would emerge based on the most practical available metalwork.[6]

From the beginning, the silver bridle and headstall decorations of European American soldiers offered prototypes for Navajo and Pueblo silver design. When we isolate certain ornament modes, the "building blocks" of early Native design are apparent. Concha plates, crescent ornaments (which became *najas*), decorative stamping from early rocker-engraved borders, butterfly-shaped spacers,

The Navajos arrived in the American Southwest not long before the arrival of the Spanish explorers and first settlers. They were disruptive marauders and efficient raiders, threatening all peaceful communities and targeting vulnerable Pueblo livestock and goods. Yet they were quick to learn, adopt local customs, and adapt to setbacks. Upon taking charge, the US government determined that Navajo rampages hindered peaceful settlement of the region. At the start of the 1860s, just as the Civil War began, the US Army gathered to break the back of Navajo defiance. By 1864, most of the tribe was rounded up by the notorious Kit Carson and sent on an enforced march to a prison camp in eastern New Mexico near Fort Sumner, known as the Bosque Redondo. One-quarter of the Navajos who made the "Long Walk" did not survive.

Necklace with shell beads on cordage, Zuni, precontact era. National Museum of the American Indian, Smithsonian Institution (12/786)

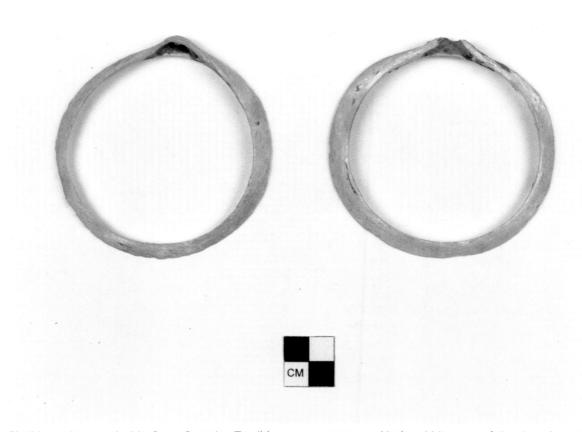

Shell bracelets, probably Casa Grandes Tradition, precontact era. National Museum of the American Indian, Smithsonian Institution (6/1211)

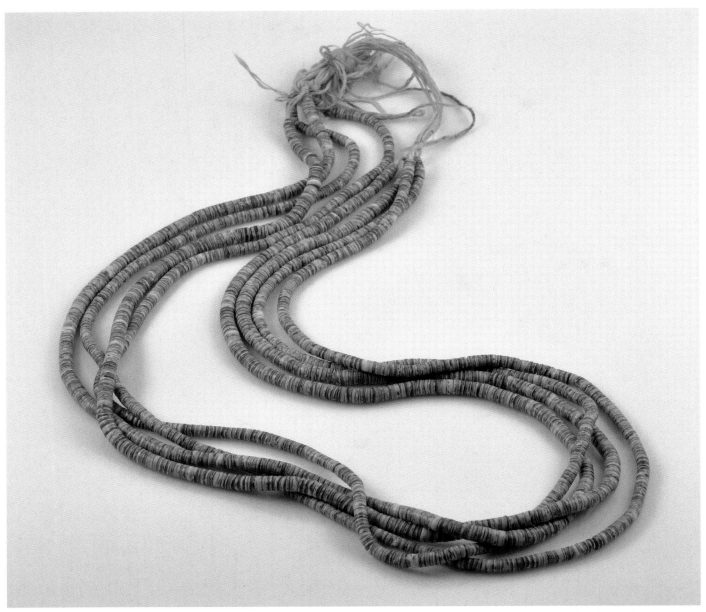

Hand–cut and hand–drilled four–strand olivella shell *heishi*, 12–inch length, 19th century. Courtesy of Eason Eige Collection

button and dress sew-ons with carinated cast ridges, fanlike silver forms, chiseled lines with contrasting relief—all these devices were distinctively translated into early Navajo and Pueblo silverwork.[7]

Iron, brass, or copper ornaments were already known. Knowledge of Ancestral Puebloan beads, carving, and pendants from natural materials had survived into the historical era. In just a few decades, a combination of traditionally made organic materials and new metal adornment would form the basis for future Native jewelry making.[8] By the 1880s, remarkable design elements emerged from this mingling of "old" ornament styles and new construction practices.

Silversmithing represented a significant step. Silver itself had a socially recognizable value, since it was used in coins issued by the Mexican and American governments.

To the Navajo, a silver ornament was "hard goods," an item of value. Wearing silver jewelry conferred status, signified prosperity, and undoubtedly evoked sacred associations, just as turquoise and coral did. Non-Natives valued silver too, whether in buttons or other personal adornment. Given the hard times of the recent past, silver jewelry fulfilled Indian needs—for personal wealth and for trade.

Slowly, the Navajos and Pueblos jointly traveled the road to economic recovery and sustainability. Both peoples practiced agriculture (although the Pueblos made it more central to their activities), harvested crops, gathered piñon nuts, and herded sheep, goats, and horses. Good neighbors shared resources as well as interests, and individuals made reciprocal agreements. The time was right to pass the knowledge of metalworking to family members and apprentices who were Navajo or Pueblo.

TURQUOIS MOSAIC OBJECTS FROM HAWIKUH

"Turquois mosaic objects from Hawikuh" from F. W. Hodges's *Turquois Works of Hawikuh*, 1921. Author's collection

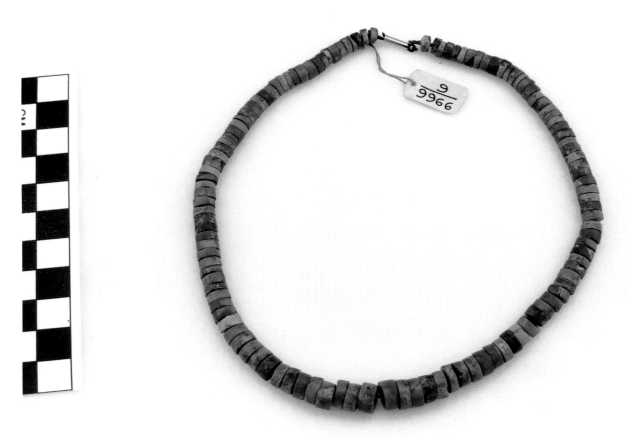

Turquoise necklace collected from Zuni by Frank Hamilton Cushing. National Museum of the American Indian, Smithsonian Institution (9/9966)

## Origins of Jewelry Designs for the Peoples' Use

Non-Native jewelry design of the pre-1870 American Southwest took inspiration from existing metalwork sources. When smiths wanted to find integral forms, they could look at the crescents on horse bridles and translate them into *najas*, or they could more readily adapt the pomegranate-blossom bead shape from Spanish colonial design into silver beads resembling the local "squash blossom" shape. Early non-Native writers stated that Native smiths had "copied" Spanish Moorish design, overlooking the reality that Native creators of silver beads were adopting such a design in order to visually adapt it. Borrowing and adapting designs comes easily to all artisans. In this case, Navajo and Pueblo smiths made a cross-cultural alteration of what they liked. Outsiders simply assumed that the European model was adopted, and they approved.[9]

Organic adornment created by Ancestral Puebloans, based on the bead shape, survived into the historical era. Design elements from these items were integrated into existing nineteenth-century jewelry creation. In addition to shape, the basic units of greatest influence include color, contrast,

and emphasis, which were drawn from raw materials such as shells, local garnets, and turquoise. Early ornament had a practical dress function, such as fastening cloth or holding up trousers. Jewelry strands in bead form, known as *heishi*, were worn by both sexes. Other early jewelry included strings of beads, wrapped choker-like around the neck; pendants (variations on amulets or medicine pouches); earrings; and circlets for fingers and wrists. Since these jewelry forms existed before the arrival of Europeans, they can rightfully be considered traditional.[10]

Work in base metals continued after 1868. They proved useful as practice materials before smiths tackled silver for the first time. The Navajos and Pueblos considered silver pieces to be "much nicer looking" than brass or copper ornaments.[11] By 1869, Navajo silversmiths were reportedly making buttons from Mexican silver coins. The first silver bracelets were simple renditions reflecting earlier efforts in brass and copper and were decorated by fluting, ridging, and twisting the metal. Atsidi Sani supposedly made the first silver concha belt, along with the first silver headstall, at Fort Defiance in either 1868 or 1869.[12] "First Phase" belts derived from Plains-style examples had large, rounded concha plaques with diamond-shaped slots cut in the center for the leather to be threaded through and then fastened with a buckle.[13]

50

The earliest forges were rough improvisations. Navajos set up theirs in outdoor arbors or ramadas, often using a discarded iron railroad tie for an anvil. Pueblo forges were generally located indoors, with access to a hearth. Tools were shaped from iron bits and scraps. Early silver and wire had to be drawn and forged by hand from cast ingots. At this time, decoration was rudimentary but strong. Patterning was done with files, cold-chisel cutting and stamping, and rocker and scratch engraving. Decades later, such makeshift techniques would be lovingly revived as a tribute to their makers' primal designs or simply because they were useful effects.

Jewelry in this preliminary period was wholly intended for personal use. Native taste was expressed in the most-wanted types of adornment: dress ornaments, belts, necklaces, simple circlet rings, bands for cuff bracelets, and silver rectangular plates for *ketohs* (wrist guards). For those Pueblos (and some Navajos) who converted to Catholicism, metal rosary crosses were fashioned, some in shapes that came directly from Europe.[14]

By 1870, two years after the return of the Diné to Dinétah, a handful of individuals began regularly producing silverwork for the first time. Their skills were transmitted rapidly across the Southwest. Within ten years a remarkable range of items

had been created, and popular forms were established. Yet these forms were not conventional in their appearance. The first silversmiths might render the same type of jewelry form, but each item's visual design was far from "typical." In truth, pieces possessed varying, atypical decorative features. Such imaginative designs attracted attention beyond the growing market of Navajos and Pueblos eager for personal adornment. Incoming non-Native traders, for example, quickly saw sales potential in this new metalwork.

Characteristic design elements do emerge from early Navajo and Pueblo jewelry creation. These preliminary elements indicate the direction that makers were taking through their unceasing experiments with surface decoration. This creative manipulation of features arises precisely because of the lack of existing precedents for metalworking. In other words, since there was no Native tradition of this technique, the early smiths were permitted to employ their personal vision more keenly than if they had learned from non-Natives only.

This early Native-made metalwork was impressive because the first smiths fashioned a new tradition from creatively manipulated design elements. The first incising tools permitted repetition of straight-line decoration only.

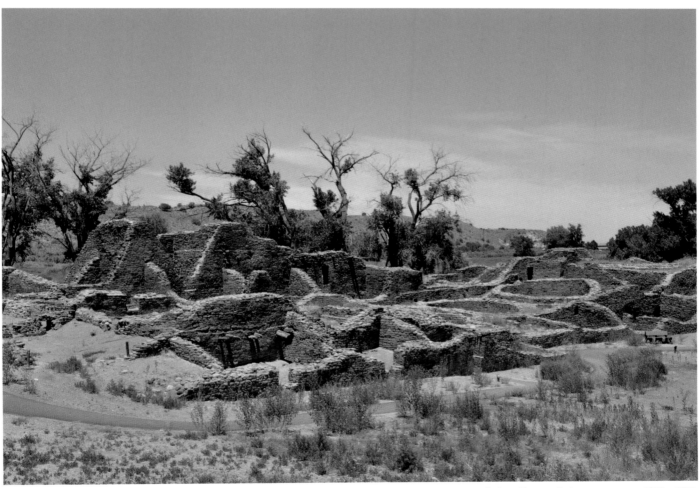

Aztec Ruins National Monument, New Mexico. Ancestral Puebloan Great House, part of the Chaco Culture system, 12th–13th century CE.

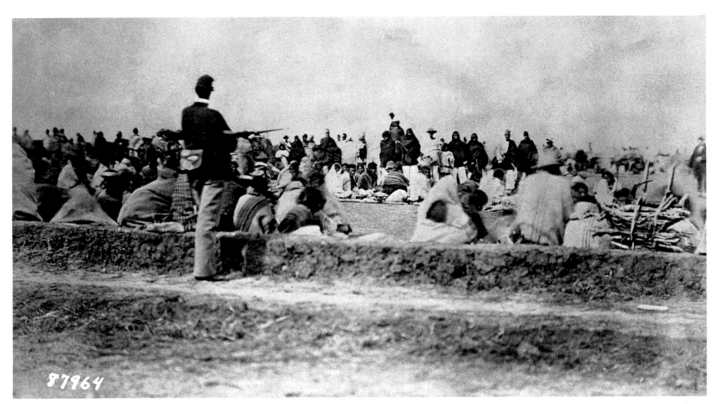

Navajo Indian captives under guard at Fort Sumner, New Mexico, 1865–66. Courtesy of the Palace of the Governors Photo Archives (NMHM/DCA), neg. no. 028534.

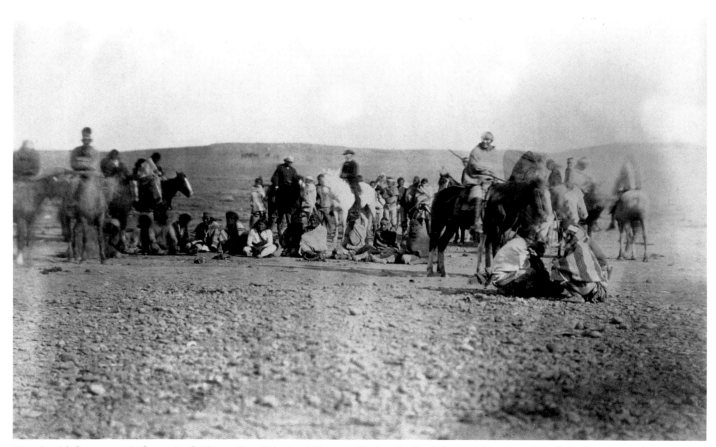

Navajo chiefs accused of counterfeiting ration tickets at Bosque Redondo, Fort Sumner, New Mexico, 1866. Courtesy of the Palace of the Governors Photo Archives (NMHM/DCA), neg. no. 038206

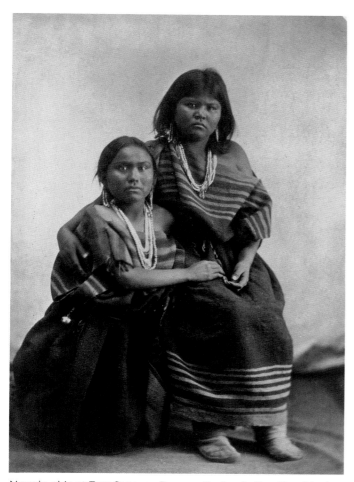

Navajo girls at Fort Sumner, Bosque Redondo Era, New Mexico, 1864–68(?). Collection of John Gaw Meem. Courtesy of the Palace of the Governors Photo Archives (NMHM/DCA), neg. no. 038208

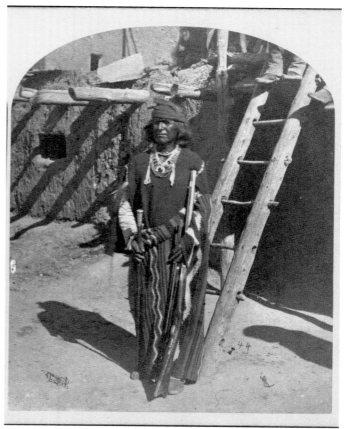

War Chief of the Zuni Indians, 1873. Timothy H. O'Sullivan, photographer. Courtesy of the Palace of the Governors Photo Archives (NMHM/DCA), neg. no. 040197

But the addition of chasing, cold chiseling, and early handmade dies and punches showed an instinctive cross-cultural understanding and borrowing from Spanish filigree and Mexican leatherwork. Although non-Native writers recognized these design variations as based on outsider cultural influence, they failed to take into account the rapid transformation of borrowed design into original choices.

This is the fundamental flaw in historical assumptions about the development of Navajo and Pueblo jewelry making as recounted by the early non-Native writers on the subject. These writers pointed to specific examples of Spanish, Mexican, or Anglo design as the sources for resultant adornment, but they failed to realize that these sources were examined, copied, and then adapted to suit Native tastes. Without historical precedents, the first smiths might adopt outsider designs, but they then experimented continually until developing visual features adapted from the original conception.

The first literature on early Navajo and Pueblo jewelry making revolved around one question: What could be deemed traditional if no tradition existed for Native metalwork design? Navajo and Pueblo smiths absorbed design concepts from the sources available to them. Then, during the early decades of endeavor, their vision sharpened to take in what worked for them and for those who would wear newly created adornment. When we look at engravings and photographs from the late nineteenth century, we can see that the way Navajos and Pueblos wore their jewelry, both organic and metal, was distinctive compared to other tribes and non-Native settlers.

Elements of jewelry design changed over the decades because of adoption, followed by ready adaptation. Nor were Native smiths afraid to discard decorative impulses that did not suit their aesthetic tastes. A greater fluidity of design elements quickly developed over the first three decades of silversmithing. Changes in design might be rapid or slow to take hold, but the quality of execution improved as technological improvements advanced. Better construction allowed design expression to flourish. This progression of craft techniques enabled Native jewelers to pursue personal design visions more freely.

Once an expanded market for Native jewelry was identified, design elements influenced by outsider concerns focused on size, scale or proportion, plus unity or harmony in surface finish. The earliest experiments in metal tended to be large scale and have strong contours and contrast.

Rain, essential for survival, became one of the most important early design motifs used by Navajo and Pueblo jewelry makers.

Casting, done with local tufa rock, created robust texture on metal openwork. Increasingly refined design elements developed when Native smiths received access to manufactured punch and stamp tools. The Navajo smiths' taste for blanching silver with almogen (ammonium sulfate) led to shinier surfaces. The arrival of non-Native Indian traders and their suppliers enabled smiths to create pieces that were more refined, and eventually Native aesthetics shifted to accommodate the non-Native preference for matching stone colors and uniformly polished finishing.

Non-Native business interests were followed by non-Native intellectual curiosity. Once the US Army departed Indian territory, the anthropologists and ethnographers moved in. Their initial interests focused on longer-running tribal creations, like pottery, but the development of new silver and stone ornament did not go unnoticed and would be collected along with other Indian arts. Soon, an arrogant and uninformed non-Native belief in the inevitable decline and disappearance of Native peoples created a stimulus for collecting and "preserving" Native arts in cultural institutions.[15]

Such a belief was not reflected in the Navajo and Pueblo worldview. Native goals were to support their culture and achieve some measure of economic recovery. Canny Native silversmiths in the late 1800s produced adornment that satisfied their peoples' spiritual and material needs. Their first efforts might be constrained by rough tools and limited metal, but they quickly realized how desirable their products were. They intuitively understood that a larger market for their goods might satisfy the goals they needed for survival.

In summary, it is vitally important to realize that the first Navajo and Pueblo silversmiths started as blacksmiths. They made objects for non-Native soldiers and settlers, such as water canteens and bridle bits. They were paid in coins containing silver. This material's value, along with iron, copper, and brass, was understood and appreciated. It took only a short leap of confidence to meld silver with organic materials containing sacred properties, like shell and stone. All at once, two separate creation streams helped these impoverished peoples with their goals: some Indians helped develop the non-Native-controlled commercial Indian jewelry industry, while others hand-wrought adornment for themselves, with an eye to an expanded market. The jewelry they made supported their cultural needs while providing them with a product for barter and trade as they began participating in the new world of American commerce.

Early Navajo or Pueblo bands, large band of Plains make, with two Victorian era non-Native rings, pre–1900. Courtesy of Robert Bauver

Early Native–made silver ring, ca. 1870. Courtesy of Andrew Muñana Collection

Traditional Navajo hogan, Canyon de Chelly National Monument.

FEMALE DANCER.
Tablita (Tablet) or Corn Dance. Pueblo of San Domingo, New Mexico.
August, 1890.

"Female Dancer, 1890," US Eleventh Census, Moqui Pueblo Indians of Arizona, 1893. Native dancing and adornment were subjects of fascination to non-Natives. Private collection

Richard K. Yazzie, *Long Walk Home*, 2005. Outdoor mural at 3rd Street and Hill Ave., Gallup, NM. Honors the Navajos' return to Dinétah.

After their return from internment at the Bosque Redondo, the Navajo Nation established their capitol at Window Rock in the Arizona Territory.

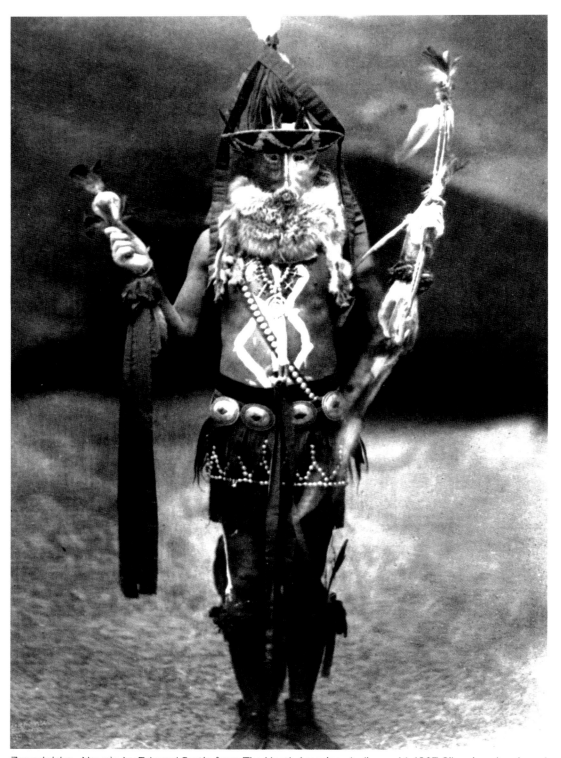

*Zanadolzha—Navajo*, by Edward Curtis, from *The North American Indian*, vol.1, 1907. Silver jewelry played a role in the depiction of the sacred. Private collection

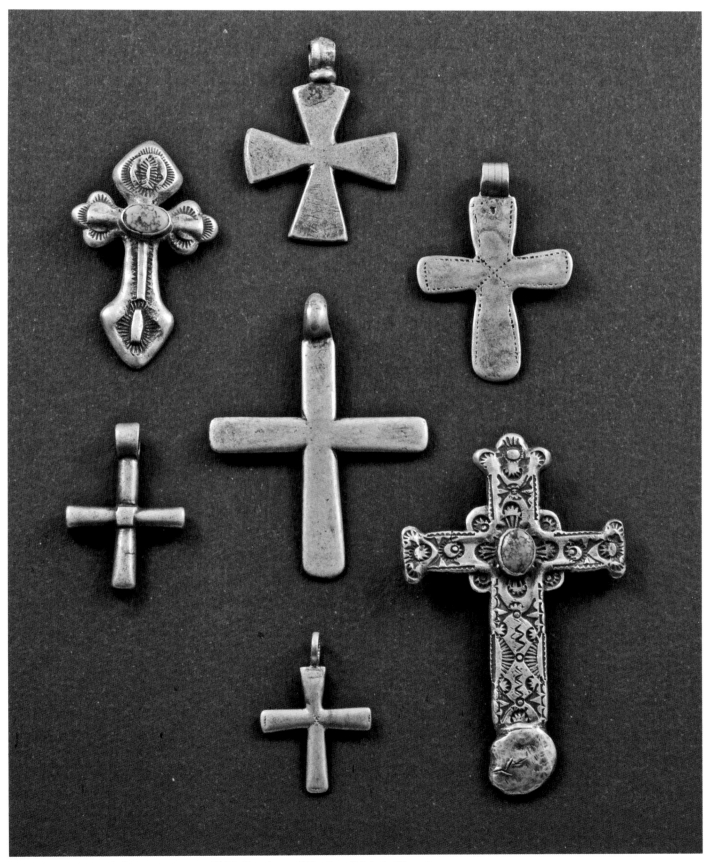

Pueblo-made small silver crosses, ca. 1900. Courtesy of Paul and Valerie Piazza

Early manta pins, 19th century. Photograph courtesy of Cyndy and Bob Gallegos

Plain *ketoh*, Navajo or Pueblo, last quarter of 19th century. Photograph courtesy of Cyndy and Bob Gallegos

## Key Jewelry Forms and Materials in Place Before 1870

### FORMS

- Hollow-formed silver beads and basic pendants, cross or (inverted horseshoe) *naja*
- Simple Plains Indian–style band cuffs or bangles for bracelets, and bands for rings
- Pueblo pump-drilled stonework, or *heishi*, with bead *jaclas* for earrings, often tied onto necklaces
- Cross-cultural design influence borrowed from Spanish and Mexican settlers' horse bridles and headstalls, leatherwork, filigree, and US Army consumers for small metal goods such as canteens and tweezers

### MATERIALS

- Buttons and sew-ons in base metals
- Iron, brass, and copper ingots and copper wire first in use before silver
- Rough forges with anvils made from railroad ties
- Early smiths concentrated in southern and western areas of the Navajo homeland near the first trading posts, railroad, and Gallup, New Mexico

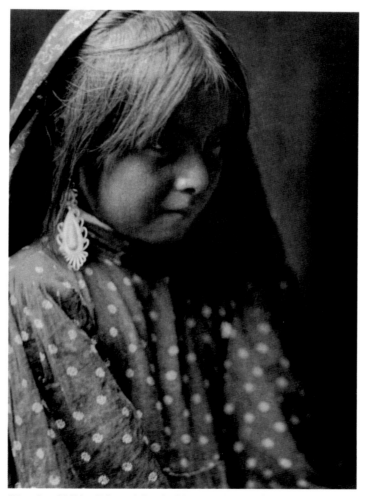

"Nambe Girl" by Edward Curtis, *The North American Indian* (1907). Curtis's portrait seems to draw attention to this Pueblo girl's delicate filigree earring. Private collection.

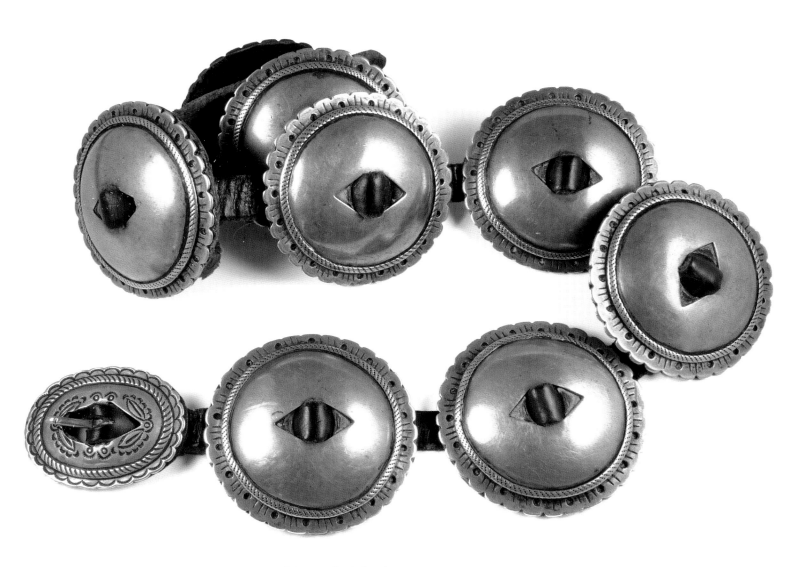

First Phase concha belt, ca. 1880. Courtesy of the Hoolie Collection

# The 1870s and 1880s:
# The Early Years
# of Jewelry Fabrication

The 1870s through 1880s were deeply significant years for the development of jewelry design and the origin of "traditional" design forms. Some writers on Navajo and Pueblo jewelry making call the period between 1868 and 1900 a "first phase." The term derives from anthropological study but doesn't wholly succeed as a satisfactory expression of growth and development for a living art.[1] Much jewelry made at this time has been lost (buried with owners, melted down, or repurposed), but the pieces that survive display a remarkably sophisticated direction for the future of metalwork construction. Most notably, jewelry forms themselves emerged fully developed in the 1870s.

Jewelry pieces made in the 1870s show a strong sense of physical design form and shape. Their lack of decorative embellishment indicates an intense concentration on the mechanics of working silver. Since there were few metalworking tools available from the 1870s through the 1880s, the need for improvisation was great. The Pueblo tradition of beadmaking had changed little from its precontact–era origins, and these laboriously handcrafted beads made from bone, shell, turquoise, and wood continued to be in demand. The Pueblos traded this adornment to their Navajo neighbors. Photographs from this period illustrate Navajos and Pueblos wearing separate strands of nonmetal beads along with silver beads ending in silver *naja* or cross pendants.

# TIMELINE

| | |
|---|---|
| **1870** | US Congress passes the 15th Amendment, granting all citizens the right to vote; Native Americans do not receive this right |
| **1870** | Reports of Native men making bridles and crosses at Isleta Pueblo |
| **1870s** | Turquoise deposits found in Colorado and Nevada |
| **1870s** | Three brothers (Navajo), including Slender Maker of Silver, are active into the early 1900s |
| **1871** | Early trading post opens at Ganado, AZ, run by Charles Crary |
| **1872** | Atsidi Chon teaches Zuni smith Lanyade how to work silver (according to Adair) |
| **1872** | General Mining Act permits homesteaders to open mines on public and private land |
| **1875** | Reports of Native–made silver cross necklaces begin to surface |
| **1876** | Lorenzo Hubbell opens his trading post at Ganado, AZ |
| **1876** | US Centennial International Exhibition opens in Philadelphia, PA |
| **1877** | Zuni Land Grant is recognized, its US reservation boundaries set |
| **1879** | US government begins sponsorship of Bureau of Ethnology expeditions to Southwest (through 1893) |
| **1879** | The railroad arrives in New Mexico; Atchison, Topeka, and Santa Fe Railroad goes through New Mexico to meet Southern Pacific Line |
| **1879** | Frank Hamilton Cushing arrives in Zuni, has silver made for him by Lanyade |
| **1880s** | Curio trade starts in Southwestern towns and cities |
| **1880s** | Turquoise mines discovered in Arizona and Texas |
| **1881-82** | Transcontinental railroad construction completed; first wave of tourism to Southwest |
| **1881** | Santo Domingo Indian Trading Post established near AT&SF rail center |
| **1882** | Hopi reservation boundaries are established |
| **1882** | Cushing brings six Zuni men east, getting wide coverage in newspapers and journals |
| **1883** | Fred Harvey Company hires first Harvey Girls to work in New Mexico |
| **1884** | Charles F. Lummis, journalist and author, first visits New Mexico |
| **1884** | Lorenzo Hubbell brings Mexican silversmiths to Ganado trading post |
| **1887** | Dawes Act establishes the forcible sending of Indian children to boarding schools; many boys are taught blacksmithing in these schools as a trade |
| **1889** | The Exposition Universelle at Paris is first world's fair to have ethnographic village displays |

## The Transmission of Metalworking

It is unclear whether silver was first worked by Navajo or Pueblo individuals. John Adair, citing his informants, credits the Navajo with this achievement.[2] Atsidi Sani, often believed to be the first Navajo to work silver (sometime in the 1850s), taught several other Navajos during the 1870s and 1880s, including his younger brother Slender Maker of Silver, whose son would later become equally famous.[3] The first smiths came from blacksmithing families in which the craft had been taught from fathers to sons (sisters and daughters observed and practiced later). This consistent talent over the generations was notable in its own right.

Contemporary writers such as Charles Lummis, a journalist and author of popular books on the Southwest, believed the Pueblo people were in the best position to learn the craft first. Lummis was among the earliest non-Native observers to claim that Navajos were superior silversmiths compared to their Pueblo counterparts.[4] This unfair value judgment would color the literature on Navajo and Pueblo jewelry design throughout the twentieth century. In Lummis's defense, however, the larger population of Navajos did produce more silverwork.

The transmission process was slower than may seem apparent in the literature. It often consisted of friends or relatives instructing one another (sometimes grudgingly). Individuals were also permitted to learn, in exchange for goods—such as livestock—when a working blacksmith visited a location by invitation. Among the Pueblos, blacksmiths with knowledge of silverworking might relocate from one pueblo to another, through marriage or religious resettling. In the first decades, a few Navajos were able to convince reluctant Mexican smiths to educate them in the process or to have a trader arrange such training.

A Navajo smith, Atsidi Chon, has been named as the first jewelry maker to set a stone in silver. In 1872 he visited Zuni Pueblo, where he taught silversmithing to a local man, Lanyade; in turn, Lanyade instructed other Zunis, including his son Horace Iule, and later traveled to the Hopi mesas, where the Hopi learned the craft from him.[5] The spread of silverwork instruction to the Rio Grande pueblos appears to have been slower, perhaps because so many individuals there were still invested in their traditional jewelry-making heritage. Yet there is little doubt that by 1900, Pueblo smiths, however few, were active silverworkers.

The transmission process during the late 1870s and 1880s was aided by Anglo traders (many were Mormons) and non-Native curio-shop owners (many of them multigenerational Nuevomexicanos). These individuals employed Navajo and Pueblo jewelry makers, providing them with

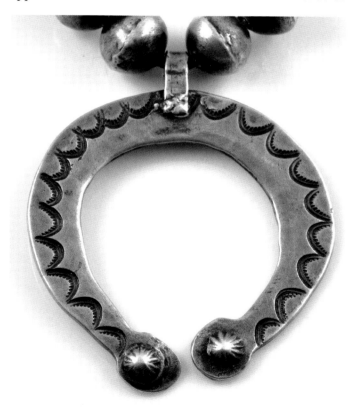

Close-up of ingot silver *naja* on beads with half-dome terminals, 1870s. Courtesy of Eason Eige Collection

The concha form evolved from 19th-century headstalls. This fine example is from 1900–1910. Courtesy of Paul and Valerie Piazza

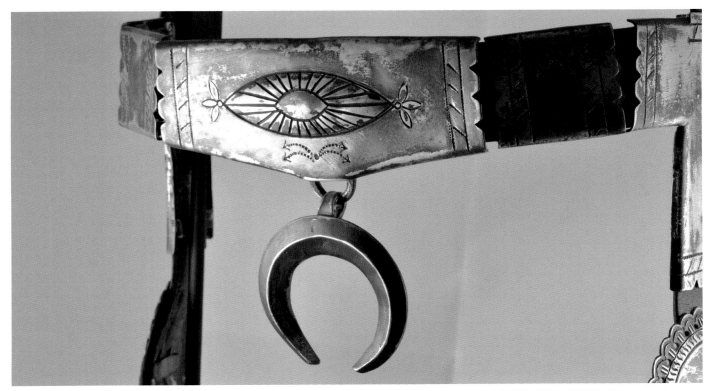

The crescent ornament on a headstall would become the form for the silver *naja* pendant, 1900–1910. Courtesy of Paul and Valerie Piazza

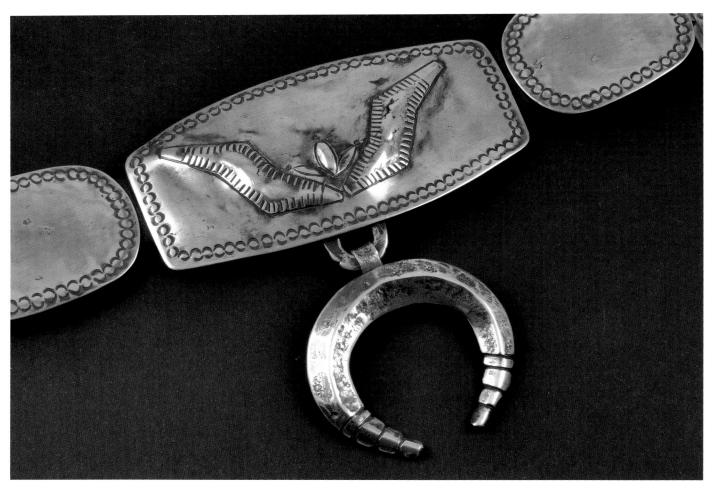

Another decorative headstall ornament with a more developed *naja* form, late 19th century. Courtesy of White Collection

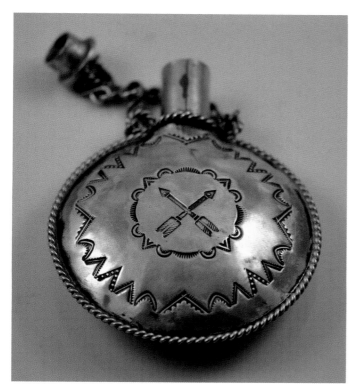 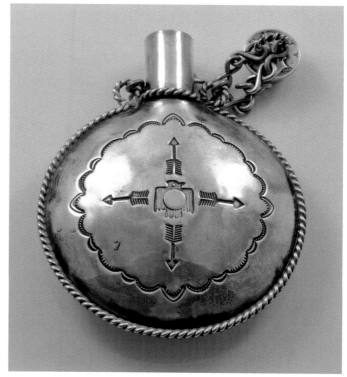

A Native-made silver canteen displays early stamping of a crossed-arrow design, 1880s. The other side features a Hopi bird and four arrows in the cardinal directions. Liberty dime added later. Courtesy of Paul and Valerie Piazza

tools and materials. In 1876, John Lorenzo Hubbell—soon to become an influential figure—established a trading post in Ganado, Arizona. A man of enthusiastic vision, Hubbell brought Mexican silversmiths to his post in 1884 expressly to instruct local Navajos.

Hubbell was one of several traders who helped make turquoise more available for Native jewelry creation. Since this material could be scarce at times, Hubbell and others also imported glass trade beads for Natives to use in creating adornment. Red glass was a favorite choice when coral proved hard to obtain, followed by opaque light-blue beads lacking the marks of matrix. The latter were so popular that they were locally named after Hubbell. Traders noted when new turquoise deposits were discovered at mines in Colorado and Nevada during the 1870s, as well as in Arizona and Texas by the 1880s, but supplying stones remained a recurrent problem.

Trader and Indian alliances have been documented, enacting a cross-cultural business practice that drew Indigenous peoples into the Southwest's barter economy. In particular, the Navajos—especially those living in remote locations—found Indian traders to be a lifeline for commercial exchange. Many Native smiths were employed by traders to do piecework. Some of these smiths eventually traveled to other Western locales in search of new opportunities during the early 1900s.

Native jewelry design in the 1870s and 1880s was largely based on its makers' tastes. Jewelry forms assumed coherent and consistent shapes, but decoration (sometimes marked by outside influences) reveals intensive trial-and-error experimentation. Differences between Navajo-made and Pueblo-made silver ornaments are virtually impossible to discern in pieces from this period. By the 1880s, the melding of silver and stonework, from turquoise to local materials such as jet and garnet, took over. Plain silverwork did not disappear, however. Most of all, the materials and methods available at this time dictated how design would progress.

## Tools for Developing Design Elements

The earliest silversmithing techniques were basic due to the lack of available tools. During the 1870s, smiths learned and developed the processes of hammering, annealing, and soldering silver coins; the work was laborious because granular silver solder involved forging and using a blowpipe. By 1875, smiths were using casting techniques, aided by the regional availability of volcanic tufa to create molds. Designs would be carved into these molds, and the molds covered with a capstone, before molten silver was poured in.[6] Non-Native observers were quickly impressed by Navajo and Pueblo ingenuity and their ability to "make do" with very basic equipment. Native smiths improvised tools out of discarded materials; they made anvils out of scrap iron or railroad ties, they created potsherd crucibles, and they fashioned goat- or sheepskin bellows.

In these early decades, smiths used coins to make silver jewelry, including US silver dollars and the Mexican peso,

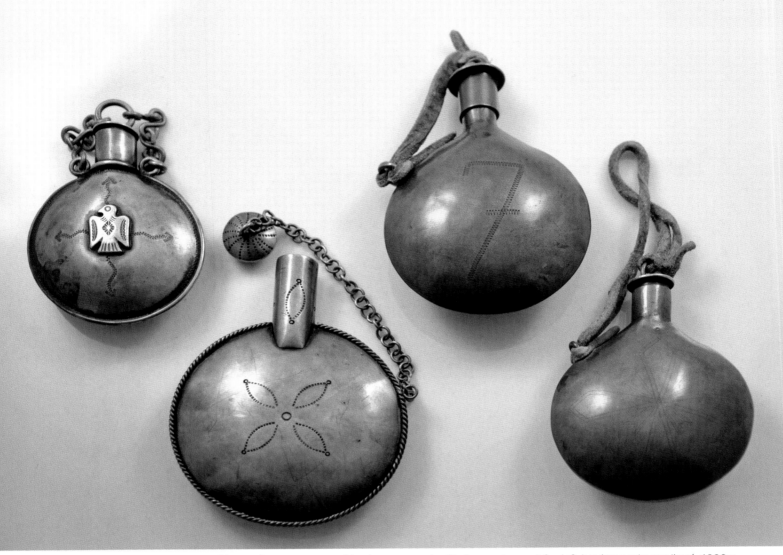

Nineteenth–century canteens: (*left*) two silver canteens with wire surround, with the canteen at far left having early appliqué, 1880s; (*right*) two brass canteens with rocker engraving, 1870s. Courtesy of Paul and Valerie Piazza

which was also called the "dobe dollar." The peso was especially popular through the 1880s because of its lighter metal-alloy composition, making it easier to melt and hammer. Coins produced from the peso had a hue that ranged from a silvery white to a yellowish tinge. The luster of the American silver dollar was generally extra blue in tone, and pieces could be given a strong, high polish. This affinity for surface brilliance has remained a popular choice for both Navajo and Pueblo jewelry makers over the years. Items made during this period often show original coin markings on their undersides, in places where the smith was unable to hammer them out completely.

The earliest types of decoration were created with cold chisels and scratch and rocker engraving. Increasingly extensive surface decoration came in the next decade, when dies and punches were introduced to create additional contrast on silver surfaces; early curved and looping designs made with these tools resemble Mexican leather punchwork. Early repoussé developed at this time as well. Male and

female dies were used to create decoration in relief form when the back of a metal piece was hammered or pushed through to produce a raised design. Repoussé could be further enhanced by the process of stamping to make the relief pattern more prominent. Navajo and Pueblo jewelry makers enjoyed making "bump ups," and this technique remains in favor today.

Design elements were affected by the limited and improvised tools available. Smiths soon shaped their own personal stamps for decorative purposes. A notable feature of this early adornment can be seen in its texture, especially for cast openwork and certain hammered pieces. Color and tone were always important—during this period, most Navajo smiths liked to blanch, or whiten, their silver. Surface decoration, related to line and contrast, was derived from punches, dies, and handmade stamps. Motifs and patterns were undeveloped, but decorative repetition can be seen on silverwork. Designs in these two decades are marked by persistent experimentation and a lack of identifying marks.

## An Eyewitness Report from the Early 1880s

By the late 1870s, a stream of archeologists and ethnographers began to organize expeditions to the region to study ancient and current Indigenous cultures. In 1879, the year that the Smithsonian Institution's Bureau of American Ethnology was established, James and Matilda Stevenson and Frank Hamilton Cushing arrived in Zuni Pueblo, New Mexico.[7] It was the beginning of an onslaught of outsiders. While their intellectual interest focused on Southwestern Indian pottery, weaving, and basketry to bring back to Eastern colleges and museums, they collected examples of jewelry and metalwork as well.

Some individuals new to the Southwest also acted as ethnographers. At the start of the 1880s, Washington Matthews, a US Army assistant surgeon, investigated the work of local smiths while stationed at military outposts in the region, including Fort Wingate, New Mexico. His observations on "Navajo Silversmiths" were published in the *Second Report of the Bureau of Ethnology, 1880–1881*.[8] Matthews was keenly impressed by Navajo ingenuity in making fine silverwork with only rough, improvised tools. His descriptions of Indian smiths' processes are invaluable. He noted that smiths welded or silver-soldered small items over coal- or charcoal-fired forges. He watched them cut molds from soft sandstone and pour melted ingots into the impressions for casting. The smiths created their own tongs, cold chisels, and dies, using them with purchased iron pliers, hammers, and files.

Matthews was impressed by the ready way in which these Native smiths devised technical solutions. For example, until they were able to obtain commercial materials for soldering and whitening, they improvised with local substances. He noted how careful the Navajo smiths were in their polishing and finishing techniques. He describes how artisans created hollow silver beads from Mexican peso coins.[9] His remarks on this last process highlight the Navajo taste for beads newly available in metal; these beads are among the first jewelry forms that Navajo and Pueblo silversmiths adopted and adapted to their own specifications.

However, Matthews's attention to the Navajo design impulse is most relevant to this discussion. He was among the first to write about their earliest decorative effects.[10] He ended his report with commentary on their design process, and his findings echo those of others attempting to discover Indigenous design sources and inspirations. He explained how the adoption of the cross shape was not a Christian symbol but rather a representation of the

"Workshop of Navajo Silversmiths," *US American Ethnology Bureau, Annual Report 2*, Plate XVII, 1880–81. Author's collection

"Drilling Turquoises," from James Stevenson's *Illustrated Catalogue of the Collections Obtained from the Zuni and Walpi . . .*, 1885. Author's collection

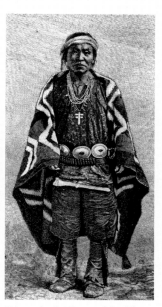

"Navajo Indian with Silver Ornaments," *US American Ethnology Bureau, Annual Report 2*, Plate XVII, 1880–81. Author's collection

morning star, even with an elongated base. At the same time, Matthews took note of Navajo "ingenuity" in working from models and drawings of new, initially foreign objects.[11] He also spoke about the smiths' lack of tools for measuring or making precise marks, and their eye for design with or without cutting out a pattern. His summary praises the Navajos' "inventive and imitative talents."[12]

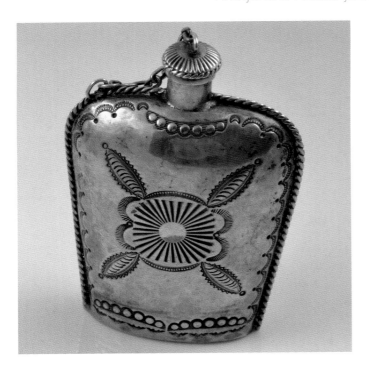

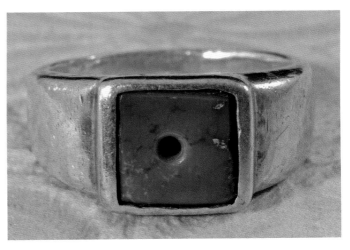

*Left:* Silver flask with cold-chisel and hand-drawn wire designs, 1880s–90s. Courtesy of Paul and Valerie Piazza

*Above:* Navajo or Pueblo cast ring with drilled bead, cast as one piece, late 19th century. Courtesy of Robert Bauver

## Jewelry Forms: Physical Characteristics

The sources of the first metalwork design forms and surface decoration were eclectic. They derived from Ancient Puebloan beadmaking practices, Spanish colonial silverwork, Spanish, Mexican, and US Army bridle gear, Mexican leather punchwork, Plains Indian bangles, and contemporany European American Victorian adornment. Indigenous sources helped determine then-current Native tastes for round beads, pendants, and early earring styles, as well as thin bangles worn and traded by Plains Indians. This initial period determined the earliest "traditional" jewelry forms and shapes, based on these sources and preferences.

The early smiths shaped jewelry forms quite rapidly. For example, they fashioned round, domed, hollow silver beads, then attached amulet-like crescent pendants of cross shapes to the end of these beads. They also bent and hammered silver bands into cuffs and finger rings. Certain jewelry forms, such as *najas* (Navajo term), concha plaques, and manta pins, dominate this decade. Another form, the *ketoh* (Navajo: *k'eet'oh*)—a wrist guard or bowguard that protected against the recoil of a bow when arrows were shot—was meant specifically for Native use. *Ketohs* were mounted with rectangular silver plates, along with plain or domed silver buttons, all on a leather backing. This form appeared around 1875. Early decoration of the rectangular silver plate was an X-shape patterning that divided the surface into quadrants.

Two immediate design sources for the earliest specific jewelry forms derive from military interaction: Spanish-colonial and Mexican soldiers, and US Army soldiers' kits. Metal canteens, decorated with small motifs—including arrow stamps (which, contrary to some literature, did appear before 1900)—and the more complex ornament found on silver horse bridles and bits offer early decorative models. Brass, copper, or silver canteens served a wholly practical function. They might be rounded or square, but their chiseled and stamped surface decoration is spare and simple, whether displaying a thunderbird motif or simply a regimental number.

Spanish silver bridles offered forms that were directly translated into adornment: these include manta pins, sew-ons, and buttons, concha belt plates and buckles, and the unique *naja* pendant. Certain forms of surface decoration, such as repoussé, also transitioned into Native jewelry making. The prototype shapes are round or crescent-like and, by the 1880s, offer a "sunburst" of chiseled or stamped **lines** that provide strong **contrast** relief on the surface, along with bump-ups and swedging (a means of creating parallel ridges on carinated lengths of silver).[13]

**Silver headstalls** displayed characteristic surface ornamentation that transferred to newly formed bracelets, domed buttons, and the *naja* ornament.[14] Some early writers overlooked this direct cross-cultural connection, implying that concha belts and *najas* were specifically Navajo in design origin. Metal adornment elements include the rich **texture** that can be associated with castwork. Casting from volcanic rock, such as local tufa, offers an identifiable Southwestern feeling in the sculptural quality of completed pieces. Early cast bracelets are among the most primal and impressive designs made at this time.

**Concha plaques** were initially round but soon included oval shapes. The plaque served a dress function for buttons, sew-ons, or belts in the nineteenth and early twentieth centuries. The first concha plates were notable for their resemblance to bridle decoration, with rocker-engraved or

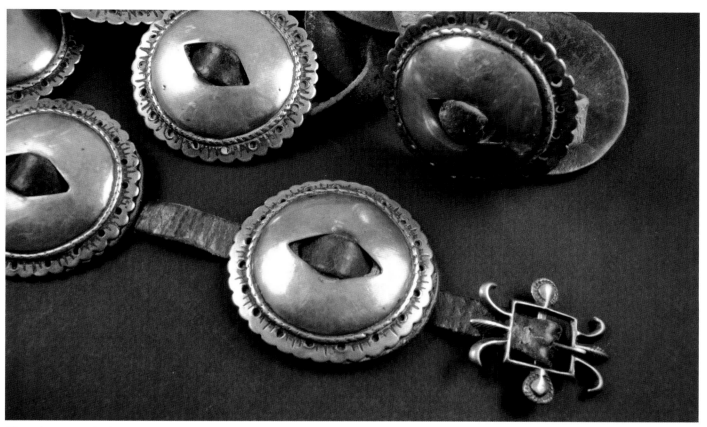

First phase concha belt on leather, 1870s–80s. Courtesy of Michael Haskell Collection

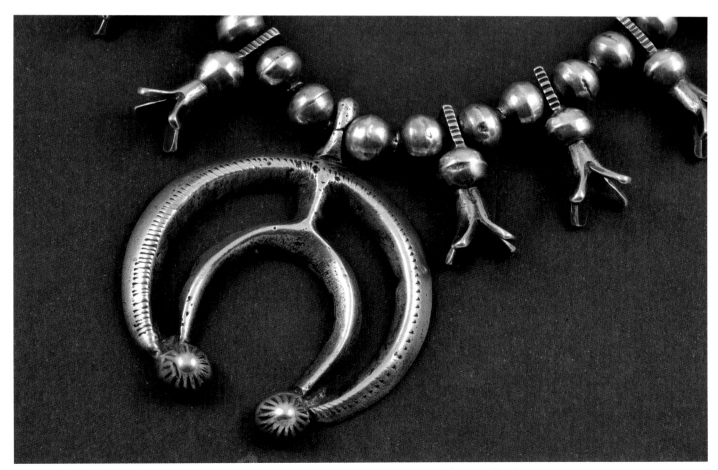

Navajo squash blossom necklace with early filing and double *naja*, 19th century. Private collection

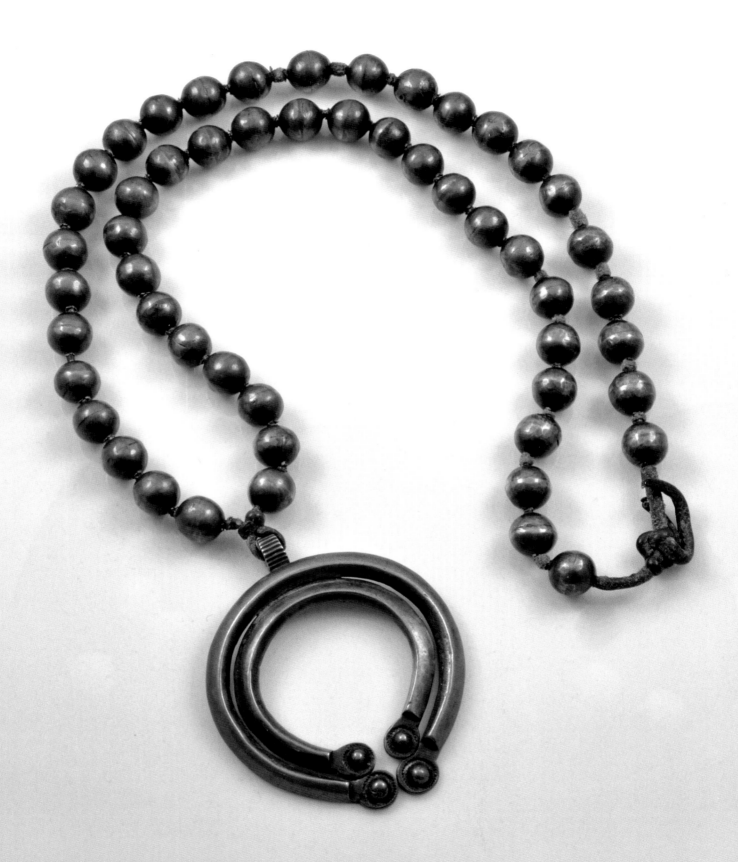

Double *naja* on hollow form ingot silver beads, 1870s.
Courtesy of Paul and Valerie Piazza

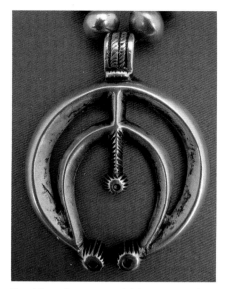

Double *naja* on squash blossom neck-lace, 1870–80. Photograph courtesy of Karen Sires

Early Navajo or Pueblo beads on cordage, pre–1900. Private collection

stamped borders and diamond-shaped openings for a leather strap to pass through. Early concha plaques were domed, featured repoussé or cut-out patterning, and could have a scalloped border. Later in the 1880s, these center plates for belts were closed and had loops soldered onto the back. Contrasts between the plaque's smooth silver center and its darkened perimeter decoration provide harmonized and well-balanced **tone**. The butterfly spacer, a wedgelike orna-ment also derived from bridle decoration, does not appear until the 1920s.

The term ***naja*** (Navajo: *najahe* or *nazhahi*) comes from the Navajo word for crescent. Fine silver headstalls con-structed with this pendant appeared on military and settler horses. Much has been made of this form being of Moorish derivation, brought by the Spanish to the Southwest. *Najas* have since been rendered in every style and material related to Navajo and Pueblo jewelry and adopted by other tribes in the region; exotic variations on the crescent **shape**, from closed circles to highly embellished terminals and center-pieces, mark the active evolution of the original form. Writers on early Native jewelry regularly commented on the Moorish design context as being representative of the "hands of Fatima" or as a ward against the "evil eye." In reality, this form likely had a completely different conno-tation for its Native makers.[15]

*Najas* were intended to be hung on **silver beads**, another 1870s form. Early round silver beads were made by half-dom-ing, when silver was pressed into a metal or wood form and hammered into a half sphere, and then soldering the two

halves together; the solder line was then ground and polished until it was level with the surface. Early beads are commonly worn alone or anchored by a *naja* pendant or a silver cross. Photographs from this era show this type of necklace to be composed of rather large beads. Once again, non-Natives claimed this form also derived from Spanish Moorish horse bridle "pomegranate" beads; having no knowledge of pome-granates, Native smiths called them **squash blossom beads** (a term supposedly devised by Indian traders). This new bead form was composed of three main elements: the shank, the bulb, and outwardly curled petals.

The use of these new bead forms characterized the equally new **squash blossom necklace**. This 1870s creation was immediately hailed as being "classic" or "traditional." A squash blossom necklace was made of round beads, spaced at intervals by a trefoil "squash blossom" bead, with a *naja* hung as a central pendant. The scholar Clara Lee Tanner noted that "early squash blossom necklaces were frequently quite long and had very few squashes on each side. In time they became shorter and often the number of blossoms on each side increased."[16] Many of the first squash blossom necklaces had only five blossom beads on each side of the *naja*, eventually increasing to eight or more by the early 1900s.

The trefoil bead also became part of the early repertoire of **earring** forms. It joined earring forms such as tab stones, plain metal hoops from wire, or suspended loops of such natural materials as stone or shell. This last type, a precontact earring form, survived into the historical era as the ***jacla***,

73

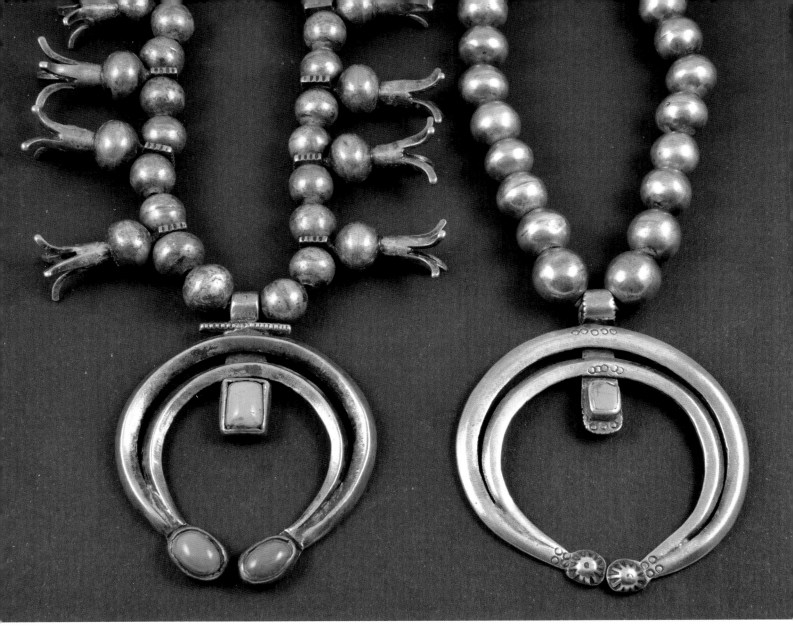

Squash blossom necklace with double *naja* (*left*), double *naja* on plain beads (*right*), 1880s–90s. Private collection

a short loop of shell or stone beads worn over the ear. *Jaclas* were usually tied onto the ends of a bead necklace. By the late 1880s, earrings were often made with wire appliqué. Earring designs from these two decades demonstrate a tendency toward either simple decorative effect or an increasingly ornate treatment through detail.

Early **buttons** and **sew-ons** took shape also as circular ornament designs from headstalls and bridle bits. The earliest buttons were worn on blouses, dresses, trousers, and leggings. Some of the most interesting and creative arrangements were placed on **bandolier bags**. This functional leather pouch on a strap was worn by men in cross-body fashion. When made in silver, the round button form could assume conical or hemispheric dimensions, with surface decoration most often filed or grooved. Most early buttons were domed, created by hammering coins in a dapping block.[17] Later, these initial forms would metamorphose into stylishly cross-cultural brooches.

The first smiths devised simple band **rings** by bending metal around a mandrel. Many of these initial jewelry forms of the 1870s and 1880s were the models for future Navajo and Pueblo creations. In addition to cigar- and cigarette-band ring shapes, Navajo and Pueblo smiths took note of Victorian-era wedding bands, signet, and seal rings as non-Native forms that adapted well to Native design. These kinds of rings usually had a central ornament, so smiths devised a plate to hold a stone or dominant design feature. Without easy access to cut stones, many makers repurposed a drilled bead as the central stone. These ring shapes were not polished or wholly symmetrical, but as material evidence of a new craft they possess an intriguing combination of imitation and innovation.

**Bracelet** construction followed a similar path. Plain silver bands of varying widths would soon be joined by strongly formed cast pieces and multiple shanks soldered onto a central plate. As with rings, the earliest bracelets

demonstrate experiments with sculptural effects. The forms for the first bracelets can be divided into four categories. The first and earliest category is composed of thin bangles with triangular cross sections, akin to the bangles worn by Plains Indians. The second form consists of a flat, broad band annealed and hammered into a cuff shape. The third category was created from two or three pieces of heavy round silver wire twisted together. The fourth category came into being after 1875, when heavy cuffs with sculptural effect were cast from local sandstone molds.

Turning to the physical design features for 1870s adornment, we see how form and shape dominate all other qualities. This was the decade when Navajo and Pueblo metal jewelry was first fashioned, and the early emphasis was on large-scale designs with distinctive outlines. Early writers noted that these first Native designs were intended to be larger in scale than non-Native jewelry. They claimed that

commercialization led to the addition of smaller sizes, which appear after 1900. This is most likely true. Nevertheless, pieces from the 1870s are bigger in terms of heft, weight, and appearance—in other words, this initial larger **scale** represents wholly Native tastes.

Some endearing overall qualities of 1870s jewelry forms lie in their slightly asymmetrical appearance. This quality can be seen in hammered and wrought pieces and castwork, slowly gaining an overall **balance** and **proportion** that would ultimately be considered "classic." Early castwork examples have strong, baroque shapes that are somewhat unwieldy at first, although they quickly grow more symmetrical through the 1880s and 1890s. Nor were the early smiths afraid to cast multiple parts. Bezel work began with rough handmade mounts for stones on bracelets and rings. Serrated bezels appear in the 1880s. All these jewelry forms are a manifestation of experimentally astute silversmithing at work.

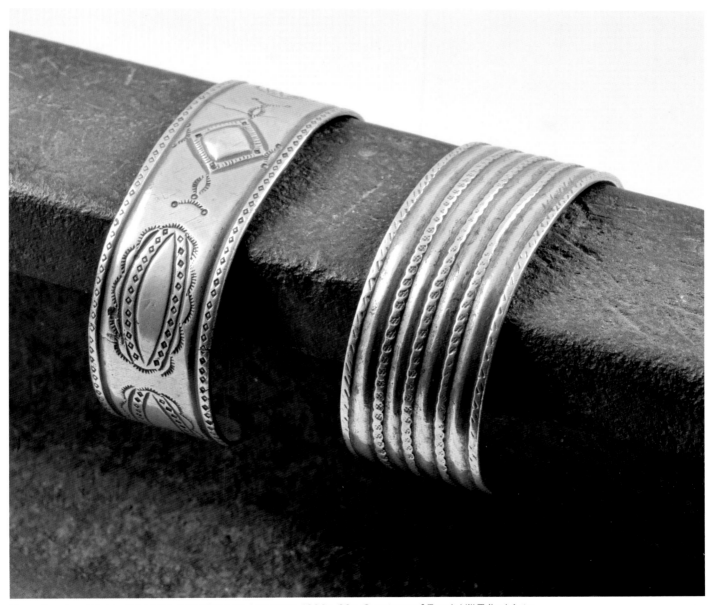

Two silver bracelets with early chisel filing and stamps. 1880s–90s. Courtesy of Frank Hill Tribal Arts

Copper bangle (*left*) and silver bangle (*right*) with early chisel work and simple stamps, 1870s. Private collection

*Left*: Navajo coin or ingot silver set with natural garnets, 1885. *Right*: Navajo silver ring with rocker-engraved design, ca. 1865–75. Photograph courtesy of Cyndy and Bob Gallegos

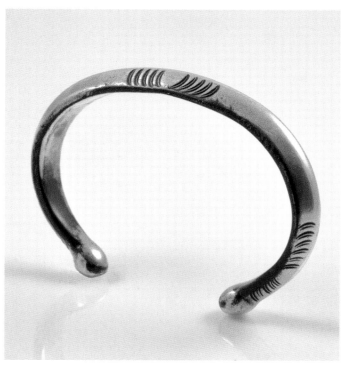

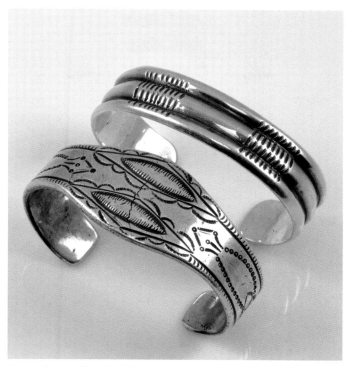

Carinated ingot silver bracelet with simple stamping and knobbed ends, 1885. Courtesy of Frank Hill Tribal Arts

Ingot silver cuff and cuff with hammered and cold-chisel surface decoration, pre–1900. Courtesy of Laura Anderson

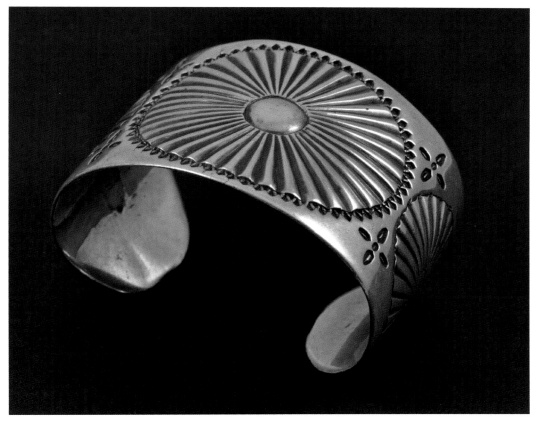

Silver wide cuff with stamped sunburst design, 1880s. Courtesy of Karen Sires

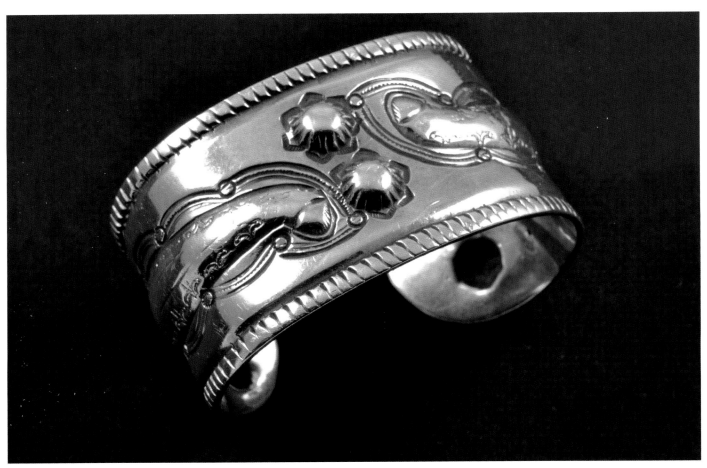

Silver band bracelet with low repoussé, 1880s. Courtesy of Hoel's Indian Shop

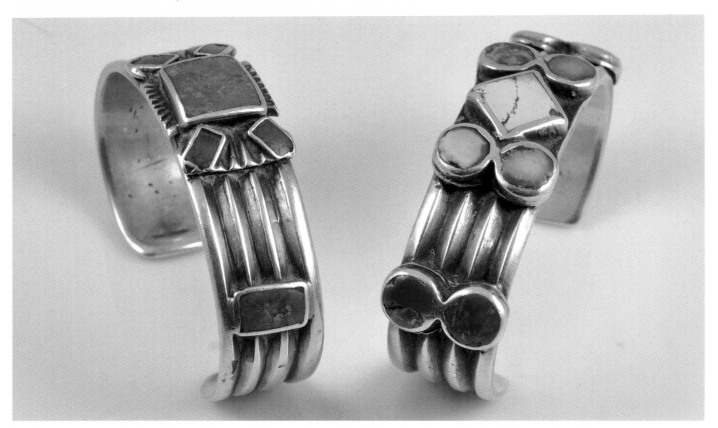

Two heavy-gauge coin–ingot bracelets, ca. 1880 (turquoise added later). Courtesy of Michael Haskell Collection

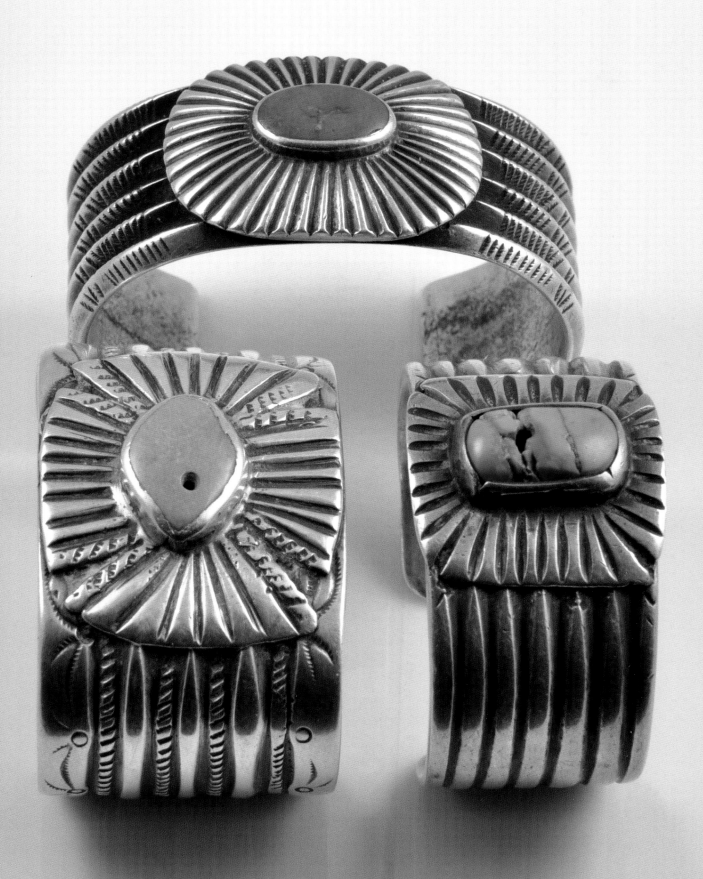

Three heavy-gauge bracelets, two with drilled beads and the other with an old Cerrillos turquoise center stone, ca. 1880. Courtesy of Michael Haskell Collection

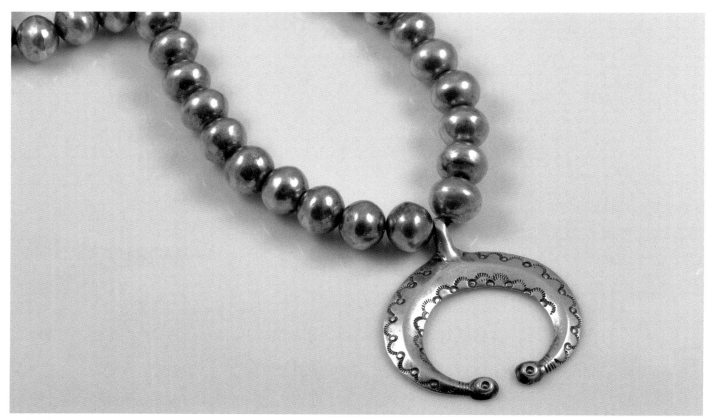

Hollow form beads, 12-inch length, ca. 1880; *naja* added ca. 1900. Courtesy of Suzette Jones

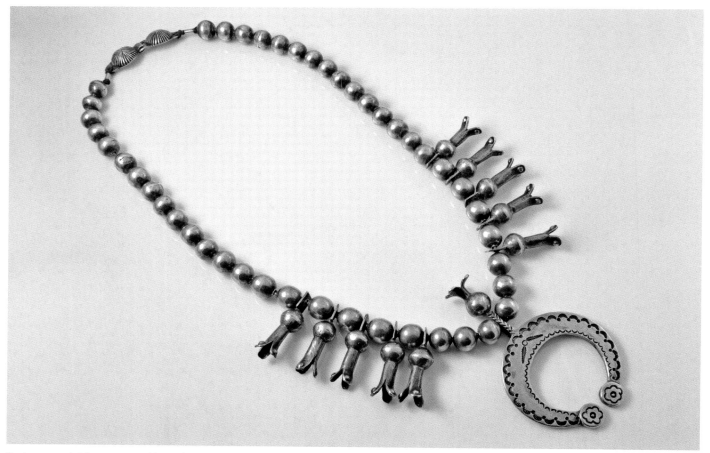

Early squash blossom necklace (ex-Struever Collection), last quarter of the 19th century. Courtesy of Janie Kasarjian and John Fujii Collection

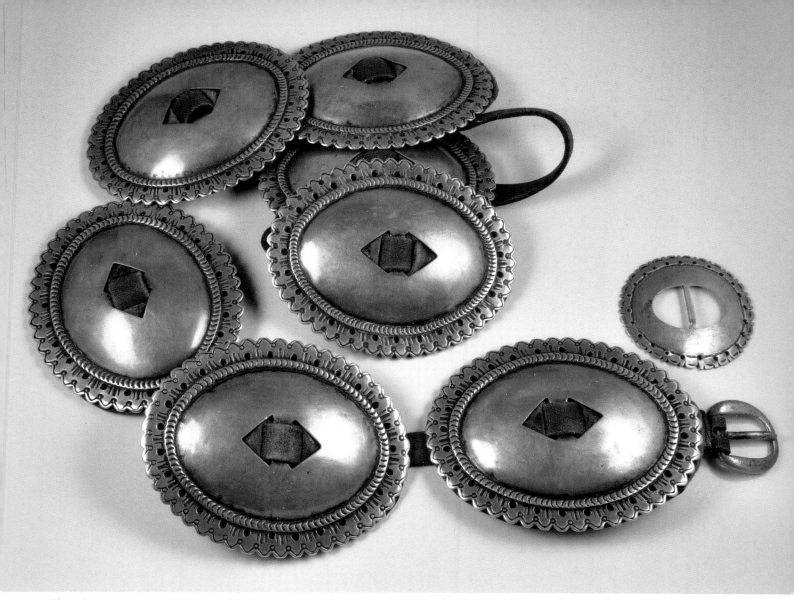

First phase concha belt, 1880–85. Made for Navajo tribal leader Henry Dodge Chee, possibly by Slender Maker of Silver; Dodge was known to obtain much silver directly from him. Courtesy of the Hoolie Collection

## 1870s Adornment Surface Patterning

The first decade of metal jewelry creation is robust and yet tentative in terms of surface adornment. This effect springs rather naturally from the limited tools on hand at the time. The process of forging or casting was hard enough, but early Navajo and Pueblo smiths must be credited with a rapid learning curve. Lacking anything pre-made, the early tools used for embellishment required extensive labor by hand. This is especially true for scratch and rocker engraving. The results are necessarily straight lines, since the process uses a short-bladed chisel. Chisel work was foremost during the 1870s. Smiths turned to dies and stamping with files by the start of the 1880s. (In fact, chisel engraving never really vanished; jewelry makers in the twentieth and twenty-first centuries have turned to this technique to achieve an old-style look.)

The straight line, therefore, dominates 1870s surface decoration. Such lines could be manipulated to look like cross-hatching. This form of patterning is intended for simple contrast. The aesthetic effect, especially the jewelry form itself free from elaboration, is attractive: the effect places **emphasis** on the metal, rather than the surface. And the result is that this early jewelry appears well made despite its rough surface. The luster of silver, especially of polished beads, aids in its overall appeal. In terms of aesthetics, 1870s Native-made jewelry is a striking foil to the ornate and fussy Anglo-European adornment of the same period.

Although the modern-era concept of minimal ornamentation would not appear for at least thirty more years, this first decade of surface patterning (done mostly by Navajo smiths) displays the same clean, restrained decorativeness that would characterize modernist non-Native design and adornment. This is an interesting visual invention in terms of early Navajo and Pueblo metal jewelry making, especially when work from this period is deemed "traditional" in mode. Later, American Indian jewelry collecting took off largely because this initial ornament fit so well with modern aesthetics.

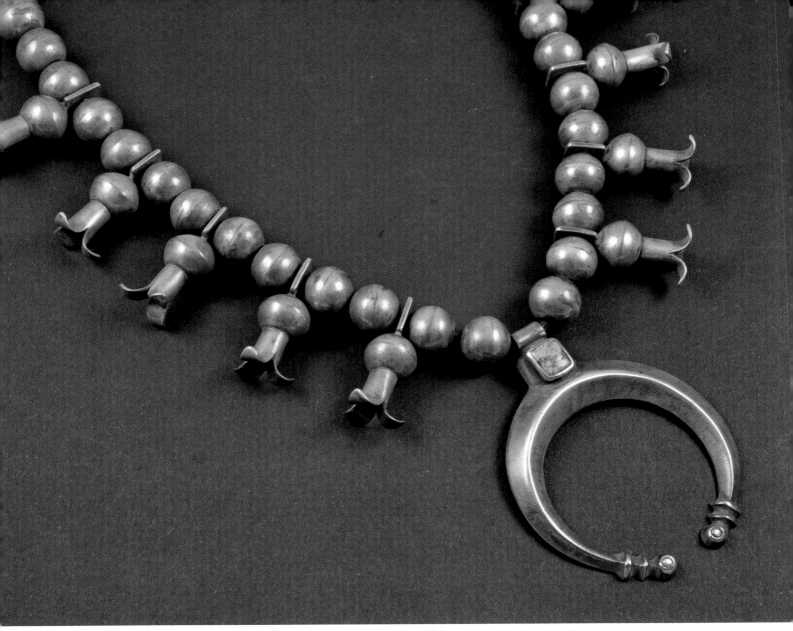

Early ingot squash blossom necklace, with five beads on each side, late 19th century. Private collection

Surface-decoration design elements were uncomplicated. Since few stones were added at first, the most significant color aspect of metal jewelry is its patina. Pueblo-made stone beads retain more vivid colors. The other three features—contrast, line, and tone—remain understated but will develop virtually in unison over the next three decades. Simple straight lines and pecks denote contrast, and patterning stayed abstract. Surface designs at this time were characterized by basic **repetition**. To be fair, this decade is one in which judgments about unity and harmony are not easy to make: the craft of silverworking was still too young.

## 1880s Jewelry Design: Subtle Changes

The next decade of production, however, does prove that **unity** and **harmony** were the ultimate goals of the early Navajo and Pueblo jewelry makers. Silversmiths multiply in number. A rapid development of techniques and craft facility can be seen. Dies and files are still handmade, but smiths now carve strong, bold stamps into them. Repoussé continues in low relief. New factors come into play. Jewelry forms and shapes have been established, including pieces to fit children. Adornment was made for Navajos and Pueblos of all ages. Silver now ornaments leather bandolier bags, worn by men.

Bracelet and earring forms and shapes grow most quickly. Bracelet decoration moves from a central focus to extend all the way to the terminals of cuffs. The biggest gain of all, however, lies in the application of stonework. These materials, whether local garnet or imported cut turquoise, encourage practice in making better bezels. The integration of natural stones becomes of paramount concern to makers and traders alike. Color emerges as a design element of importance. Yet the significance of matching stone colors was not a Native priority at this time.

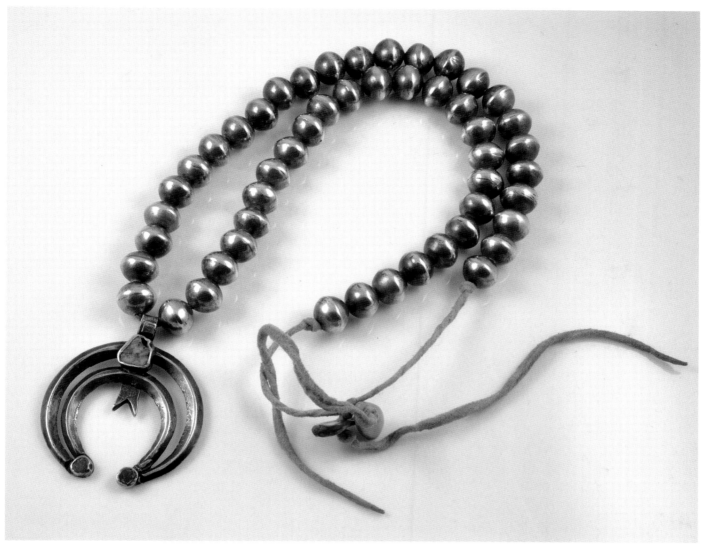

Navajo squash blossom necklace with double *naja* and early turquoise, 1880–90. Private collection

## 1880s Adornment Surface Patterning

The creation and use of strong stamps on silver now takes priority. Smiths recognize the importance of moving beyond straight-line tools for marking metal, and they understand the need to reproduce curves and contours for better effect. Echoing the effects of leather punchwork, decorative patterning achieves geometric as well as organically rounded shapes. End-of-die and file stamps create small dots and circles, while low repoussé forms lozenge-like shapes on surfaces. Although patterning remains abstract, surface decoration with stamp work begins to show individual design choices.

The 1880s display the results of enriched surface texture and patterning. Line and contrast sharpen, visually improving overall design. Geometric patterning can be alternated with forms that are more organic, such as crescents punctuated with small dots. By the end of the decade, soldering skills strengthen as early attempts at appliqué appear. Experimentation continues apace. The result shows a greater confidence in enhancing the metal surface.

Design advancement in this decade is dominated by a search for visual balance and emphasis. Surface patterning extends to all areas of a jewelry form, including more attention to the decoration of bracelet terminals. Varieties of ring and earring styles develop. Looking more closely, the newly aroused cultural aesthetic senses of metalsmiths can be discerned. If the 1870s were all about beginning, the 1880s reveal more extensive experiments with creating balance and harmony.

Such accomplishments, however, involved a better engagement with surface design elements that stressed dominance and emphasis. Hand-hammered pieces most particularly featured attempts to better balance proportion, scale, and repetition. This aesthetic and craft struggle will continue for decades. Perhaps the most significant factor about 1880s creation is that silversmiths were wholly absorbed in devising works that fit their personal cultural vision. By the next decade, outsider commercial pressures begin to take hold in Navajo and Pueblo jewelry patterning.

Bow–drilled green turquoise tab earrings, a "classic" style, last quarter of the 19th century. Private collection

## Forging a Shared Cultural Identity into a Tradition

Throughout the 1870s and 1880s, craft tradition and construction show progression and increased viability. The earliest smiths used and improved simple tools most successfully. They worked willingly with Indian traders and other non-Native suppliers to meet construction needs. Design elements improved with experience. More important, it was the early smiths' forward-looking personal aesthetic vision that raised Navajo and Pueblo adornment to prominence. This determination, shaped by economic need, was responsible for the growth in popularity of silverwork and beadmaking, offering Indigenous wearers a product that would make them proud.

Non-Natives didn't understand or care about such motivation. Nor did they discern between Navajo and Pueblo metalwork adornment design: their jewelry became conflated in viewers' perceptions. From the nineteenth century on, the fortunes of Navajo and Pueblo jewelry makers were increasingly tied together. Outside the Southwest, reports and illustrations in magazines and newspapers depicted these Natives dressed in fine jewelry. An article in

the August 1882 issue of *Century* magazine reproduced portraits of some of the Zuni men whom Frank Hamilton Cushing had brought to the East Coast; these individuals wear a rich assortment of silver and stone beads.[18] In 1889, Europeans were offered an opportunity to view Southwestern Indian jewelry, along with other Native arts, at the ethnographic villages of the first world's fair, the Exposition Universelle in Paris.

In just twenty years, this initial exposure to the world permitted two very different peoples to share their cultural identity through adornment in a manner very different from the recognition of tribally defined arts, such as pottery and weaving. Receptive non-Natives found an exotic, barbaric splendor in the silver beads, *najas*, concha belts, and cross necklaces they viewed. Their critical thinking speculated: surely this silverwork came from a long-standing traditional craft. The very traditional beadwork of the Pueblos and the very new silverwork of the two tribes looked like nothing recently made. After all, both types of jewelry possessed a visual superiority that must have resulted from years of practice—didn't it?

In terms of tradition, Native jewelry making was expected to carry the same cultural deliberation that went into Indigenous pottery, weaving, and basket making.

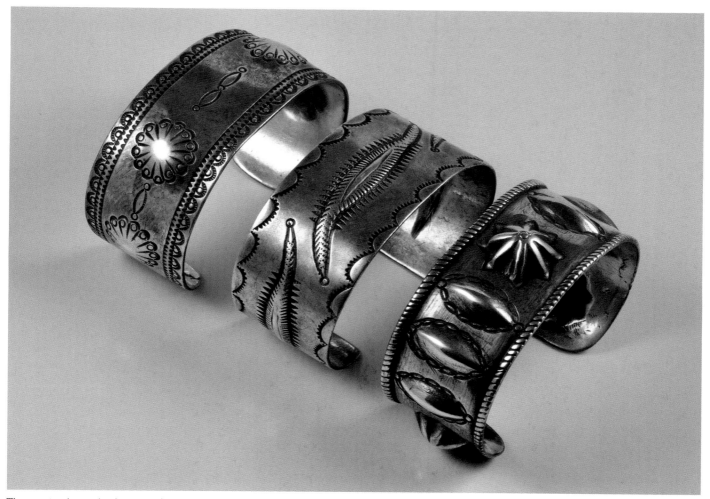

The center bracelet has centipede-like center; it is flanked by two other bracelets with repoussé buttons and ovals, last quarter of the 19th century. Courtesy of Ken Wolf

Shouldn't there be intriguing design similarities with these other crafts? This was definitely true, since potters and weavers might be family members or neighbors of jewelry makers. When museum experts began to study Navajo and Pueblo silverwork, there appeared to be shared decorative-feature choices, including border patterns and organic vegetal shapes. Smiths were able to incorporate even more of these shared designs as files and rough end-of-file stamps became available in the 1880s.

The innate success of the first two decades of Navajo and Pueblo metal jewelry making guaranteed the accomplishments of succeeding decades. Such pieces made handy hard goods or acceptable curios/souvenirs. Jewelry forms agreeable to outsider tastes thrust their makers into a wider marketplace. Their work now had "value." The timing was impeccable. A budding tourist trade created by transcontinental railroads and promoted by the ambitious Fred Harvey Company would soon seize upon this portable commodity for souvenir purposes.

Native jewelry makers and non-Native traders and curio shop owners were complicit in building a market for a newly popular Indian craft. The artful union of stone (or shell) with silver permitted two cultural traditions, one old and one new, to become comingled. This successful coupling allowed those involved to present their product to the world as an established Indian art, on a level with other Indian arts. By enlarging their market appeal, Navajo and Pueblo jewelry makers fully exercised creative self-determination.

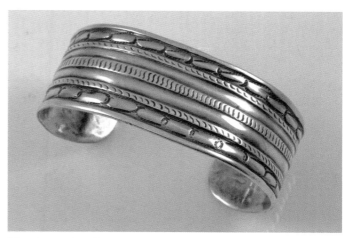

Silver bracelet with early cold-chisel and filing decoration, pre-1900. Courtesy of Laura Anderson

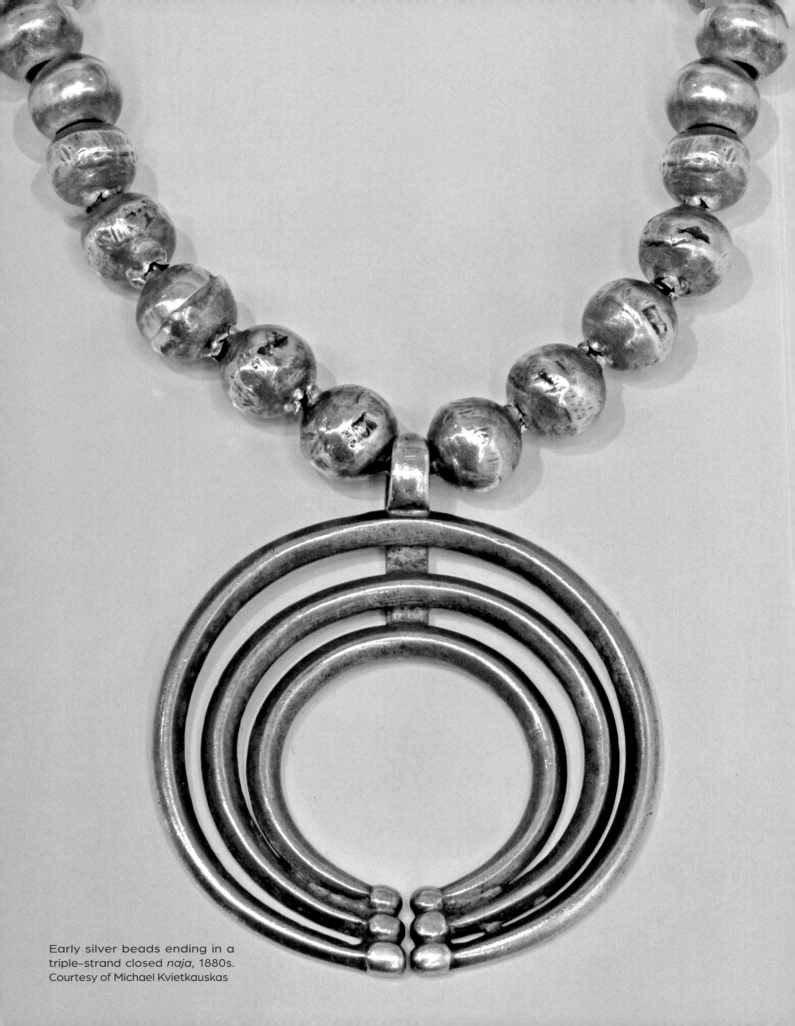

Early silver beads ending in a triple-strand closed *naja*, 1880s. Courtesy of Michael Kvietkauskas

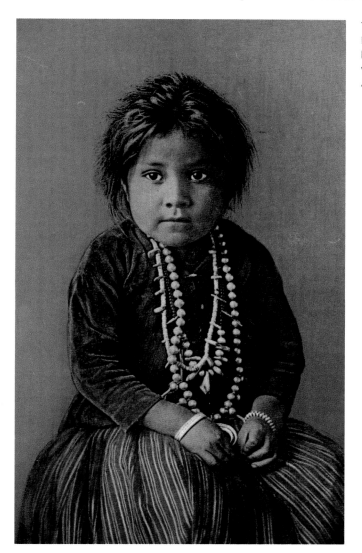

This colorized postcard of a Navajo girl wearing silver and beads shows how Native people wore these intermingled materials. Author's collection

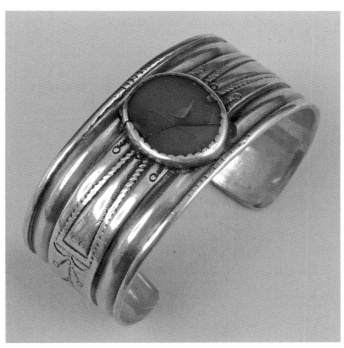

Navajo ingot silver cuff with single center stone, 1885. Photograph courtesy of Cyndy and Bob Gallegos

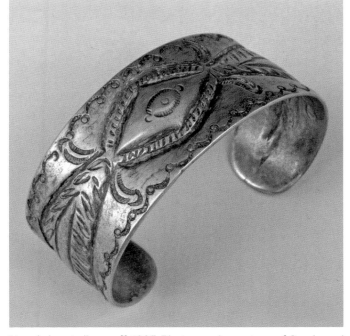

Navajo ingot silver cuff, 1885. Photograph courtesy of Cyndy and Bob Gallegos

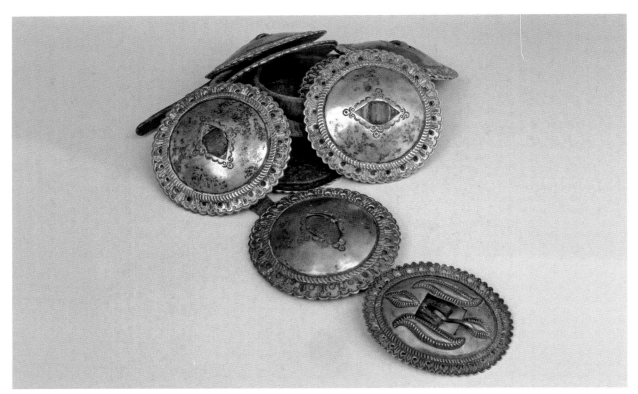

Navajo first phase concha belt, ingot or coin silver, with original leather strap and concha backings. Photograph courtesy of Cyndy and Bob Gallegos

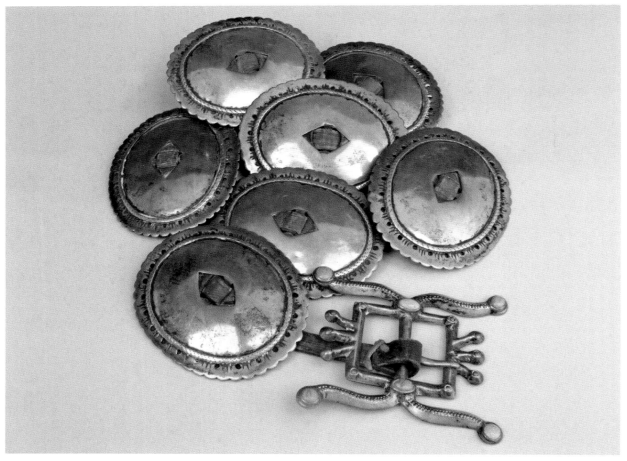

Navajo first phase concha belt, ingot or coin silver, ca. 1870–75; original leather strap and concha backings and sand–cast buckle, ca. 1885. Photograph courtesy of Cyndy and Bob Gallegos

# Key Design Developments 1870s–1880s

## FORMS

**1870s**
- Functional and dress jewelry forms in base metals and silver appear
- Canteens and practical articles made for US military personnel
- Round and pomegranate-shaped bead necklaces
- Cross and *naja* pendants
- **First Phase concha belts** with open diamond slots and round plaques
- Buttons, manta pins, and sew-ons; basic earrings
- Bowguards with rectangular plates
- Band, bangle, and split shank bracelets and rings

**1880s**
- Jewelry forms and styles more decorative
- Large-scale lengthy squash blossom necklaces and belt buckles
- *Najas* have more elaborate bands, hands for terminals; hoop earrings and ring designs more varied

## MATERIALS

- Tools from scrap iron and railroad ties
- Dies made from scrap metal
- Silver forged from cast ingots; imported Mexican coins (which create a blue tone) are preferred
- Hand-drawn and forged wire
- Imported glass trade beads; hand-drilled *heishi* beads
- Early stone settings using local garnets and jet appear around 1875, more common after 1890
- Use of turquoise starting in the 1880s
- Brass and copper used through the decades, most often for practice or commercial purposes

## TECHNIQUES

- Scratch and rocker engraving until late 1870s
- Chisel stamping and cutting; early file work
- Openwork casting (direct design) begins around 1875
- Forge and blowpipe soldering (using charcoal and bellows)
- Traders introduce basic hand tools, borax, emery paper, and fine files early in the 1880s; later in decade they also encouraged the use of end-of-file stamps and dies
- Hand-cut turquoise settings include heavy hand-made bezels and serrated bezels
- Shallow repoussé and fluting done by filing add textural definition
- Early handmade stamps, many based on leatherworkers' designs
- Blanching silver with almogen becomes a popular Navajo finish by end of the 1880s

## MOTIFS

- Decorative abstract and geometric lines on surface patterning, lozenge-like shapes and other decoration appears somewhat organic

## ELEMENTS

- Form; dominance; scale; surface decoration; texture; tone

## NOTABLE MAKERS

- Navajo and Pueblo smiths have working knowledge of base metals prior to 1870
- *Navajo:* Atsidi Sani (Peshlakai), Navajo blacksmith is reputed to be the first to set silver. His pupils include Atsidi Tso (Big Smith), Crying Smith, Long Moustache; also his brothers: Slender-Old Smith, Slender Maker of Silver
- *Zuni:* Atsidi Chon brought silversmithing to Zuni. First-generation blacksmith at Zuni: Hatsetsenane (Sneezing Man); first silversmith: Balawade

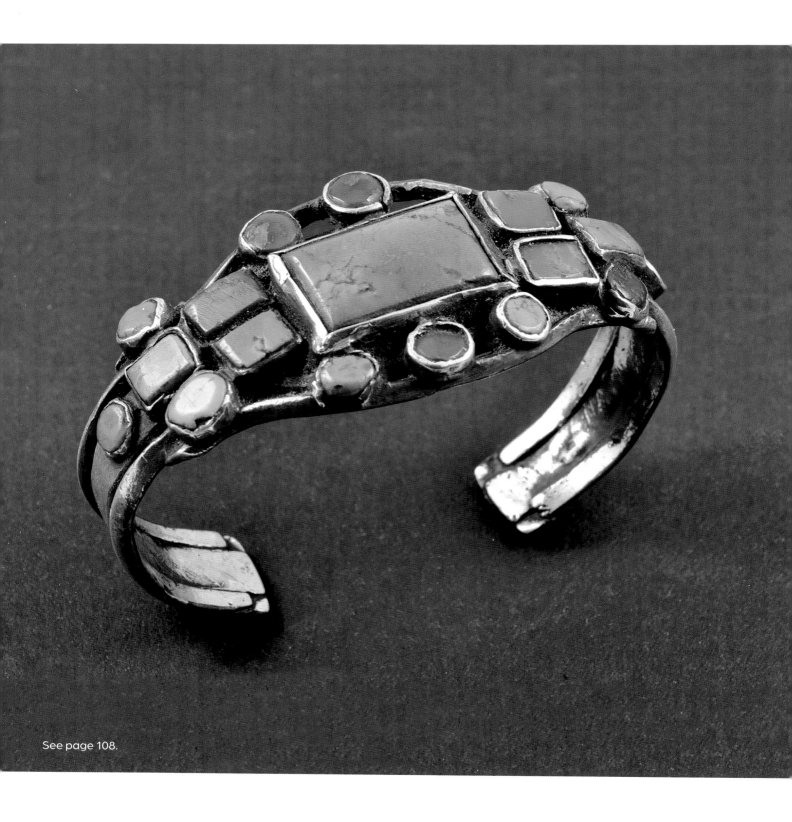

See page 108.

# The 1890s:
# Pairing Silver with Stone

Silver jewelry made in the 1890s followed the forms created in the previous two decades. New fabrications reveal a steady increase in viable surface patterning, appliqué, and lapidary work. The inclusion of silver and stone was a Native design imperative, reflecting the growing availability of materials largely supplied by non–Native traders and intermediaries. Turquoise, always in demand, was still limited in supply. Some smiths reused older stones, including drilled beads from earplugs or necklaces, or opted for trade beads instead.

This last decade of the nineteenth century was when turquoise and silver became *the* ideal combination for Native–made jewelry. From this point on, turquoise was the gemstone of choice, and Navajo and Pueblo construction led the way. Local lapidary resources remained standard alternatives: garnet, jet, malachite, and agate. Coral and various types of shell, when available, continued to be important. At the start of the 1890s, single–stone settings appeared regularly on rings, bracelets, and *naja* pendants, with small groups of multiple settings increasing over the next five years.

# TIMELINE

| | |
|---|---|
| **1890** | US Army massacres more than 150 Lakota Sioux at Wounded Knee, SD |
| **1890** | US government prohibits use of coins in making silver ingots |
| **1890** | Indian traders now stock Mexican coins only |
| **1890** | Santa Fe Indian School established |
| **1890** | Hubbell sends Cerrillos turquoise to Germany to be cut and polished |
| **1890** | Adair reports Keneshde is first Zuni to set turquoise in silver |
| **1892–93** | World's Columbian Exposition in Chicago features exhibits of Plains and Southwest tribes; Slender Maker of Silver demonstrates Navajo silverwork in 1893 |
| **1895** | Hubbell begins importing Persian turquoise |
| **1898** | Lanyade trains Hopi's first smith, Sikyatala |
| **1899** | Herman Schweizer, buyer for Fred Harvey Company, begins supplying silver and cut turquoise to Indian traders, who then farm it out to Native smiths in their area |

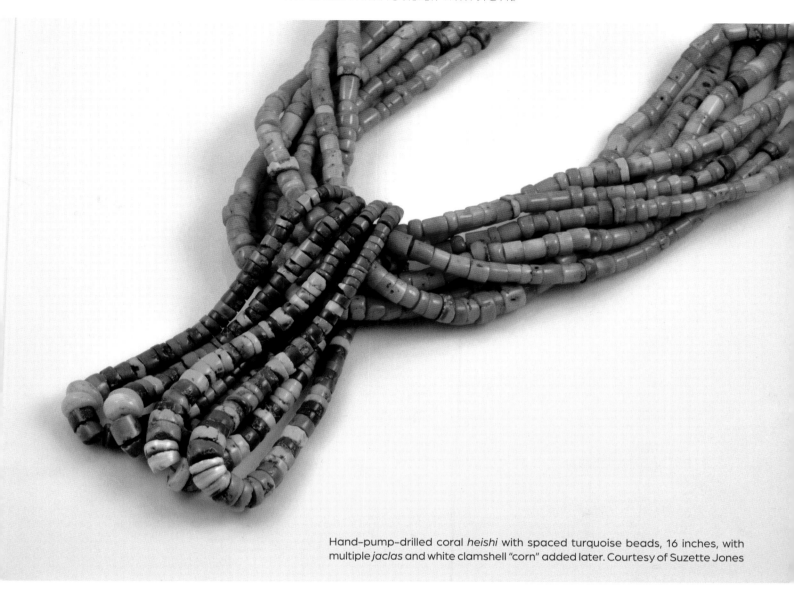

Hand–pump–drilled coral *heishi* with spaced turquoise beads, 16 inches, with multiple *jaclas* and white clamshell "corn" added later. Courtesy of Suzette Jones

## Historical Developments

Indian traders were quickly made aware of the need for shell and stone materials, which were often in limited supply. They found a substitute in glass trade beads. At Ganado, John Lorenzo Hubbell first imported Persian turquoise in 1895, when local deposits were becoming scarce. He, and others, also imported trade beads made in Eastern and Central Europe. Popular types were blue padre beads used by missionaries in Africa and North America, followed by clear and opaque red glass beads. By 1890, many jewelry makers regularly finished a silver and stone necklace with a handful of these red beads near the fastening.[1]

The role of trade beads in Southwestern Indian jewelry design deserves more research and scrutiny. Although color clearly plays a role in design integration, the overall importance of these beads lies in their use as substitutes for stone and shell. That such beads ceased being purchased from abroad by the mid-1920s speaks to this fact. Nevertheless,

re-creations of older designs incorporating particular bead types endured well into the twentieth century. Beading for jewelry continues among a small population of Southwestern Indigenous makers to this day.

The 1890s was a critical decade for the transmission of silversmith work to the Rio Grande Pueblos, even though a few, such as Acoma and Isleta, had makers who worked in base metals. A handful of Pueblo men, trained through reciprocal agreements, made jewelry and dress ornaments to suit the tastes of their communities. Such pieces show a predilection for cross forms, large manta-pin shapes, and, in the case of Zuni, a more profuse use of small turquoise stones. Inevitably, this choice reenforced the reputation of Pueblo jewelers as lapidaries, even as they mastered the mingling of silver and stone.[2]

José Rey León was making silver at Santa Ana in 1890. Ralph Atencio of Santo Domingo learned the process from a non-Native jeweler in Santa Fe around 1893. The Lewis family of Acoma produced copper ornaments. At Isleta,

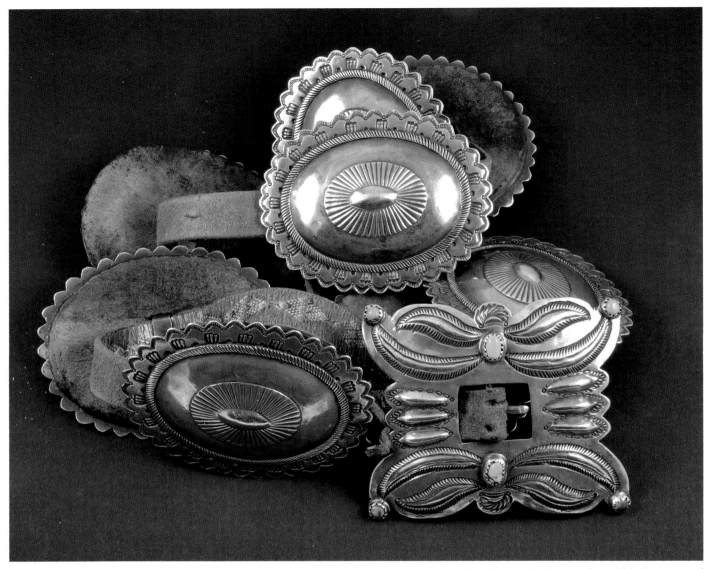

Second Phase concha belt with eight plaques backed on leather, 1890s; buckle set with mismatched turquoise, 1900. Courtesy of Hoel's Indian Shop

Jose Jaramillo and Diego Ramos were known to be working silversmiths by 1900. In line with emigration and other social interchanges established at the end of the century, silversmithing came to Hopi from Zuni. Lanyade taught the first smith, Sikyatala of First Mesa, in 1898. Silver creation spread to Second Mesa by 1904 and reached Third Mesa around 1907. Silversmithing often became a family occupation: Sikyatala's nephew Roscoe Narvasi was a noted smith on First Mesa by the early 1900s.[3]

This last decade of the nineteenth century ensured that Navajo and Pueblo jewelry forms had a secure identity, although designs on these forms were not fixed or typical. The union of metal with stone linked both peoples together. Non-Native chroniclers tended to overlook this essential point—that from then on, the two cultures were connected in terms of jewelry making. Instead, these writers promoted a most insidious labeling aimed at qualifying Navajo and Pueblo design facility on the basis of the larger numbers of

Navajo smiths versus Pueblo silverworkers. In the name of "tradition," Navajos were pronounced to be superior smiths, while the less numerous Pueblo jewelry makers were dubbed lapidaries. This erroneous viewpoint colored most subsequent non-Native research and observation.

In fact, reciprocal relations were clearly at work as transmission spread. One reason was increasing family connections through intermarriage. For example, a Navajo man might acquire a Hopi or Zuni brother-in-law, who might get trained in silversmithing or lapidary work and be willing to instruct his new relative. This highly effective form of craft diffusion would multiply over the coming decades. Indians also might ally themselves with Hispanic (or mixed Nuevomexicano) families. Such exchanges helped foster shared design solutions between these peoples. Indeed, more fluid interactions existed among Native peoples of the Southwest and their neighbors than have been conventionally recorded.

## Popular Culture and the Marketplace

From 1870 to 1890, Navajo and Pueblo jewelry was primarily created to meet its makers' needs. Only a small amount of metalwork was created for non-Natives, many of them soldiers stationed at forts in the region. But the coming of Indian traders brought a growing realization that this jewelry could be an attractive commodity to outsiders, with a market value beyond Native consumption. Canny individuals such as John Lorenzo Hubbell and J. B. Moore were ready to feed non-Native collector interest. Change was inevitable; American commerce in the Southwest was beginning to fasten on to ways to exploit the curio appeal of Indian arts.

All at once, European American intellectuals who felt they were the natural guardians of genuine Indian design began a first round of fruitless hand wringing. They worried that the effects of commercialization would destroy Indians' "primitive" authentic expression. This theme would rule literature written by non-Natives, and complemented the belief held at the time that Indians were preindustrial and doomed to extinction. The photographer Edward Curtis shared this same viewpoint as he began his massive documentation of a "vanishing race" at the end of the 1890s.

This perception—that Indians would soon be gone, assimilated by the dominant society—seemed foretold by the violent massacre of Lakota people, including women and children, at Wounded Knee, South Dakota, in 1890. It was a terrible ending to the merciless Indian wars waged by the US government. What followed in the next decade was as perilous as that last brutal conflict: legal attempts to destroy Indigenous culture. These included the forcible removal of Indian children (including Navajos and Pueblos) from their homes to boarding schools, where their hair was cut and they were whipped if they lapsed into their native language.

How ironic, how utterly resilient would be the growth of Native metalworking during this era, powered by the longing for economic opportunity. Equally ironic were the two opposing non-Native impulses that sought to make money from Indian arts by cheapening their appeal while at the same time championing attempts to "preserve" traditional elements. We will note specific examples of this push-and-pull paradox as the decades progress.

The 1890s were hugely impacted by those non-Natives who brought business to the Navajo and Pueblos: Indian traders and the first curio store owners. These merchants were the conduit through which Native jewelry makers could better understand the effects of a dominant popular culture. The arrival of Indian traders brought a system of barter and trade closer to Native homes. Jewelry made from silver and turquoise, along with beads, joined wool and piñon nuts as items they could borrow against to acquire desired goods. Their adornment might also be pawned for necessary items and then redeemed for ceremonial or other purposes. In other words, personal jewelry became lucrative "hard goods."

The United States was beginning its first great wave of Western tourism, aided by the railroads. Southwestern Indian arts and their colorful makers (picturesque and friendly, of course) were a subject of interest to visitors. Not only were these tourists fascinated by the Southwest's beautiful and dramatic landscape, but they were equally entranced by Indian dances, ceremonies, and dress. Navajos and some Pueblos accepted this exploitation as a kind of reciprocal arrangement: they would reveal parts of their culture in return for a chance to boost their inadequate incomes (thus practicing a vital form of survivance).

When commercial, manufactured Indian jewelry spread after 1900, traders and shop owners countered by deliberately guiding handcrafted Navajo and Pueblo jewelry creation into a market beyond local exchange. They foresaw how Indian jewelry would be indelibly associated with turquoise and silver. The addition of turquoise as a significant material defined the last decade of the nineteenth century. Designs for hand-wrought and commercially made pieces separated into two modes: the unique and untypical versus the stereotypical.

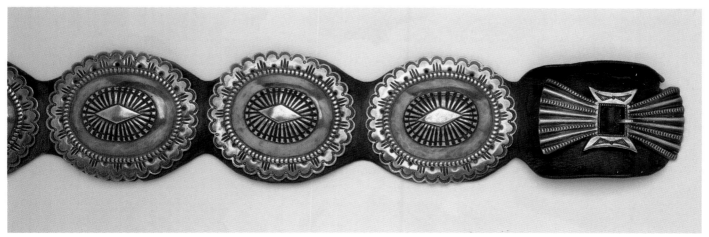

Navajo belt, 1890, with a closed, raised center, decorative stamping on plaques and added stamping on cast buckle. Courtesy of the Heard Museum, Phoenix, Arizona. NA–SW–NA–J–522

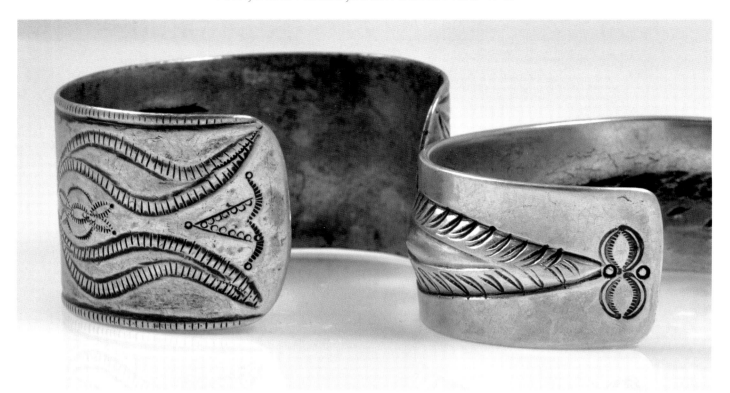

Two silver bands, possibly Pueblo, showing budding floral design motifs on the terminals: (*left*) flat surface decoration, pre–1900; (*right*) with raised repoussé, 1910. Courtesy of Laura Anderson

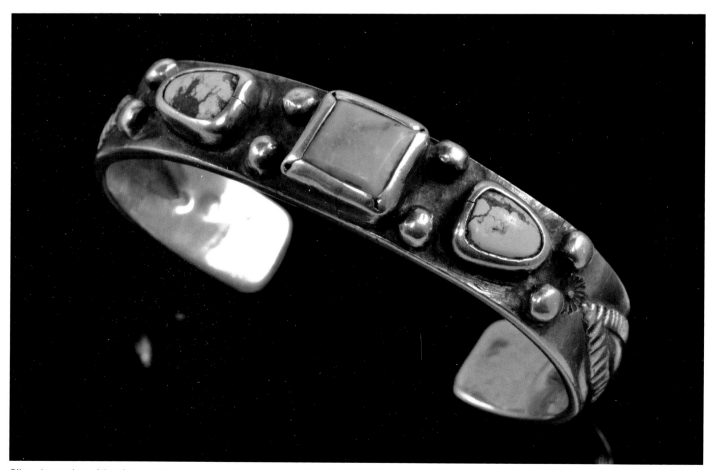

Silver bracelet with mismatched turquoise in handmade bezels, 1890. Courtesy of Laura Anderson

## Turquoise Takes Hold

Turquoise, along with shell, was a material rife with sacred associations. Quantities of the stone were found at the sites of the Ancestral Puebloans, Hohokam, and Mogollon peoples. Precontact-era Native traders sought shell and turquoise for multiple purposes. Shell represented water, among other things. Turquoise, usually exposed within veins of copper, was not plentiful but it was significant as a design material. It could be blue or green, so it represented both the sky and water—life-giving and essential. To wear turquoise meant honoring these elements and how they brought health and prosperity in their wake.[4]

By the end of the 1800s, this new interest of Anglo settlers buoyed the search for turquoise mines. The semiprecious gemstone was cut into cabochons or carved rather than faceted and was not particularly popular in European and American Victorian jewelry making at the time. European turquoise of the 1600s and 1700s was almost always paired with gold. Therefore, the idea of pairing turquoise with silver was somewhat novel to nineteenth-century non-Natives. As American settlers searched for mining opportunities in the Southwest—mainly gold, silver, and copper—they also paid attention to the turquoise deposits they discovered.

In the past, some turquoise sites had been locally mined by Indigenous peoples of the Southwest, who visited them on occasion but never worked them extensively. Several sites throughout the region contain precontact-era mines that yielded turquoise. The most prolific were located in the Cerrillos Hills, about 20 miles southwest of Santa Fe, and the best known of these was at Mount Chalchihuitl. Several claims were established during the 1890s in the Cerrillos area by non-Native enterprises, such as Tiffany & Co., based in New York City.[5] Indian traders gradually located regional sources for their turquoise, mindful that non-Native taste for this gemstone would grow sales for their Indian workers.

Unlike the Indigenous peoples of Central and South America, the Navajo and Pueblo of the American Southwest did not have a tradition of working gold, nor did they particularly care for the metal. Instead, they combined turquoise and silver into something unique, something that established an evocative identity for their adornment. This union strengthened the preexisting Puebloan tradition of turquoise beadmaking and carving that, when added to silver, transformed jewelry into a vehicle for distinctive design. Gold was worked for jewelry infrequently at this time; its integration into Southwestern Indian adornment is a post-1945 development.

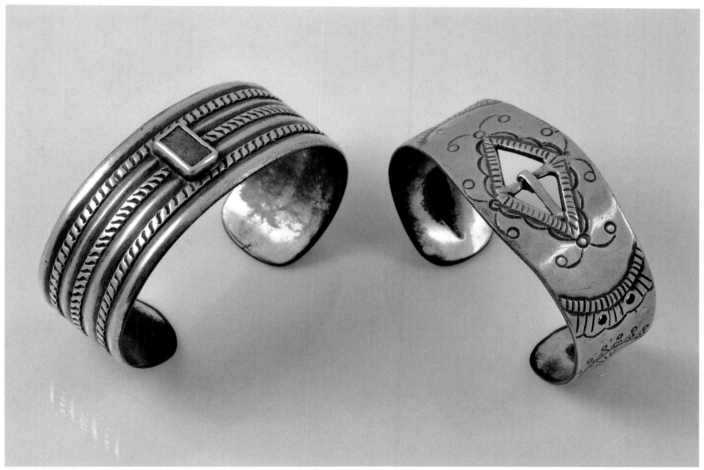

Two 1890s silver bracelets, each strongly designed: (*left*) set with rectangular natural green turquoise; (*right*) creative surface pattern resembling a concha belt buckle. Private collection

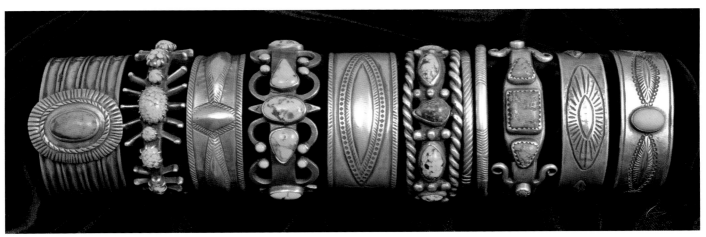

A bar of pre–1900 hammered and cast silver bracelets, notable for their shapes and texture. Private collection

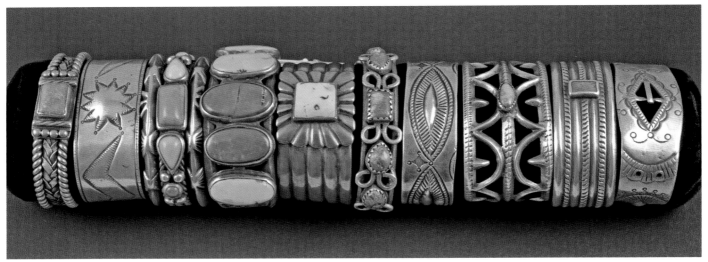

A bar of pre–1900 silver bracelets with contrasting forms, turquoise colors, and surface decoration. Private collection

The Navajos prized turquoise's association with Mt. Taylor, the sacred mountain of the east-bounding Dinétah.[6] The ancestors of the Pueblos had always venerated turquoise. Both peoples agreed that silver, called the "metal of the moon," made a good setting for a stone, evocative of the sky and its release of vital water. There were other associations as well. Over the years, turquoise adornment would feature prominently in Navajo and Pueblo dances and ceremonies. Indian traders understood this custom and sought ways to facilitate acquisition of the material.

In 1890 there were nine traders working on reservation lands, with some thirty posts surrounding their borders.[7] John Lorenzo Hubbell continued to play a key role in recognizing the market potential of turquoise and silver jewelry. He also performed a major service in aiding cross-cultural communication between his Navajo clients and non-Native intermediaries during the first years of this melding of metalwork with stone.[8] Hubbell encouraged his colleague C. N. Cotton, who worked in merchandising out of Gallup, to recognize the commercial possibilities

of this new silverwork.[9] Cotton had produced an illustrated mail-order catalog in 1896, and Hubbell followed suit in 1902, although silverwork was subordinated to other crafts such as Navajo blankets.[10] Also by 1902, Hubbell had established himself as the Fred Harvey Company's largest wholesaler of Navajo jewelry.[11] Not all turquoise came from Indian traders, however. Zuni smiths and lapidaries continued their long-standing practice of purchasing Cerrillos turquoise from Santo Domingo traders.

Because turquoise still was not widely available in the 1890s, regional stones and abalone shell were used, as were coral or garnet, jet, and malachite; the colors of these materials—white, red, black, and green—possessed distinct meaning related to the six directions and other contexts. The decade also marks the start of more extensive use of turquoise in spatial design on individual pieces. Writers have claimed that Zuni was responsible for this acceleration in small-scale stonework. This assertion needs more verification, but Zuni was indeed well known for its fine lapidaries and a long tradition of handling turquoise.

## Surface Decoration Patterning on Metal by the 1890s

### STRAIGHT LINES

- Hooked
- Intersecting
- Zigzag

### COMPOUND LINES (OFTEN REPEATED CONTINUOUSLY)

- Chevron (V shape or inverted V shape)
- Meander (resembles Greek fret)
- Parallel lines in angles
- Serrated forms (bezels, borders)
- Stepped lines ("kiva steps")
- Triangular elements (appliqué)

### CONTOURS (ON METAL, OR ADDED WITH WIRE FOR APPLIQUÉ)

- Circles (two- and three-dimensional)
- Curved lines
- Curved points
- Dots (spatial punctuation)
- Scallops (border and framing)
- Spirals (maze or decorative for emphasis)
- Waves

These effects produce line, tone, contour, texture.

They are used to create contrast, dominance, emphasis, repetition.

Comparable examples of compound lines appear in weaving, examples of contours appear in pottery, and some early organic, floral effects appear in Pueblo embroidery.

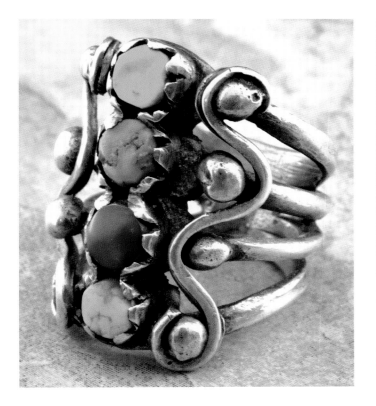

*Above:* Two early band rings with rocker engraving and Hubbell glass bead in hand formed bezel, 1890s. Private collection

*Left:* This distinctive ring design features early rough silver balls, handmade serrated bezels, and mismatched turquoise stones, 1890s. Courtesy of Robert Bauver

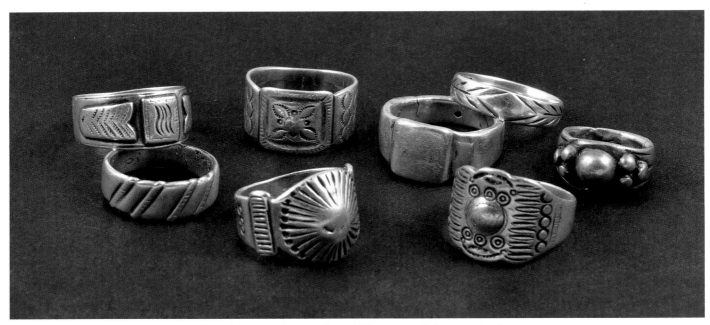

Eight early silver cigarette and cigar band roughly shaped rings, 19th century. Private collection.

## Design Elements Grow More Expressive

Color emerges as a notable characteristic for jewelry in the 1890s. More settings of stones on silver permitted smiths to improve bezel construction, although rough edges continue into the early 1900s. The bold, vibrant blueness of imported Persian turquoise set the bar for visually beautiful stones. Cerrillos turquoise had been the most available stone for early Navajo and Pueblo work; material extracted from the mines could be green or blue, and, once set in silver, natural Cerrillos turquoise tended to age into warm, deep tones of green. At this time, matching stones could still be difficult to assemble, but variations in color within a piece fail to detract from its appearance.[12] The Native taste for matching color stone sets arrived later, when materials became more available.

Among the design elements that enhance 1890s surface decoration are dominance and proportion. The use of turquoise, either as single or multiple stones, accentuated these visual elements. Stones set on silver rings, bracelets, and *najas* in particular make compositional features more sculptural and dominant. When these settings were well proportioned, the effect was aesthetically pleasing. During this decade, the introduction of fine files (usually repurposed from scrap metal) allowed smiths to make stamps with curvilinear lines.[13] Surface designs with curves and circles rendered decorative patterning more sophisticated through added detailing. Such detailing, however, remained abstract. As noted in the chart on page 117, decoration is made up of a pattern of lines, curves, and dots, varying in length and depth. Stamps do not yet include representational motifs. It is important to remember that Native hand-wrought work did not feature the realistic motifs devised by non-Natives

for commercial pieces. Nevertheless, stamped designs on silverwork grew stronger in both hand-wrought and early tourist jewelry. Although 1890s surface decoration clearly shows experimentation for visual purposes, the concept of design intended as narrative does not take effect until later in the twentieth century.

A noteworthy development of the 1890s is the increased use of silver wire for add-ons and embellishment. Just as repoussé clearly plays a major role in the decoration of silver surfaces, wire appliqué enlivens pieces and makes

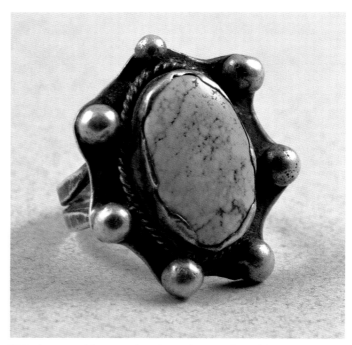

This ring set with turquoise shows how early smiths struggled to fashion smooth bezels and "raindrop" balls by hand, 1890s. Courtesy of Eason Eige Collection.

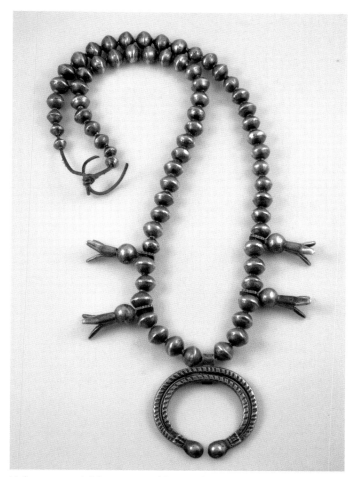

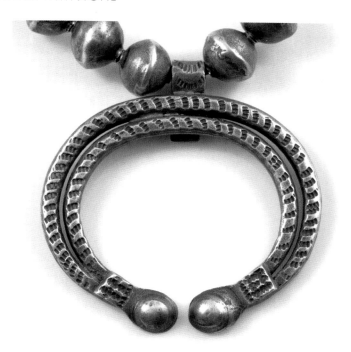

Close-up of *naja* on necklace

Unique squash blossom necklace, with cold chiseling instead of stamping on *naja*, and half-domed beads on *naja*'s terminals, 1890s. Courtesy of Eason Eige Collection

them more sculptural in tone. Small silver balls, called raindrops, shots, or dots, add to design features. There is less apparent asymmetry in the 1890s than in the previous two decades; cast openwork chiefly benefits from this advance. Cast bracelets, in particular, are pointedly enhanced when set with turquoise.

The first three decades of Native silverwork share several affinities. There is still no clear way of distinguishing Navajo from Pueblo silver jewelry. At the same time, this period reinforced the jewelry forms that would endure into and through the twentieth century. These forms remained actively chosen adornment types that would eventually be deemed "traditional." When these advances in surface decoration are added to genuinely traditional Pueblo lapidary work, we see more successful compound constructions in terms of design.

The first silversmiths made decoration based on definite Native choices. They crafted half-domed silver beads, which could be worn alone or with the amulet-like *naja* or the ambiguous cross-shaped pendant. Concha belts, derived from silver bridle ornament, were initially round but moved toward oval-shaped plaques by the end of the 1890s. Dress ornaments and early buttons had fluted or ridged surfaces.

Rings and bracelets became the palettes for specific shapes imposed over a standard band or cuff. Ring construction consisted of cigar bands, signets, and multiple (most often triple) shank circlets with a central square or round plate. Bracelet cuffs, including central plate and terminals, would become platforms for further stylistic elaboration.

These basic Navajo and Pueblo jewelry forms soon became the models for budding "Indian jewelry" mass production. The public's perception of generic American Indian adornment would be shaped by specific forms destined to become stereotypical. Those most often copied tended to be rings and, above all, bracelets. At the same time, non-Native manufacturers dispensed with the growing complexities of crafting multipart bracelet styles.

John Adair understood that the original intentions of the nineteenth-century smiths were enhanced by their use of "compound" bracelet features, such as a triangular cross section, flat wide bands, and heavy twisted wire.[14] Whether hand-wrought or bench-produced, these configurations paved the way for future composite bracelet fabrication. This especially applies to carinated, keeled, and grooved bracelet forms, often soldered together to create width. Manufacturers, by contrast, focused on the plain silver (or cheaper copper) bangle, band, and central-plate forms; they included stamping to evoke the item's aboriginal character. In many ways this imitation should be seen as an underhanded tribute to the continuing design power of original Navajo and Pueblo silverwork.

As well, new life was breathed into the making of traditional Pueblo stone jewelry. Well-known forms such as hand-drilled beads used in *heishi*, whether smooth shells or combined with turquoise tabs, might now be strung amid

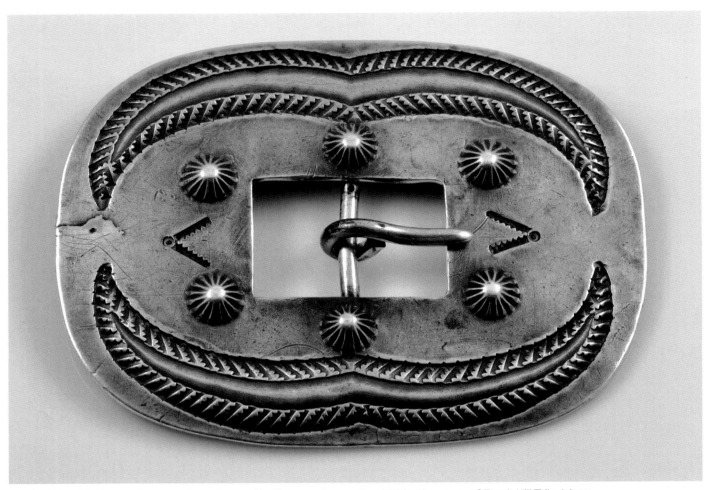

Belt buckle with elegant lozenge stamping and half–dome decoration, 1890s. Courtesy of Frank Hill Tribal Arts

silver beads. The use of pump drills continued. *Jaclas* remained in use, now most often tethered to the bottom of a necklace; a *jacla* string could also serve as barter for trade. Pueblo beads had always been in demand, and this enduring form would be increasingly integrated into new adornment, eventually replacing glass trade beads by the late 1920s.

## Reception of Native Jewelry Designs

The 1890s represent a critical point in the development of Southwestern Native jewelry, primarily because it was the time when silver and turquoise were so emblematically paired. Yet this was also when stronger construction details gave pieces a sophistication not seen before. Bezel holders and silver wire contributed to this effect. Native silver design was an acquired craft, but it so successfully presented Indian aesthetics that non-Native advocates grew more vocal about "preserving" it. Contradictory? Yes. At this time, the rapid development of such attractive metalwork, earning itself a place amid truly traditional Indian arts, was perceived as being equally threatened by commercial imitations.

For the most part, the making of hand-wrought jewelry remained local. The pawn system allowed Navajos to bank their personal jewelry with trusted traders until they could redeem it. The trading post routinely became a place of safekeeping until such adornment was needed for a ceremony or social dance. Traders also issued piecework to nearby jewelry makers. Late nineteenth-century tourism brought a growing number of visitors to trading posts to admire the items there. Some of them might buy a new or dead pawn piece that had been owned by an Indian, bearing it back home as a valued souvenir from their travels. Traders would soon expand their market reach by issuing catalogs offering such items for sale.

Down the road, the pawn system would fall out of favor, and the terms *old pawn* and *dead pawn* became confusing shorthand for jewelry made and worn by Indians. At the end of the nineteenth century, however, trading posts served as fairly acceptable centers for "frontier" commerce; the Indian trader performed various services for customers, including providing materials and suggestions to silversmiths. Traders might recommend changes to jewelry to make it more appealing to non-Native consumers—such as the use of thinner silver, smaller-scale forms, or the application of more turquoise—but they saw no compelling reason to interfere with design impulses. Traders felt little need to agitate for visual design changes before 1900, except

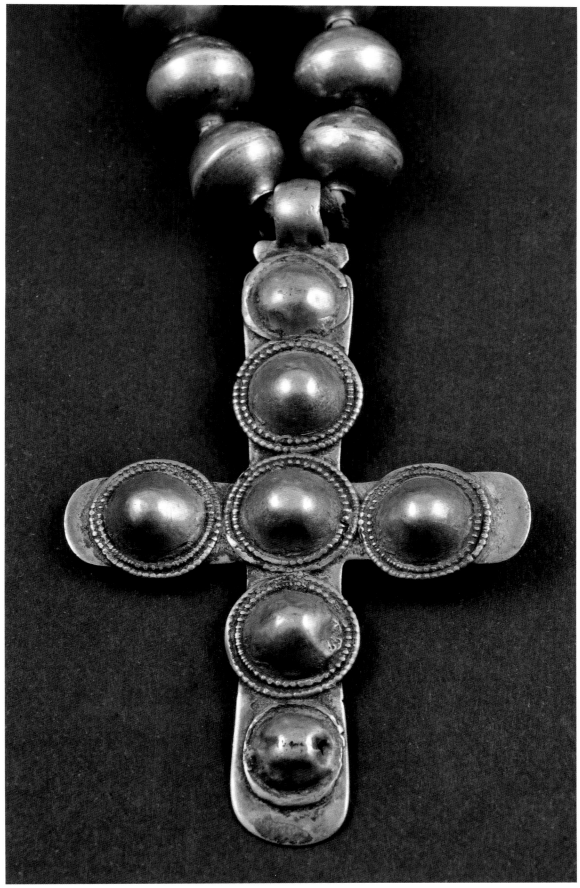

Navajo cross necklace made with bumped-up circles and edges from Mexican coin silver, 1890s. Courtesy of Michael Haskell Collection

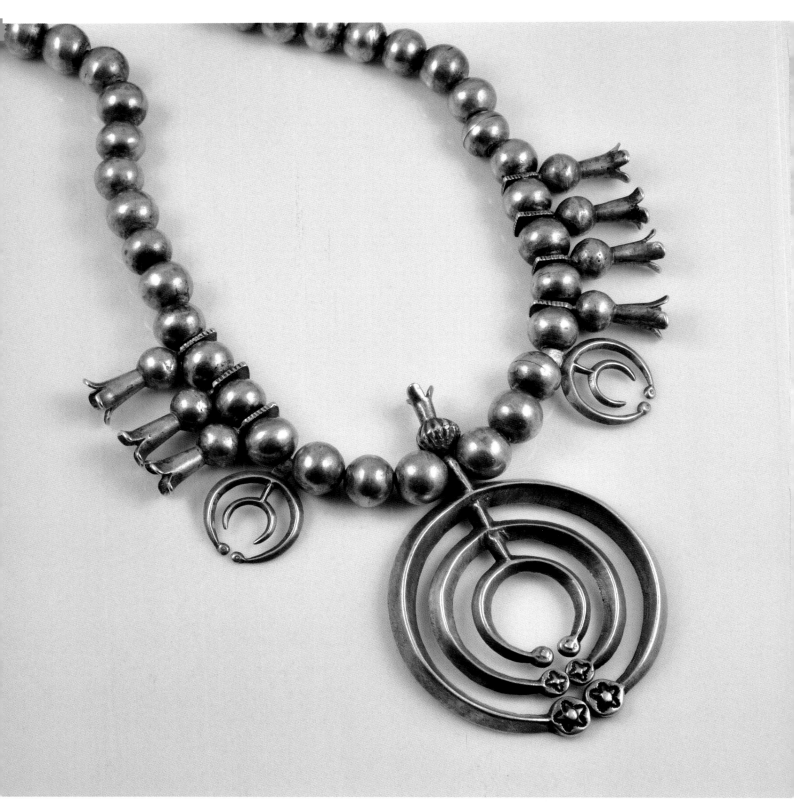

Unique squash blossom necklace with three silver squash petals and one *naja*–like ornament on each side and triple–barred *naja* pendant, late 19th century. Courtesy of Michael Haskell Collection

to encourage stronger stamping or more polished turquoise stonework. Once the twentieth century began, however, traders felt some pressure to clarify design goals when manufacturers and curio stores introduced less expensive bench-produced jewelry.

Devotees of original hand-wrought Navajo and Pueblo jewelry quickly became worried at the rise of commercialism. Non-Native supporters of handmade silver jewelry, now prized for its newly discovered design ingenuity, rightly feared that this work would be adulterated and debased when made more cheaply. Initially, Indian traders who stocked handmade jewelry had not viewed commercial pieces as competition, but they grew alarmed when machine-made goods undercut their prices for the genuine article.

For the Navajo and Pueblo peoples, the notion of a "vanishing race" needed to be kept at bay. Edward Curtis's shadowy and haunting photograph of Navajos on horseback crossing Canyon de Chelly alarmed non-Natives intent on aiding Native cultural survival. The best response lay in working cooperatively to support tribal economies, and by the 1890s the Southwest's Indigenous peoples were taking major steps on the path of survivance. But to non-Native arts advocates, commercialized Indian arts spelled a direct threat to everyone's well-being. The issue was, in fact, more complex.

The romantic portrait painted by those profiting commercially from stereotypical "Indian" products was of Navajos and Pueblos as preindustrial peoples. Their way of life was under threat. Children were taken to boarding schools to give them the "benefits" of the civilizing, dominant society. Behind these moves lurked the notion that Indian culture would not persist in the face of widespread industrialization. Thus, authentic Indian goods, those later deemed "classic," could now be encouraged as more genuine souvenirs by those non-Natives who would appreciate their value. This kind of tension between commercial and advocate outlook would drive demand for both types of jewelry.

In 1899, the Fred Harvey Company planned to outfit and sell genuine Navajo and Pueblo arts, including jewelry, to travelers to the Southwest. It did this mindful of manufacturers geared up to produce generic "Indian jewelry." The next three decades would see Indian arts advocates campaign vigorously against the rise of debased mechanized arts. Even the US government would get into the act. In the meantime, Navajo and Pueblo smiths and jewelers kept working, devising designs that would survive into the new century. Little did they imagine that they would be lucky enough to catch a rising cultural wave. A newborn modernist aesthetic, tied to abstraction, would render their creations even more popular and durable.

Lightweight ingot silver bracelet with decorative holes on central plate and terminals, 1890s. Courtesy of Michael Haskell Collection

Verso of bracelet, showing unique terminal design

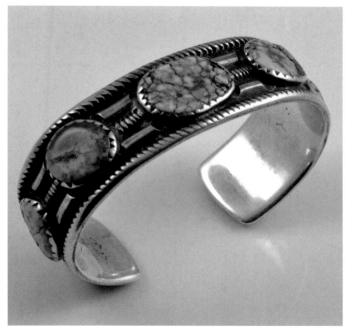

Early row bracelet with handmade serrated bezels, set with dark green natural turquoise, 1890s. Courtesy of Michael Haskell Collection

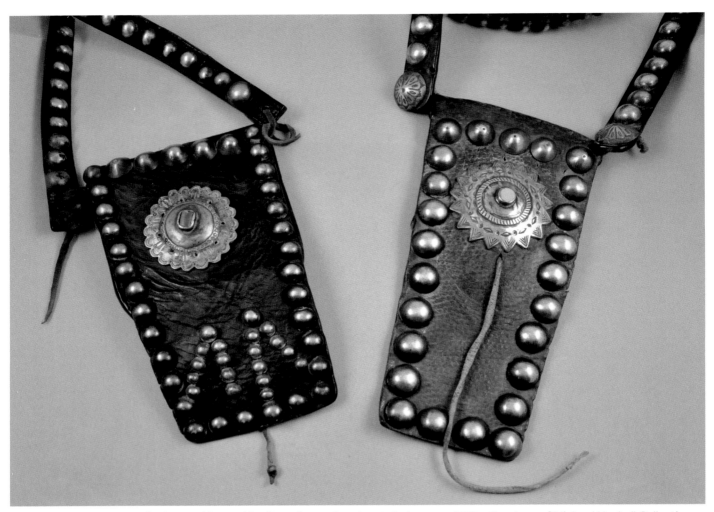

Two 1890s leather bandolier bags with notable silver disc and sunburst designs, ca. 1890s. Courtesy of Michael Haskell Collection

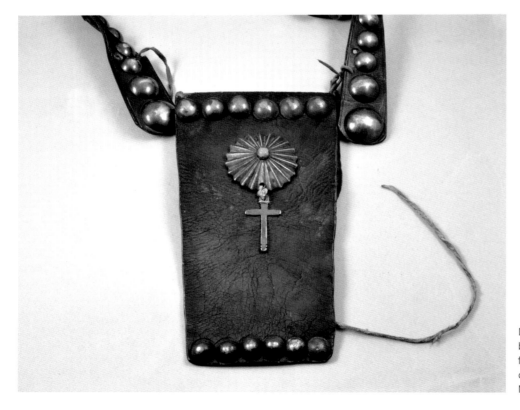

Distinctive silver designs on leather bandolier bag with half-dome disc and fluted ornaments and a small cross attached, ca. 1890–95. Courtesy of Michael Haskell Collection

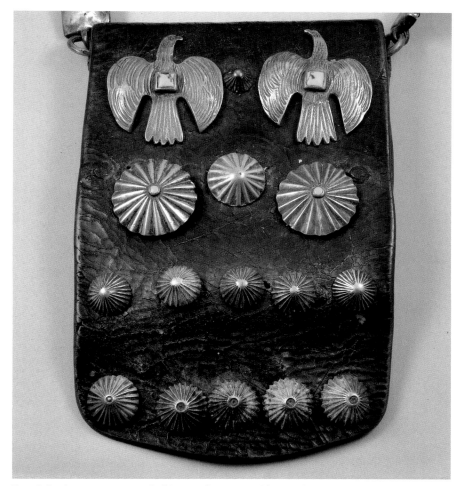

Bandolier bag ornamented with two silver water bird designs, square turquoise center stones, three fluted discs, and ten fluted, pointed half domes, ca. 1890s. Courtesy of Michael Haskell Collection

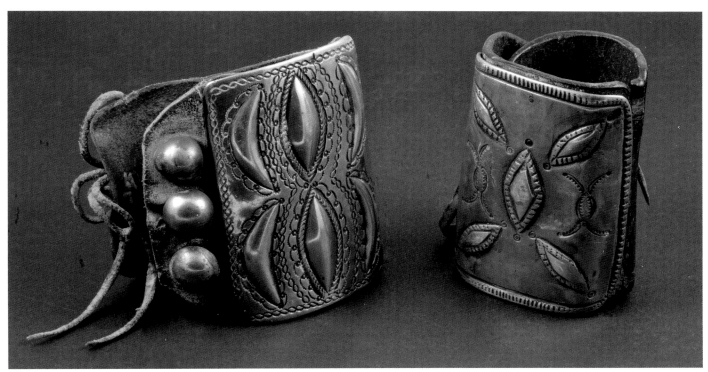

Two silver *ketoh* plates on leather showing surface decoration of the 1890s. Courtesy of Michael Haskell Collection

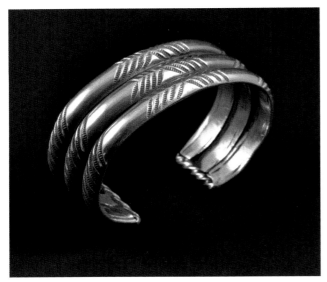

Silver composite cuff with twisted square wire, 1890s. Courtesy of Suzette Jones

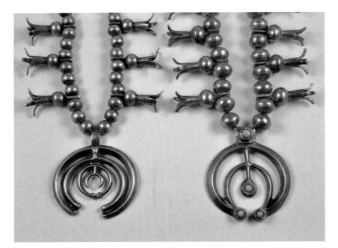

Two unique squash blossom necklace designs: (*left*) all silver triple *naja* with inset crescent; (*right*) double *naja* with high-grade Persian turquoise stone, ca. 1890s. Courtesy of the Hoolie Collection

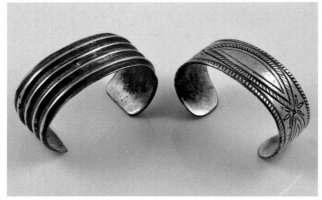

Two late 19th-century ingot cuffs, nail-point filed and stamped. Private collection

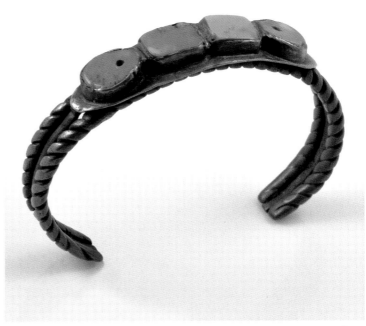

A composite bracelet—copper telegraph wire, brass bezels, silver plate with four turquoise stones, two drilled. This piece shows the ingenuity that late 19th-century smiths exhibited in creating works with limited materials. Private collection

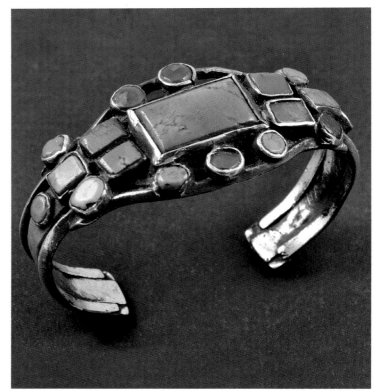

An early small stone cluster-style turquoise bracelet, possibly Zuni, with pounded ingot silver, ingot bezels, and hand-cut stones, lacking filing or stamping, late 19th century. Private collection

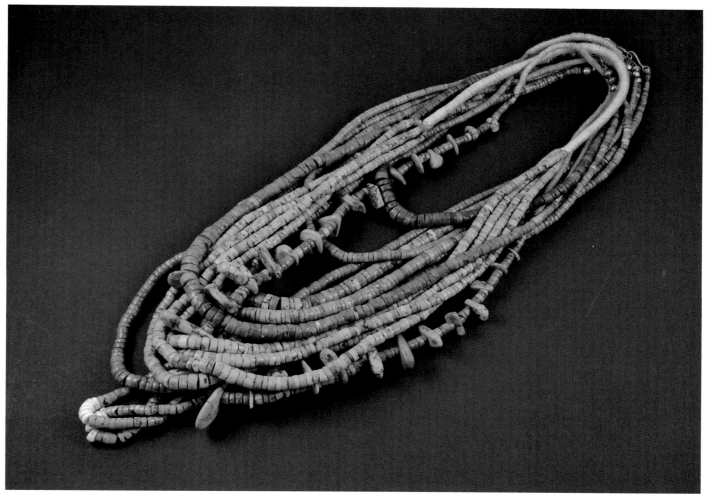

Group of three-strand and single strand green turquoise *heishi* necklaces, hand and bow drilled, late 19th century. Private collection

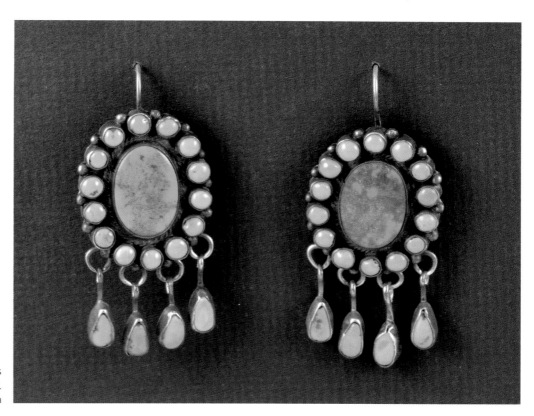

Early cluster-style earrings
with dangles, ca. 1900.
Private collection

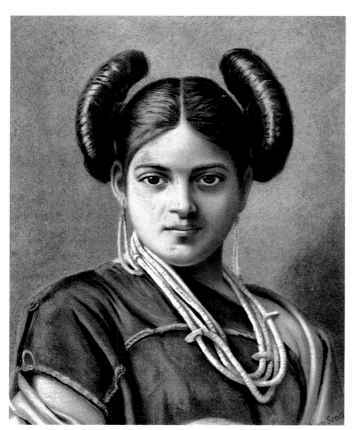

"Poobitcie–Moqui Girl" from the US Census Office, Moqui Pueblo Indians of Arizona, 1893. Private collection

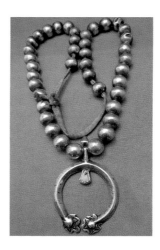

Slightly asymmetric carinated *naja* on silver beads, 1890s. Photograph courtesy of Karen Sires

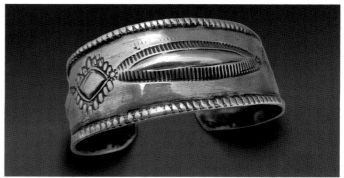

Silver cuff with abstract foliate surface decoration, 1890. Photograph courtesy of Karen Sires

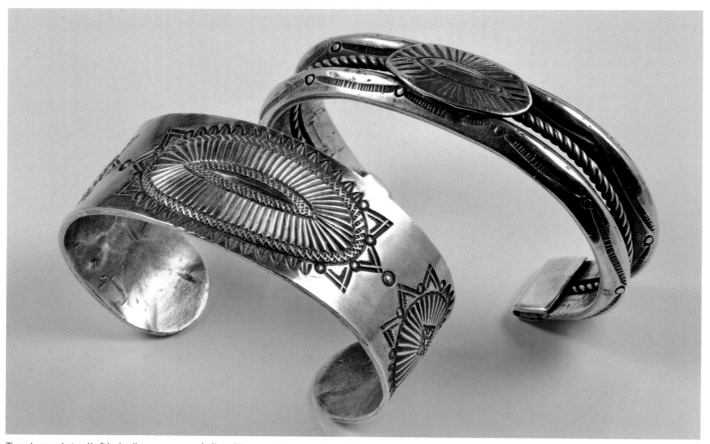

Two bracelets: (*left*) shallow repoussé, fine filing, and stamping; (*right*) carinated silver and wire, ca. 1890s. Courtesy of Peter Szego

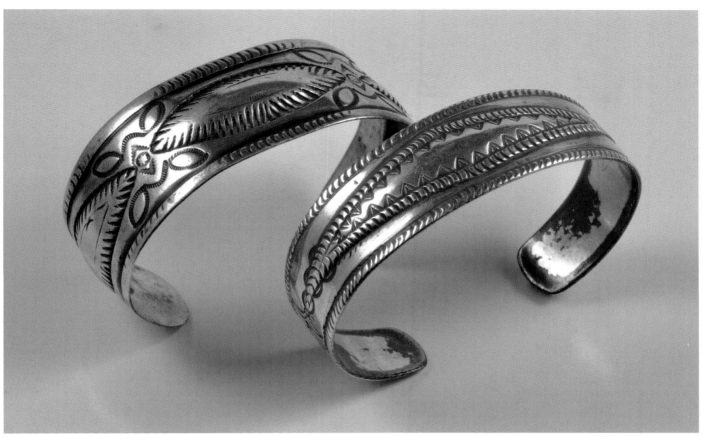

Two silver bands: (*left*) shallow repoussé; (*right*) elongated lozenge repoussé, 1890–1910. Courtesy of Peter Szego

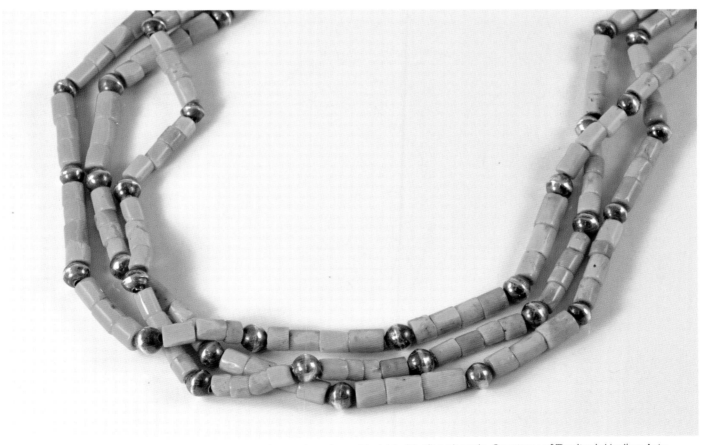

A popular style of the late 19th century: restrung three-strand coral *heishi* with silver beads. Courtesy of Territorial Indian Arts

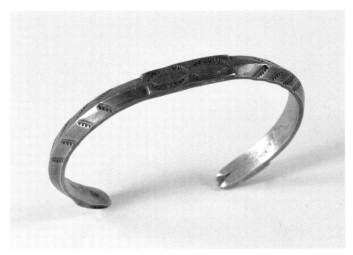

Old ingot silver carinated bracelet, late 19th century. Courtesy of Territorial Indian Arts

Verso of bracelet showing stress on silver from being placed into steel trough to shape it

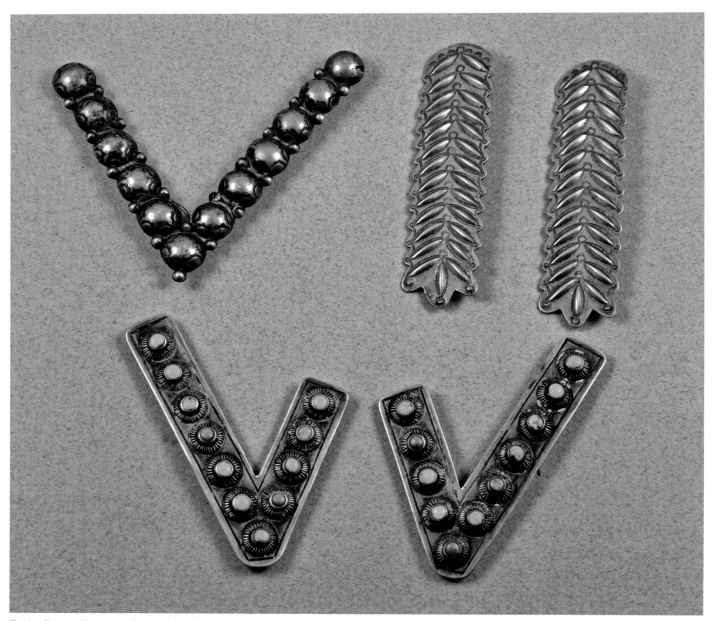

Early silver collar stays in varying shapes and decorative styles, 1890s–1910. Courtesy of Hoel's Indian Shop

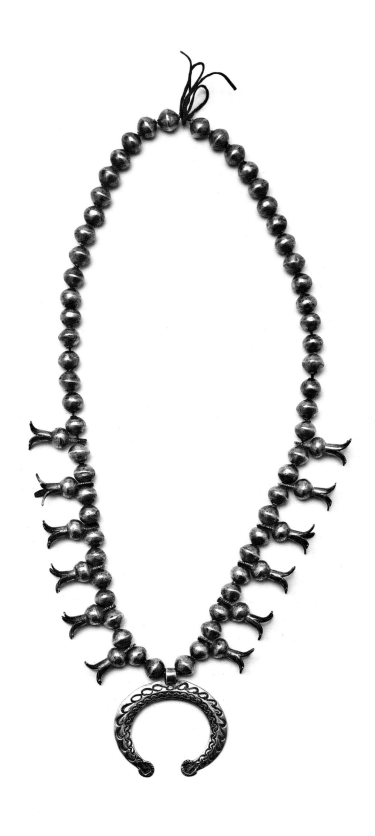

Navajo necklace, ca. 1900. The power of this jewelry form is evident in its stark, yet compelling design. Courtesy of Heard Museum, Phoenix, Arizona. NA–SW–NA–J–574

Chester Kahn, "Native American Trading," outdoor mural, 3rd St. and Coal Ave., Gallup, NM. Acknowledges the economic power of Indian arts.

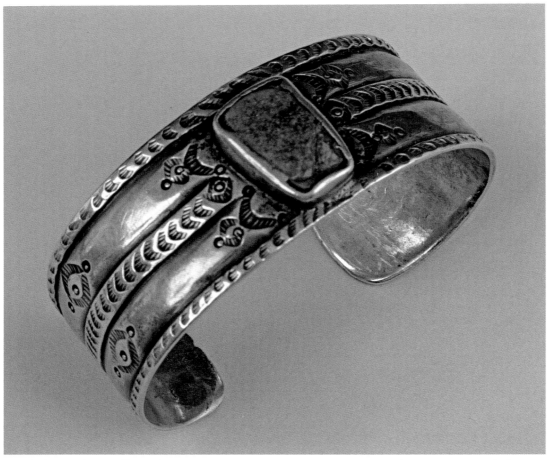

Navajo ingot–silver cuff with single stone, 1885–95. Photograph courtesy of Cyndy and Bob Gallegos

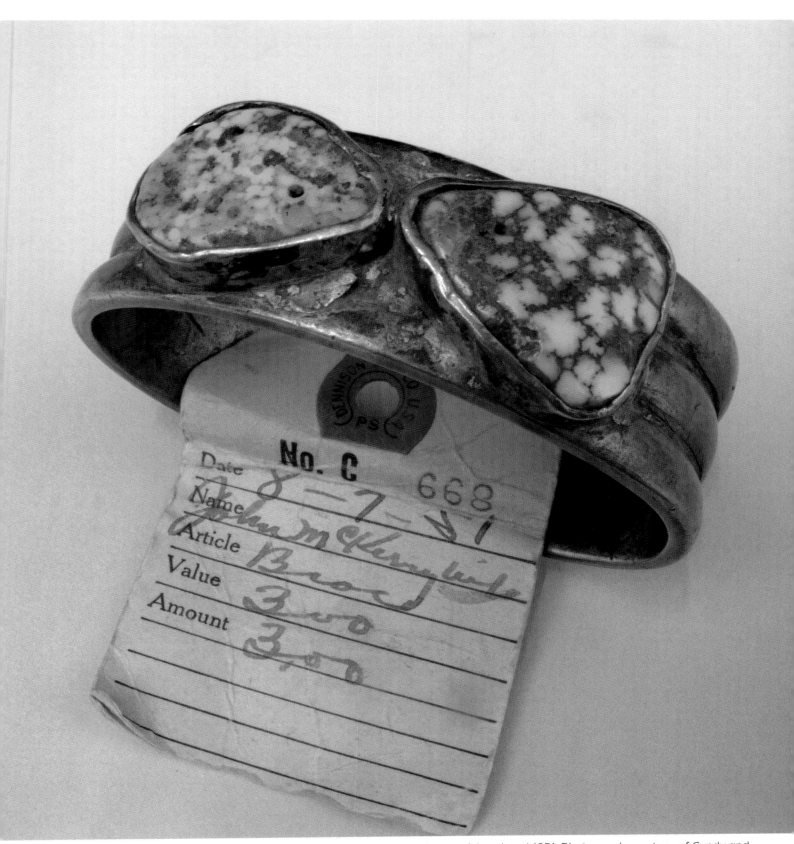

Thick ingot– or coin–silver Navajo cuff with two stones, c. 1890; original pawn ticket dated 1951. Photograph courtesy of Cyndy and Bob Gallegos

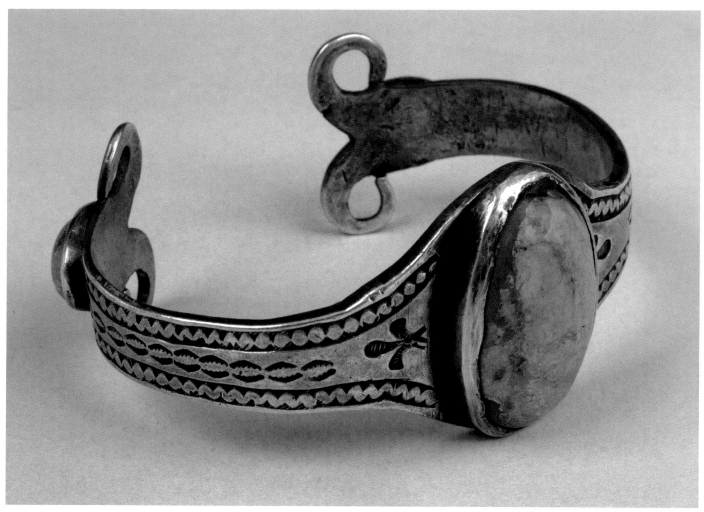

Ingot silver bracelet, possibly Pueblo because of swirls at the end, 1890. Photograph Courtesy of Cyndy and Bob Gallegos

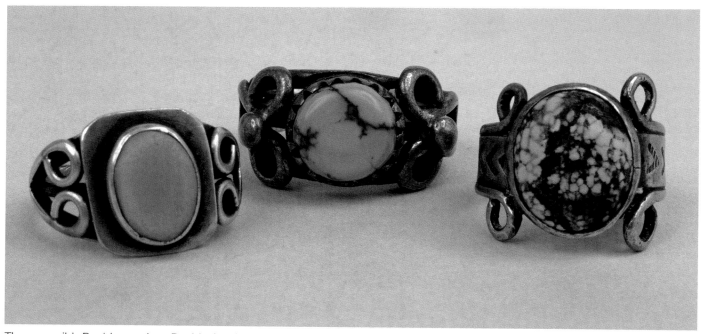

Three possibly Pueblo–made or Pueblo–inspired rings, all ingot or coin silver with strong appliqué frames, ca. 1890 to 1920. Photograph courtesy of Cyndy and Bob Gallegos

# Key Design Developments in the 1890s

## FORMS

- Established jewelry forms become more decorative
- **Second Phase concha belts** with closed centers, mostly oval plaques, and more elaborate buckles (to early 1900s)
- Silver beads are more abundant
- Cross necklaces are made by Pueblos, especially Isleta, and some Navajos
- Silver squash blossom necklaces with *najas* grow more elaborate and varied
- Drilled bead necklaces can have *jaclas* attached at bottom
- Composite silver cuffs and cast bracelets appear
- A basic early-row bracelet form appears
- "Styles" on rings and bracelets influence commercial tourist-jewelry designs

## MATERIALS

- In 1890, the US government prohibits melting its coins in ingot molds to make silver; Indian traders now stock Mexican coins only
- Use of small-stone turquoise proliferates
- Hand-drawn wire is used for decoration on pins, earrings, and bracelets
- Turquoise is imported from Persia; Cerrillos and Morenci turquoise mining already in process
- Local mines open: Bisbee, Hatchita, Kingman, and Tyrone
- Glass trade beads are added to *heishi* beads
- Stones used on jewelry have more varied shapes and sizes
- Trend for multiple small stones is reported as deriving from Zuni lapidaries

## TECHNIQUES

- Bezels are still rough, but handmade serrated bezels improve from last decade
- Mine-cut stones are set flush with bezels or domed
- Silver wire used for appliqué and filigree add embellishment
- Handmade stamps become more prevalent during this decade
- Fluted circles, half-dome, and lozenge surface decoration appears
- Low repoussé and early silver ball "raindrops" appear
- Silversmiths increasingly integrate silver and organic materials
- Sculptural qualities are enhanced through hammering and casting

## MOTIFS

- The earliest Navajo and Pueblo jewelry designers objectified significant natural elements through their worldview, such as rain, the sun, corn, landscape features, and colors
- The representation of these elements, along with experimental geometric patterns, helped build a shared repertoire of integral design

## ELEMENTS

- Texture and tone intensify; contrast, dominance, and proportion increase

## NOTABLE MAKERS

- *Navajos:* Atsidi Tso (Big Smith); Atsidi Yazzie; Slender Maker of Silver
- *Isleta:* Jose Jaramillo
- *Santo Domingo:* Ralph Atencio
- *Hopi:* Sikyatala of First Mesa, Tawahonganiwa
- *Zuni:* First silversmiths: Keneshde; Lanyade (father of Horace Iule), Balawade; Hatsetsenane (Sneezing Man and grandfather of Horace Iule)

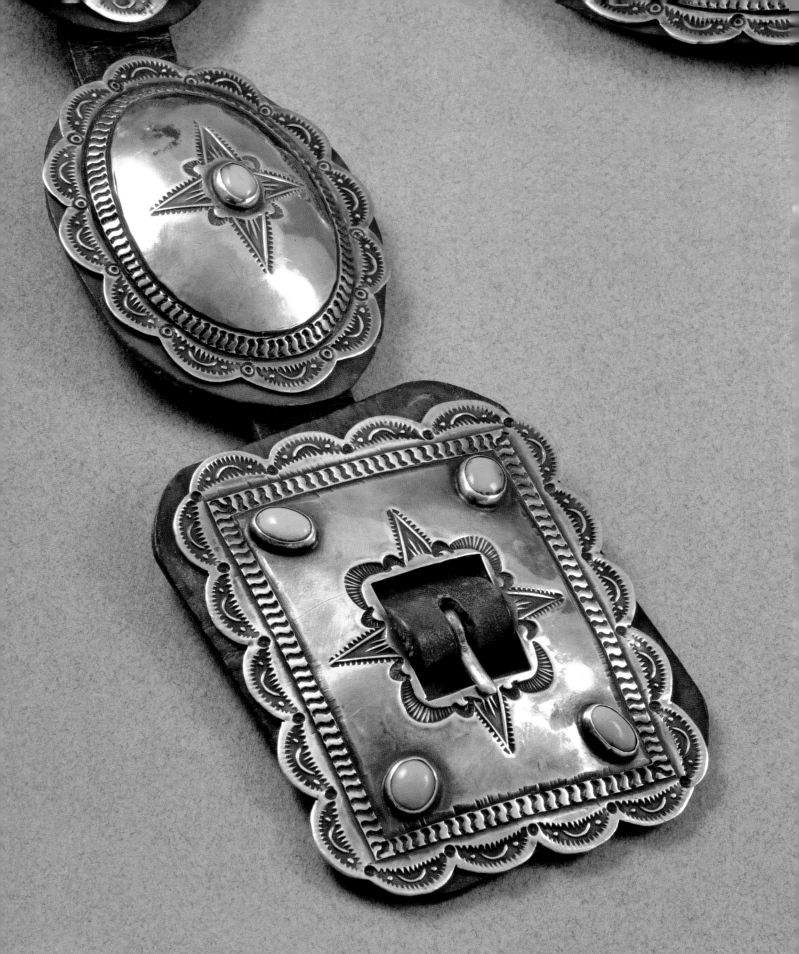

See page 135.

# CHAPTER 5

# 1900–1915:
# Reevaluating Commercialism

The advent of commercially made "Indian jewelry" had a powerful effect on the development of Navajo and Pueblo jewelry making, but not wholly in the negative way that most twentieth-century writers and critics claimed. In fact, the development of a manufactured, generic product helped Native makers of curio and original jewelry clarify future design needs, especially regarding design motifs and incorporating new technology to their advantage.

With the benefit of historical perspective, we now understand that the inevitable technological changes of the new century helped Native jewelry makers adopt, adapt, and selectively discard commercially driven design processes for the better. Navajo and Pueblo smiths adopted commercial tools for improved construction purposes and took advantage of new commercial materials like sheet silver. Working in curio shops, their exposure to benchwork allowed them to earn wages and learn how to run a business.[1] This kind of employment, however, also educated Native jewelry makers in what design quality really entailed.

# TIMELINE

**1900s**    Hopis begin making silver jewelry

**1901**    Grand Canyon Railway's first passenger train reaches South Rim in September

**1901**    Fred Harvey Indian Department established in Albuquerque

**1902**    Alvarado Hotel, Albuquerque, opens in May; sells Indian goods

**1902**    John Lorenzo Hubbell offers first Indian silver in a catalog titled *Navajo Blankets and Indian Curios*

**1903**    Edward Curtis photographs Navajo and Pueblo subjects in New Mexico

**1905**    Hopi House opens at Grand Canyon; employs Hopi dancers and artisans

**1906**    Congress passes Antiquities Act, allowing national monuments

**1906**    J. B. Moore, in Crystal, NM, publishes *Illustrated Catalogue of Navajo Hand-Made Silverwork*

**1906**    H. H. Tammen Co., Denver, starts to manufacture Southwestern-style jewelry

**1907**    School of American Archaeology is established in Santa Fe; renamed School of American Research in 1917

**1908**    Grand Canyon becomes a national monument

**1909**    Museum of New Mexico is established in Santa Fe, NM

**1910**    Tammen Co.—manufactured "Indian jewelry" now undercuts Indian trader prices

**1912**    New Mexico and Arizona become states

**1915**    Panama-California Exposition in San Diego shows Southwestern Indian arts in "Painted Desert" living-desert re-creation

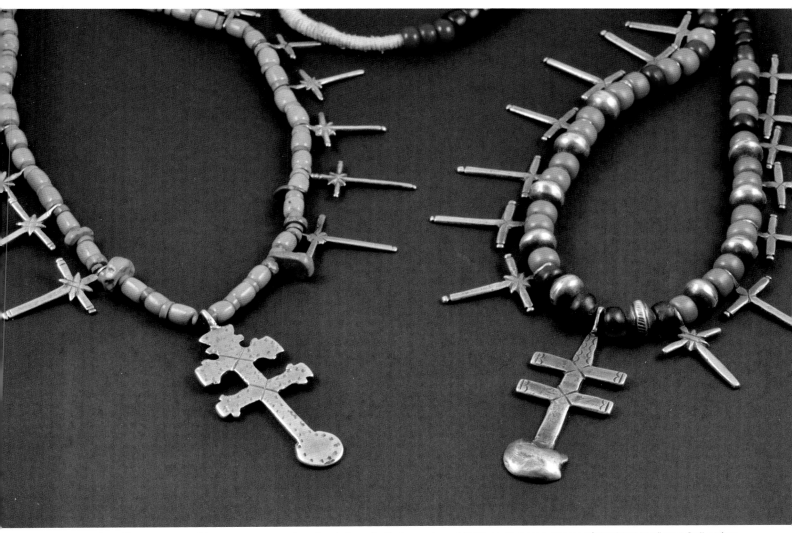

Two Pueblo silver cross necklaces strung on glass trade beads, first quarter of 20th century. Courtesy of Andrew Muñana Collection

## Historical Developments of the New Century

Commercial "Indian jewelry" posed a paradox: although it aided Native jewelry making and established the popular-culture recognition of these pieces as souvenirs, it also created a means of devaluing Native jewelry in general and inaugurated a low-end market for this work. Among other faults, the commercialization and mass production of Indian jewelry designs led to distorted assumptions about symbolism in Navajo and Pueblo imagery.

Native design was not the network of symbols claimed by those who hawked souvenir jewelry. From the start, jewelers deliberately chose motifs, whether abstract or figural, that reflected their individual and cultural perspectives. Beginning around 1900, however, Navajos and Pueblos were adjusting to the imposed need to sell to non-Natives. This new market necessitated modifications in designs. Commercial manufacturers wanted imagery that would easily identify as "Indian"; they urged stereotyped designs that they felt would help sell the jewelry, ignoring what Natives wanted to depict.

Indian traders and commercial manufacturers parted company on who their target customers were. The traders attracted on-site visitors who liked buying something well made by an Indian, and they encouraged collectors with a taste for quality. Manufacturers sought buyers who were actively traveling, less engaged in contact with another culture, and seeking inexpensive, portable souvenirs. As a consequence, manufacturers encouraged makers to use newly available commercial sheet silver since it was thinner and lighter, to produce more ornately stamped and obviously "Indian" motifs, and to reduce the size and scale of such popular forms as bracelets and necklaces.

The Fred Harvey Company played an indelible role in this transformation while promoting both hand-wrought and bench-production jewelry for sale. Its Indian Department, headed by John Frederick Huckel (1863–1936) and managed by Herman Schweizer (1866–1928), was started in Albuquerque, New Mexico, in 1901. Huckel labored to build a strong inventory of saleable Indian products and to increase non-Native access to the products, especially travelers who lacked the time or ability to visit a trading post. At the

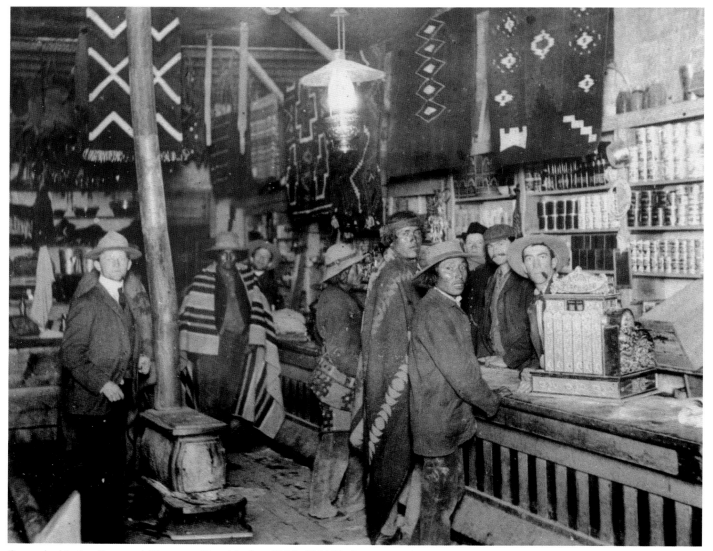

Group inside trading post, Thoreau, New Mexico. 1900–1920(?). Courtesy of the Palace of the Governors Photo Archives (NMHM/DCA), neg. no. 009123

Grand Canyon, a surefire draw, the Harvey Company architect Mary Colter (1869–1958) built Hopi House, which opened in 1905; this popular tourist attraction served as a place where Navajo and Hopi artisans demonstrated their crafts, including silverwork, and sold them to visitors.

As the era of US tourist travel developed, the Fred Harvey Company tirelessly promoted Native arts. The company worked with various Indian traders, including John Lorenzo Hubbell, who also gathered items for major clients such as William Randolph Hearst, an avid collector of Navajo silver and textiles. At the same time, the Harvey Company seriously collected prime examples of noncommercial silver and jewelry. This collection, now housed at the Heard Museum in Phoenix, Arizona, represents an unadulterated array of finest-quality early Navajo and Pueblo jewelry and metalwork.[2]

The first fifteen years of the new century saw a steady increase in less-expensive, souvenir-type objects, mainly rings, bracelets, and flatware such as Navajo-made spoons.[3]

At this time the railroad town of Gallup, New Mexico, became a large mercantile center for Indian goods. Manufacturing firms, including the H. H. Tammen Company, based in Denver, Colorado, churned out "Indian-style" jewelry. Their prices undercut the traders and thoroughly compromised the concept of jewelry handmade by Native labor. Commercialism had bypassed authenticity for profit found in mass-production techniques.

Curio shops in the Southwest, mostly notably in New Mexico, started selling souvenir Indian goods in earnest at this time. They sought to promote their jewelry by hiring Natives, many from Rio Grande pueblos, to work in their shops. These employees turned out ornaments that were mostly mass-produced, adding touches that the shop could claim as "Indian made." Machinery in these stores was usually hidden from view; visitors without knowledge of the real process were offered demonstrations of Indians working on pieces at benches.[4] Advocates of Indian arts became alarmed by such deceptive practices.

To be fair, a number of curio stores did permit Native silversmiths to create mostly hand-wrought pieces for higher prices; these goods were bought by more discriminating tourists with deeper pockets. Some consumers, including non-Native locals, were taken with the idea of having a piece of jewelry expressly made for them. Indian traders, however, were more likely to provide such a service.

Even the traditionally made *heishi* of Pueblo individuals was affected by outsider interest at this time. Beadmakers slowly began to employ new approaches to bead shapes and lengths for necklaces worn by fashionable non-Natives, and they started adding silver beads to those made from stone and shell. Despite these changes, such necklaces were still created by meticulous manual shaping, including the use of a pump drill.

Silversmiths welcomed new and better tools for creating ornamentation by hand. This advantage had started in the 1890s and continued through the first decade of the 1900s. Access to metalworkers' saws, crucibles, dividers, and tin shears eased the creative process. Commercial solder, tools adapted for doming and shaping, and the introduction of blowtorches made the fabrication of jewelry easier. Commercial stamps became available in a greater variety of patterns, which led to stronger and more intricate designs on silver.

## Primitivist and Modernist Perceptions

Commercially made Indian jewelry borrowed certain broad design elements and rendered them fairly stereotypical in the process. The impetus came from European American business philosophies. Such outsider attitudes directly affected Navajo and Pueblo design when, as early as 1903, consumers of domestic furnishings took part in an "Indian craze." Native-made blankets, weavings, basketry, and pottery—the decorative products of material culture—could now be viewed in carefully staged department-store settings or ordered through catalogs.[5] The origins of this craze involved the materialistic embracing of an artistic concept called "primitivism." Elite European painters such as Pablo Picasso and Paul Gauguin had turned to non-Western artistic endeavors in a search for what artists would call a form of genuine, primal "authentic expression." This shift brought about new views related to modernist thought and representation, daringly challenging and replacing the artistic conventions of the previous century.

Hand-wrought Navajo and Pueblo jewelry design fit surprisingly well within these primitivist and modernist viewpoints. Weren't some of the jewelry forms strikingly primal and original in their creation? Didn't their abstract

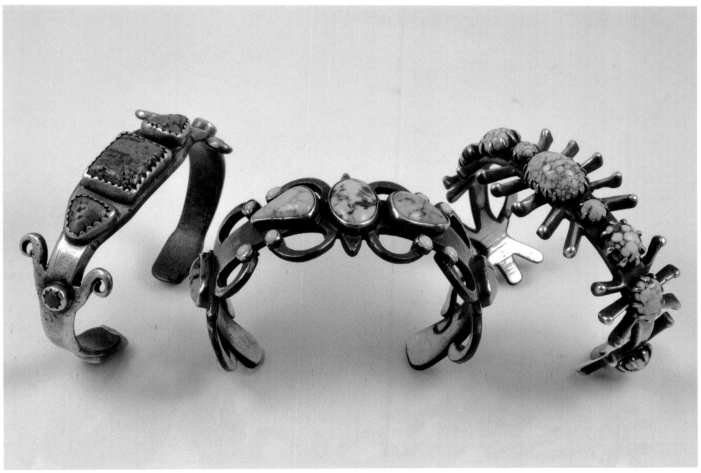

Three silver bracelets, ca. 1900: (*left*) wrought with dark green turquoise; (*center*) sandcast five-stone; (*right*) wrought with high-domed turquoise. Private collection

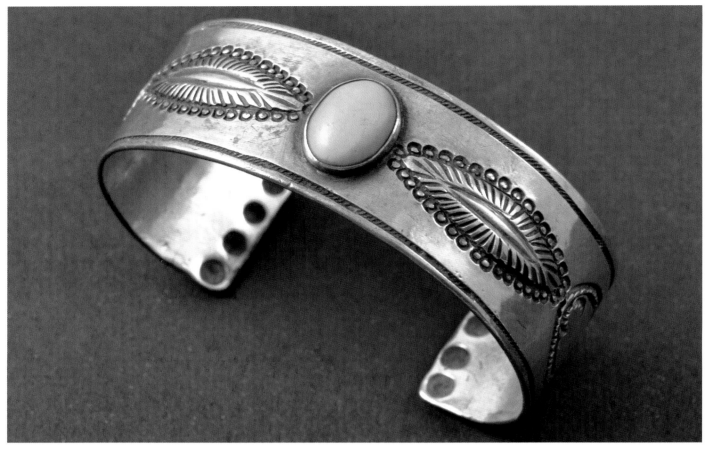

Silver cuff set with blue Hubbell glass bead, ca. 1900. Private collection

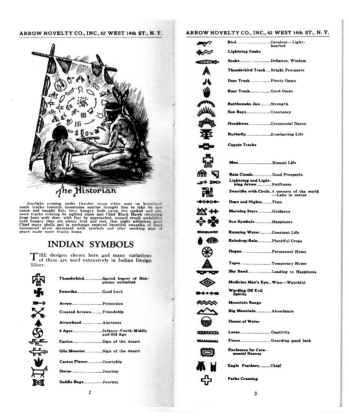

"Indian Symbols" chart from 1912 trade catalog. Author's collection

surface patterning fit the geometrical resolution of early modernist innovations? This reinforced non-Native designers' notions that Navajo and Pueblo design was liberated by its primitivism and susceptible to the cleansing, streamlined aesthetics of modernism. These perceptions even took in commercial and inauthentic "Indian jewelry" designs, permitting them to be worthy and aesthetically acceptable examples of new (and liberating) technology.

Modernist expression arrived in the United States rather abruptly between 1900 and 1915. This development happened just when national monuments in the West were gearing up for increased visitors, and the first institutions devoted to studying and exhibiting Indians were established in Santa Fe. Tourism, tuberculosis, and a search for a picturesque environment brought many newcomers to the Southwest, from artists and their patrons to literary figures, ready for a tricultural interaction with Indians and Nuevomexicanos. Outspoken non-Natives soon felt that they best understood what Native and Hispanic peoples required to advance artistically.

Many non-Native advocates of Indian arts espoused antimodernist viewpoints related to commercial products. They were wary of the dominant-culture marketplace demand for mechanized arts that might endanger authentic Native expression. However, the belief that Navajo and Pueblo silver and metal jewelry making was already

Eight representatively styled early rings set with Hubbell glass or turquoise, late 19th–early 20th centuries. Private collection

Four Pueblo-style rings with spiral wire, first quarter of 20th century. Private collection

Brass bracelet with Hubbell glass, 1910s. Private collection

traditional seems more than a little incongruous when this "tradition" was only thirty years old. Enthusiasts overlooked the fact that the design standards applied to Native weaving, basketry, and pottery—all of them older arts—did not wholly apply to silverwork.

Non-Native traditional purist critics were shortsighted. Worried that Native culture would be assimilated or terminated, they failed to recognize that the Southwest's Indians were growing beyond cultural limitations and expanding into a world of diversity. Rabid non-Native advocates preferred to freeze Native artistry, restricting its scope for the sake of so-called ethnic traditions, rather than allowing modernization to move it forward. Nor did they understand that modernism was a mode well suited for a people finding their way into contemporary design expression. Native artistic exploration already embraced abstract decorative principles.

Those truly concerned with finding a viable market for Navajo and Pueblo arts ignored ideological arguments and supported the marketplace concept of an "Indian craze." The endorsement of primitivist theories by non-Native advocates was based on the perception that Indians were premodern in their economics and still culturally backward.[6] Such an attitude reflects intellectual ambivalence about the

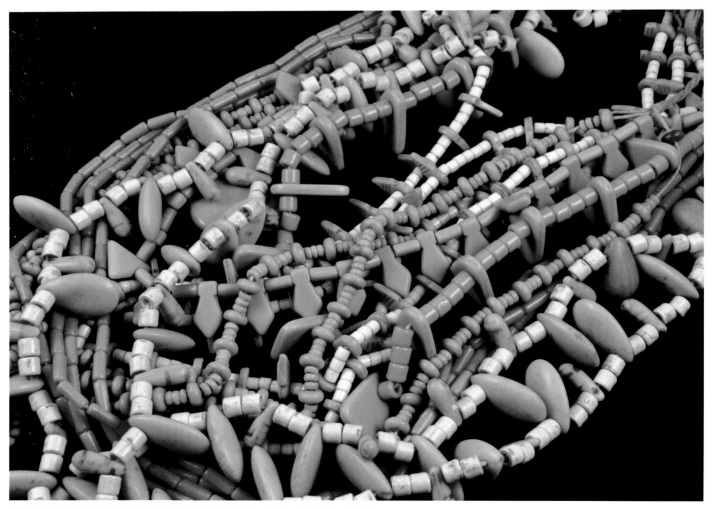

Six necklaces with Hubbell and red glass, 1900–1910s. Private collection

direction that modern civilization was taking. Rapid changes in technology at this time left many people uncomfortable.[7] The taste for American primitivism in arts, especially interior and decorative design, fit well with prevailing vogues.

The effects of the Arts and Crafts movement in America also aided appreciation for Native hand-wrought goods. Native material culture could be collected, and its design impulses fit nicely with the tenets of both primitivist and modernist cultural production. Native designs became sought after by arts educators and illustrators in the new century. Non-Native intellectuals in the Southwest were eager to build on the appealing aspect of Navajo and Pueblo design elements. Incoming non-Native artists, many from New York's schools of social realism, would choose to portray Indians, especially those from the Taos and Hopi pueblos, as picturesque subjects tied to their landscape.[8]

## Commercialism and Its Impact on Design

Critics of commercialism would remain vocal through the first half of the twentieth century. Many of their complaints were valid. The design impulses of Native jewelry makers were curbed, subordinated, or overridden by companies in the quest for profits. These outsider businesspeople believed they knew best what specifications should go into the creation of Indian jewelry. There were real parallels in other Indian arts; John Lorenzo Hubbell hired an Anglo artist to paint "traditional" designs that he displayed on his trading-post walls for his Navajo weavers to emulate.[9] Manufacturers exercised control over their "Indian jewelry" designs through the use of motifs employed as dubious symbols. The Fred Harvey Company's Herman Schweizer thought nothing of asking Native smiths to follow company requirements or work on designs that he wanted.[10]

The greatest danger of mechanical processes was how they could cheapen the look of Indian jewelry and encourage shoddy designs. Poor-quality pieces mimicking the real thing entered the market. Most arts have a thriving black market in fakes and reproductions, and inevitably Southwestern Indian jewelry gained a particularly insidious and harmful one. In this respect, a successful American product became brazenly imitated. Uncontrolled mass production quickly undercut hand-wrought jewelry assembly, diluting the appeal of Native-made pieces.

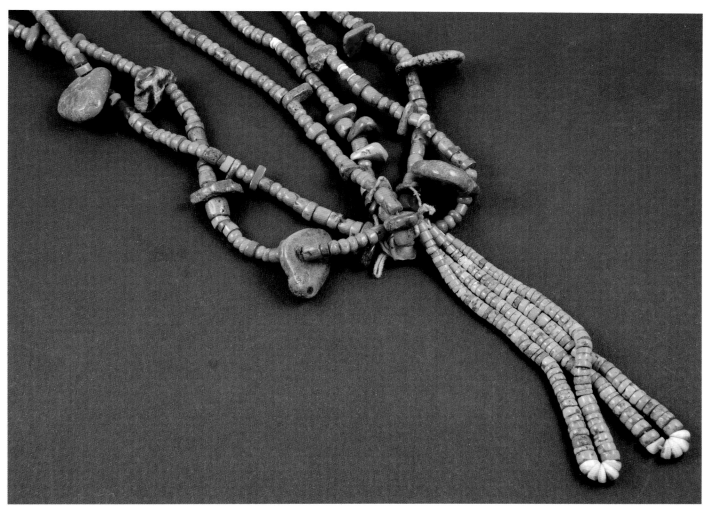

Three-strand Pueblo *heishi* made with turquoise and early coral beads with two jaclas, 1910–1920s. Private collection

Early postcard of the Hopi House at Grand Canyon South Rim, where Indian arts were demonstrated and sold. Author's collection

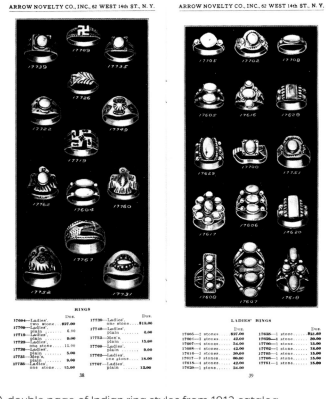

A double page of commercial Indian bracelet styles in Arrow Novelty Co. (NY), 1912 sales catalog. Author's collection

A double page of Indian ring styles from 1912 catalog

The worries of early twentieth-century Indian arts advocates centered on keeping commercialism away from authentic Native design and fabrication. Their premise was naive at best, racist at worst. Non-Native purist champions of genuine Indian design were afraid that "traditional" designs and techniques would be degraded through commercial innovations. They failed to see that Navajo and Pueblo jewelry creation was a living art, and it was not in danger of disappearing. Writers on Indian jewelry continued to lose sight of how the makers took the best from every situation—including commercialism—while retaining long-term design control.

On the positive side of the push and pull of commercialism, we should note that curios themselves were derived from the older tradition of cabinets of curiosities. The collection and exhibition of "exotic" objects from other cultures could awaken viewers' appreciation and interest in new acquisitions. Both handmade and commercially produced Indian souvenirs could turn into collectibles. Future treasures for museums would come from the holdings of devoted collectors.

The Arts and Crafts movement focused new attention on American handicrafts. Consumers now had a choice of two collectibles: the hand-wrought jewelry of the Navajos and Pueblos and the less-expensive, generic "Indian-made" item. Original Navajo and Pueblo jewelry forms were the inspiration for generic Indian jewelry in terms of identity and public recognition. Over time, concha belts, squash blossom necklaces, and turquoise and silver beads, bracelets, and rings became well-known, even iconic, symbols of Native America.

In 1915, Joseph Pogue's book *The Turquoise* sparked collectors' passions for this gemstone. Initially published in a scientific society manual, this study highlighted the emerging importance of the turquoise industry and tied the stone firmly to Native American culture. Ranging from the geological to the ethnological, this key publication helped build the growing number of collectors who sought high-quality Southwestern mine turquoise set in Indian silver jewelry. It established an American character for turquoise itself, even though the mineral could be found in distant countries around the globe.

A major positive aspect of Navajo and Pueblo commercial involvement has been reiterated more recently in Jonathan Batkin's book *The Native American Curio Trade in New Mexico*: young Native men and women found needed wage work in curio shops.[11] They learned the value of commercial tools in making well-finished products and received useful training not just in fabrication but also in customer service, and some even gained enough confidence and acclaim to go into business for themselves. Once self-employed, these individuals controlled and guided their design impulses for economic gain and personal satisfaction. This was a major step toward cultural accommodation and survivance.

Tourism encouraged intercultural communication in these early decades. Encounters at tourist stops, from railroad hotels to the Grand Canyon's Hopi House, allowed visitors to bridge the cultural/language gap through their admiration of Indian arts. Learning to be comfortable with outsider customers readied influential individuals such as Fred Peshlakai (1896–1974) and Awa Tsireh (1898–1955), who would go out on their own, to work in places away from their origins and expand their design repertoire. These innovative steps permitted Navajo and Pueblo jewelers in the years ahead to gain confidence in their identities as independent workers.

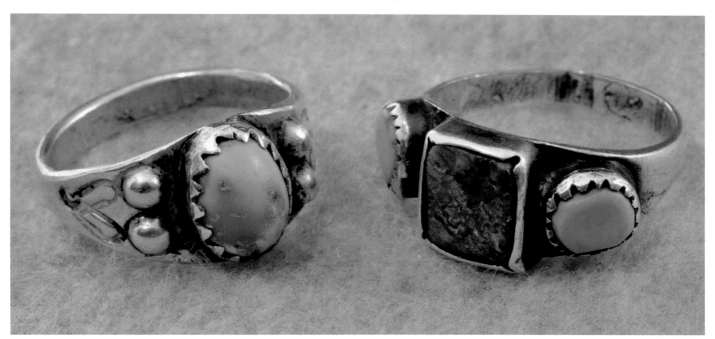

Navajo and Pueblo early 20th-century oval and three-stone rings. Courtesy of Robert Bauver

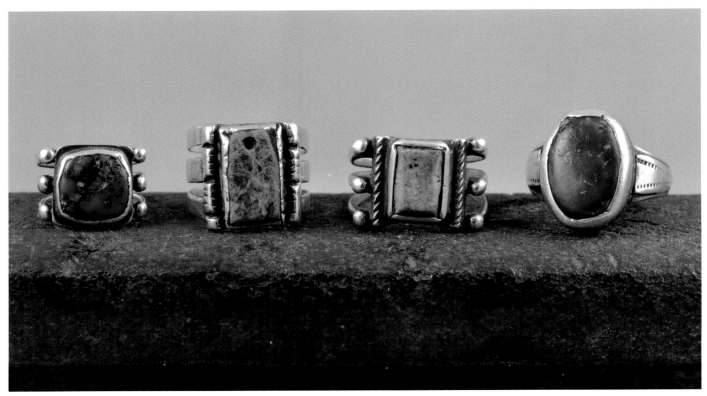

Four single–stone rings, 1895–1920. Courtesy of Frank Hill Tribal Arts

## Reevaluating Design Intentions

Changes in hand-wrought jewelry making during the first fifteen years of the twentieth century initially don't seem much different from those of the 1890s. By contrast, surface decoration gains a wide variety of symmetrical, repetitive markings, including prominent bosses in circle, star, and lozenge shapes, and keeled (elongated raised) surfaces are characteristic of this period. Smiths engaged in fabrication took advantage of the improved tools and commercially cut and polished stones that came their way between 1900 and 1915. Although an increased elaboration of surface detail can be seen after 1900, forms remained the same. Their execution, however, hints at a greater pursuit of personal vision.

Earrings with multiple stones and dangling parts multiplied after 1900. Cast-on work was created for decorative additions to bowguards, bracelets, and belt designs. Cast bracelets are crowned with stonework. More-elaborate *naja* designs arrive, with stronger embellishment at the top and on the terminals. Clara Lee Tanner, among others, noted that Zuni *najas* made after 1910 were inevitably decorated with small stonework.[12] Twisted wire and carination play a larger role in the composition of bracelets. The first generation of proto-clusterwork styles appears on bracelets and rings; these early "clusters" were more often butterfly shaped than round. Repoussé designs with lozenge-like centers sprout more vegetal borders. Stamps provide tentative animal outlines, on occasion.

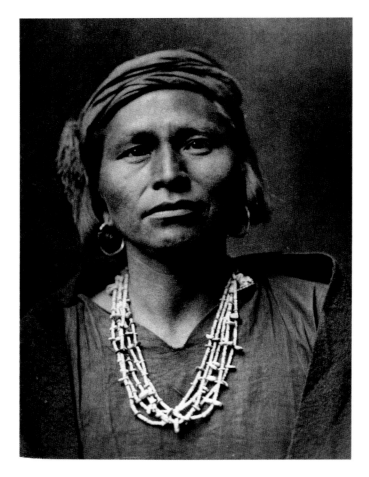

Edward Curtis, *Zuni Governor*, from *The North American Indian, vol. 17* (1907). Private collection

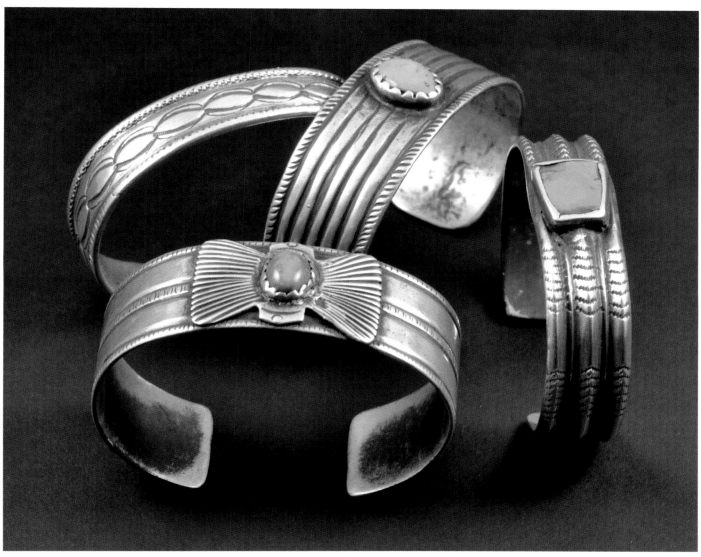

Four early bracelets with appliqué added later, ca. 1900. Courtesy of Frank Hill Tribal Arts

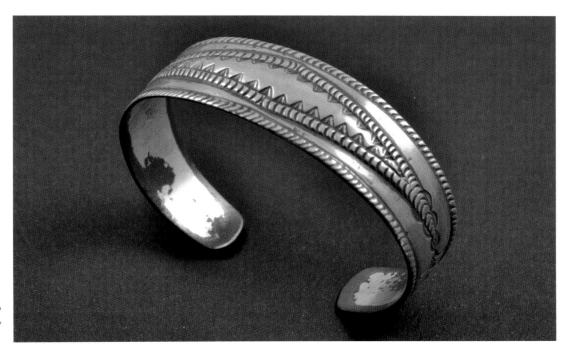

Early silver cuff with low repoussé, ca. 1900. Courtesy of Frank Hill Tribal Arts

131

Two pairs of Pueblo earrings, first quarter of 20th century. Courtesy of Frank Hill Tribal Arts

*Naja* with simple filing on silver beads, ca. 1900. Courtesy of Frank Hill Tribal Arts.

Continuing attention to texture, proportion, and decorative contrast as leading design elements marks the first ten years of the new century. A 1912 commercial trade catalog from the Arrow Novelty Co. of New York City documents tangible styles of composition; these now-more-familiar forms and shapes could serve as role models for what would eventually be designated as classic and traditional designs. At the same time, this catalog (like so many others) has a key list of "Indian Symbols." These grew out of existing Native-made stamps, but most of the images' meanings were completely fanciful.

Looking inside this commercial publication we find several bracelet styles: stamped silver bands with one central stone setting, an early small-stone row bracelet, a carinated bangle with several stones, an early small-stone arrangement, and bird and snake decoration. Surveying the rings section, existing styles are depicted. Some have a central stone on a plate, whereas others show vertical rows of small stones on a split shank. Two rings have cutout or stamped whirling-log motifs, which also appear on other contemporary Indian arts. This particular catalog echoes mainstream American business practices by mingling novel or "exotic" designs with conventional jewelry styles.

During this period, more-elaborate surface decoration is apparent. Seed and foliate patterning increases, especially around repoussé. The sunburst motif expands, replacing simple circles with rounded or elliptical designs in which lines radiate from a circular or diamond-shaped center. Concha forms more often have scalloped edges and borders. Bezels on rings and bracelets retain serrated (or sawtooth) ends, many with a rough edge. Such unpolished characteristics reflect the work of the increasing number of new smiths after 1900.

Between 1900 and 1915, three design elements become customary: repetition, emphasis, and a growing hierarchy of arrangement. These effects demonstrate a concerted attempt to bring principles of *hózhó*—the need to live in harmony and beauty—to prevailing design elements. Fundamental jewelry forms begin to be made in styles that will have value beyond the local market. Such subtle commercial tendencies mark the Native creator's desire to please a wider range of consumers. To this end, many smiths actively devise their own stamps.

By 1900, Native American identity was a confused and volatile subject in the minds of the American public. Opinions ranged from a belief in aiding Indians to a conviction that Native peoples were in decline and failing. Advocates of Indian arts worried that Native crafts would dwindle in the face of mass production. In the meantime, American commerce continued to make money selling Indian souvenir trinkets. Curio shops did good business between 1890 and 1920, as the first wave of tourism to the West blossomed. No matter what, everyone in the tourist industry agreed that Navajos and Pueblos were part of the regional fascination of the American Southwest.

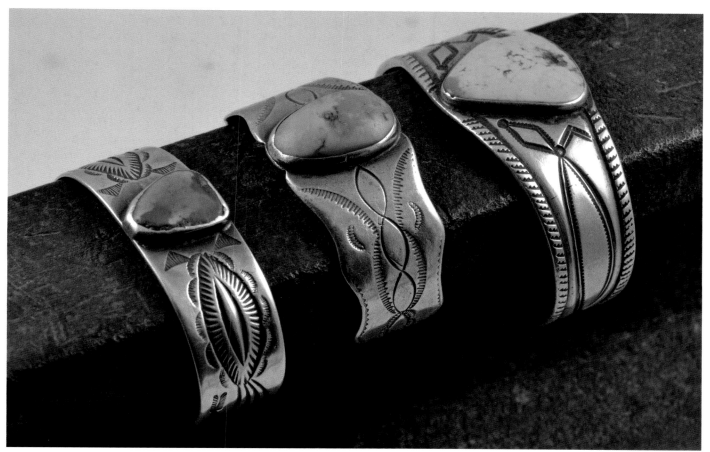

Three classic–design cuffs with single turquoise stone, first quarter of 20th century. Courtesy of Frank Hill Tribal Arts

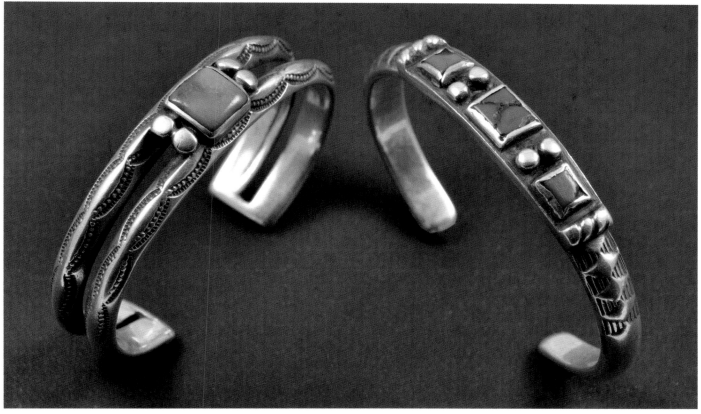

Two narrow band bracelets: (*left*) single stone, 1920; (*right*) triple–stone, first quarter of 20th century. Courtesy of Frank Hill Tribal Arts

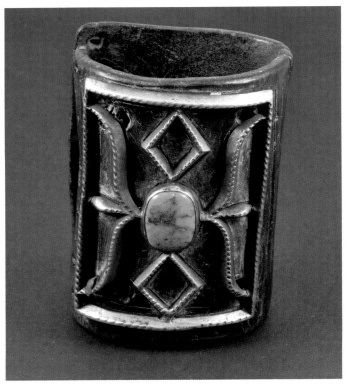

Classic rectangular *ketoh* silver frame design, ca. 1900. Courtesy of Michael Haskell Collection

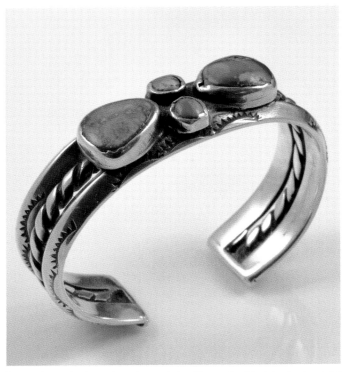

Drawplate design silver bracelet with central twisted wire and dark-green turquoise stones set in early butterfly cluster pattern, 1900–1910. Courtesy of Suzette Jones

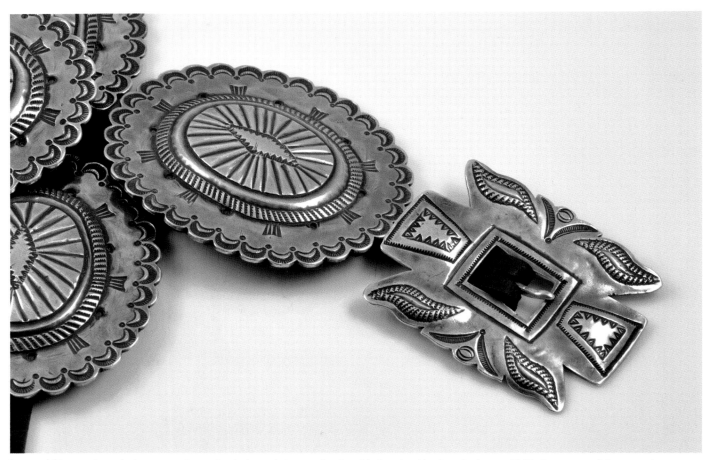

Second Phase closed plaque oval concha belt and decorative buckle inspired by *ketoh* shape, 1915. Courtesy of Suzette Jones

The ethnographic nature of the 1915 Panama-California Exposition, held in San Diego, was on display when it opened with a 10-acre exhibit titled *The Painted Desert*. The design team included John Huckel, Herman Schweizer, and Mary Colter, along with the museum director and educator Edgar Lee Hewett. A re-created trading post featured Native smiths in residence, busily demonstrating the making of copper and silver adornment; nearly 300 Southwestern Indians were temporarily employed during the fair.[13] Sponsored by the Atcheson, Topeka and Santa Fe Railway, *The Painted Desert* was yet another vital opportunity to draw visitors to the charms of the Southwest.

An interesting and significant description of Navajo silvermaking appears in *Rings for the Finger*, published in 1917. The author, George Frederick Kunz (1856–1932), was a noted New York City gemologist who, at age twenty-three, became a vice president at Tiffany & Co. In 1916 he had traveled to New Mexico and was so impressed by Navajo silver that he included a page of rings made at the Grand Canyon in his book. He'd studied the Indians at work and was moved to report:

> While the art of the work produced can scarcely be termed finished, when judged by very high standards, still the silver ornaments executed by the Navajos possess at least the charm inherent in individual work, as contrasted with the more harmonious and finished productions of merely mechanical art, where thousands of objects of a given type of design are turned out annually in a highly organized silversmithing establishment. With these Indians we have the "personal note" that is too often missed in the ornaments of our day.[14]

Kunz was able to cut through the non-Native perceptions about the effects of commercialism, primitivist impulse, and modern technology to see that Navajo design was inherently individualistic. Outsider anxieties would continue for the next thirty years or more, but this expert understood at once that design artistry lay in the hands of the makers.

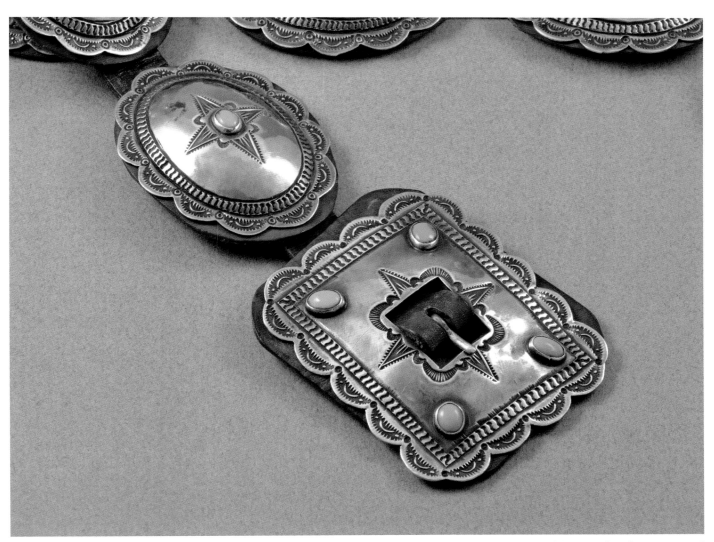

Second Phase concha belt with nine oval center stamped concha plaques and square buckle all set with turquoise, first quarter of 20th century. Courtesy of Suzette Jones

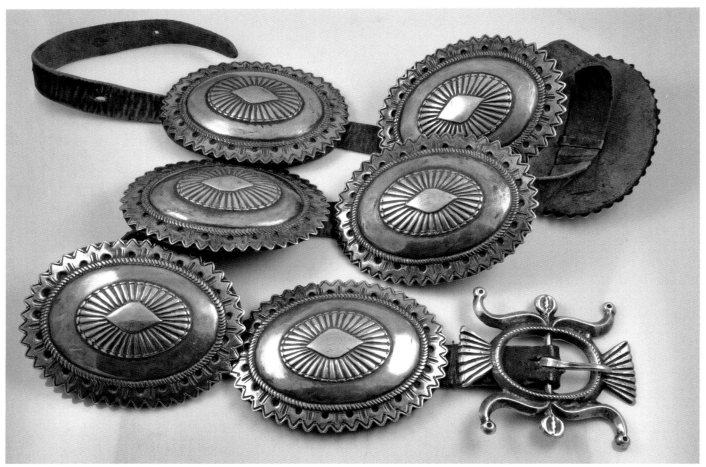

A Second Phase silver concha belt with six plaques backed on leather and cast buckle, ca. 1900–1910. Courtesy of Janie Kasarjian and John Fugii Collection

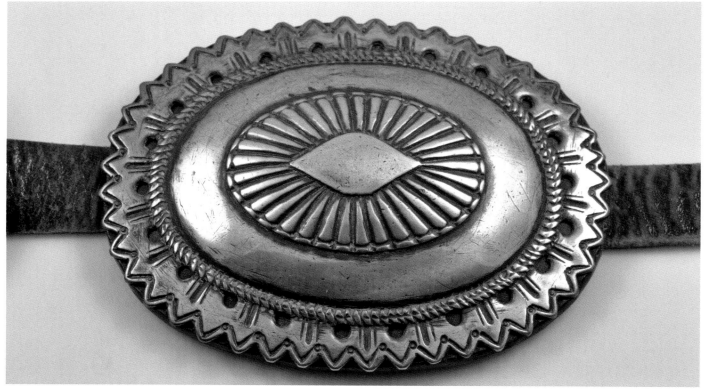

Close-up of concha with sunburst, wire effect, and other surface decoration

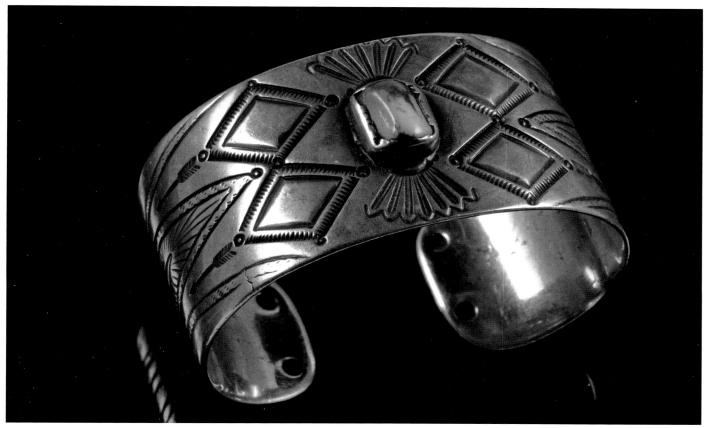

Wide Navajo cuff with early coin-silver squares, first quarter of 20th century. Courtesy of the Hoolie Collection

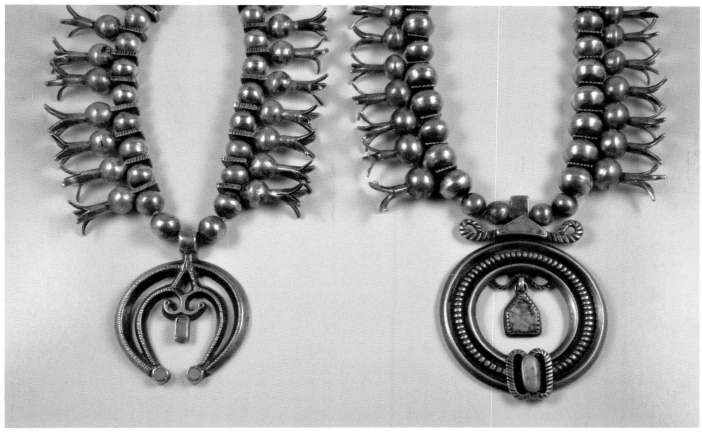

Two squash blossom necklaces with artful *naja* designs, possibly School of Slender Maker of Silver: (*left*) double *naja* with inset turquoise and on terminals, 1895–1915; (*right*) closed *naja* from hand-drawn silver, ca. 1910. Courtesy of the Hoolie Collection

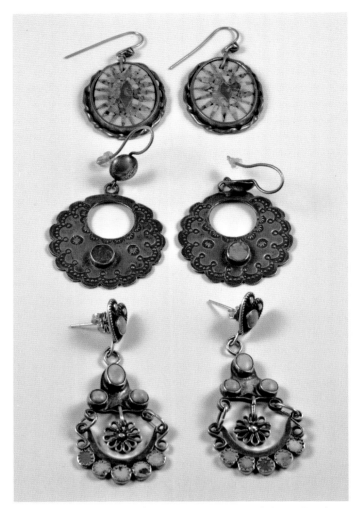

Three pairs of popular earring styles (*top to bottom*): Santo Domingo, Navajo, Pueblo, 1900–1930s. Courtesy of the Hoolie Collection

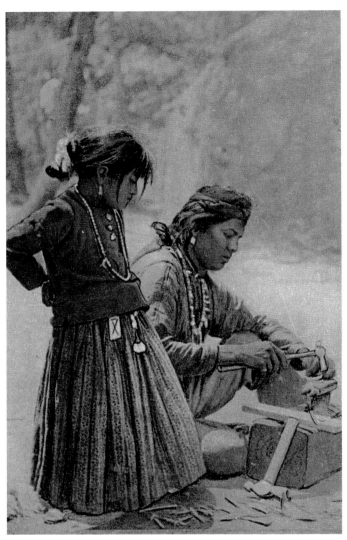

Fred Harvey Company postcard of Navajo smith with daughter looking on. Private collection

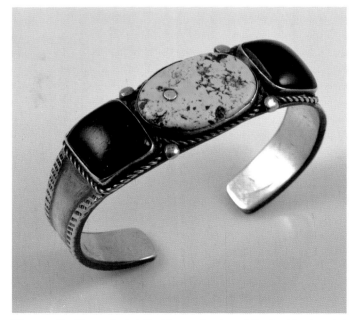

Silver cuff with central drilled turquoise bead flanked by two jet stones, ca. 1915. Courtesy of Andrew Muñana Collection

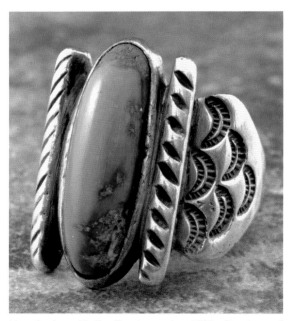

Navajo ring with Cerrillos turquoise, 1910s. Courtesy of Robert Bauver

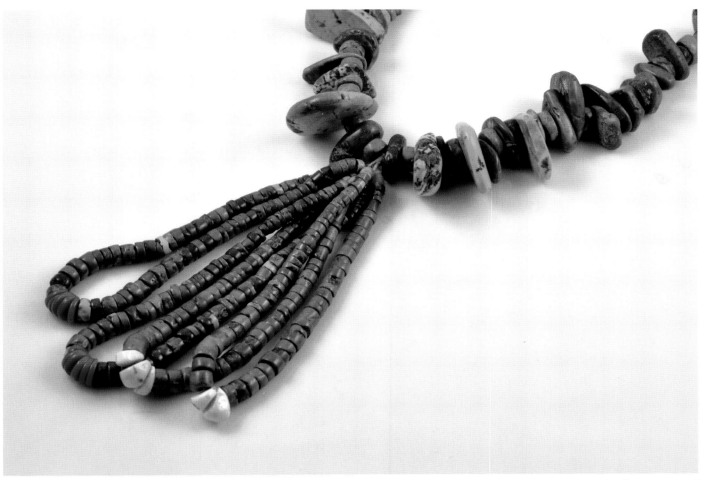

Navajo or Pueblo early nugget and tab necklace of green turquoise stones with three *jaclas* and red and white corn, first quarter of 20th century. Courtesy of Andrew Muñana Collection

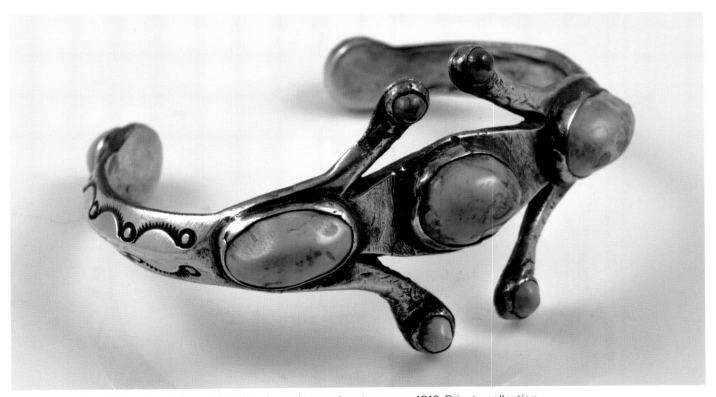

Cutout bracelet with handmade bezels for high domed turquoise stones, ca. 1910. Private collection

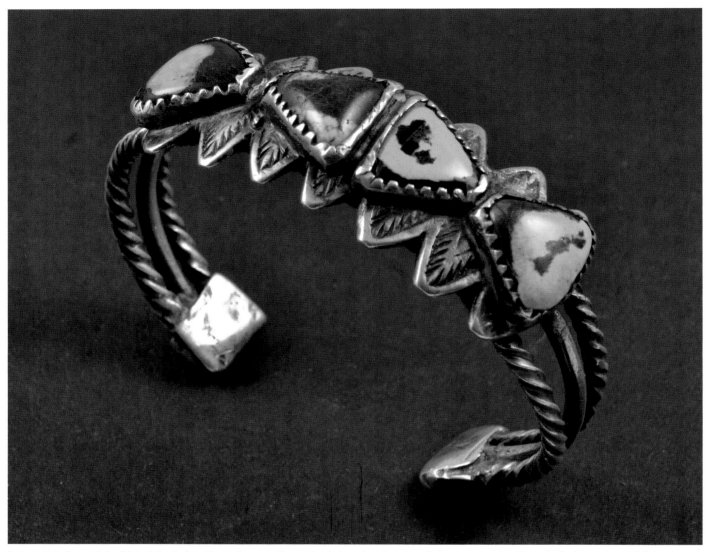

Ingot plate bracelet with twisted wire, stamping, and inventively hand–cut stones in heavy serrated bezels, first quarter of 20th century. Private collection

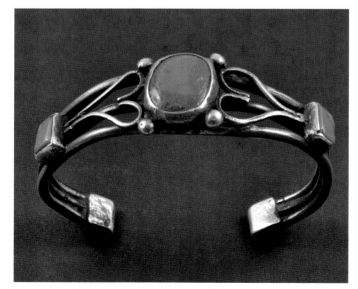

Bracelet styled with pulled ingot wire, hand–cut stones, and bow drilled tabs, no stamping or filing, probably Pueblo, ca. 1900. Private collection

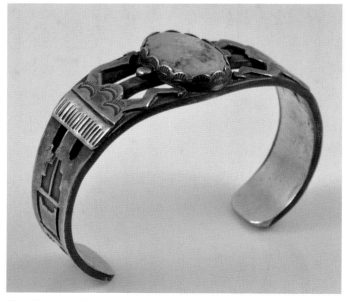

Classic design, fine stamping on top plate and on well–made bezels (possible precursor to Hopi overlay?), ca. 1900. Private collection

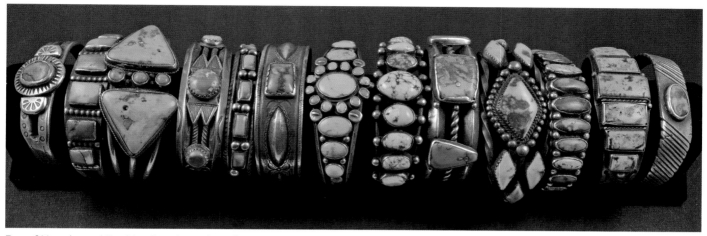

Bar of Navajo and Pueblo silver bracelets, first quarter of 20th century. Private collection

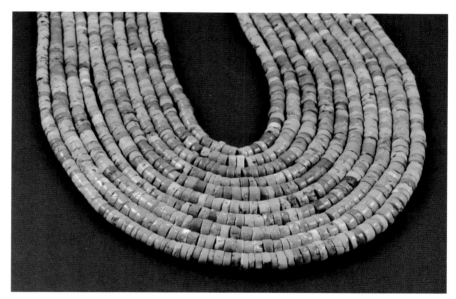

Detail of "Cleopatra" graduated strands green turquoise *heishi*, first quarter of 20th century. Private collection

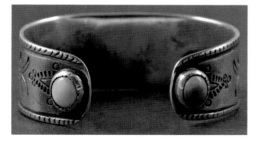

Detail of bracelet terminals with mismatched turquoise stones

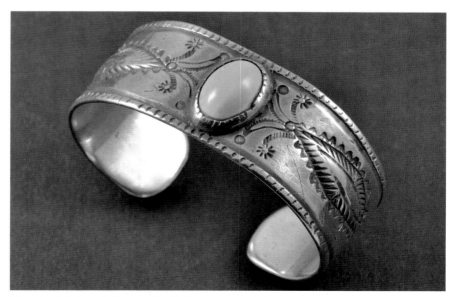

Classic wide band silver cuff with three spaced stones, ca. 1910–20. Private collection

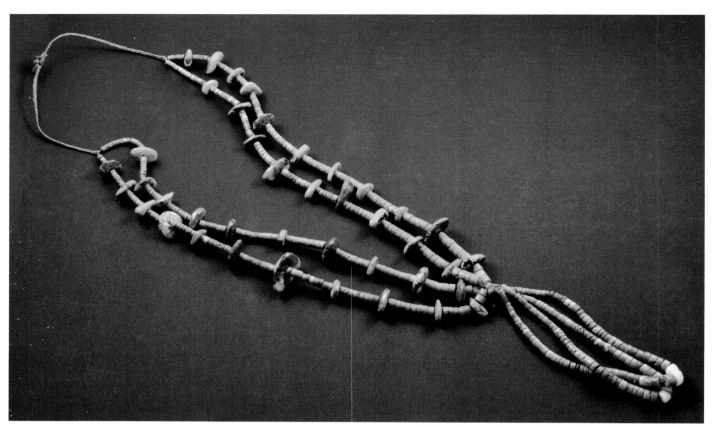

Two-strand natural turquoise *heishi* with tabs in a popular style with two added *jaclas*, Navajo or Pueblo, 1910s. Courtesy of Paul and Valerie Piazza

Tourist-era money clip, cuff, and silverware with popular commercial design motifs, abstract and figural, ca. 1910–20s. Courtesy of Paul and Valerie Piazza

Three commercial-designed spoons with whirling logs, comic figures, and snake motifs, 1910–20s. Courtesy of Paul and Valerie Piazza

Three tourist-era commercial spoons with crossed arrows and figural "Indian heads," ca. 1910s–20s. Photograph courtesy of Karen Sires

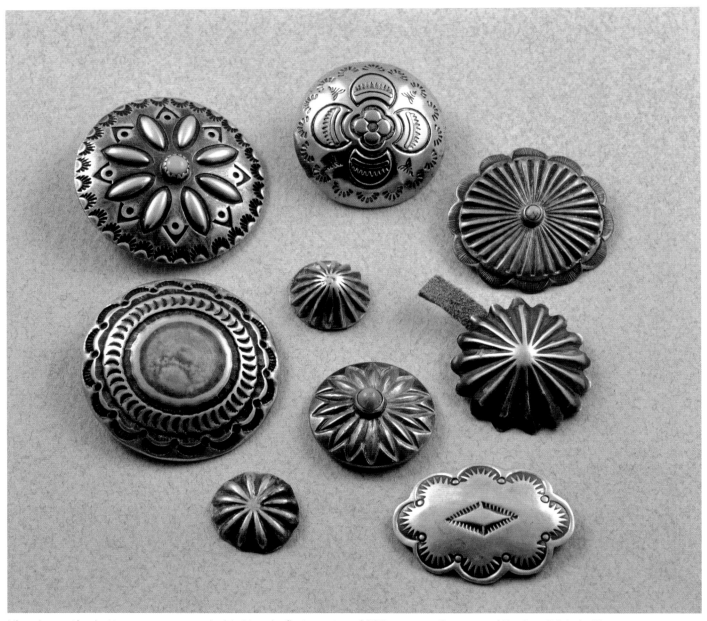

Nine decorative buttons, sew-ons, probably Navajo, first quarter of 20th century. Courtesy of Paul and Valerie Piazza

Jewelry design borrowed abstract chevron details from contemporary and older pottery, as in this Laguna–Acoma pot, 1910–20. Courtesy of Paul and Valerie Piazza

Navajo textiles of the first quarter of the 20th century show shared abstract design. Courtesy of Paul and Valerie Piazza

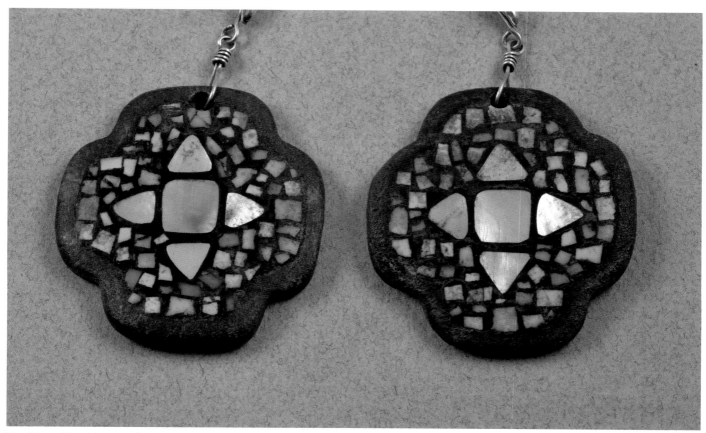

Traditional Pueblo mosaic design on leather earrings, ca. 1915. Courtesy of Karen Sires

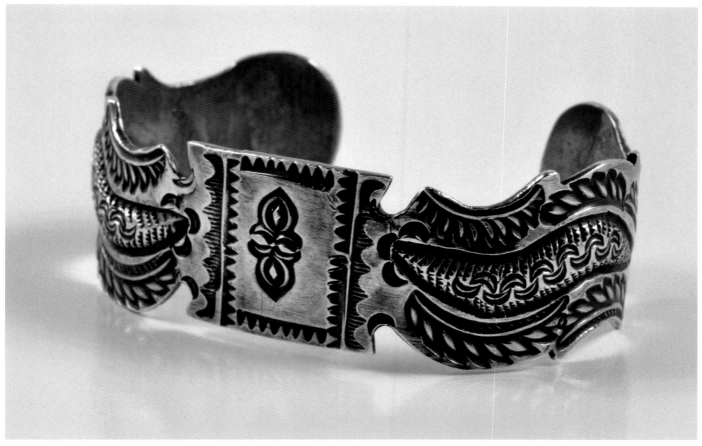

Tourist bracelet, first quarter of 20th century. Courtesy of Karen Sires

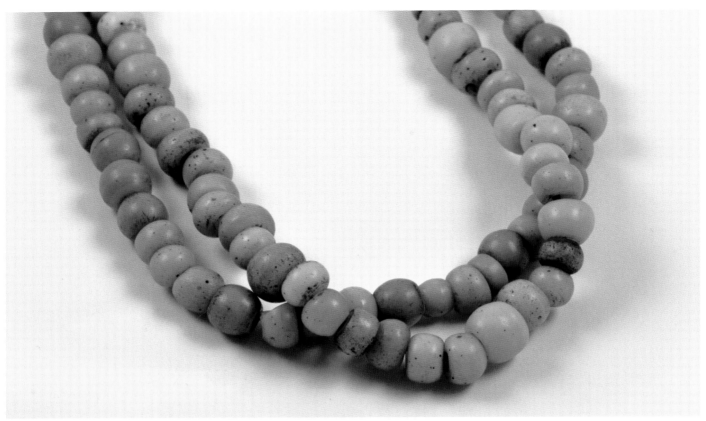

Two-strand "padre beads," one of the most prevalent glass trade beads of the American Southwest, ca. 1900. Courtesy of Karen Sires

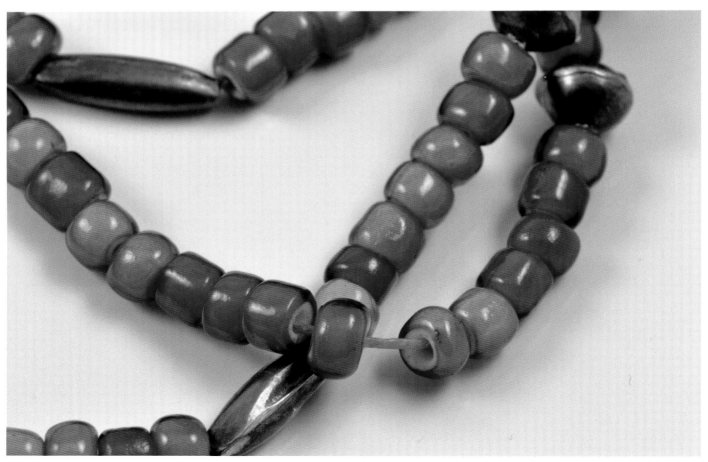

Detail of red trade beads' centers, called "whitehearts," very popular in the Southwest, ca. 1910s. Courtesy of Karen Sires

Four early chisel split design silver bracelets, 1900–1915. Photograph courtesy of Karen Sires

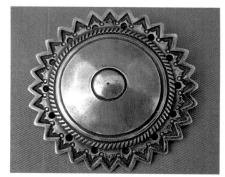

Silver button with classic borders, 1900. Photograph courtesy of Karen Sires

Early Hopi three-stone ring, early twentieth century. Courtesy of Robert Bauver

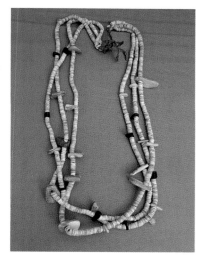

Pueblo-made two-strand olivella shell *heishi* with turquoise, pinshell, and spiny oyster tabs, 1910–20. Photograph courtesy of Karen Sires

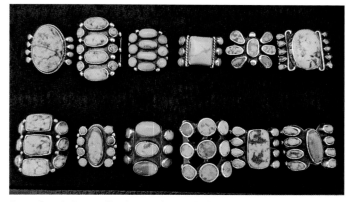

Box of early butterfly cluster rings, 1900–1914. Photograph courtesy of Karen Sires

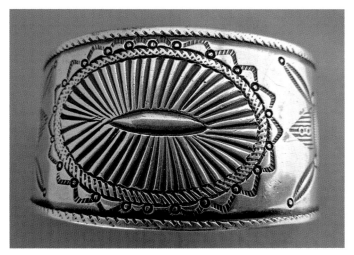

Wide silver band cuff with oval sunburst and classic stamping, 1900. Photograph courtesy of Karen Sires

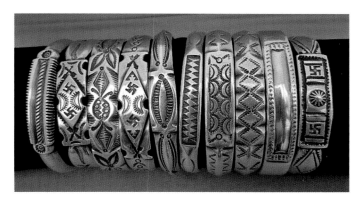

Bar of Navajo bangles with characteristic stamping designs, first quarter of 20th century. Photograph courtesy of Karen Sires

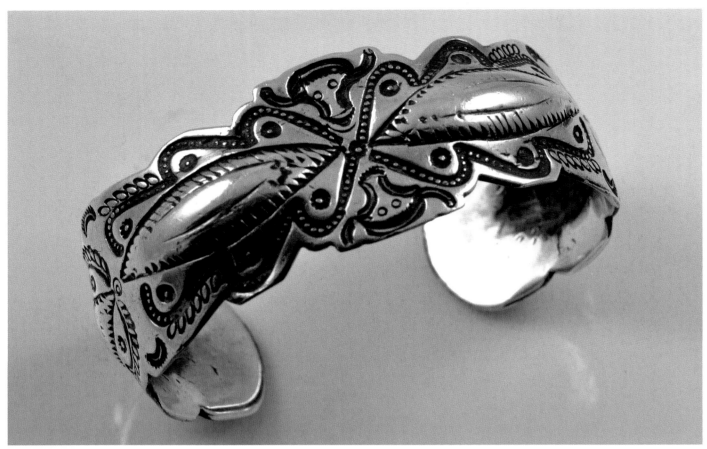

Navajo bracelet with shallow repoussé and early steer heads figural design motif, ca. 1900. Courtesy of Karen Sires

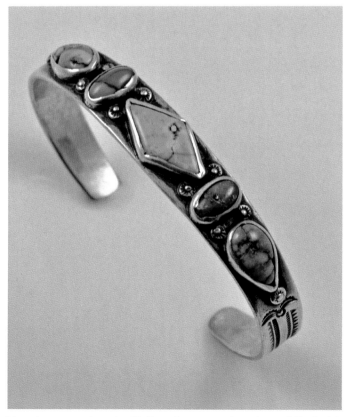

Navajo narrow band with five stones, center stone drilled with silver peg, ca. 1915. Courtesy of Karen Sires

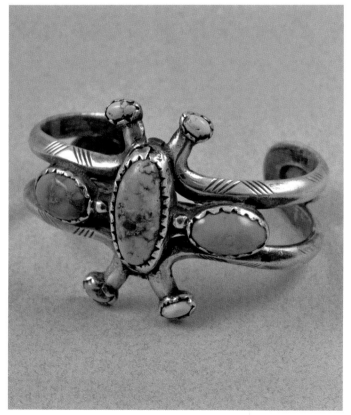

Bracelet cast in multiple parts with mismatched turquoise, first quarter of 20th century. Courtesy of Karen Sires

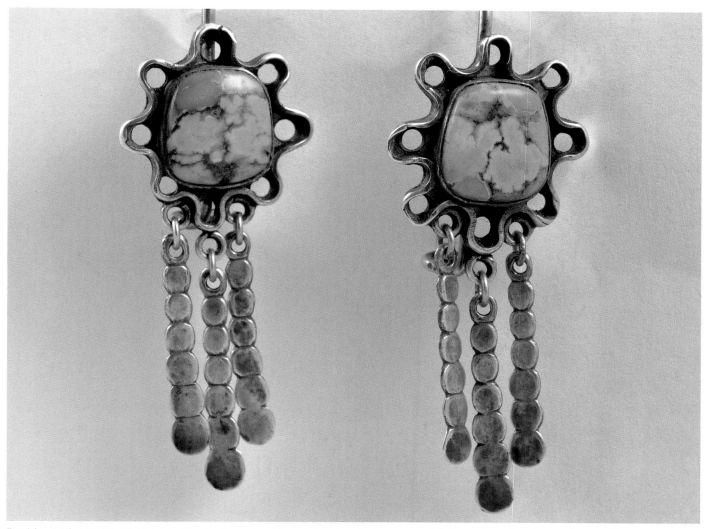

Pueblo earrings with green turquoise body and laddered dangles, first quarter of 20th century. Courtesy of Karen Sires

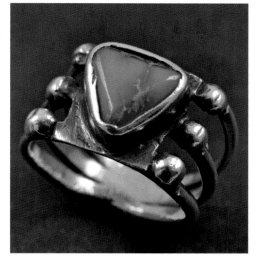

Navajo ring with dark-green triangular center stone, first quarter of 20th century. Courtesy of Karen Sires

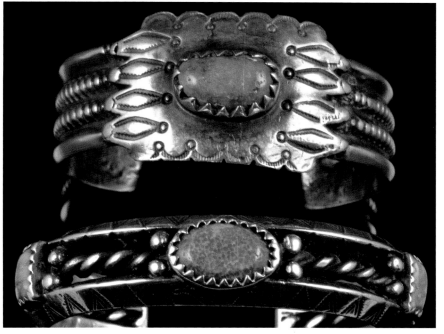

Two green stone silver bracelets with good sawtooth bezels, first quarter of 20th century. Courtesy of Peter Szego

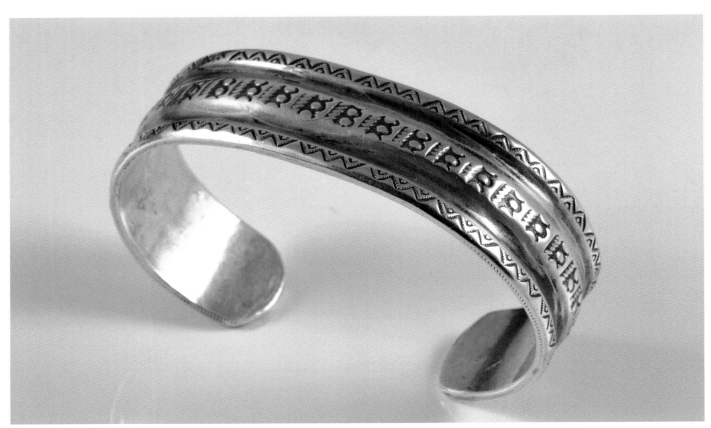

Ingot silver cuff with filing and stamping that may have been done by old tools, first quarter of 20th century. Courtesy of Territorial Indian Arts

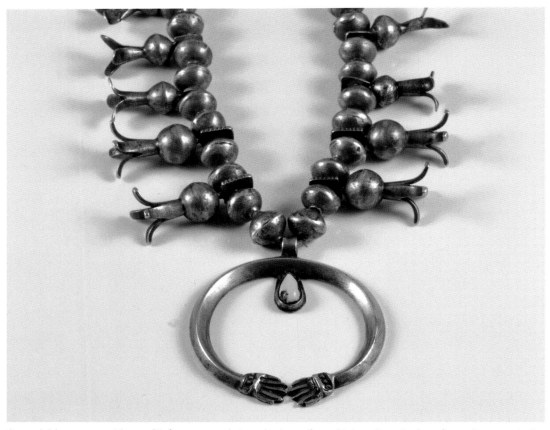

Squash blossom necklace with focus on *naja* terminals ending with hands, a device of growing popularity on Native design, ca. 1900. Courtesy of Territorial Indian Arts

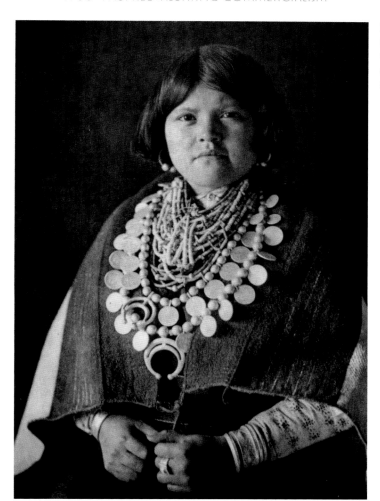

*Zuni Ornaments* (1907), one of Edward Curtis's portraits with visual focus on the Native girl's array of jewelry. Private collection

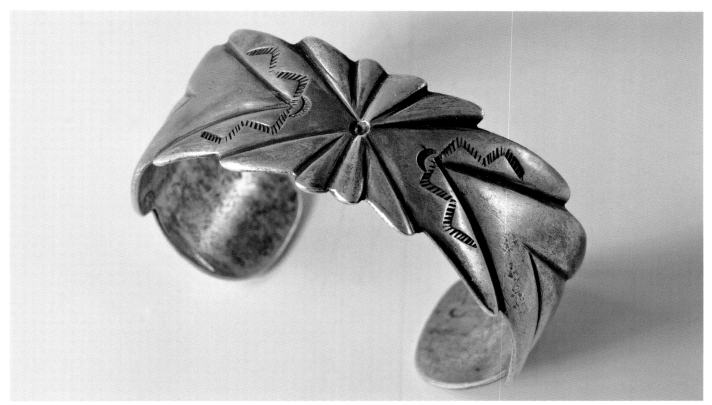

Well-finished flat sandcast bracelet with repair, ca. 1900–1915. Courtesy of Territorial Indian Arts

Slim bracelet of braided round wire with rolled, faceted hammered finish, probably a shop piece, early 1900s. Courtesy of Territorial Indian Arts

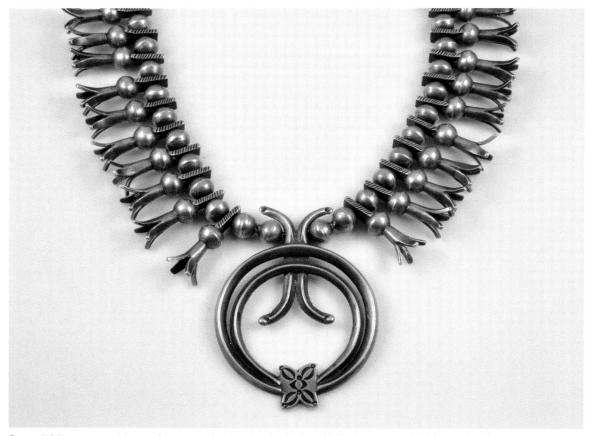

Squash blossom necklace with unusual closed *naja* design, 1910. Courtesy of White Collection

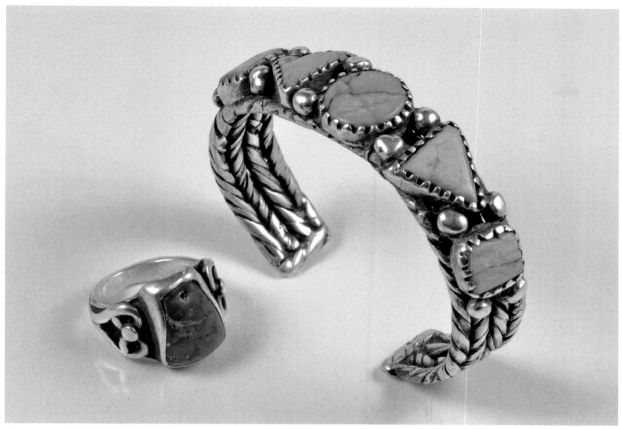

Five–stone heavy twisted–wire Navajo bracelet with a ring with drilled repurposed stone, 1900–1915. Courtesy of Ken Wolf

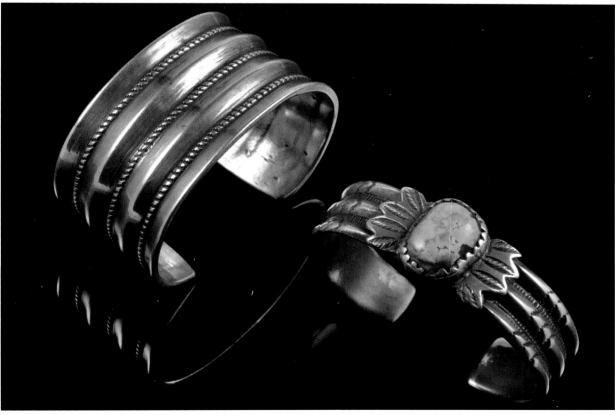

Two bracelets: (*left*) cast ingot and filed cuff with stamped wire; (*right*) cuff with appliqué center plaque and natural turquoise in sawtooth bezel, 1900s–1910s. Courtesy of Ken Wolf

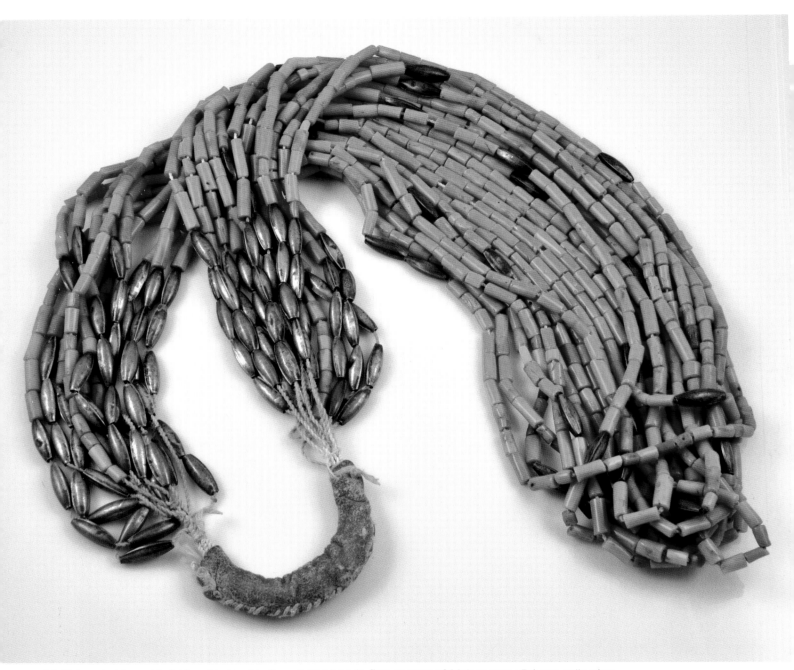

Multistrand old coral *heishi* necklace with silver melon beads, first quarter of 20th century. Private collection

# Key Design Developments in 1900–1915

## FORMS

- Established forms acquire discernable styles
- Central single stones on rings and bracelets and increased appliqué appear
- Enlarged range of earring styles features more small parts such as stones, dangles, and hoops
- Stamped, domed, and fluted buttons and sew-ons are used
- Carinated and compound bracelet styles increase

## MATERIALS

- Harvey Company and traders obtain cut turquoise from local mines
- Fox, King's Manassa, Royston, and Villa Grove mines open during this period
- Commercially cut and polished turquoise and stones are available, along with commercial solder

## TECHNIQUES

- New era of commercial tools and processes begins
- Machine-processed silver in sheets, wire, and beaded wire is used
- Silver drops are made as either round or flattened spheres
- Thin bezel settings proliferate, and serrated bezel edges are more uniform

## MOTIFS

- Surface decoration covers larger surface area of jewelry forms
- Smiths hand-fashion stamps to satisfy personal design choices
- Some impact from commercial designs is seen, as in increased use of arrow symbols
- Twisted wire is used with greater sophistication to make appliqué decorations
- Early cluster styles appear in stones arranged on bracelets and rings in butterfly shapes

## ELEMENTS

- Color; contrast; dominance; line; shape; tone

## NOTABLE MAKERS

- *Navajos:* Dogache (Red Whiskers); Grey Moustache; Hosteen Goodluck, Shorty-Silver-Maker
- *Isleta:* Juan Rey Churino, Jose Jaramillo
- *Hopi:* Duwakuku; Lomawunu (Second Mesa); Washington Talayumptewa; Tawanimptewa, Tawahonganiwa (Third Mesa)

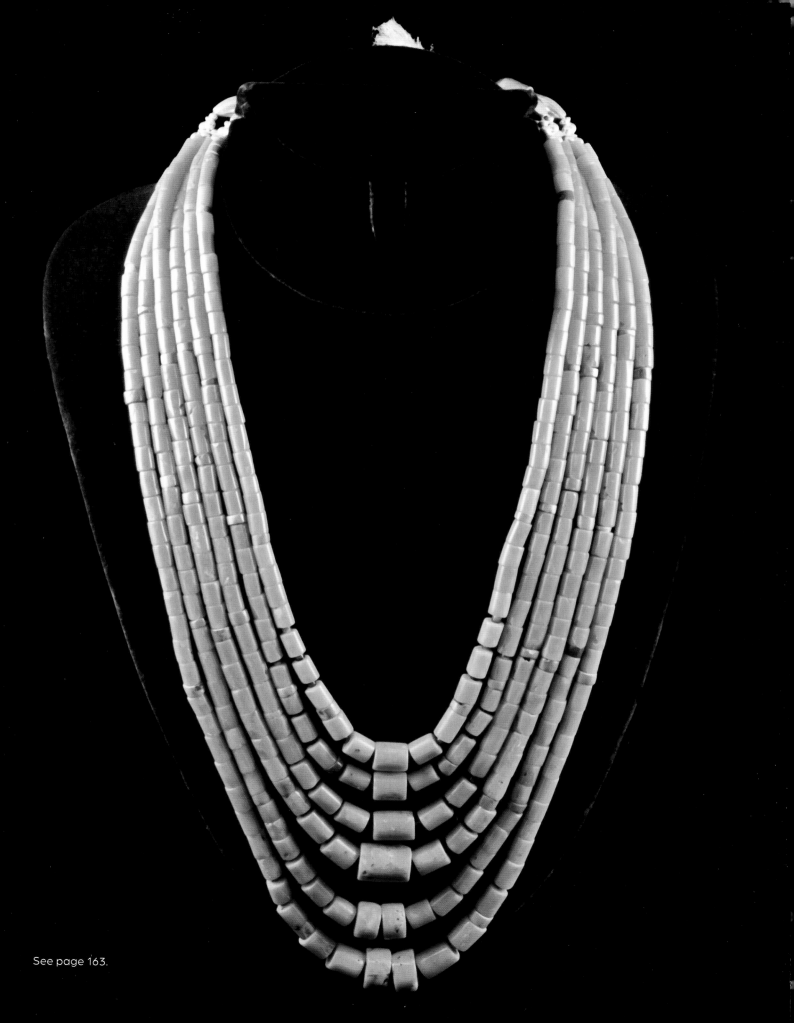

See page 163.

# 1916–1930:
# Classic Design

This active period in American history solidified advances in jewelry design. The previous fifteen years had allowed Native jewelry makers to develop a strongly ingrained sense of original form and to experiment with styles. Now, however, European American commercialism and business culture played an influential role in determining the look and feel of Native art. Slender Maker of Silver passed away in 1916. His young son Fred Peshlakai would go on to become part of a new generation of influential instructors in the craft, eventually relocating to California to run his own business.[1] By 1917, the year of the US entry into World War I, Navajo and Pueblo women entered the ranks of practicing silversmiths.[2]

For better or worse, the opposing tenets of unique impulse versus commercialism would help shape a more focused type of metalwork design. Tourism played a potent role in the growing non–Native consumer market for Indian jewelry. By 1920, new and improved tools and techniques were becoming widely adopted, rendering the creation of contemporary metalwork adornment easier and more efficient. With Mexican coins now banned from being melted down, smiths turned to the latest commercial sheet silver, although coin silver does not completely disappear from use.

# TIMELINE

**1916**    Congress creates National Park System and National Park Service

**1916**    Julius Gans opens Southwest Arts and Crafts curio store in Santa Fe; employs up-and-coming Native smiths

**1917**    United States enters World War I

**1918**    The 1918 influenza kills over 3,000 Navajos, along with many deaths in the Pueblos

**1918**    The Native American Church is founded

**1920s**    Roads in the Southwest and on reservations, once rough tracks, are improved

**1922**    First annual Indian Fair held in Santa Fe

**1922**    Inaugural of annual Gallup Inter-Tribal Ceremonial

**1923**    Fred Harvey Company builds El Navajo Hotel in Gallup, NM

**1923**    Formation of Navajo Tribal Council

**1923**    Maisel's Indian Trading Post, in Albuquerque, NM, hires Indians under supervision using commercial sheet silver

**1924**    Snyder Act admits Native Americans to citizenship but leaves voting rights to be determined on a state-by-state basis

**1924**    Adair reports that Zuni silversmiths began making jewelry for outsiders this year

**1925**    *Arizona Highways* begins to be published

**1926**    Highway from Chicago through Albuquerque to Los Angeles renamed Route 66

**1926**    First Fred Harvey Company Indian Detour automobile excursions begin

**1927**    Maisel's jewelry making is mechanized, but the equipment is kept from public view

**1928**    Museum of Northern Arizona opens in Flagstaff

**1928**    Merriam Report to Congress reveals widespread poverty and poor services on Indian reservations, prompting calls for reform

**1929**    Heard Museum opens in Phoenix, AZ

**1929**    American artist William Spratling arrives in Taxco, which becomes a center for Mexican silver jewelry design in the following decades

**1929**    Stock market crash in October signals start of the Great Depression in the United States

## Equating Native Design with Modernist Conventions

Visually, this period saw the joining of ancestral tastes with streamlined contemporary aesthetics. Jewelry forms routinely acquire increased decorative enhancement. Regional materials, including petrified wood, come into vogue. Even as the 1920s and 1930s were the decades when Navajo and Pueblo metalwork design would be characterized as classical, innovation continued apace. The term classical best applies to those high-quality pieces that are evocative of early metalwork but much more finished in execution.

By this time, archeological sites had yielded fine prototype examples of Puebloan beads and shaped adornment. Native jewelry makers now had visual inspiration for carving turquoise and reviving certain bead types. Looking at the years between 1916 and 1930, we see Navajos and Pueblos concerned with refining techniques through focused creation. Invention centered on the creation of tentative design motifs, small stonework patterning evolving into clusterwork, and pieces no longer wholly anchored by a large central stone.

The effects of commercialism affected Native design in various ways. Some Indian traders, along with non-Native intermediaries employed by the Fred Harvey Company, used customer preferences to drive specific imagery and design choices; the items that sold the best were reordered. Costs paid to makers were dictated by the amount of stone setting and detail work. When material supplies grew scarce or too costly, makers became inventive. The best example occurred at Santo Domingo, where jewelry makers used repurposed and found materials in creatively appealing designs for tourist sales.

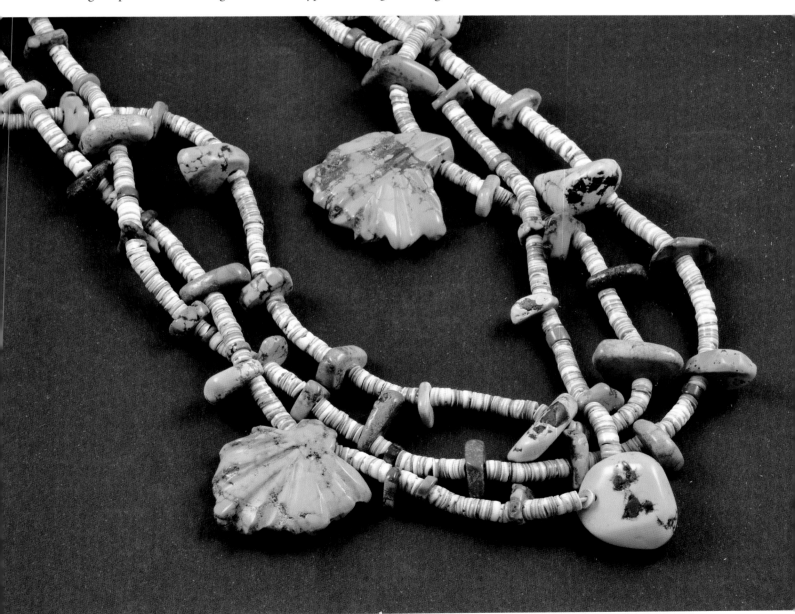

Zuni necklace with carved leaves possibly by Leekya Deyuse, 1915–30. Courtesy of Hoel's Indian Shop

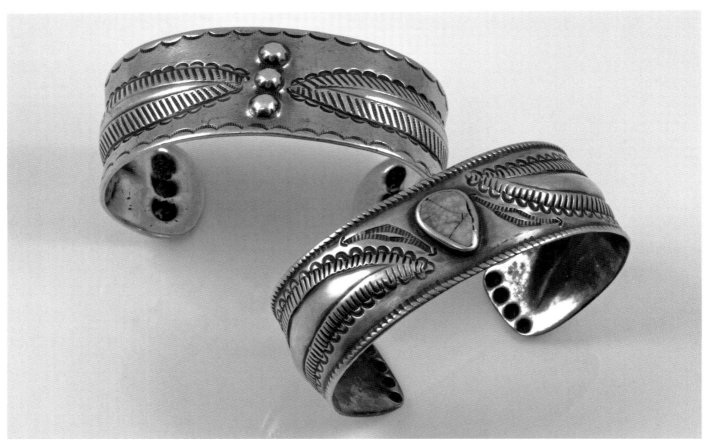

Two Navajo bracelets, one with shallow repoussé, other set with turquoise and classic surface decoration, 1910s. Courtesy of Laura Anderson

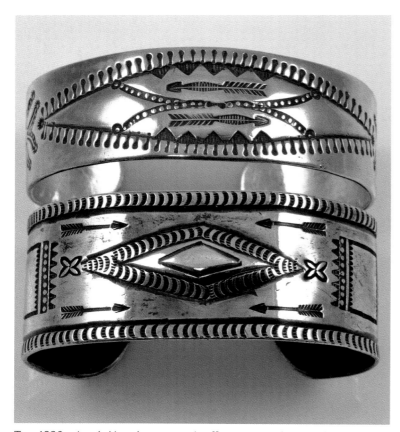

Two 1920s classic Navajo stamped cuffs; arrow design motifs likely show commercial influence. Courtesy of Laura Anderson

Postcard showing El Navajo, a Fred Harvey Company hotel built in Gallup, NM, in 1923. Private collection

The establishment of Western national parks and, in 1916, the National Park Service led to new venues for the sale of both authentic Indian jewelry and commercially made imitations. With tourism booming, silversmiths and beadmakers increasingly brought their wares to trading posts and stores in the railroad towns of Gallup, Winslow, and Flagstaff, among others. In Albuquerque, shops offering mass-production benchwork geared up, including Maisel's in 1924 and Sun Bell in 1935. Indian jewelry-making demonstrations to tourists increased—lured by the slogan "See Indians at work"—and souvenir pieces went home to many different geographic locations.[3]

## A New Maturity in Design

The trend during this period was most definitely decorative elaboration. For example, earrings fashioned with dangles, in the Zuni style, became models for more detailed multipart designs. Bead necklaces with tied-on *jacla* loops as central pendants functioned as conventional wear, especially now that the *jacla*'s original purpose as an earring (worn over the ear) had faded. Silversmiths devised a fluted silver-bead necklace in the 1920s that became greatly popular.

More-intricate bracelets were made in compound bands and soldered together. Double-twisted wire was used to produce filigree-type ornament, and Navajo and Pueblo smiths developed designs that ranged from embellished organic shapes to the cross-cultural valentine heart. After the mid-1920s, *naja* designs grew more ornate, with closed crescents and horizontal "oxbow" bars on top of the beads, many with dagger-like or fleur-de-lis outlines.

These design expansions met with strong criticism from non-Native arts advocates; they claimed that changes such as the valentine heart shape were derivative and not genuine. Museum experts cast about for designs uncovered from newly excavated sites to serve as models for authenticity. In the late 1920s, for example, the Museum of New Mexico uncovered Mogollon culture sites, yielding a variety of Mimbres Phase (900–1150 CE) imagery from pottery. The 1920s and 1930s witnessed many attempts by non-Natives to propose an Indigenous visual vocabulary for silver jewelry that would be distinctive, even as Native designers were already engaged in such a process.

Changes in commercially made and supplied materials eased jewelry fabrication in the 1920s. Premade bezel strips and varieties of silver wire, including twist and bead wire, could be ordered and stocked. Commercial sheet silver became available in a range of thicknesses, increasing in demand and usage by the end of the 1930s. "Hubbell glass" turquoise trade beads disappeared after a final shipment in 1923. In the meantime, additional regional turquoise mines opened during the 1920s, including Lone Mountain and Villa Grove. Coral was often difficult to obtain during this fifteen-year period.

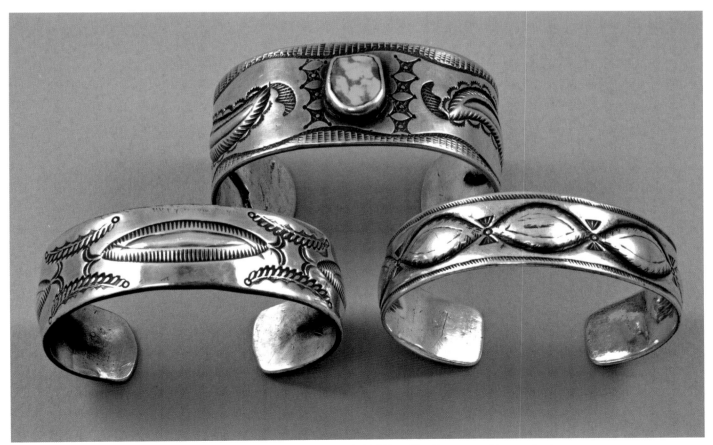

Three Navajo or Pueblo silver bands show less repoussé than relief, 1910s–20s. Courtesy of Laura Anderson

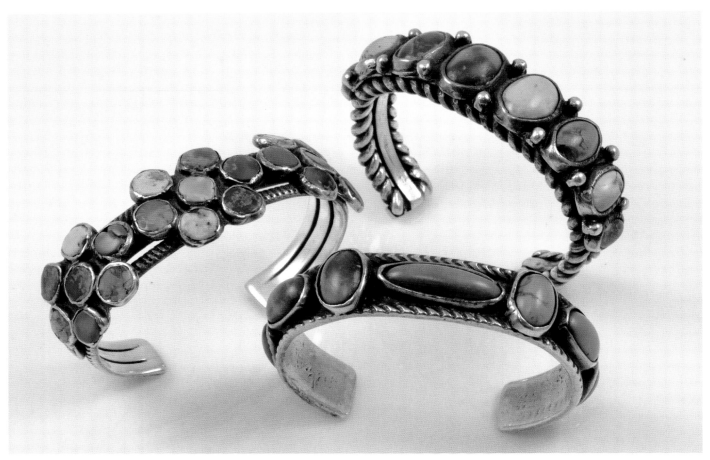

Three bracelets with green turquoise, all in classic styles. *Left to right:* early butterfly, nine-stone, and row bracelet, 1910s–30s. Courtesy of Laura Anderson

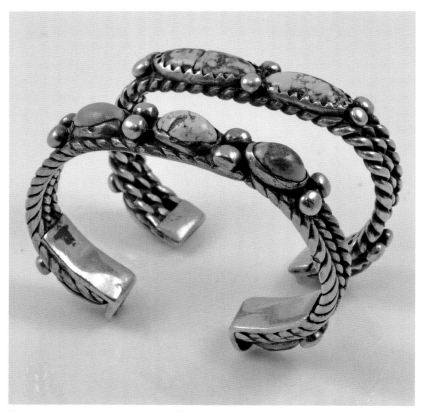

Two bracelets with triple-twisted wire, good turquoise, and well-realized rain-drops, 1920s. Courtesy of Laura Anderson

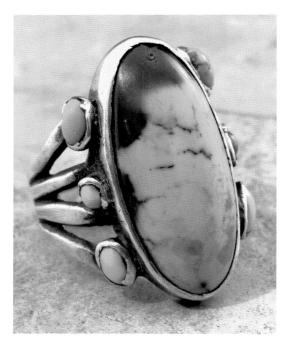

Navajo or Pueblo turquoise ring with perforations on shank, 1920s. Courtesy of Robert Bauver

Silver hair comb designed for Navajo woman, early 1920s–1930. Private collection.

Similar changes took place with the increased availability of previously scarce jewelry-making equipment, including machines for cutting metal and stone, as well as the all-important rolling mill, which turned sheet silver and silver wire into varying gauges of thickness. Rolling mills had been in short supply throughout the Southwest; once widely available, they became essential for jewelers working on their own. Blowtorch soldering was introduced after 1920. By the end of that decade, Navajo reservation smiths and traders were able to obtain necessary materials and equipment from three large warehouses: Cotton Company, the Gallup Mercantile Company, and the Kirk Brothers.

Of course, the remoteness of the vast Navajo lands and some of the pueblos made access to these improvements difficult. Many pieces created between 1916 and 1930 still exhibit imperfect features, such as handmade bezels, that fall short of being well finished. Roads were still poor, and electricity would not be available for some decades. This reality is a useful reminder when evaluating jewelry made in this period. At no time during the early to mid-twentieth century can Navajo and Pueblo jewelry making be considered consistent in construction.

Two events with long-term effects occurred in 1922. The first Southwest Indian Fair took place in Santa Fe; originally organized by influential non-Native supporters of Indian arts and culture, this event was the forerunner of the annual Santa Fe Indian Market that continues today. On September 25–30, the first Gallup Inter-Tribal Ceremonial was held, and it soon became another important annual venue for the display and sale of Native arts, including jewelry. Unlike the Santa Fe market, the Gallup Ceremonial was dominated and driven by the mercantile interests of area Indian traders.

Entering these shows and displaying creations for potential awards was a major step for Native artists. Psychologically, this form of competition must have been jolting to those brought up in a culture that avoided public recognition. These shows also meant that Indian arts would now be judged by standards not of the jewelers' making. Whatever the effects,

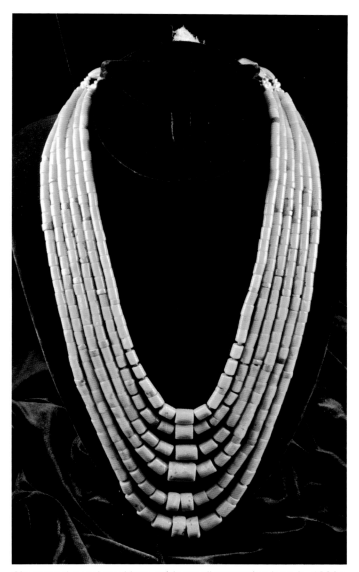

Six-strand coral necklace with small turquoise beads, 1920s. Courtesy of R.B. Burnham & Co. Collection

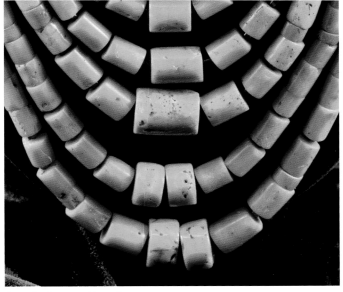

Detail of central beads

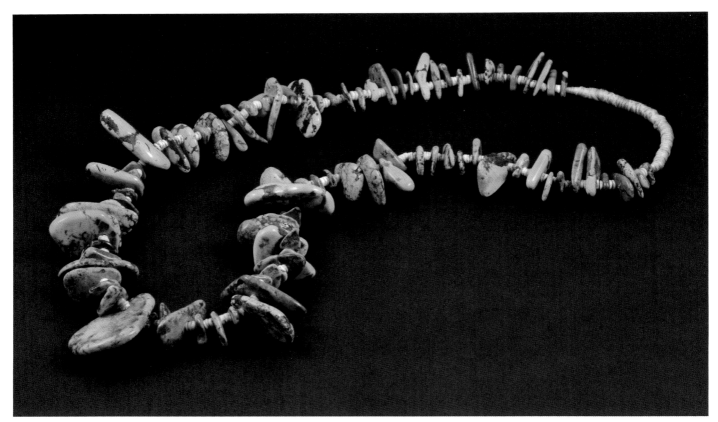

Turquoise tab necklace with uneven pendant stones, 1920s. Courtesy of Joan Caballero

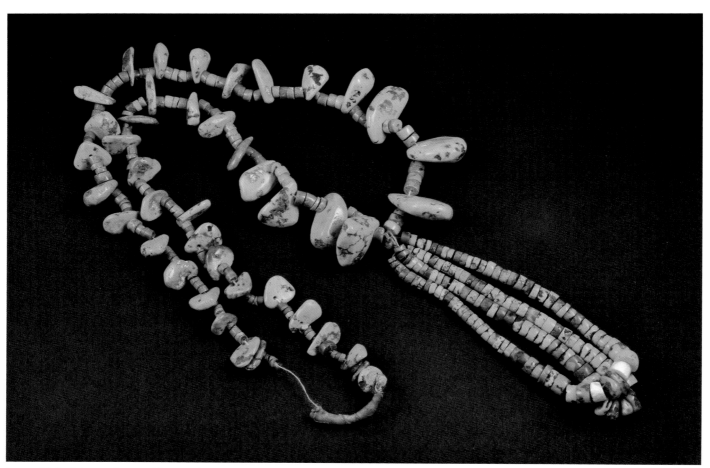

Long, 16-inch turquoise necklace, tabs graduated in size, with two jaclas, 1920s. Courtesy of Joan Caballero

jewelry makers entered such events and persisted in taking part in them. In terms of design creation, their involvement clearly led to a better understanding of what outsiders considered important and worthy of purchase.

Also in 1922, a California couple, Charles de Young Elkus and Ruth C. Elkus, began assembling a Southwestern Indian art collection filled with remarkable historical examples of silver and turquoise jewelry.[4] Two other "firsts" occurred in 1926. On May 15, the Fred Harvey Company started its Indian Detours, bringing tourists to various locales in Harvey Cars, accompanied by female non-Native guides wearing handsome concha belts, squash blossom necklaces, and multiple bracelets and rings. On November 11, the soon-to-be-famous Route 66 was officially named and established, running through New Mexico and Arizona; this highway often paralleled the railroad and passed through reservation border towns. These developments made it easier than ever for people to visit the Indian arts fairs, curio stores, and regional attractions (such as the Grand Canyon), where jewelry could be bought from merchants or the Native makers themselves.

Two museums were founded in the 1920s. The Museum of Northern Arizona, in Flagstaff, was started in 1928 by Easterners Harold and Mary-Russell Ferrell Colton, enthusiastic supporters of Indian arts. It became an important venue for high-quality Indian arts shows and sales, and its founders would soon play a noteworthy role in the development of Hopi silver jewelry. In 1929, the year of the US stock market crash, the Heard Museum was established in Phoenix, Arizona; this institution, too, would gather and promote fine Indian arts, eventually including examples that had been originally collected by the Fred Harvey Company.[5]

## Lapidary Gains

By 1916, the use of stones on silver was an expected and desirable feature. Over the next fifteen years, Navajo and Pueblo jewelry makers devised lapidary skills to complement their silverwork. The advent of commercial silver strips for bezels made stone setting much easier. Precontact-era techniques brought to light by archeological excavations were revived, with the approval of purist advocates. Indian traders chose to encourage pieces created by Pueblo lapidaries set into Navajo-made silverwork. This decision was usually less about collaboration than economic calculation by traders acting as intermediaries.[6]

Cluster stonework took shape during this time. The Zunis have been credited as being the first to create certain types of small-stone shaping, but soon Navajo and other Pueblo jewelry makers were actively borrowing this technique. Early examples feature small stones set in bezels that are arranged in patterns resembling a saddlebag or butterfly. Clusters appear on bracelets, pins, and squash blossom necklaces, moving on to virtually all jewelry forms. By the 1930s, clusterwork was the favored adornment worn for ceremonial and social dancing. This style gained refinement when petit point stonework (with one end rounded and one end pointed) developed.

Tentative mosaic and channel inlay designs appeared in the mid- to late 1920s. Mosaic work, with its precontact-era origins, involved placing small pieces of stone or other natural materials into (or glued onto) a shell or silver base; pieces made before 1930 lack finesse in execution. Channel inlay entailed setting precisely cut stones between silver spacers to form a pattern. The Zunis excelled at both techniques but, as with clusterwork, Navajos and other Pueblos also worked in this mode.

Zuni's leading role in lapidary work was actively promoted by the larger than usual number of Indian traders who settled in and near the pueblo. Established trader families, including the Kelseys, the Kirks, the VanderWagens, and newcomer C. G. Wallace (who arrived in 1918), spotted

Wide silver cuff shaped by swedging, 1920s–1930. Courtesy of Joan Caballero

Verso of swedged cuff showing grooves

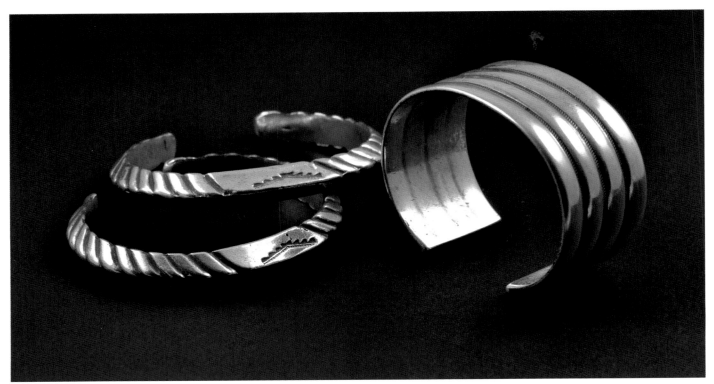

Silver bracelets from the 1920s: (*left*) two carinated ingot bangles; (*right*) cuff with four bands. Courtesy of Joan Caballero

and encouraged talented individuals as well as family members who showed similar ability. Wallace in particular became adept at marketing the pueblo's image as lapidary leaders through the 1920s and 1930s.

Between 1917 and 1923, Frederick Webb Hodge led an excavation (sponsored by the Heye Foundation) at Hawikuh Ruins, located near the present-day Zuni pueblo. A number of young Zuni artisans assisted at the dig. Artifacts unearthed inspired new design creations. C. G. Wallace was much more active than other traders in suggesting design motifs. He encouraged the depiction of two sacred spirits meaningful to the Zunis: the Knifewing and Rainbow Man deities.[7] These designs may be called a breakthrough of sorts in terms of figural designs, coming well before other Pueblo jewelry makers were willing or permitted to do the same.

Zuni silversmiths Juan Dedios and Horace Iule were among the first to experiment with casting these designs, starting in the late 1910s and continuing through the next decade. Iule has been credited with creating the first silver Knifewing figure for decorative purposes in the late 1920s. The proliferation of Zuni artisans between 1916 and 1930 was remarkable. Only eight silversmiths were active in Zuni in 1920, but this number had grown to ninety by the time John Adair visited the pueblo in 1938. Such talent was hereditary: multigenerational families of jewelry makers developed specific designs, many in inlay, that would be copied and shared over the years. *Shared* is the key word here—Zuni notions about ownership of design images differed significantly from those of European Americans.

## Design Motifs: Symbols or Not?

Symbols in conventional society have identifiable meaning; they are a form of communication. People rely on symbols to help them choose the correct bathroom, to navigate roads, and to recognize brands by their distinctive logos. Symbols occur across the globe. Some even appear in cultures, ancient and modern, that are widely separated geographically. One such example is the swastika, or whirling logs design. Such visual imagery, including those motifs used on jewelry, are part of an overall design scheme; they can appear singly or in repetitive patterning. These designs are cerebral and internalized. The Navajo and Pueblo smiths did not deliberately construct symbols; rather, they developed motifs of abstract and (much later) representational, or realistic, imagery.

When European Americans began to build the Indian arts industry, they sought symbols—devices that could be recognized by potential buyers. After 1890, more and more Native silversmiths were creating their own stamps, which included arrows and whirling logs, among other objects. Non-Natives in charge of manufacturing or supervising Native benchwork pushed for design motifs with understandable symbolic imagery that expressed spiritual values, such as wisdom, fertility, or friendship.

A good example was the whirling logs motif, known to many societies as a swastika. It appears in North America in the early Mound cultures of the American Midwest and has relevance as a design for Havasupai and other Pai peoples' baskets in the Southwest. The Hopi viewed it as a migration representation, whereas the Navajo refer to the story of this

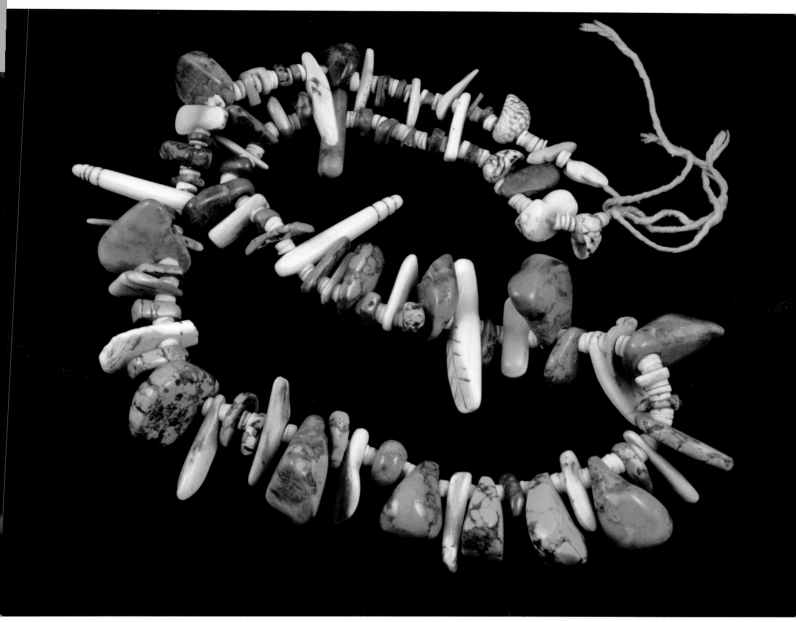

Pueblo necklace strung with turquoise, spiny oyster, white stones on cordage, 1920s. Private collection

figure in the Night Chant ceremony. The whirling logs were a meaningful design in Navajo weaving and sandpainting, representing positive healing and prosperity.[8]

Non-Indians assigned the whirling-logs or swastika design a meaning of "good luck." The Indian jewelry industry justified this stretch in context as a way to bridge cultural understanding and please consumers, not unlike the practice of offering fortune cookies after a meal in a Chinese restaurant. Another image approved for decoration, the culturally widespread Thunderbird image, was dubbed a symbol for "happiness." A few of these interpretations might contain a kernel of truth, but most were so fantastic as to provoke rolled eyes by both Natives and non-Natives alike.[9] Naturally, the purpose of design symbology was therefore cheapened.

By the 1910s, lists titled "Indian Symbols" were firmly entrenched in the ethnic arts marketplace, and they have stubbornly survived to the present day. Such lists (mostly in the form of postcards) appear most often in tourist and down-market shops in the Southwest. Even though they have no genuine authority, their survival has proved remarkably resilient.

Did pre-1945 Navajo and Pueblo jewelers accept these commercial surface-design motifs as true symbols? The answer is yes and no. When making commercial jewelry, they accepted such imagery as part of the product, but they didn't take it to heart. In this conservative era, Indians did not think to, or were unable to, articulate artistic ideas about creating designs. Why? Because Navajo and Pueblo jewelry makers saw the world with a different aesthetic sense than European Americans did. Native artists viewed nature and life in terms of relationships and representations; the world around them was not inanimate.

167

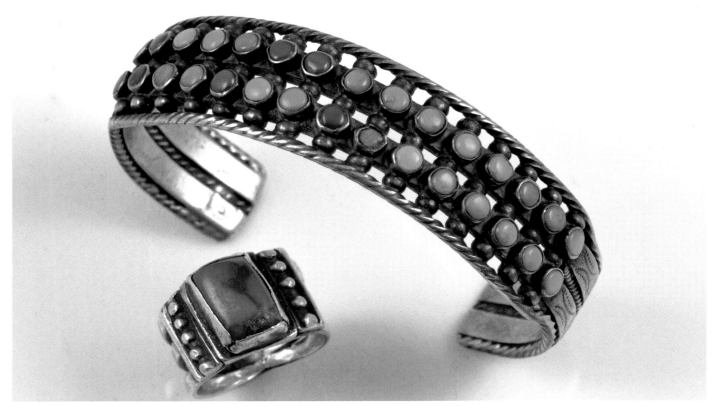

Navajo ring with Cerrillos turquoise and Zuni ingot two-row bracelet with round turquoise cabs ("dots"), c. 1915–1920s. Courtesy of Eason Eige Collection

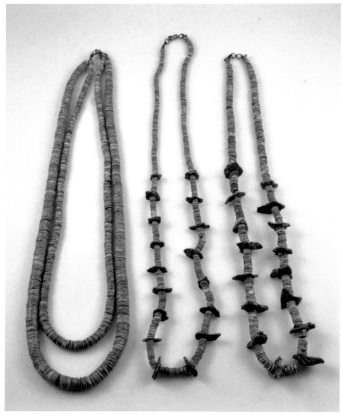

A two-strand olivella shell heishi necklace, with two single-strand shell necklaces with turquoise nugget beads, both traditional Pueblo designs ca. 1920s. Courtesy of Eason Eige Collection

This point is important to understand. It helps explain why physical objects (e.g., shell and turquoise) could be the very essence of design for both peoples. When objects in nature possess sacred meaning, their visual representation becomes much more than a symbol—such deliberate design evocation was a connotation, invoking hidden or abstract meaning to Indigenous wearers and viewers. Both Navajos and Pueblos at this time were traditionalists in their beliefs. Sacred images, such as depictions of kachinas or even ancient petroglyphs and pictographs, weren't meant for show or sale, and they rarely figure as design motifs until much later than 1945.

Once Native jewelry was offered to an outsider marketplace, makers were confronted by non-Native demand for design motifs that were less about internal content and more about conventional representation. As a result, commercial Indian jewelry embellishment was expected to show symbols with identifiable meaning as a form of cultural accommodation. These design motifs quickly attracted consumers who wanted to know something about Native culture. For example, where crossed arrow stamps previously meant nothing more than attractive decoration, the institution of commercialized Indian jewelry symbols now gave this imagery an optional meaning, such as an invented association with friendship.

Going forward, therefore, Navajo and Pueblo jewelry design motifs should be seen as part of an ongoing process

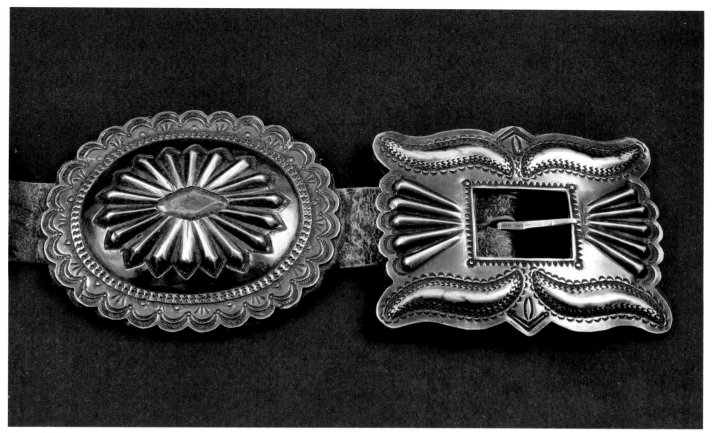

Second Phase concha belt detail: closed plate and *"ketoh* design" buckle, 1920s. Courtesy of Frank Hill Tribal Arts

of accommodating both Native connotation and non-Native desire for signs and symbols. This practice would reach new heights in the mid-twentieth-century "craft" creation years before giving way to the nuances of Native fine-artist jewelry making. This means, then, that the pre-1945 Native jewelry maker was free to adopt, adapt, or discard contrived design motifs popular with potential buyers as a matter of personal choice.

A much better way of looking at design motif development in the early to mid-twentieth century is to understand that the compromise worked well because Native aesthetic expression matched the aims of the modernist era. Non-Natives more easily accepted Indian decoration that displayed a necessary abstraction. Silver bracelets rendered with bold geometric or richly organic-looking patterning were visually pleasing. Later, when Navajos were pressed to decorate their arts with representations of sacred spirits, the Yei deity they visually created (also seen on weavings) is an excellent compromise, since it displays cubist-like abstraction for ornamental effect.

Navajo and Pueblo society remained carefully conservative in religious practices during the early twentieth century. Their spiritual leaders sought to protect certain representations of sacred and ceremonial imagery. Indians engaged in commercial jewelry making such as creating silver spoons decorated with human figures substituting for the kachinas that their employers would have preferred. Fortunately,

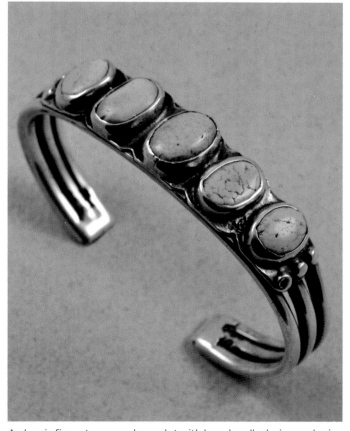

A classic five-stone row bracelet with hand-pulled wire and rain-drops, ca. 1920. Courtesy of Frank Hill Tribal Arts

European Americans, too, were adjusting their popular-culture aesthetics to take in abstraction and less-figurative depictions. Modernist art offered viewers steeped in traditional representational imagery another way of seeing the world. This compatibility between European American and Native standards of visual beauty and interest set the stage for the development of future design features.

John Adair, conducting fieldwork among the Navajos in the late 1930s, tackled head on the issue of design meaning. At one time, he showed five silversmiths various designs that had been stamped on copper; they laughingly came up with differing, tentative interpretations. No one agreed on the purpose of any one design.[10] Two identifications, in particular, bore some resemblance to cloud and lightning imagery found in sandpainting, but Adair came away from this experience convinced that designs on jewelry had no symbolic intentions. His research led him to discern four specific design types on stamps and dies: a crescent; a triangle; a circle with lines issuing from the center; and long thin lines with parallel edges. He noted that these four basic patterns possessed variations. Adair also confirmed that Indian symbols on commercial jewelry were not based on fact but were there as "sales promotion."[11]

Texas steel cowboy spurs by Crockett, with Navajo-made silver and turquoise overlay, 1920s. Courtesy of Frank Hill Tribal Arts

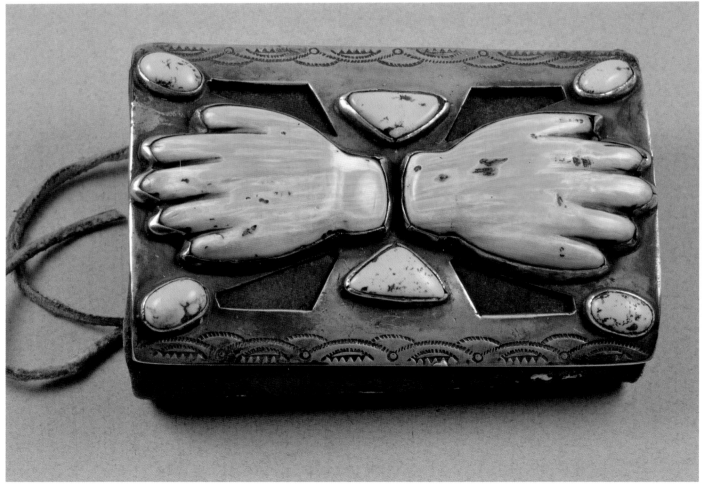

This silver *ketoh* made in 1925 with inset turquoise and spiny oyster hands appears in C. G. Wallace's 1975 sales catalog. Courtesy of Michael Haskell Collection

## Emerging Design Motifs: Original versus Commercial

### HAND-WROUGHT MOTIFS, 1900–1945: UNIQUE, PERSONAL EXPRESSION

- Vegetal (seeds, rudimentary leaves)
- Foliate (petals, rudimentary flowering)
- Insect (butterfly, dragonfly)
- Animal (bear, deer, steer heads)
- Reptile (snake, water serpent)
- Bird (Pueblo bird, thunderbird, water bird, eagle)
- Selected Sacred Figures, Zuni Knifewing, Rainbow Man (after 1920)

### COMMERCIAL MOTIFS, 1900–1945: GENERIC, STYLIZED

- Arrowhead
- Arrows, crossed arrows
- Whirling logs (swastika)
- Thunderbird
- Horses, dogs
- Snake, lightning snake
- Tepee
- Valentine heart
- Stylized human figures (on flatware)

Unique and commercial motifs produce balance, hierarchy of arrangement, scale, proportion.

Unique and commercial motifs call attention to: form, emphasis, unity, harmony.

Shared motifs: arrows, swastikas, cross, star, lightning, and rain clouds

Most common motifs: bird, butterfly, snake

Cross-cultural motifs: arrowhead, stylized human figure, tepee, valentine heart

## Defining Classical and Traditional Design

By the mid-1920s, officials at the Harvey Company were already reporting difficulties in finding older Indian goods.[12] The pawn system remained active throughout this period, and tourists admired the silver and beadwork for sale at trading posts and curio shops. Pieces were still billed as curios, but the terms dead pawn or old pawn now attracted souvenir sales. These labels offered potential buyers an opportunity to purchase a piece that had been worn by an Indian. Dead pawn was the best category of saleable items, since the term implied that the previous owners were not around to need or want the jewelry. Most traders played fair, knowing that selling active pawn would alienate their Native customers and sow mistrust. The term old pawn eventually grew ambiguous, however, since it didn't address ownership but gave the impression that items were of older and rarer (and hence more valuable) provenance.[13]

Scholars such as Harry P. Mera and John Adair wanted and needed to explain Navajo and Pueblo design in terms related to classic (or traditional) as well as modern expression. Such characterizations helped distinguish Native-inspired aesthetics from those drawn from modern society. By the late 1910s and 1920s, advocates like members of the Taos Society of Artists and other non-Native intellectuals and patrons were ready to compare primitivism in Native arts to then-current modernist principles. The popular culture definitions of Navajo and Pueblo "primitive" jewelry as both traditional and classical were intended to be complementary, another way of showing the superiority of Native-derived design over the contrived motifs of tourist merchandise.

Why is this terminology important to consider? In essence, these categorizations profoundly affected the marketplace and turned future makers of Native jewelry onto a pathway that eventually led to fine artistry. Although "primitive" was the label assigned to Native American culture because it was preliterate, it was the very aesthetics

At this point, the intrusion of the term **style** requires examination. This word is yet another whose meaning is often split. A formal definition describes style as a distinctive, formal, or characteristic manner of expression. As a result, writers refer to "traditional-style" Indian jewelry as meaning adornment created in the historically defined period from 1870 to the 1940s. In Western art terminology, Art Deco is a style, yet modernism was an art movement. Interestingly, Art Deco changed its mode with every migration to a different country; hence, we can see deco style in contemporaneous Pueblo Deco architecture of the American Southwest, along with cross-cultural deco stylistic influence on Native jewelry designs of the 1920s and 1930s.

Turning to the significance of **classic/classical** Navajo and Pueblo jewelry design, we should note that this word has been used in various contexts. Writers frequently link traditional and classic. At this point, we should revisit the art historical description of "classical" since it better fits the impetus of design over time. Classic works of art have recognized and established aesthetic value. Just as the finest artworks of ancient Greece and Rome, along with literature and philosophy, were considered classics, so too can we agree that the most finely made Native jewelry—high-quality works of outstanding design—deserve the "classic" label. In a 1984 essay, Adair defined the years between 1880 and 1910 as a "Classic Period."[14] Whether applied to a specific era, as Adair chose to do, or simply as an expression of visual beauty, distinctively traditional and well-made jewelry forms and designs qualify as classical.

Over the decades, writers on Navajo and Pueblo jewelry have used the labels traditional, style, and classic interchangeably. Throughout the 1920s and 1930s, the jewelry forms and designs that were drawn from older decades retained a characteristic appearance in line with the first several generations of makers' concepts of beauty. Classic Southwestern Indian jewelry of this time achieved a recognizable identity based on specific forms, emergent styles, and intriguingly untypical design features—these should be designated as visual properties. When cross-cultural influence appears, however, it can be detected in such features as modified necklets, or chokers, based on non-Native styles like Art Deco.

Any potential confusion about the use of these terms for Navajo and Pueblo jewelry creation lies in the fact that traditional and classic forms were remarkable for not being typical in their decorative details. Each smith added just enough of an original touch to render a piece stylistically different, or unique. This was the quality that Kunz spoke about, that Adair realized in his studies, and that we notice when looking at examples in museum collections, in books, and at antique Indian arts shows. A squash blossom necklace might retain the typical forms—round beads, central *naja* pendant, and so on—but the item was created in such a way that some element of its ornamental

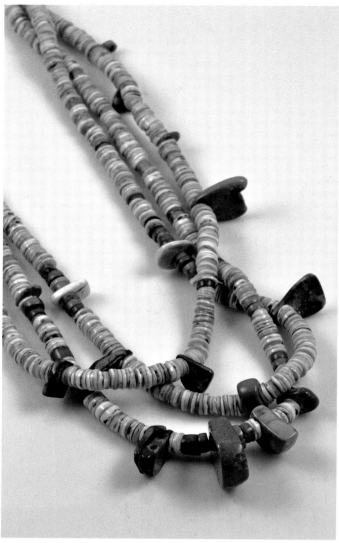

Three-strand *heishi* hand-pump drilled turquoise and shell tabs, 1900–1920. Courtesy of Suzette Jones

of primitivism itself, rooted in the primal and original, that aroused the admiration of Western culture and gave Navajo and Pueblo jewelry design a resounding cachet. When we understand that this appreciation developed in the era of early twentieth-century modernist expression, it becomes easier to understand why Native jewelry design earned both traditional and classic labels.

How, then, shall we define **traditional** from classic when these terms share key design features? We know that "traditional" nonmetal Pueblo jewelry design had truly ancient origins, as in beadwork, stone carving, and early mosaic work. Navajo and Pueblo metalwork began in the mid-nineteenth century; existing jewelry forms and surviving design features date from this origin era and retain these qualities up to the 1930s and early 1940s. For this reason, Native American scholarship recognizes jewelry making of this period as being traditional. This term embraces silverwork in general as well as specific styles, such as small-stone clusterwork.

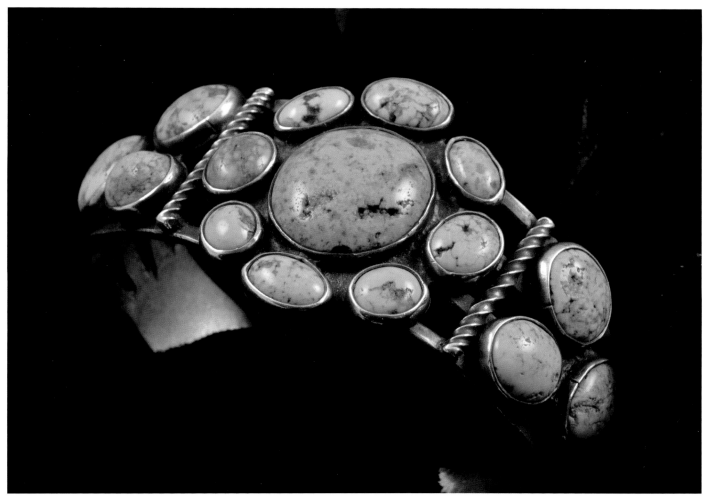

Cluster bracelet, possibly Pueblo, with unusual terminals, ca. 1920s. Courtesy of Suzette Jones

construction is distinctively atypical compared to related pieces. Today, we would hail such distinctiveness as artistry.

Certainly, a parallel (and to many minds, bastardized) line of tourist jewelry—thinner, cheaper, and highly stylized, with bogus symbols—competed with the authentic hand-wrought work, but the uniquely conceived jewelry was firmly fixed as a more desirable and, hence, more valuable commodity. Indian artists, whether smiths, weavers, or potters, even saw their identities transformed into icons of regional Indigenous culture as the result of touristic Indian "demonstration" practices in the Southwest, such as those hosted by the Fred Harvey Company, national parks, Indian markets, and curio stores. This was already true for the potters Nampeyo and Maria Martinez and the weaver Elle of Ganado.[15]

For some historians of Southwestern Indian jewelry, the year 1930 serves as a demarcation line. The rationale arose precisely because of experts' antipathy to the increasing volume of tourist-era mass-produced jewelry. One expert, Harry P. Mera, collected examples of Navajo silver in 1932, determined to name those properties and qualities that

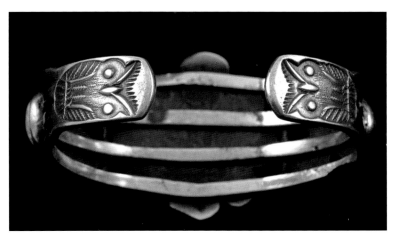

Verso of bracelet, showing owl-stamp terminals

separated classic jewelry from inferior goods. Later, the line would be pushed to 1940. Although, for collectors, authentic handmade silver and turquoise jewelry of the 1930s displayed a satisfactory retrospective quality in its overall design, commercial jewelry designs continued to hold nostalgic appeal. In due time, tourist-era jewelry became historic Americana collectibles.[16]

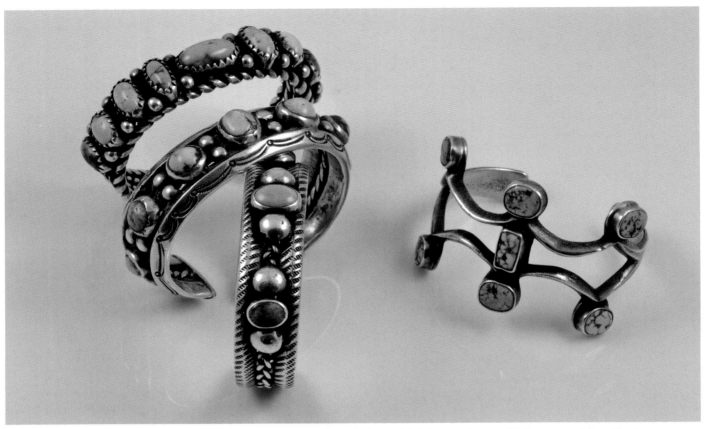

Four 1920s bracelets: (*left*) three wrought silver with decorative raindrops; (*right*) a sandcast cuff. Courtesy of Suzette Jones

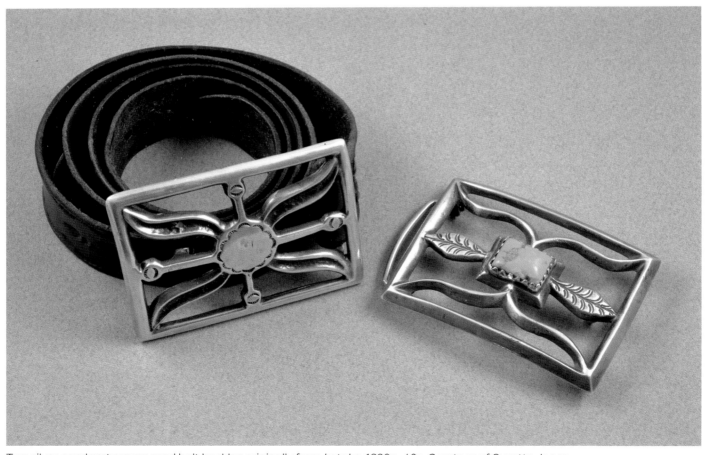

Two silver sandcast repurposed belt buckles originally from *ketohs*, 1920s–40s. Courtesy of Suzette Jones

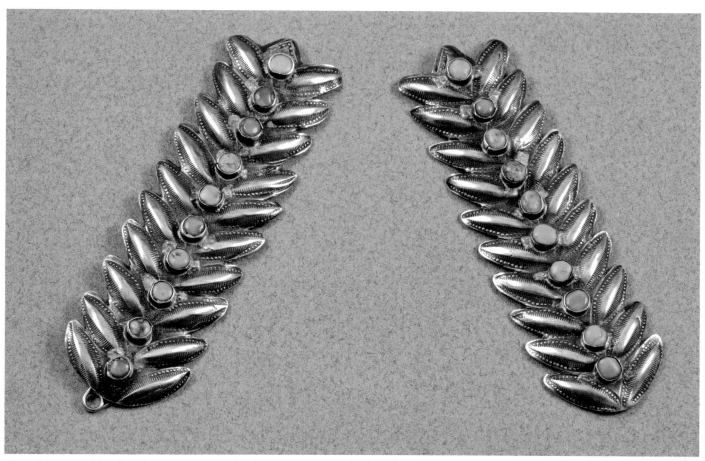

Two silver straight collar stays ornamented with turquoise cabs, 1920s–30s. Courtesy of Suzette Jones

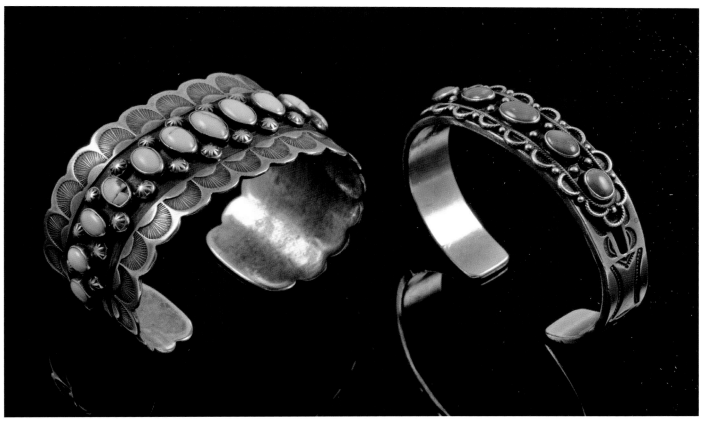

Two silver and turquoise bracelets made by Hosteen or Billy Goodluck, 1920s–30s. Courtesy of the Hoolie Collection

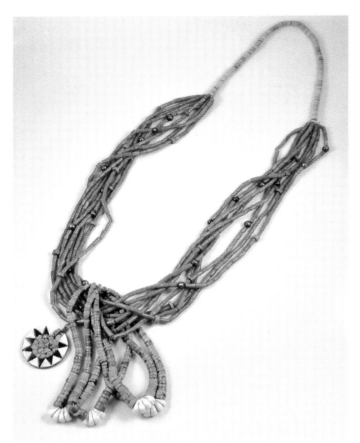

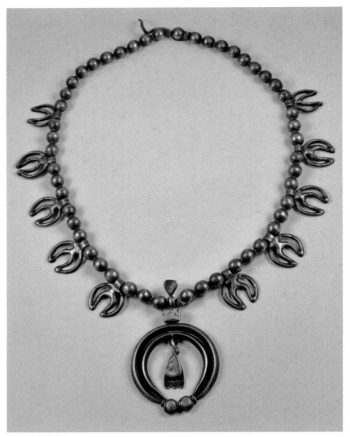

Eight-strand Mediterranean coral necklace, 31-inch length, with small turquoise and silver beads, with four *jaclas* and Santo Domingo medallion, c. 1920. Courtesy of the Hoolie Collection

Unusual Navajo bead necklace with five cast *najas* instead of pomegranate beads, and closed pendant *naja* with turquoise, all strung on leather, c. 1920s. Courtesy of the Hoolie Collection

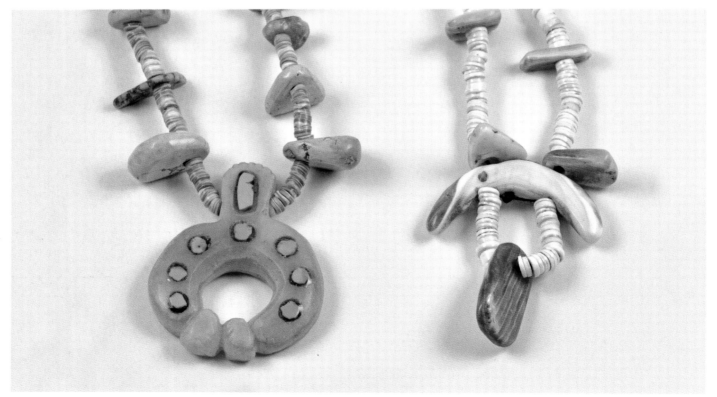

View of two necklaces' pendant ends: (*left*) clamshell with turquoise and spiny tabs and bone *naja* pendant; (*right*) Navajo white shell with spiny tabs, 1920s–30s. Courtesy of the Hoolie Collection

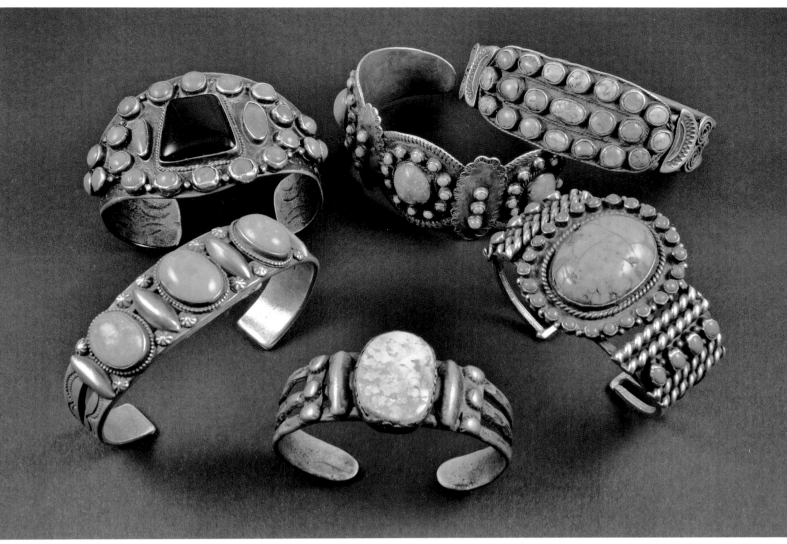

Five Navajo and Pueblo silver bracelets, and one copper band, all with an assortment of turquoise stone styles, 1920s. Courtesy of Andrew Muñana

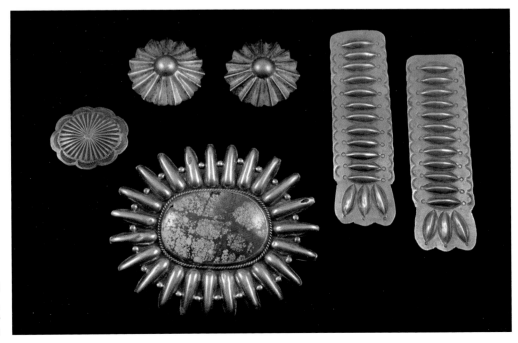

Six silver adornment pieces: Zuni sunburst pin, Navajo collar stays, and older button designs, 1910s–1930. Courtesy of Andrew Muñana

177

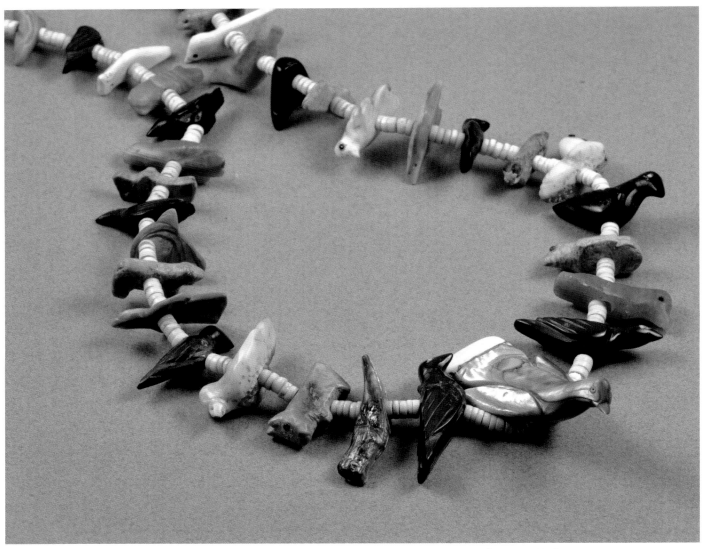

Pueblo carved fetish necklace on white shell beads by Theodore Kucate, 1920s. Courtesy of Andrew Muñana

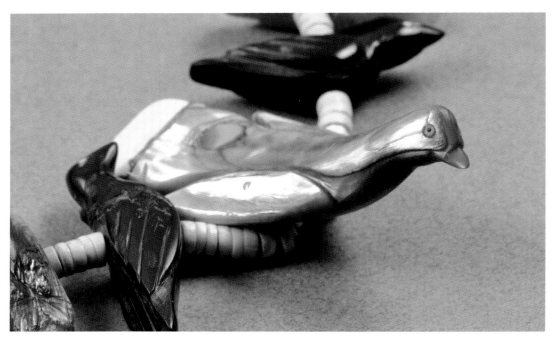

Detail of larger central bird fetish carving

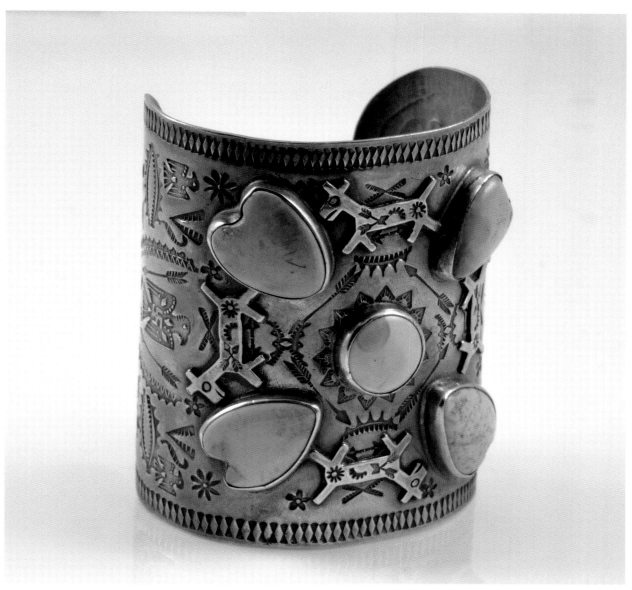

Tall silver cuff with Fred Harvey—era hearts and animal design motifs, 1920s. Private collection

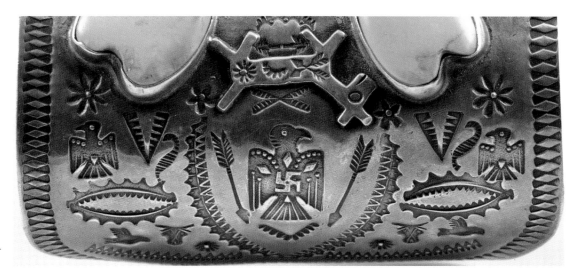

Detail of tall cuff's decorative stamping

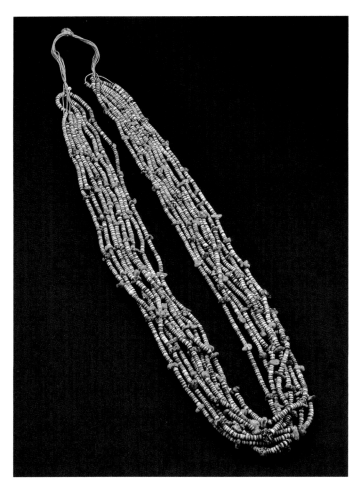

Eight-strand clam shell *heishi* with small turquoise beads, ca. 1920s. Courtesy of Paul and Valerie Piazza

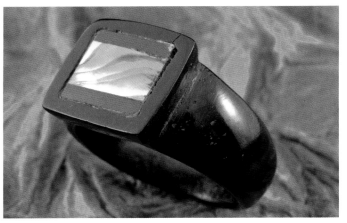

This carved jet ring from Santo Domingo with abalone and plastic inlay resembles prehistoric-era Ancestral Puebloan prototypes, 1920s. Courtesy of Robert Bauver

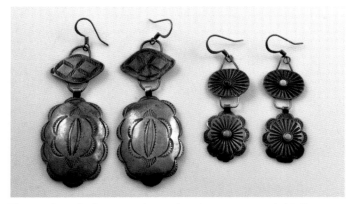

Two pairs of silver earrings showing commercial influence, c. 1910s. Courtesy of Paul and Valerie Piazza

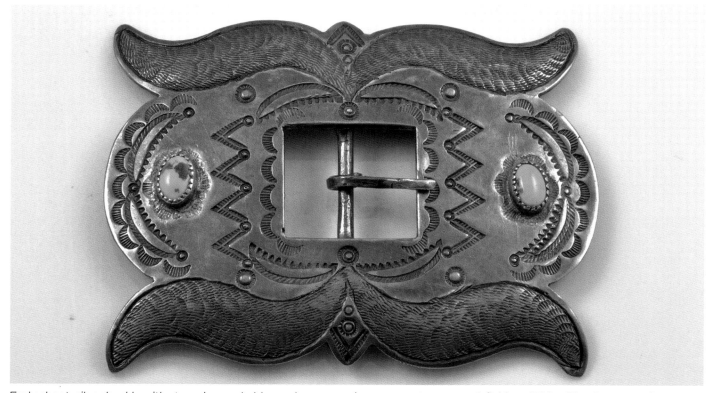

Early sheet-silver buckle with stamping and older rocker-engraving process to create definition, 1920s–30s. Courtesy of Paul and Valerie Piazza

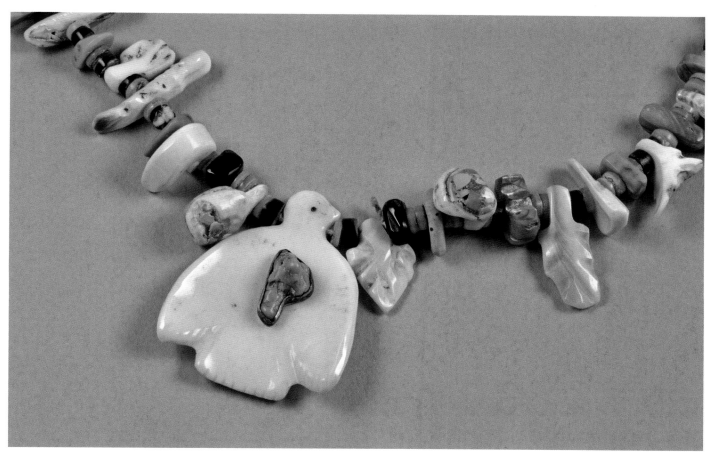

Unusual Pueblo fetish necklace with small shell birds and turquoise in bezel on larger central bird, first quarter of 20th century. Courtesy of Karen Sires

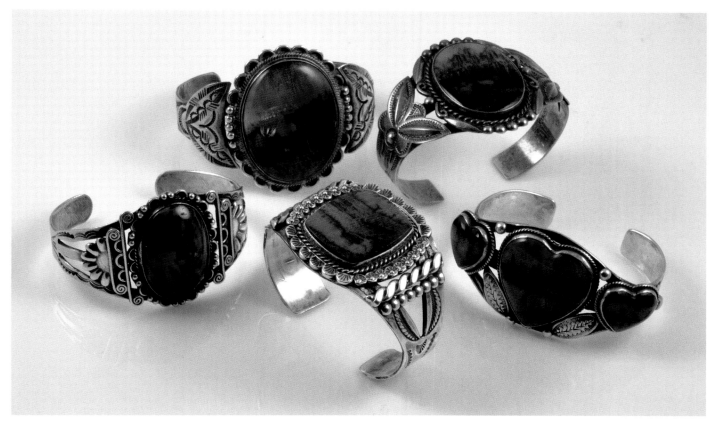

Five curio silver cuffs with petrified wood, 1920s–30s. Courtesy of Elizabeth Simpson

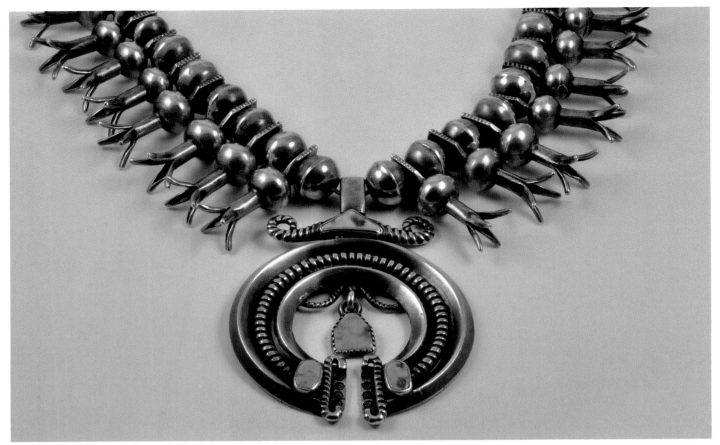

Squash blossom necklace with ornately styled *naja* by Etcitty–Tsosie, 1920s. Courtesy of Karen Sires

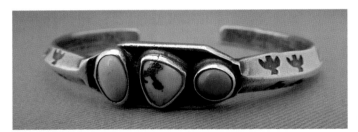

Three–stone bracelet, 1915. Photograph courtesy of Karen Sires

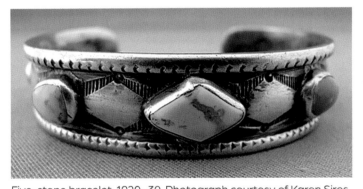

Five–stone bracelet, 1920–30. Photograph courtesy of Karen Sires

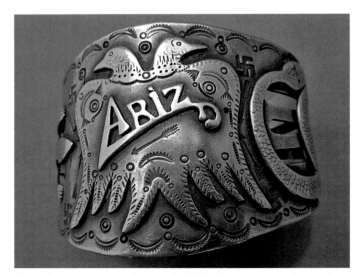

Playful souvenir silver bracelet, 1920–30. Photograph courtesy of Karen Sires

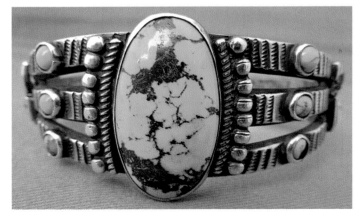

Complex silver cuff with eleven stones, 1920–30. Photograph courtesy of Karen Sires

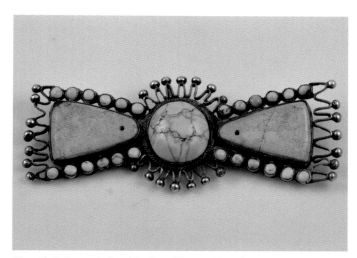

"Bowtie" shaped pin with silver filigree, Navajo or Pueblo, second quarter of 20th century. Courtesy of Karen Sires

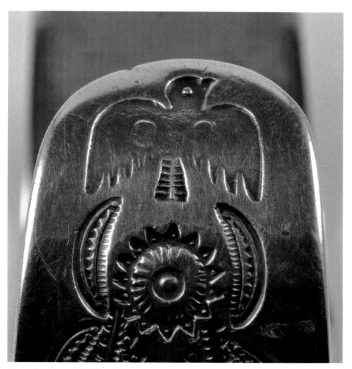

Terminals of 1920s silver bracelet with somewhat unusual (commercially influenced?) bird stamp. Courtesy of Peter Szego

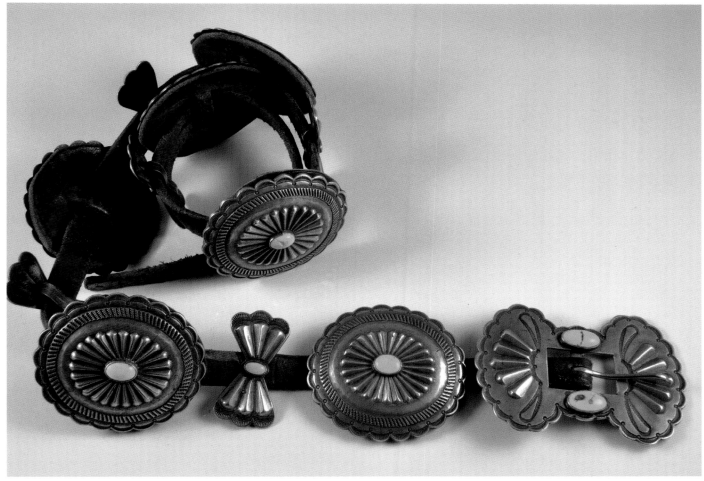

Second Phase concha belt by Hosteen Goodluck, ca. 1920s; six round conchas, five butterfly spacers, and flared buckle. Courtesy of Territorial Indian Arts

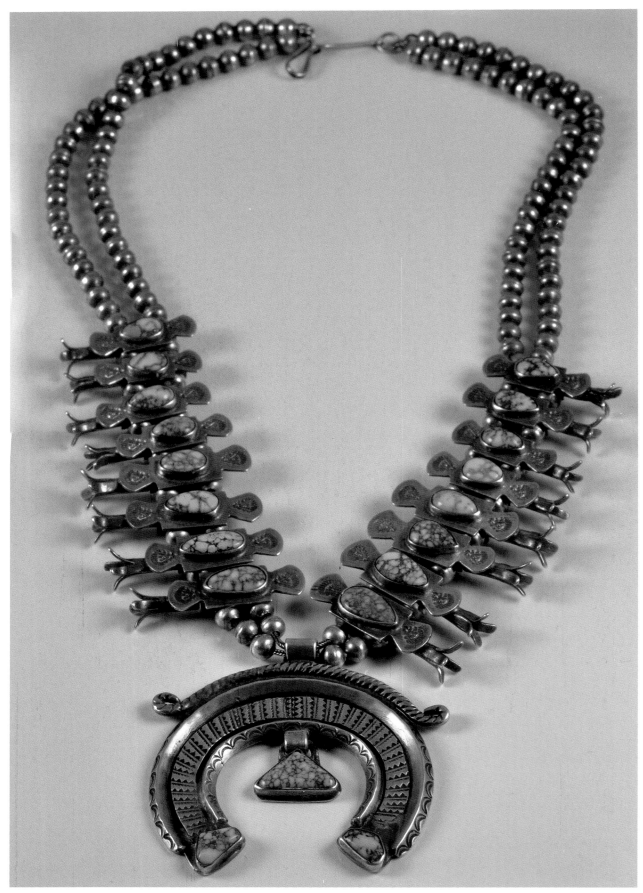

Squash blossom necklace attributed to Etcitty-Tsosie with early boxbows, decorated silver surfaces, ornate *naja*, late 1920s. Courtesy of Territorial Indian Arts

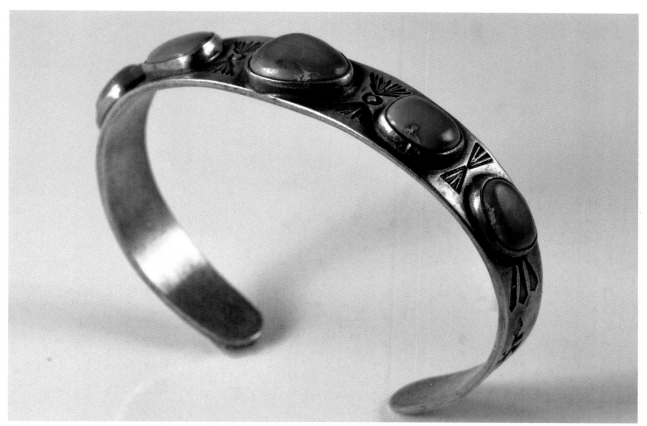

Classic bracelet style, medium weight sheet silver with handmade noncommercial stamps, 1920s. Courtesy of Territorial Indian Arts

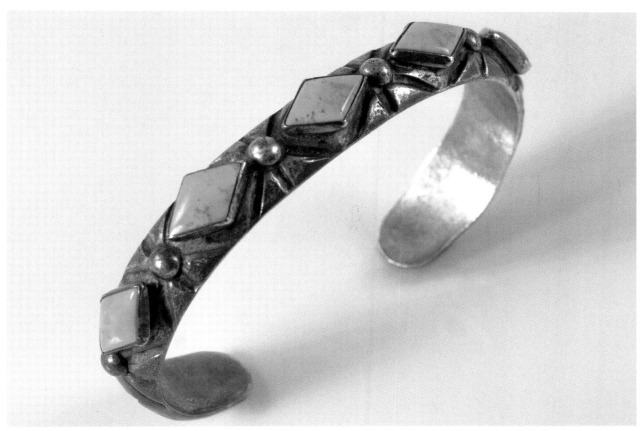

Striking silver cuff with five diamond-shaped turquoise stones in commercial bezel cuts, an early shop piece, cast and hammered, 1920s–30s. Courtesy of Territorial Indian Arts

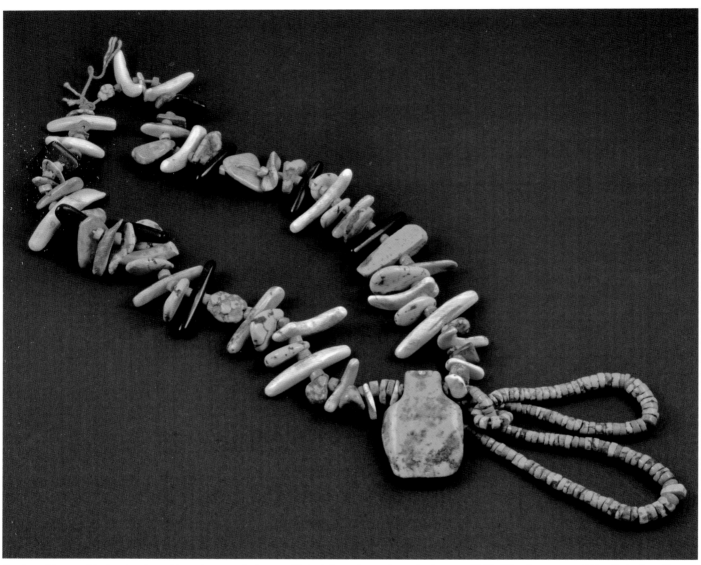

Zuni necklace with single-strand hand-carved stones, 15-inch length, and two *jaclas*, ca. 1915–30s. Courtesy of Hoel's Indian Shop

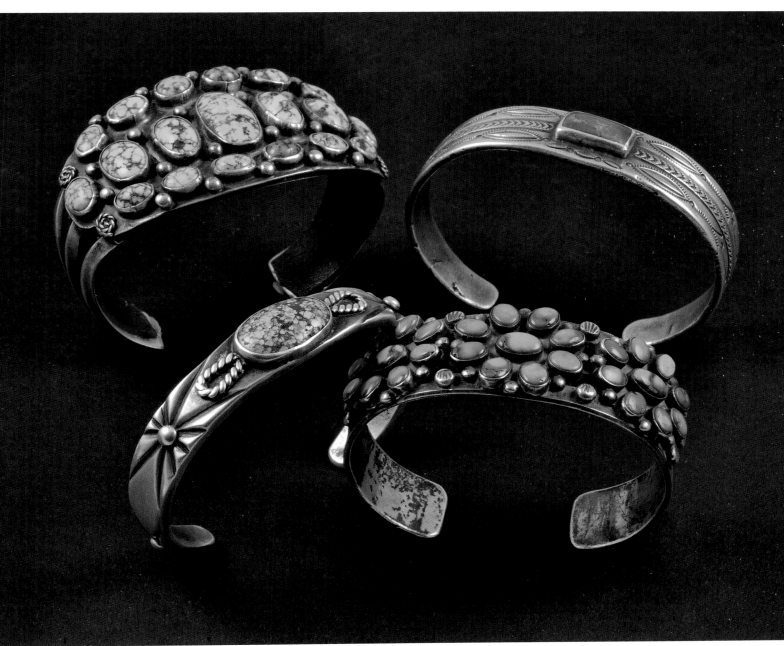

Four silver bracelets in classic stone-set styles, two multiple small-stone, two single-stone, 1920s–30s. Courtesy of White Collection

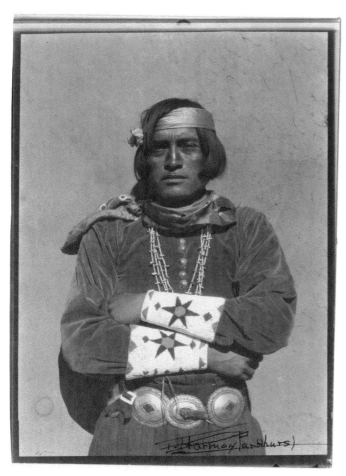

Patricio Calabaza, Santo Domingo Pueblo, New Mexico. T. Harmon Parkhurst, photographer. 1925–30(?). Courtesy of the Palace of the Governors Photo Archives (NMHM/DCA), neg. no. 046763

Endpaper from Joseph Pogue's *The Turquoise* (1915). Author's collection

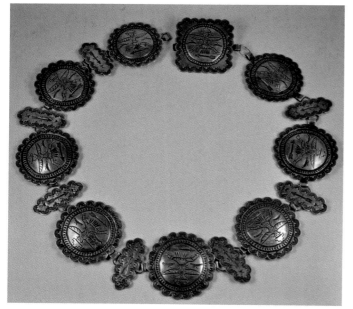

Silver sterling tourist–era link belt, hand stamped Knifewing and arrows, ca. 1920s. Courtesy of the Hoolie Collection

# Key Design Developments in 1916–1930

## FORMS

- Experimentation with styles
- Older style pieces made and deemed to be classic or traditional
- **Third Phase concha belts** in the 1920s acquire vertical silver *butterfly spacers* between oval plaques and are often set with turquoise
- Link concha belts appear in the 1920s
- Squash blossom necklaces are occasionally made with double rows of beads
- *Fetish necklaces* with carved stone birds and other animals attract outsider attention
- Collar tips in V and rectangular shapes were created between 1920 and the 1940s
- Manta pins transform into brooches; possible cross-cultural influence
- Fluted silver beads appear

## MATERIALS

- Mexican government stops exporting coins for jewelry in the 1920s
- Czech glass beads cease to be imported around 1923
- Sheet silver is available in a variety of thicknesses
- Half-round wire rolls, twist and bead wire, and commercial bezels are now available
- Local materials, such as petrified wood and jasper, are incorporated into silver designs

## TECHNIQUES

- Improved and more accessible tools: hacksaws, jewelers saws, sharp-nose pliers
- As a result, more bracelets and earrings are made as composites
- Increased access to metal rolling mills and ingot molds by 1920
- Workshops have gasoline blowtorch soldering and soldering frames by 1920
- Swedged work appears along with wider cuffs
- Earrings gain multiple parts to make ladders and "chandelier" styles
- Channel and mosaic inlay starts in this period, mostly at Santo Domingo and Zuni
- Better organized early row- and clusterwork starts, especially on bracelets, pins, and necklaces
- Silver raindrops are better integrated on settings

## MOTIFS

- Some carryover from commercial design motifs, such as animals, arrows, whirling logs, figures on flatware; first appearance of Knifewing deity (Zuni)

## ELEMENTS

- Color; contrast; dominance; form; emphasis; graduation; proportion; repetition; tone

## NOTABLE MAKERS

- *Navajos:* Charlie Bitsui; Tom Burnside; Etcitty-Tsosie (Eskiesose); Billy Goodluck
- *Zuni:* Della Casa Appa; Horace Iule; Willie Zunie
- *Hopi:* Roscoe Narvasi; Grant Jenkins
- Slender Maker of Silver (b. 1850) dies in 1916
- Significant smiths and jewelers born in this period include Juan Luhan, Acoma (1911); Silviano Quintana, Cochiti (1913); Kenneth Begay, Navajo (1913); Charles Loloma, Hopi (1921)

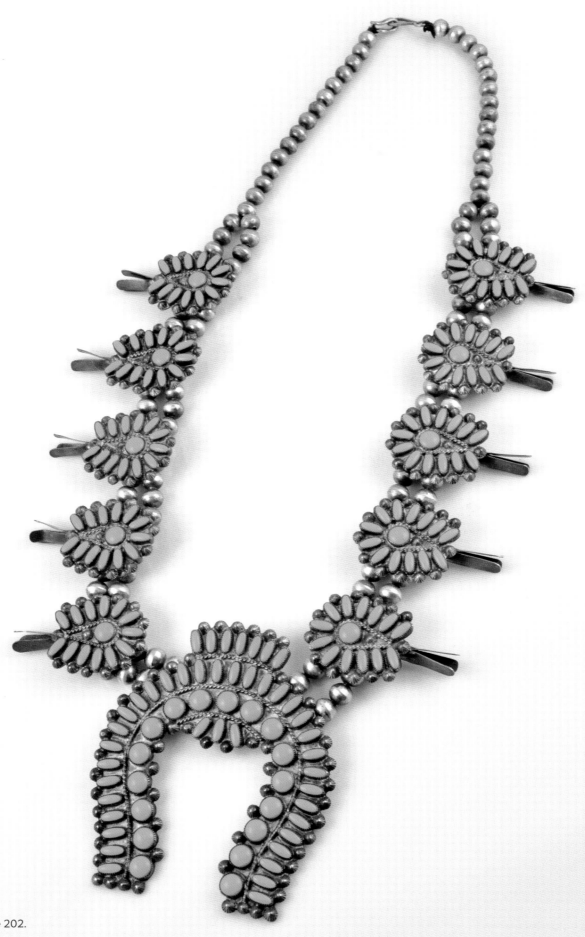

See page 202.

# The 1930s: Patronage and Expansion

The 1930s in the United States were the years when standards of quality and beauty inherent in Navajo and Pueblo classic design reached new heights, and pieces truly acquired fine finishes. More jewelry makers were at work than ever before. Quietly brilliant Native individuals were appointed to teach silversmithing at the various Indian schools. Inventive designs flourished despite the Depression era. Indian arts advocates enlisted governmental patronage with mixed results. While the Navajos and Pueblos struggled with mandated governmental directives aimed at altering their way of life, a newly empowered Indian Arts and Crafts Board (established by the US Department of the Interior in 1935) attempted to impose protections and sanctions—including registered hallmarks—as a means of aiding Native arts.

The influential trader John Lorenzo Hubbell passed away in 1930. This indefatigable promoter of Southwestern Indian arts brought to the Native jewelers who worked for him better materials, a wider market, and opportunities to become more confident designers. Hubbell's last years had been plagued by the kind of financial reversals suffered by many businesspeople at this time. The Navajos and Pueblos faced the burden of the Depression by tightening their belts and carefully moving forward. These were bitter years for many after Indian Commissioner John Collier implemented livestock reductions. More than ever, sales of jewelry grew increasingly important to the Native economy, whether as a home industry or as wage work in a curio shop.

# TIMELINE

| | |
|---|---|
| **1930s** | The Great Depression is felt across the US; after Roosevelt's election as president in 1933, governmental programs are implemented to assist people, including Native Americans |
| **1930** | Museum of Northern Arizona hosts first Hopi Craftsman Show |
| **1930–31** | Grand Central Art Galleries' *Exposition of Indian Tribal Arts* opens in New York and travels through the US |
| **1930** | By this date there are 154 trading posts on or near Navajo homeland |
| **1931** | United Indian Traders Association (UITA) is formed in Southwest |
| **1931** | Key individuals hired to teach first silversmithing classes at region's main Indian schools: Haske Burnside at Albuquerque Indian School; Fred Peshlakai at Fort Wingate; Ambrose Roanhorse at Santa Fe Indian School |
| **1932** | Federal Trade Commission sues Maisel's Trading Post, claiming misrepresentation of products |
| **1932** | Harry P. Mera, of Santa Fe's Laboratory of Anthropology, makes an extensive buying trip to Navajo reservation trading posts, purchasing many bracelets and other silverwork |
| **1932–37** | Dorothy Dunn comes to Santa Fe Indian School and teaches Indian students easel painting in Santa Fe Studio style |
| **1933** | US Secretary of the Interior bans sales of imitation "Indian jewelry" in national parks and monuments |
| **1933** | Southwest Indians, especially the Navajos, protest Indian Commissioner John Collier's plans for live-stock reduction |
| **1934** | Indian Reorganization Act (Wheeler–Howard Act) by Congress aims to decrease federal control of Native Americans and promote more self-determination |
| **1934** | Committee on Indian Arts and Crafts created by Congress to report on status of current Native arts |
| **1934** | Fred Peshlakai demonstrates silversmithing at Century of Progress World's Fair |
| **1935** | Navajos reject Indian Reorganization Act |
| **1935** | Window Rock, AZ, is chosen as Navajo Nation's capital |
| **1935** | US Department of Interior establishes Indian Arts and Crafts Board (IACB) |
| **1935** | Bell Trading Post in Albuquerque, NM, runs small store with Pueblo and Navajo smiths |
| **1936** | Maisel's cleared of charges by FTC when they label jewelry that is whole or partly machine made |
| **1936** | Indian Arts and Crafts Board Act passed by Congress |
| **1937** | Frank Patania Sr. opens Thunderbird Shop in Tucson, AZ |
| **1937** | Department of Interior approves "Standards for Navajo, Pueblo and Hopi Silver and Turquoise Products" on March 9 |
| **1938** | IACB issues US Navajo and US Zuni guild hallmarks on April 6 |
| **1938** | Availability of new hallmarks for Native use becomes problematic; fails to reach many silversmiths, and traders do not receive all that they ask for |
| **1938** | First experiments in developing Hopi overlay, leading to sales in the 1940s; Harold and Mary-Russell Colton of the Museum of Northern Arizona announce museum will support Hopis in creating a new silver design plan |
| **1938** | Anthropologist John Adair arrives in Pine Springs, AZ, to begin fieldwork for eventual publication; he works with numerous Native informants |
| **1938** | John Adair records 90 active Pueblo jewelers; number jumps to 139 by 1941 |
| **1939** | Maisel's opens new curio flagship on Route 66 in downtown Albuquerque; building designed by John Gaw Meem |

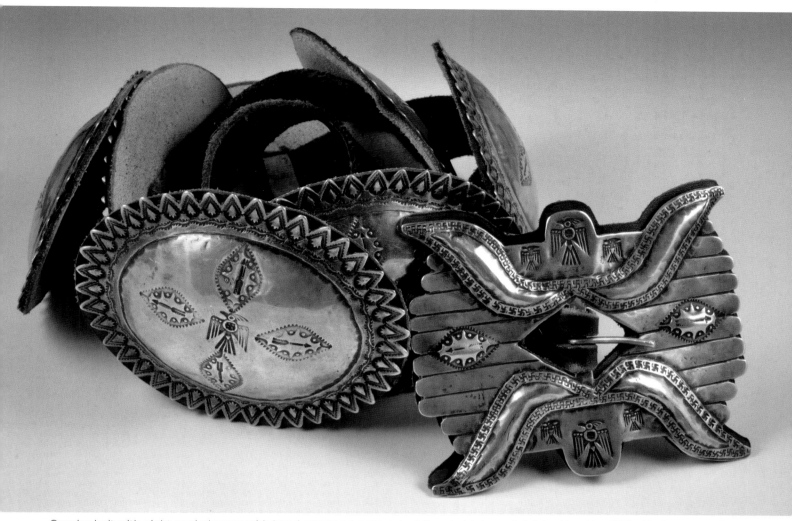

Concha belt with eight oval plaques with hand-stamped arrows and thunderbirds, well-finished buckle, 1930–40. Courtesy of the Hoolie Collection

Jewelry makers were still relatively anonymous artisans. For example, on August 29, 1931, the *Gallup Independent* reported that the trader C. G. Wallace won the best display of new silver at the Gallup Inter-Tribal Ceremonial; no Native smiths were mentioned by name. This practice encouraged the assumption that Indian traders guided, inspired, and directed the design of Indian jewelry. Writers at this time might quote a trader at length about the state of Native creativity, but never an Indian. Traders believed themselves to be sufficient voices for their jewelers.

Through the 1930s, however, a number of silversmiths emerged as influential figures. During this period, silversmiths who taught in the region's Indian schools, notably in New Mexico at Fort Wingate, Albuquerque, and Santa Fe, would inspire and instruct students who eventually became important figures in jewelry making. Fred Peshlakai taught the next generation's leading Navajo smith, Kenneth Begay, at the Fort Wingate Boarding School. Wilfred Jones became an instructor at the Shiprock Indian School around 1939. Zuni jeweler Teddy Weahkee taught silversmithing to students at the Santa Fe Indian School, as did master

smith Ambrose Roanhorse (page 289). Dooley Shorty, Roanhorse's student, would teach at Fort Wingate in the late 1930s. Another remarkable Roanhorse student, Chester Yellowhair, would go on to teach at the Albuquerque Indian School.[1]

Zuni Pueblo, which had several Indian traders on-site, experienced a dynamic jump in silversmiths during this decade. Venerable smith Lanyade was still alive in 1937, along with Keneshde, known to be one of the first to set small turquoise stones in silver at the pueblo. A few individuals, such as the gifted female silversmith Della Casa Appa, Horace Iule, and carver Leekya Deyuse, had already attracted notice with their work. Jewelry and lapidary production at the pueblo soared as makers created both traditional and inventive new styles.

Navajo jewelers of note who worked at Maisel's and other curio shops included Mark Chee, Frank and John Platero, David Taliman, and Ambrose Lincoln. Key Pueblo silversmiths who worked alongside these individuals were Leo Coriz, Jose Abraham Jojola, Manuel and Paul Naranjo, and Joe H. Quintana. This last silversmith became a significant figure

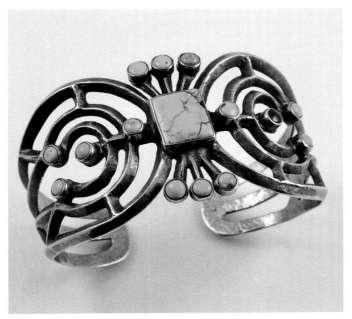

Tufa–cast silver and turquoise bracelet by Charlie Houck, John Adair's Navajo informant, 1930s. Courtesy of Michael Haskell Collection

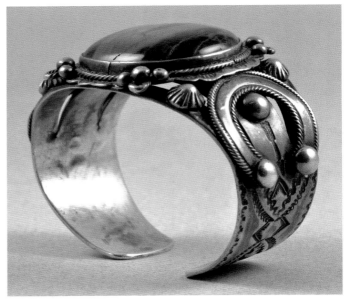

Heavy–gauge cuff fabricated out of sheet silver with appliquéd *naja*/horseshoe design on sides, petrified wood center setting, 1930s. Courtesy of Andrew Muñana Collection

in the decades ahead, with his works prized by collectors. Many others trained in curio shops or worked for Indian traders who commissioned piecework from them.[2]

The Museum of Northern Arizona instituted Indian arts shows that would support fine Southwestern Indian jewelry design. A Hopi Craftsman Exhibition, initiated in 1930, featured the display of 200 items and sales nearing $1,000. This event is now an annual festival of Hopi arts.[3] A Navajo Craftsman Exhibition was added in June 1936, held at Wupatki National Monument. Over time, these two festivals were joined by a Zuni show, with all events now conducted on museum grounds during summer weekends.

Throughout the 1930s, intensified marketing activities—such as the creation of the New Mexico Tourist Bureau in 1935—were founded to counter the effects of the Depression. By 1936, the annual sales show held in Santa Fe had become an "Indian Market"; the market's sponsor, the New Mexico Association on Indian Affairs, a political advocacy group, was beginning its slow transformation into the organization known today as SWAIA (Southwestern Association for Indian Arts). Occasional retail campaigns appeared. For example, in 1934 R. H. Macy & Co. in New York City advertised and marketed Southwestern Indian products, including a collection of silver jewelry.

In 1939, the promotion of Southwestern Native jewelry received a boost at the Golden Gate International Exposition in San Francisco. Large exhibits of Southwestern Indian arts were viewed by 1.25 million visitors. Navajo silverwork on display received much public approval. This acclaim led the newly established Indian Arts and Crafts Board to foster future exhibition ideas. Key museum professionals from the East Coast were among those impressed; their approval brought about significant developments in the next decade.

## Patronage in the New Deal Era

Commercial Indian jewelry was plentiful by the start of the decade, and critics put forward various plans to stem this flood of cheap and derivative goods. Activists were out-and-out purists who loathed the advent of mechanization, plus advocates of traditional silversmith work as it first developed.[4] Many of the biggest names in Southwestern arts called for bans on bogus "Indian-made" products; they ranged from academics such as Oliver La Farge, Edgar Lee Hewitt, and Ruth Bunzel to writers and artists like Mary Austin, Mabel Dodge Luhan, and John Sloan. In Washington, DC, economic advisors to the federal government developing theories about "frontier commerce" studied its effects on Navajo productivity. The trading-post system was even criticized for causing an unfair Native economic dependency on its services.[5]

In 1931, the United Indian Traders Association (UITA) placed labels on the silver jewelry it sold that stated "Indian Reservation Hand Made" or "From Solid Coin Silver Slugs." In 1933, the US Secretary of the Interior banned the sale of imitation Indian arts and crafts in the national parks. Despite these efforts, the effects of the Depression took a toll: prices for hand-wrought Indian jewelry fell in 1936 and 1937 to levels that barely matched the value of the silver used in their creation. More Native smiths went to work at curio shops to earn steady wages.

On August 27, 1935, the Indian Arts and Crafts Board (IACB) was created, another agency in the fostering spirit of New Deal federal programs, intended to provide oversight of—and protection for—authentic Native arts. The IACB was authorized to promote exhibitions, marketing, and related activities.[6] It allocated grants to the Navajo and Zuni

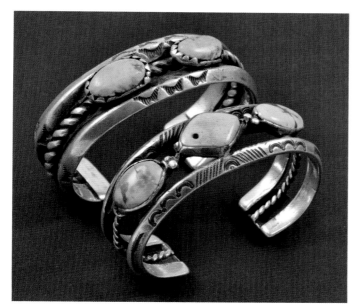

Two silver composite bracelets: (*top*) two-stone with twisted wire; (*bottom*) carinated three-stone, center stone is a drilled bead, 1930s. Courtesy of Laura Anderson

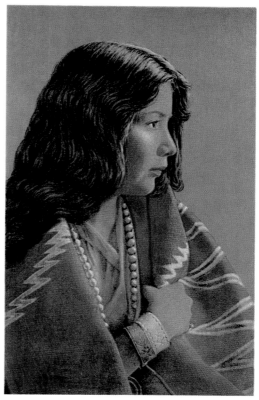

Fred Harvey Co. postcard "Lo-lee-ta, a Pueblo Girl of Laguna, New Mexico," a romantic portrait of a Native woman in modestly basic jewelry forms, 1920s–30s. Private collection

tribes for the eventual creation of guilds, or arts cooperatives. In 1937, the IACB was granted permission by the Secretary of the Interior to establish official stamps guaranteeing that an item was genuinely handmade by an Indian. Between 1938 and 1942, stamps marked "U.S. Hopi," "U.S. Navajo," and "U.S. Zuni" were available to participating smiths for use on silver jewelry; the program did not last much past the end of World War II.[7]

How effective was such regulation? The IACB provided excellent educational materials, but the value of its stamp program is now primarily a means of dating Native jewelry made during the period of its operation. Regulating artistic design and creation was a difficult aim in the best of times for any governmental body. And as the 1930s ended, the struggles for obtaining materials and wage work would soon be overshadowed by the national war effort.

Non-Native attitudes about contemporary Navajo and Pueblo jewelry production took various forms throughout the 1930s. One author, writing in the March 1934 issue of *Design*, claimed that the Native "art of silversmithing degenerated and died out" by this decade.[8] Many serious collectors deplored the new look and quality of contemporary jewelry construction aided by better tools and processes, preferring older, more unpolished compositions. Museum professionals were divided over the direction of Southwestern Indian jewelry design. Most visibly, such division drew a line between traditional pieces with a fixed set of design elements and new work that felt insidiously influenced by technological commercialization.

This controversy sparked a desire by some Indian traders, dealers, educators, and museum curators for jewelry that looked unique to a specific Native group. This newfound interest in "tribal styles" was a reaction to a period of social

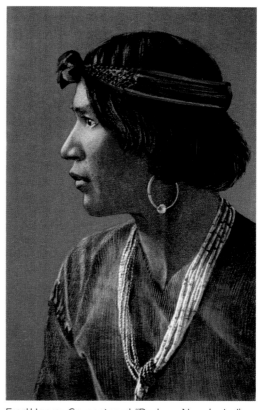

Fred Harvey Co. postcard, "Pedro, a Navaho Indian, New Mexico," a colorized version of a studio portrait, 1920s–30s. Private collection

change for American Indians. Also related to this development was an aspiration, voiced by the IACB, that authentic Navajo and Pueblo jewelry making in the mid-twentieth century be labeled "craft" work. Such a definition fit in well with the encouragement of tribal guilds.

Native artisans demonstrating their "crafts" at expositions, world's fairs, and major tourist locations had taken hold in the public imagination. The Garden of the Gods in Manitou Springs, Colorado, had Pueblo smiths wear feathered headdresses because the northern tribes had trading links with Plains Indians. Hopi House on the Grand Canyon featured Navajo and Pueblo artisans working side by side. These calculated demonstrations tended to romanticize Native culture and creations. Fred Harvey Company advertisements in the 1930s worked to achieve a similar effect. Postcards and booklets depicted Native men and women wearing selective adornment carefully choreographed to suit Anglo tastes, such as a single strand of Navajo silver "pearls" or a well-placed dress pin.

## Designs Stimulated by Outsider Influence

These trends choreographed by non-Natives peaked in one of the most significant developments of the 1930s, namely, the planning that went into devising Hopi overlay, a new style of Native tribal jewelry design. The origins of Hopi overlay were based on an honest desire to economically aid the remote and isolated Hopi communities. Silverwork at Hopi had developed later than in other pueblos and had fewer practitioners. Hopi smiths were encouraged to develop a tribally distinctive silverwork

technique and style, using designs from traditional Hopi weaving and pottery, combined with other motifs drawn from earlier Indigenous cultures.

Patronage for this project came from the Museum of Northern Arizona director Harold Colton and his curator wife, Mary-Russell F. Colton. Their ideas about the project and its evolution have been misinterpreted over the decades. In 1938, only twelve Hopi smiths were at work, compared to ninety at Zuni. In response, the Coltons envisioned the launch of the Hopi Silver Project. The project would be interrupted by the entry of the United States into World War II but resumed thereafter in full force.

Since Mary-Russell Colton's role in this development has been misunderstood, it's instructive to look at her own description of the Hopi project. Colton wrote an article in a 1939 issue of *Plateau* that reveals ideas about design related to Hopi silversmithing. Her first concern was that Navajo silverwork design predominated the public's view of how Native silverwork should appear. She wrote:

> This is due to the fact that differences in design are superficial rather than fundamental, and are produced not by the character of the larger forms, but by an elaboration of turquoise settings, small stamped designs, wire work and beading.[9]

She went on to note how new Hopi design was "to be applied in a manner so very simple as to appear almost 'modern,' which in fact is the true character of Hopi design." Her article also reveals concerns in concert with other arts experts; she deplores benchwork and machine-driven "short cuts" and endorses the work of the IACB in establishing standards and tribal stamps.[10]

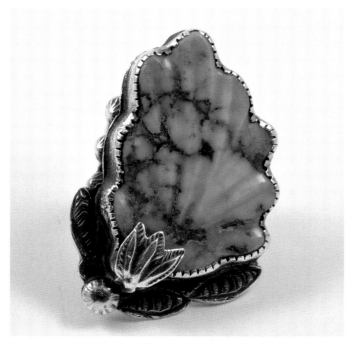

Steer head carved turquoise on silver ring by Leekya Deyuse, 1930s. (Steer head is angled on the central plate.) Courtesy of Karen Sires

Turquoise carved leaf on silver ring attributed to Leekya Deyuse, ca. 1930s–40s. Courtesy of Karen Sires

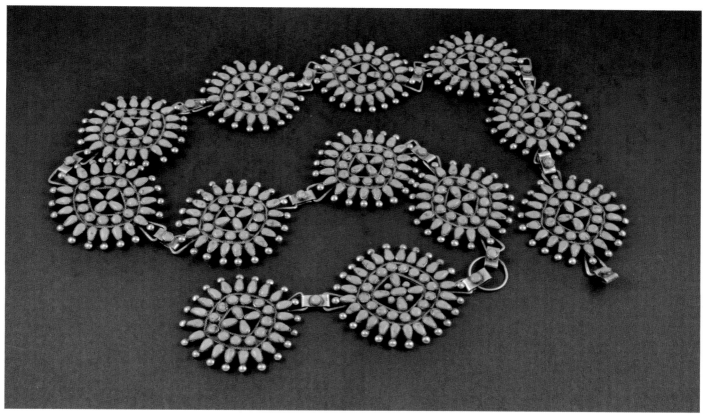

Zuni link belt with Blue Gem turquoise clusterwork, late 1930s–40s. Private collection

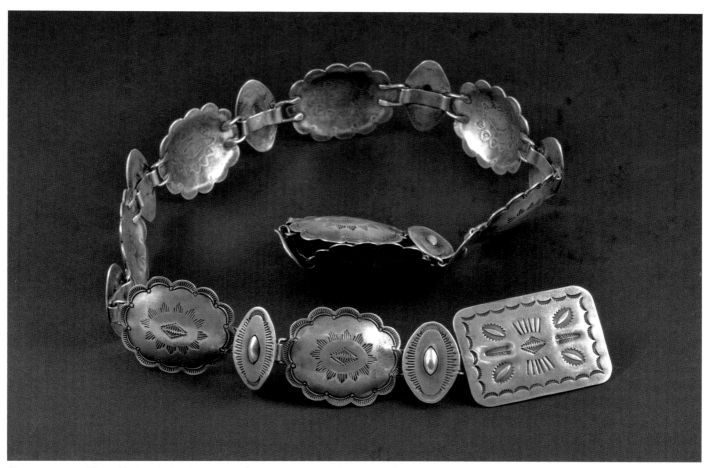

Silver stamped linked belt, 1930s. Courtesy of R. B. Burnham & Co. Collection

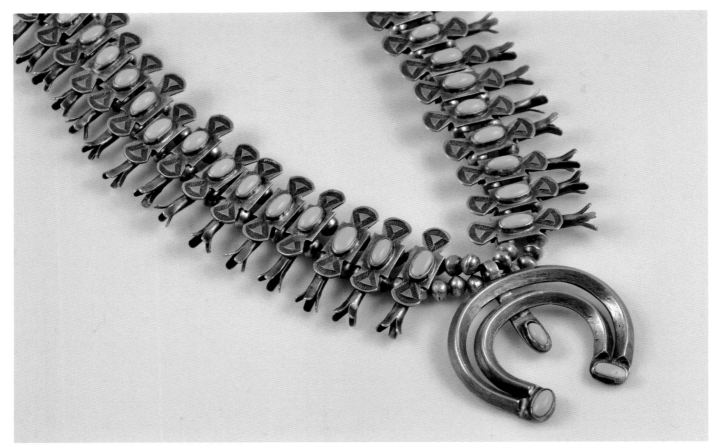

Classic squash blossom necklace with turquoise and silver boxbows, 1930s. Courtesy of R. B. Burnham & Co. Collection

Zuni circular petit point cluster pins, 3 inches in diameter, 1930: (*lower left*) steer head by Juan Dedios; (*lower right*) back of pin showing conversion of steer-head pin to coin-centered pin. Courtesy of Joan Caballero

Colton concluded her article by describing how the museum staff created a series of designs to "stimulate" ideas, which were then given to individual Hopi smiths. However, contrary to what has been written about the origins of Hopi overlay, she clarifies that these designs were intended to "act as suggestive material only."[11] In other words, she did not invent or strictly dictate Hopi overlay design choices, leaving that job in the very capable hands of the smiths. Colton also emphasized—ahead of her time—that Indian silversmithing was a true art.

The overlay technique was not unique to the Hopi; it was also used by other Native silversmiths. The smiths used two pieces of silver that were soldered onto each other. The top layer was made up of a cutout design, with the bottom layer within that design oxidized to make a darkened contrast against the silver top layer. The designs produced by the Hopi, however, were unparalleled in visual effect and embodied the essence of midcentury-modernist motifs. For the first time ever, this union of technique and imagery would soon be decisively labeled "Hopi overlay."

These imaginative overlay designs based on Indigenous decoration proved to be highly popular. The clean, sleek silver and its motifs fit in well with modernist aesthetics. It successfully demonstrated the demand for an appropriate tribal style. Two highly gifted individuals, artist Fred Kabotie and silversmith Paul Saufkie, helped build this vital art; the

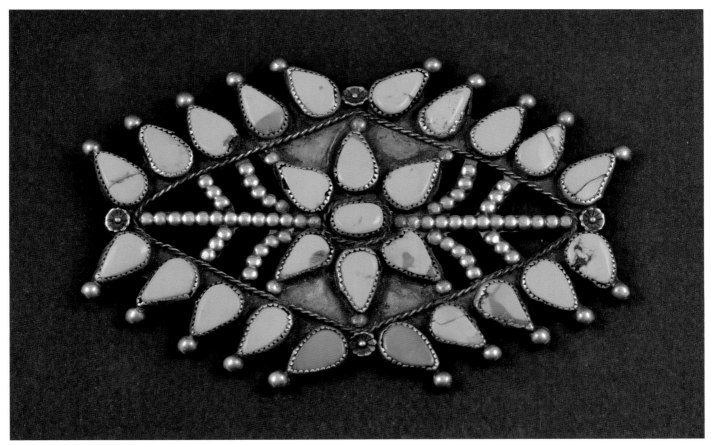

Navajo cluster brooch, 4 inches wide, with green and dark-green stones and early shadow box, 1935–45. Courtesy of Joan Caballero

design development was strictly Native in interpretation, albeit encouraged in concept by the Coltons. Hopi overlay, in addition to featuring abstract patterns, also introduced representational motifs, such as Mimbres-pattern animals, to an appreciative public.

The inception of the Hopi Silver Project coincided with the presentation of more realistic design motifs. During the 1930s, Zuni lapidaries began offering carved lifelike objects such as carved turquoise leaves and frogs set in silver. Snakes, steer heads, birds, and human hands—all early design choices—appear more frequently on silverwork. The end of the decade would see a slow transition in depicting clan symbols and some tentative figural work. While sacred spirits were still off-limits, a few carefully revised approximations show up in Zuni silver and mosaic inlay. Writers from a trader background would call this the early evolution of a "kachina style," which manifested itself in the 1950s and 1960s.[12]

This slow development into the 1940s is in sharp contrast to curio designs. Silver spoons made by Navajo smiths often whimsically portrayed Indians themselves on the handles as early as the 1890s.[13] By the 1930s, tourist curio silverwork actually had an indirect but increasingly creative effect on all Native design. The often generic stamped and incised imagery devised for flatware, along with other commercially generated tourist metalwork, helped Indian jewelers develop

more figural imagery by the 1950s. Once again, although non-Natives might claim they provided the economic impetus for this kind of design, Native jewelers reacted by implementing realistic design motifs that they felt comfortable with and that reflected personal choices.

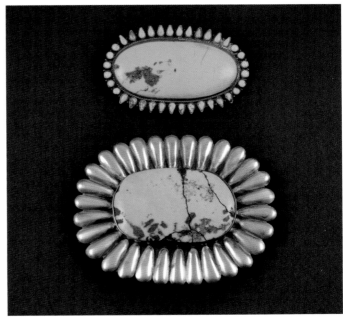

Two sew-ons with silver edges, 1930s–40s. Courtesy of Joan Caballero

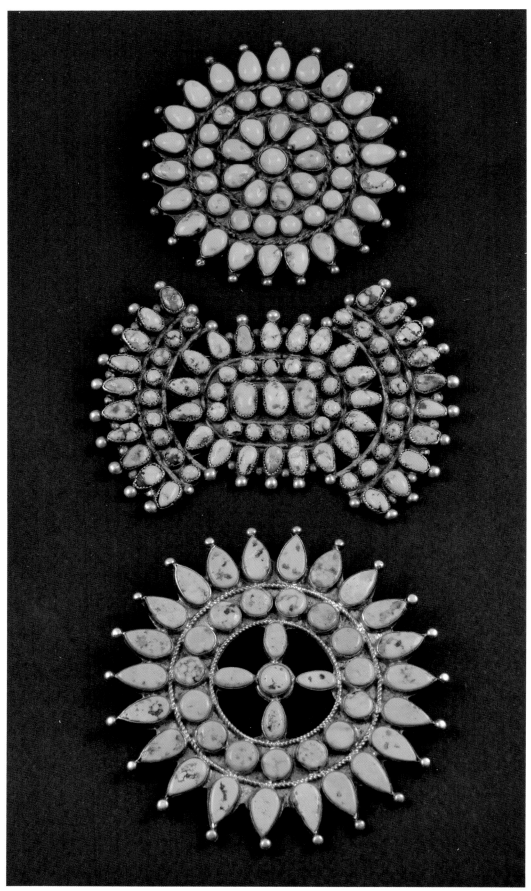

Three finely designed cluster brooches with round and petit point turquoise stones, 1920s–30s.
Courtesy of Joan Caballero

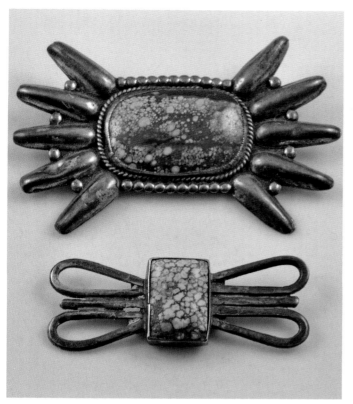

Two Pueblo–made sew–ons, both with #8 turquoise, 1930s. Courtesy of Eason Eige Collection

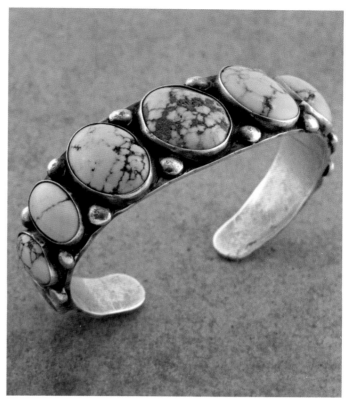

Bracelet by Da–Pah, classic style made ca. 1930, with nine turquoise stones. Photograph courtesy of Pat & Kim Messier

Colorized postcard "Navajo Silversmith (Da–Pah) Plying His Trade," 1930s. Private collection

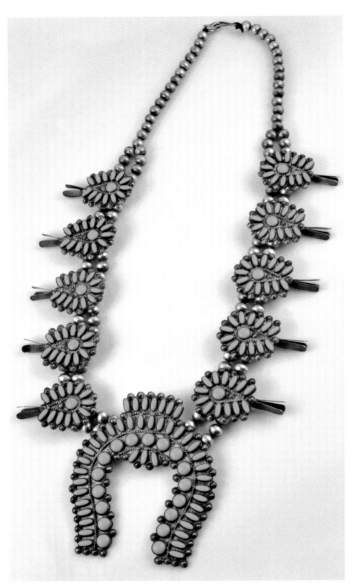

Imitation turquoise cluster squash blossom necklace, Navajo or Zuni, 1930s, purchased in 1939 by a buyer who didn't like matrix in turquoise. Courtesy of Eason Eige Collection

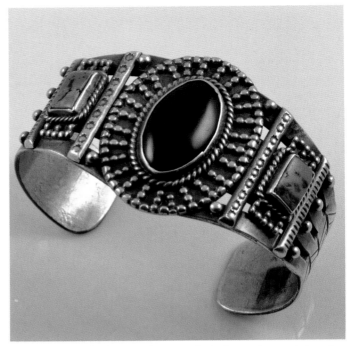

Navajo wide cuff with creative use of raindrops, Acoma jet center stone flanked by turquoise stones, 1930s. Courtesy of Eason Eige Collection

## Overall Design Change in the 1930s

How was jewelry design affected in this decade? Despite the social turmoil and economic adversity, creative adaptations and developments steadily mark the 1930s. Traders and smiths worked together to implement improvements in materials and techniques; as a result, silverwork achieved a refinement and finish that enhanced its design characteristics. From 1932 on, Native smiths used 1-ounce slugs made from refineries in the Los Angeles area. By 1938, the use of coins for silver largely faded away in favor of newer and more malleable sheet silver.

Brass and copper were used when available, but machine-made nickel-plate jewelry pieces increased as well. Traders were still able to stock commercially precut and polished stones for lapidary setting: in addition to turquoise, these included agate or "picture stone," jasper, lapis, and petrified wood. Coral (usually in branch form) was available until mid-decade, before becoming scarce again until the 1950s.

In the 1930s jewelry makers improvised, reusing older stones or seeking creative substitutions. The residents of Santo Domingo Pueblo, already known for their fine *heishi* beadwork, employed great ingenuity by making adornment from found and recycled materials that became iconic in their own right. These skilled lapidaries fashioned designs inlaid with a variety of clever alternative resources. In place of jet and abalone, such unusual materials as automotive battery cases, phonograph-record plastic, piano keys, and toothbrush handles were substituted.

The American Southwest never attracted a silverwork industry like the one established in Taxco, Mexico, by American designer and architect William Spratling (1900–1967).[14] A somewhat comparable environment, however, was created in the late 1920s and 1930s by Italian immigrant Frank Patania Sr. He arrived in Santa Fe as one of many artists seeking recovery from tuberculosis, and he established his first Thunderbird Shop there in 1927. He opened another studio in Tucson in 1937. Patania rejected the Indian-trader business mode for a workshop environment that produced custom-made silver jewelry and metalware. He also created a number of classic and influential designs and employed Native smiths who would become well-known designers themselves by midcentury. Patania's cross-cultural studio-jeweler model proved significant in the post-1945 development of Navajo and Pueblo craft and artistry.[15]

Silver bird brooch by Pueblo master smith Awa Tsireh, 1930s. Courtesy of Frank Hill Tribal Arts

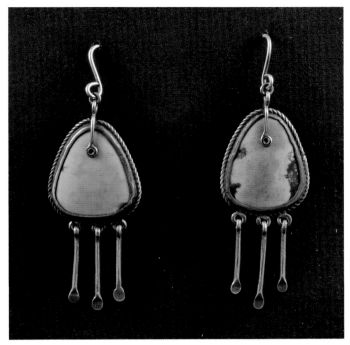

Classic Navajo turquoise stone earrings with dangles, ex–Adair collection, 1930s. Courtesy of Frank Hill Tribal Arts

Santo Domingo design tenets were more restricted than those in Zuni. But their utilization of old-style Pueblo lapidary modes in these repurposed and found materials was creative in vision. They constructed thunderbird necklaces, pendants with simple *najas* and hanging tabs, and creative dangling earrings in bird shapes. Their bird pendant designs moved beyond the typical thunderbird with outstretched wings to variations on the Pueblo or Hopi bird form. Years later, these unique creations won their own label as "Santo Domingo Depression Era jewelry" and remain interesting collectibles.

Clusterwork pieces became dominant designs in this decade. Often still called "Zuni style," both Navajo and Pueblo artisans carefully arranged small-stone turquoise on classic jewelry forms. These stones were set into rows, circles, or concentric bands and in some cases were placed into asymmetrical patterns on castwork. This new attention to multiple stonework was spread by improved tools and equipment for effective cutting and polishing of nugget-shaped or smooth cabochon turquoise. Cluster styles in matching turquoise color sets could now be rendered as large-scale adornment for dances and ceremonial processions—a trait still popular today.

Smiths embellished their pieces with fine round wire coiled into spiral shapes for decoration, augmenting these shapes with tiny round silver raindrops created from commercial bead wire. Raindrops were a common and persistent decorative feature in the 1930s, often encircling stone patterns or framing the central plate on a bracelet. Spherical, button-style earrings took their place with laddered and chandelier dangles. Traditional bracelet forms ranged from

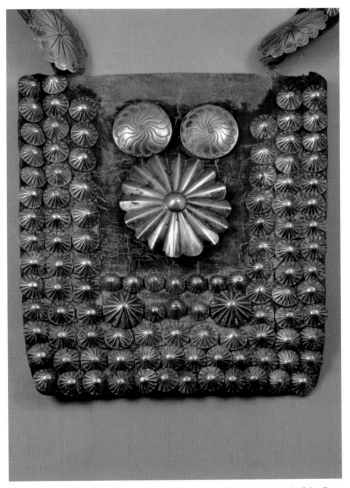

Large bandolier bag, 6 by 8 inches, profusely decorated with silver fluted and pointed half domes with experimental larger pieces on bag and straps, 1930s. Courtesy of Michael Haskell Collection

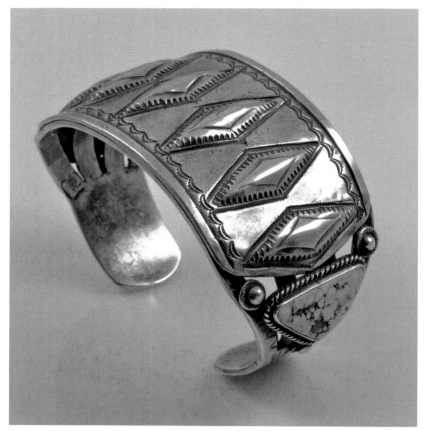

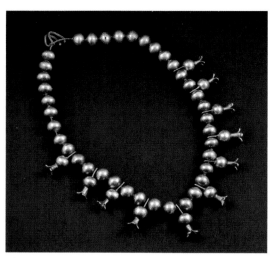

Single strand of silver hollow form beads with five squash–blossom–petal beads on each side and petal bead on bottom center instead of a *naja*, possibly Hopi, 1930s. Courtesy of Suzette Jones

Manta pin, created 1915–20s, incorporated onto 1930s silver cuff. Courtesy of Suzette Jones

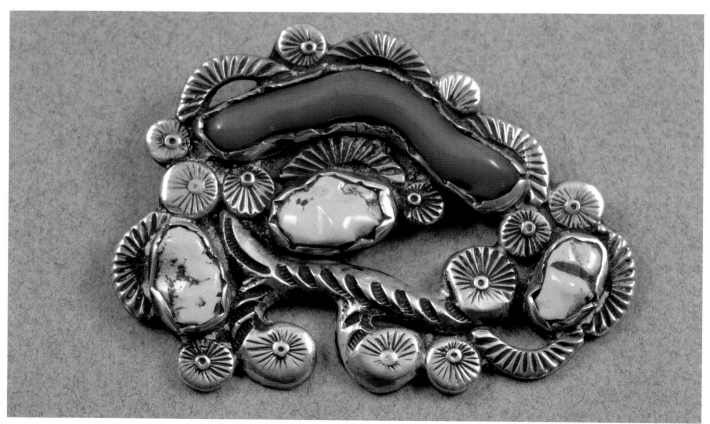

Silver brooch with cast pieces, coral, and turquoise stones, made 1936 or 1938, possibly an early piece by Dan Simplicio. Courtesy of Suzette Jones

Classic Navajo hatband, silver and turquoise, 1930s. Courtesy of Suzette Jones

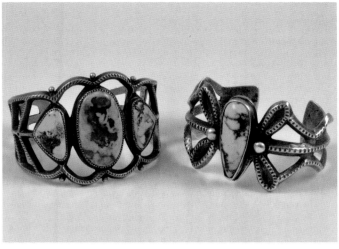

Two Navajo cast bracelets, ca. 1930: (*left*) by Charlie Houck; (*right*) by unknown maker. Courtesy of the Hoolie Collection

the classic row bracelet to more ornate cuffs. Concha plaques grew smaller in size and greater in number, so that the seven or eight conchas normally found on belts before 1900 were now replaced by as many as twelve to twenty plaques, sometimes enhanced with a single small central stone.

Unusual motif embellishments, like the fleur-de-lis and elongated feathers, arrive on the scene at this time, presaging the gradual introduction of more cross-cultural designs. In many cases, such as with the fleur-de-lis, these designs resemble imagery found on Hispanic weaving and Art Deco–styled adornment. Even current events affected designs, as in the case of the late 1930s discontinuation of the swastika or whirling logs motif, which was banned outright in 1940 as disapproval of Nazi Germany grew. Such modifications in styles, materials, and forms reveal clear-cut accommodations to the non-Native market and popular culture.

Squash blossom necklaces were more frequently made with a double row of silver beads. One design change occurred as a result of this massing of beads; smiths created an added rectangular plate ornament called a "boxbow" that was placed on top of the squash blossom beads. These could be made in a variety of styles, with added turquoise. Boxbow variations added a decorative dimension worthy of anything devised by a contemporary non-Native silversmith.

Artful examples of mosaic inlay also took root in this decade. Mosaic borders on whole shell pendants used for dancing became popular. Mosaic inlay in the 1930s was now set onto silver mounts or temporary backings made from aluminum. Zuni led the way in skillful designs. Despite some writers' insistence on Zunis functioning as lapidaries rather than silversmiths, they were equally adept in creating silver frames around their carved stones. Such inlay design motifs depicted birds with outstretched wings, brightly colored dragonflies, and some domestic animals. Channel inlay remained mostly abstract in patterning, developing more fully in the 1940s.

Navajo and Pueblo silversmiths began flexing their creative skills with organic-looking surface decoration representing vegetation and flowering plants. Lightning and rain-related natural phenomena joined the morning star and other cosmological design motifs taking shape in this decade, but they differ from commercial offerings in presenting more elegant and restrained patterns. Silver appliqué on rings and bracelets favored spirals and triangles, and even some nascent leaf shapes developed in the late 1930s. Decorative borders continue to favor stepped lines, chevrons, fretwork, and scallops.

Between 1931 and 1939, motifs grew more prominent on jewelry forms. Although they remained largely abstract, some newly revealed tendencies toward realistic imagery slowly evolved. Forms remain conventionally shaped, but their surface patterning (added stonework, appliqué, stronger stamping) affected sizes and textures. Elaboration and experimentation are obvious on squash blossom necklaces, *najas*, bracelets, and rings. Ornamentation enhanced line and tone on silverwork. The new attention to motifs and related patterning enlarged dominance and emphasized design elements. Better-quality fine finishing made for more sophisticated pieces and heightened overall unity and harmony—justifying 1930s work as classic design.

## John Adair Investigates Silverwork

One of the most consequential activities of the decade was the fieldwork undertaken by a young anthropologist, John Adair. In 1937 and 1938, combined with a study of jewelry in major museum collections, Adair interviewed Native informants with memories going back to the first decades of silverwork creation. His definitive study, *The Navajo and Pueblo Silversmiths*, was published in 1944 by the University of Oklahoma Press and reprinted numerous times since.

Adair's research allowed him to reconstruct direct lines of silver craft transmission after the Navajos returned from the Bosque Redondo. He learned the names of the first silversmiths, their construction techniques and design preferences, and how relationships developed between Native silversmiths and Indian traders. Adair interviewed Navajo informants living in and around Pine Springs, Arizona, and also spent time at Zuni Pueblo. He tracked the spread of silverwork across cultures from Navajo to Pueblo smiths and gathered historically significant documentation about contemporary smiths active in the region.

Adair focused on sorting out the kinds of jewelry forms being made at this time, from plain silver beads to squash blossom and cross necklaces. He identified bracelets, rings, buttons, and pins with relevant illustrations. Adair also carefully detailed the range of tools and equipment being used: homemade blowtorches, bellows, drawplates, and railroad-tie anvils. He supplied specifics about the various steps in casting from a mold. The scope of information he was able to chronicle was invaluable, including his examination of design processes in action.

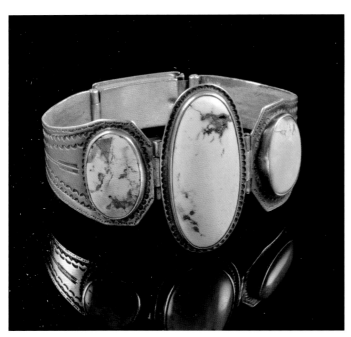

Three-stone silver bracelet with unusual closure clasp, 1930s. Courtesy of the Hoolie Collection

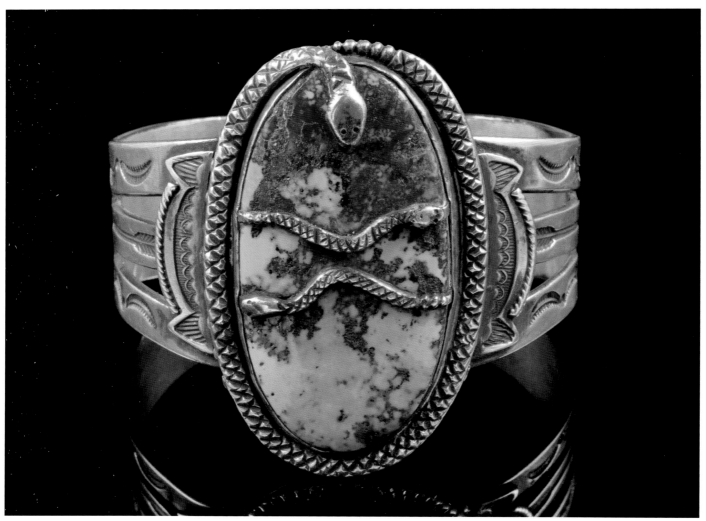

Single stone encircled by silver snakes, with two smaller appliqued across stone, second quarter of 20th century. Courtesy of the Hoolie Collection

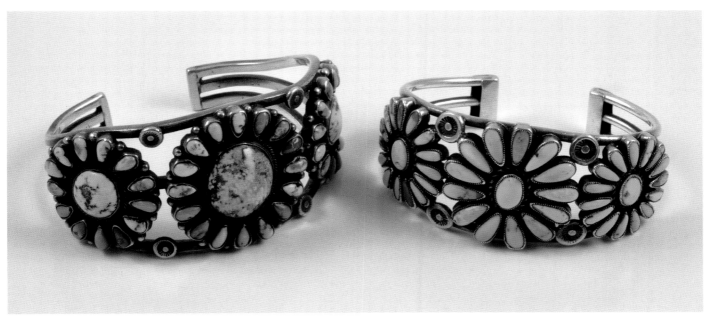

Two Navajo cluster bracelets, 1930s–40s. Courtesy of the Hoolie Collection

The next significant publication was a compilation of pamphlets in 1945 by Harry P. Mera of the Laboratory of Anthropology in Santa Fe. Initial distribution was limited, but the pamphlets would be compiled and published posthumously in 1959. As a museum professional, Mera was deeply disturbed by what he perceived as the bad effects of commercialized Indian jewelry on authentic design.[16] Mera focused primarily on aesthetic qualities, rather than the ethnographic. He had made a collecting trip around the Navajo homeland in 1932 and later subjected each piece he'd gathered to intensive examination and analysis. Collectors treasured Mera's analysis of traditional design features; at the same time, they were disappointed he did not attempt to date most of the items he depicted and discussed.

These studies appeared at a time when the market for older, traditional jewelry was being defined. Adair and Mera helped explain the value and quality of pre-1940s Navajo and Pueblo jewelry. The 1930s unquestionably became a period when more accurate definitions of traditional and classical jewelry design were established. This was important timing because attitudes toward Navajo and Pueblo jewelry creation at the time were changing.

Those who wished to protect the authentic Navajo and Pueblo jewelry design process felt they also needed to change its identity. For the first time, a truly concerted attempt was sponsored by the IACB to create official hallmarks on silver. This was a recognition, at last, that individual smiths and jewelers should possess name recognition. These champions chose the term *craft*, citing the prevalence of multigenerational silversmiths and lapidaries and the formation of craft guilds for tribal designs and hallmarks. This choice was intended to be positive but it wasn't wholly accurate. Nevertheless, this newest label would serve usefully enough over the next three or four decades and in literature on the subject.

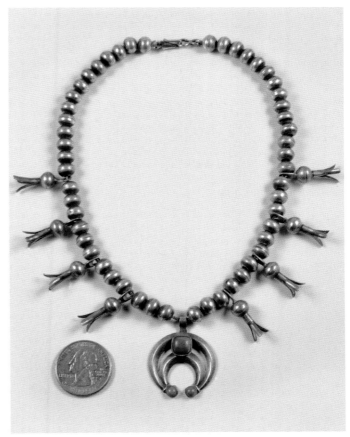

Squash blossom necklace by James Chee, 13½ inches, scaled to child's size, 1930s. Courtesy of the Hoolie Collection

Two pairs of earrings: (*left*) taken from a Fred Harvey tourist belt; (*right*) popular style Navajo work, 1930s–40s. Courtesy of the Hoolie Collection

Two pairs of Zuni earrings with Knifewing design: (*top*) inlay on silver by Frank Vacit, 1930s; (*bottom*) inlay on jet by Robert Leekity, ca. 1940. Courtesy of the Hoolie Collection

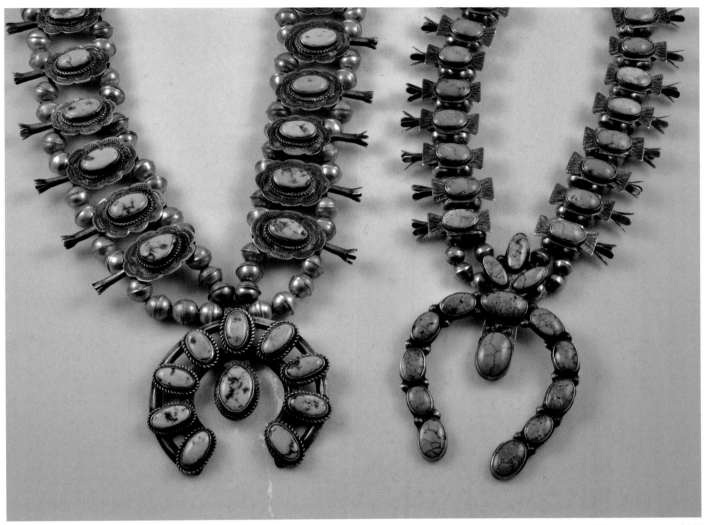

Two squash blossom necklaces: (*left*) with Morenci turquoise, 1930s; (*right*) with Fox turquoise and longer *naja*, 1940s. Courtesy of Bill and Minnie Malone

Group of six sew-ons with green turquoise centers, mid–1930s. Courtesy of Bill and Minnie Malone

Handsome and unusual collar stays with natural turquoise, 1930s. Courtesy of Bill and Minnie Malone

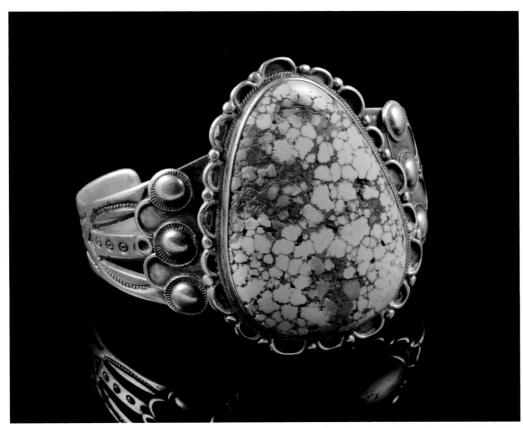

Large #8 turquoise stone on silver cuff with cold chiseling for detail work on shank, 1930s–40s. Courtesy of Bill and Minnie Malone

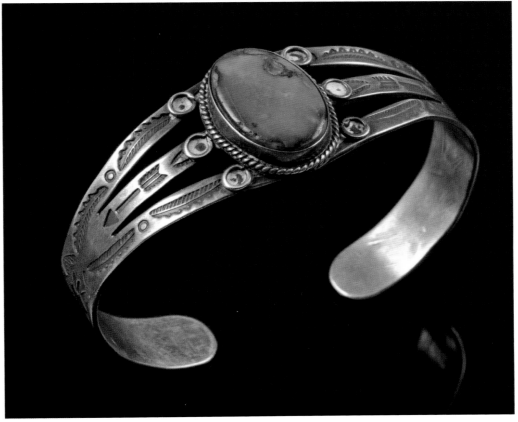

Bracelet with single Blue Gem turquoise stone, gentle stamping, twisted wire around bezel plate, and six decorative wire circles, 1930s. Courtesy of Bill and Minnie Malone

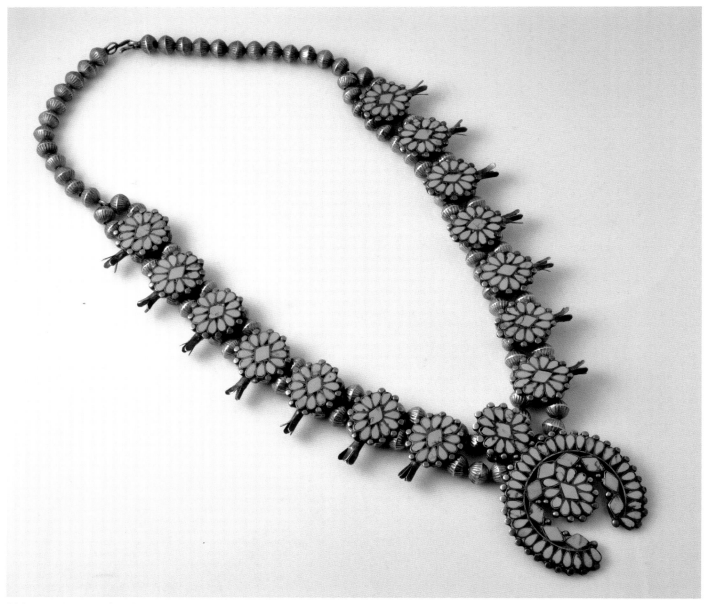

Dishta-style turquoise cluster squash blossom necklace, hand-cut stone, 1930s–40s, worn by Harvey Detour guide Lucille Martinez. Courtesy of Andrew Muñana Collection

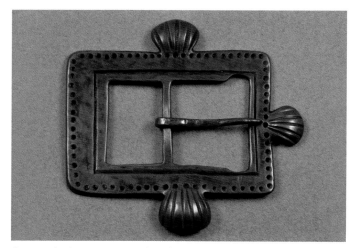

Copper belt buckle, possibly from Laguna, pre-1940. Courtesy of Andrew Muñana Collection

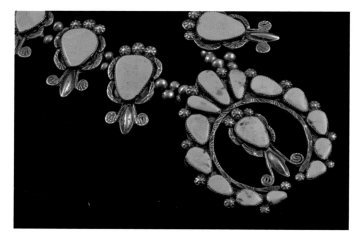

Elaborate squash blossom necklace with light-green hand-cut turquoise, carved silver surfaces, 1930s. Courtesy of Andrew Muñana Collection

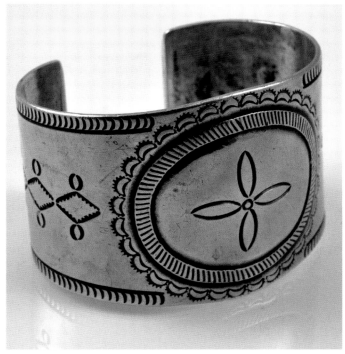

Classic wide silver cuff design, 1930s, which will inspire future Navajo Guild silversmithing. Private collection

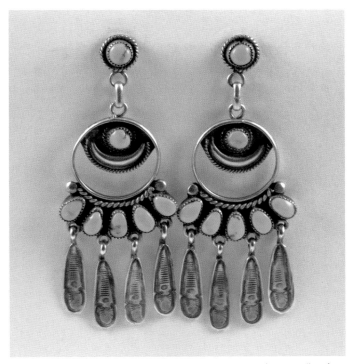

Zuni "chandelier" dangles with turquoise, 1930s. Private collection

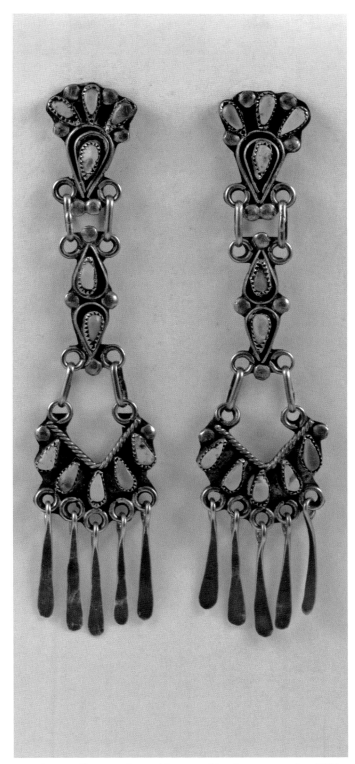

Navajo "satellite" earrings with green Blue Gem turquoise, 1930s. Private collection

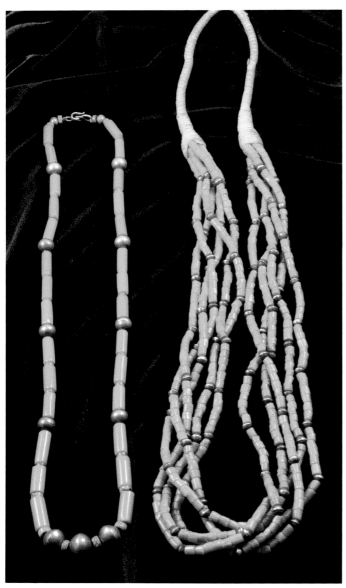

Two coral and silver bead necklaces in styles popular with both Navajo and Pueblo wearers, 1930s. Courtesy of Paul and Valerie Piazza

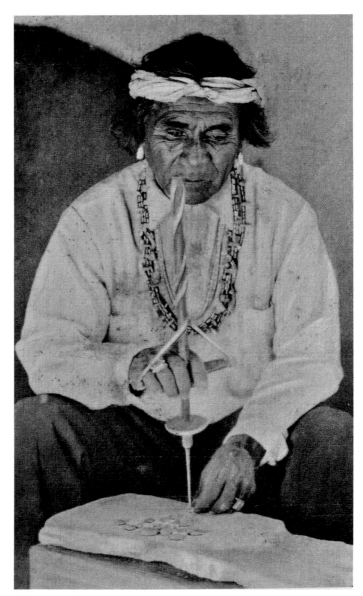

Postcard of Pueblo Indian turquoise driller, second quarter of 20th century. Private collection

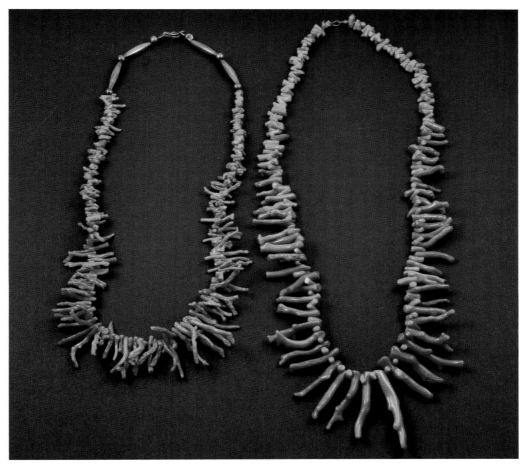

Two branch–coral necklaces, 1930s–40s. Courtesy of Paul and Valerie Piazza

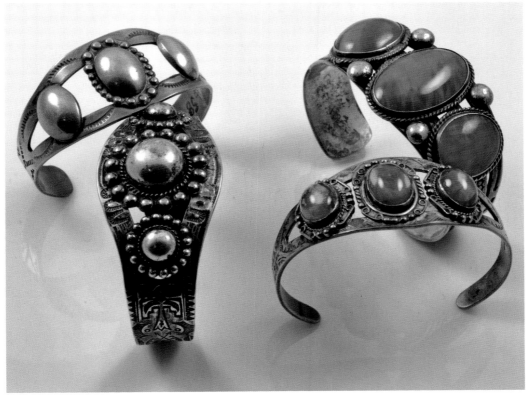

A group of four 1930s-style curio store bracelets; (*bottom right*) Dragon's Breath red glass cabochons. Courtesy of Paul and Valerie Piazza

# Santo Domingo Jewelry

## (pages 216–219)

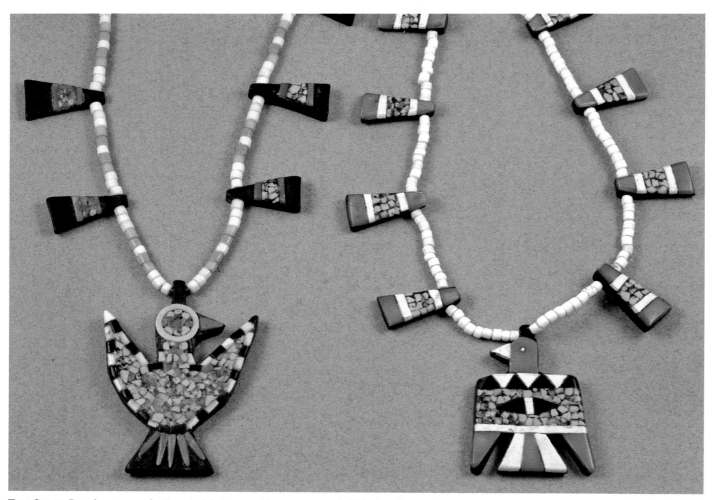

Two Santo Domingo mosaic thunderbirds on cotton wrap, each 14 inches long, 1930s. Courtesy of Bill and Minnie Malone

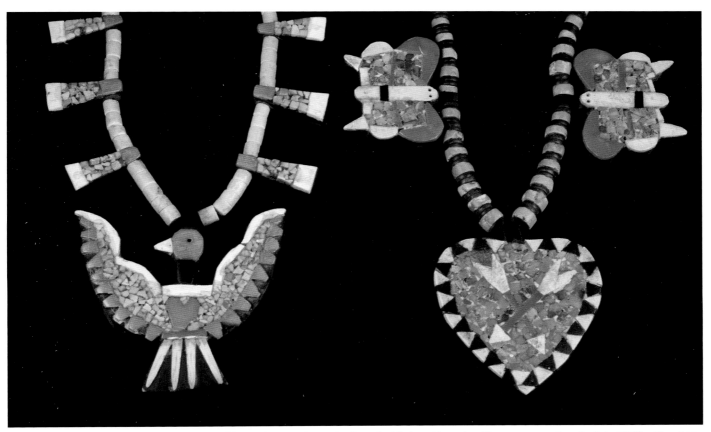

Two Santo Domingo Depression–era necklaces in mosaic–style, thunderbird and heart, with repurposed materials, 1930s. Courtesy of the Hoolie Collection

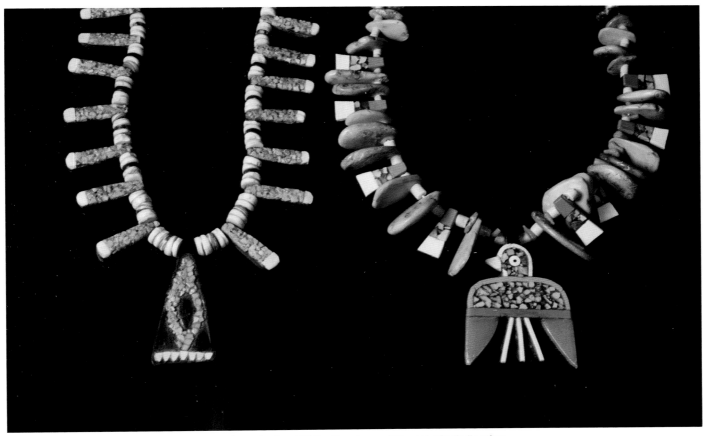

Two Santo Domingo necklaces with mosaic and tabs, 1930s. Courtesy of the Hoolie Collection

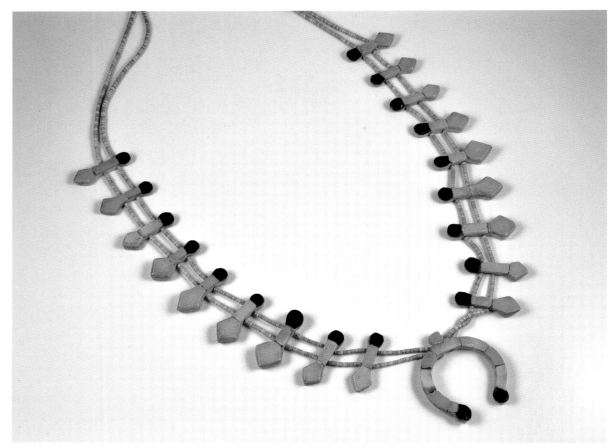

Santo Domingo shell bead necklace with mosaic *naja* and matching tabs, 1930s. Courtesy of the Hoolie Collection

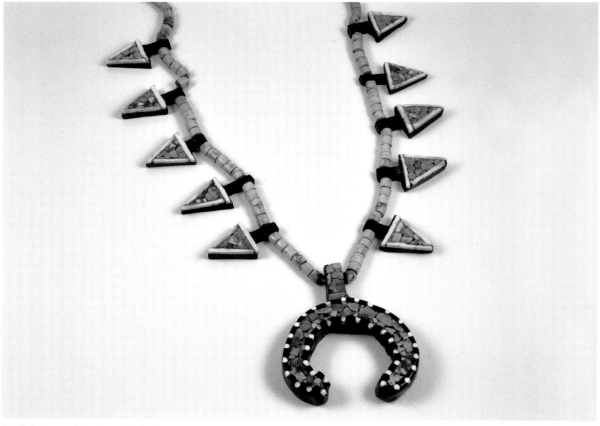

Stylish Santo Domingo *heishi*, mosaic *naja* and triangular tabs, 1930s. Courtesy of the Hoolie Collection

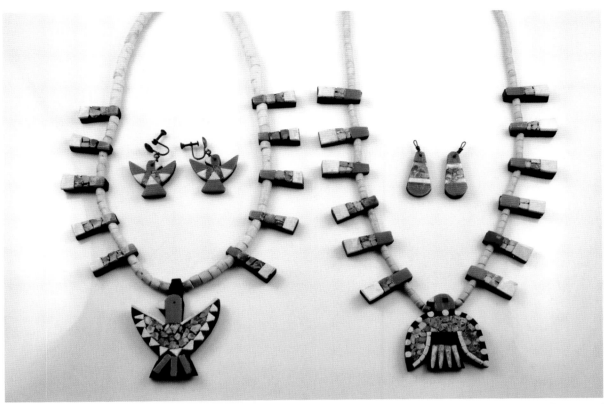

Two popular Santo Domingo Depression–era necklace styles with matching earrings, 1930s. Courtesy of Paul and Valerie Piazza

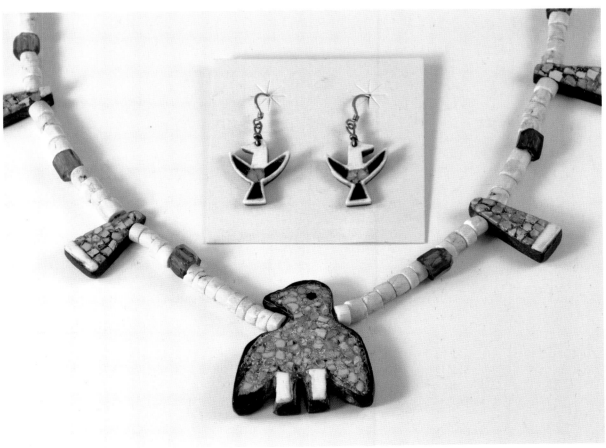

Santo Domingo shell necklace with added traded beads and similarly styled earrings, 1930s. Courtesy of Territorial Indian Arts

Copper tray with boxes, ashtrays, and bracelet with matching design purchased in 1939 while a tourist couple were on honeymoon. Courtesy of Paul and Valerie Piazza

Pierce Kewanwytewa selling jewelry at the Museum of Northern Arizona, Flagstaff in 1936. Courtesy of MNA Photo Archives, C–100 (1936).2

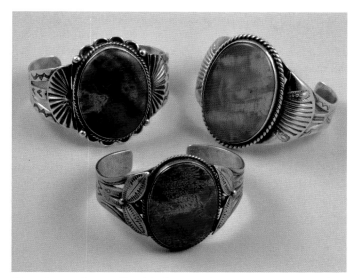

Three large silver cuffs with dinosaur bone and good stamping, 1930s. Courtesy of Elizabeth Simpson

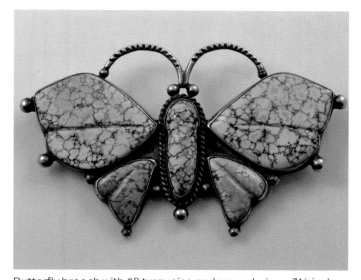

Butterfly brooch with #8 turquoise and carved wings, 3½ inches, 1930s. Courtesy of Karen Sires

Three pairs of tourist earrings similar to designs in Maisel's catalog, Navajo or Pueblo, 1930s. Courtesy of Karen Sires

Zuni laddered turquoise earrings made in multiple parts, 1930s. Courtesy of Karen Sires

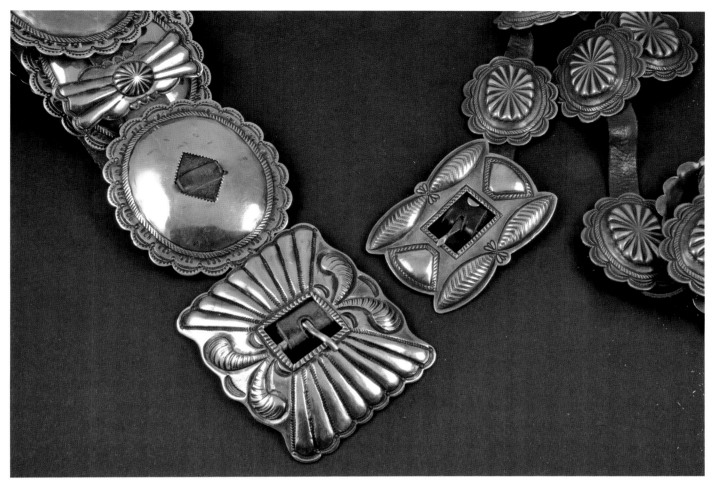

Two 1930s concha belts: (*left*) old–style; (*right*) tourist style. Courtesy of the White Collection

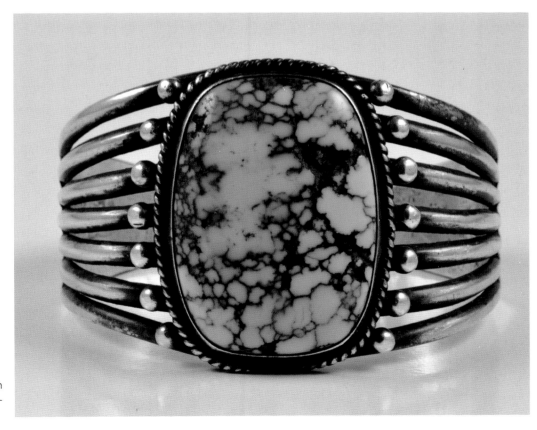

Large silver cuff with Burnham turquoise stone, flanked by rain-drops. Courtesy of Karen Sires

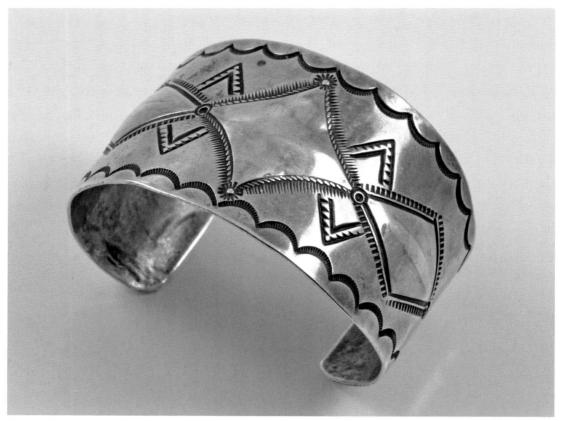

Silver wide tourist cuff made at the Garden of the Gods, Colorado, ca. 1930s. Courtesy of Karen Sires

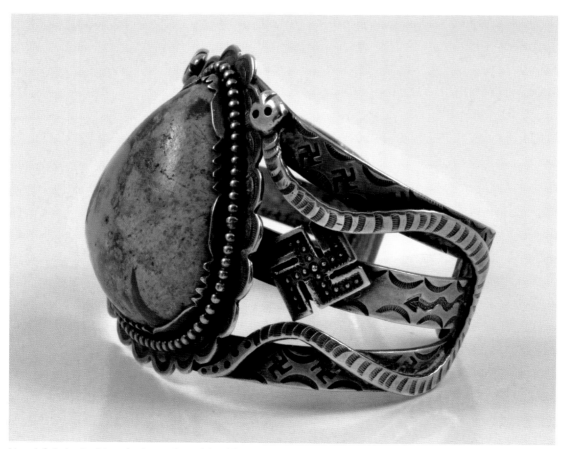

Hand-fabricated tourist bracelet with whirling logs and snake design motifs, 1930s. Courtesy of the Hoolie Collection

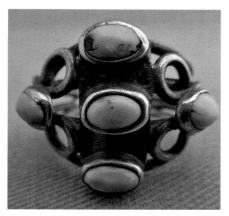

Pueblo silver and turquoise ring, 1930s. Photograph courtesy of Karen Sires

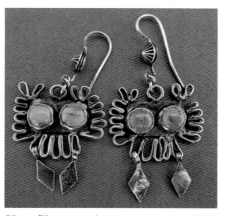

Silver filigree and green stone earrings, 1930. Photograph courtesy of Karen Sires

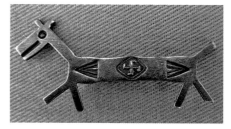

Commercial silver tourist dog pin, 1930s. Photograph courtesy of Karen Sires

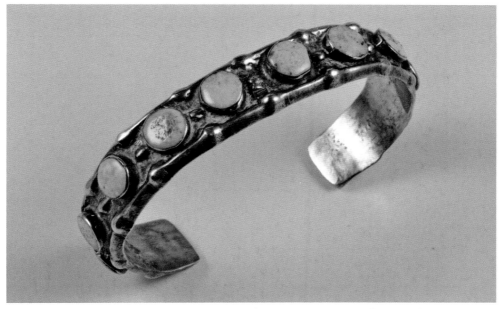

Zuni turquoise and silver bracelet by Juan Dedios, 1930s. Courtesy of Karen Sires

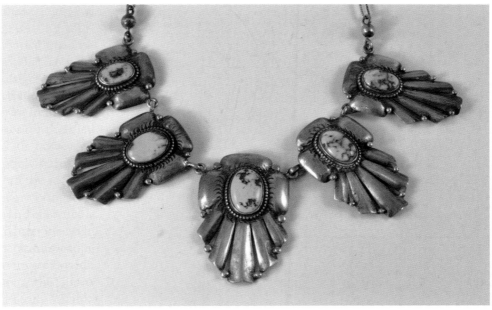

"Pueblo Deco" silver and turquoise necklace, 1930s–40s. Courtesy of Territorial Indian Arts

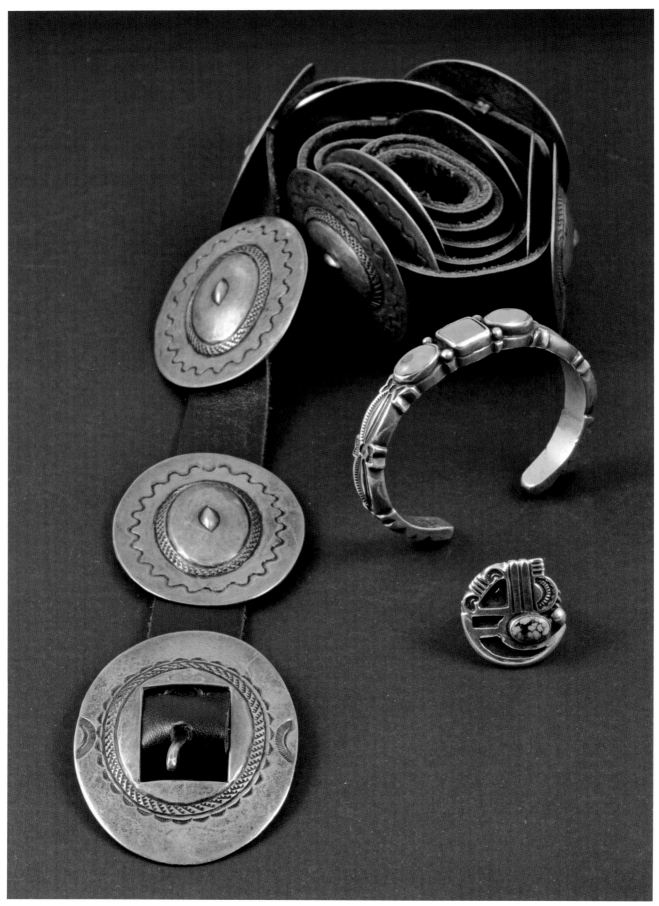

Jewelry by Hopi master smith Morris Robinson: early ring, concha belt, and bracelet, 1930s–1945. Courtesy of the White Collection

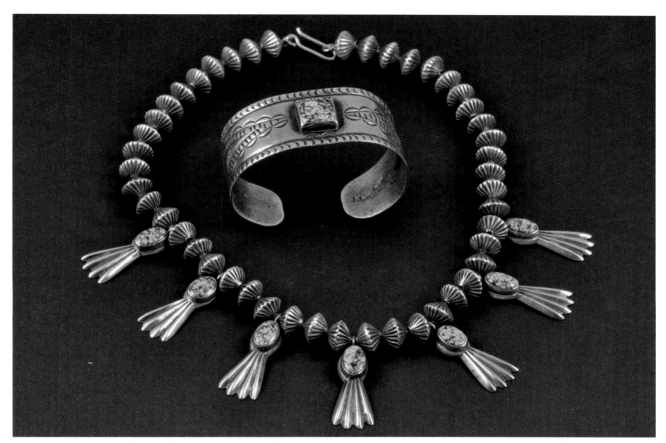

Another variation on "Pueblo Deco": a necklace with fluted beads and turquoise silver pendants, and a lightweight bracelet with matching turquoise, 1930s. Courtesy of the White Collection

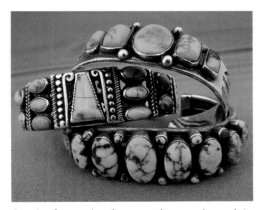

Stack of two classic turquoise row bracelets with a multistone designed cuff in the middle, 1930s. Photograph courtesy of Karen Sires

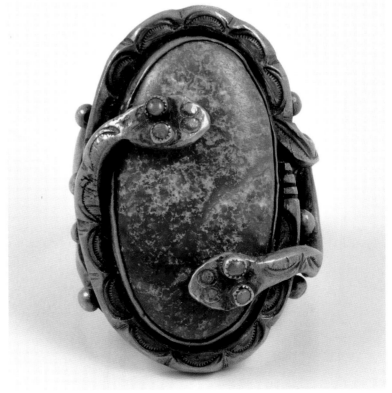

Natural turquoise ring with snake motif, a popular style for Zuni men in the 1930s–40s. Author's collection

227

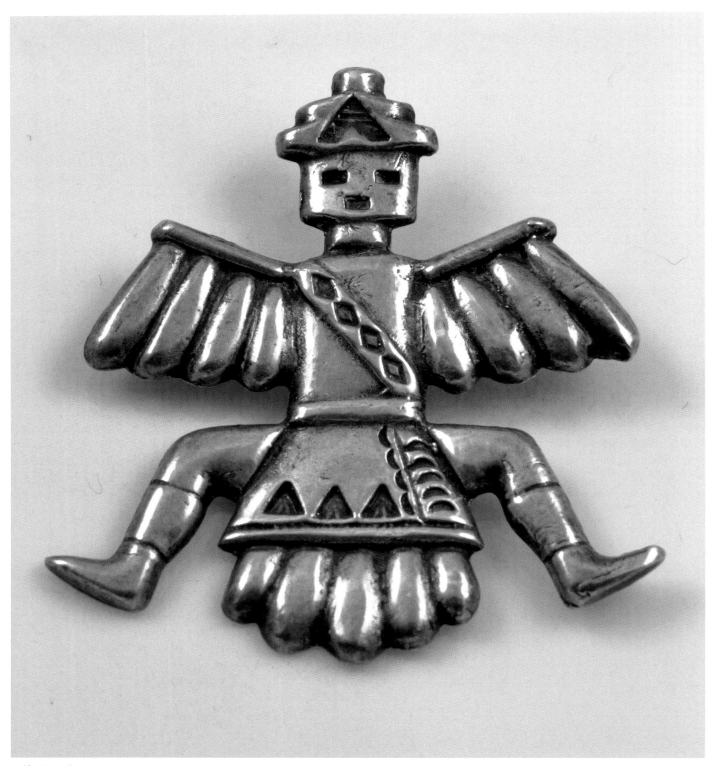

Knifewing pin pendant by Horace Iule, a design made popular by him (and much imitated), 1930s–40s. Courtesy of Paul and Valerie Piazza

# Key Design Developments in the 1930s

## FORMS

- By 1930, Navajo and Pueblo jewelry forms' design characteristics were now fifty years old and considered traditional and classic
- Choker necklaces, possibly a cross-cultural effect, appear as a new metalwork form
- Row bracelets are now well shaped
- Dress ornaments, V-shape collar ornaments, multiple pins are soldered together
- Squash blossom necklaces acquire a "boxbow" ornament intended to lie above the beads

## MATERIALS

- Ingot silver begins to phase out
- One-ounce-square sterling slugs from Los Angeles refineries replace most coin silver
- Coral grows scarce, and branch coral is used as a substitute
- Santo Domingo jewelry makers use repurposed found materials, including plastic
- More mines open; Blue Gem begins working in 1934. More turquoise colors are now available

## TECHNIQUES

- Stamping, boosted by commercial usage, grows more sophisticated
- Jewelry pieces achieve finer finishing
- *Heishi* jewelry is made with variable-sized beads and chunk nuggets
- Zuni stone and shell carving reaches a high point
- Pueblo clusterwork, as well as channel and mosaic inlay designs, grows steadily (Clusterwork is also made by Navajos)

## MOTIFS

- Figural (animal, human) design motifs are created
- Clean, less ornamented silver surfaces develop

## ELEMENTS

- Balance; color; contrast; emphasis; form; hierarchy of arrangement; line; proportion; repetition; unity; harmony

## NOTABLE MAKERS

- More individuals than ever before receive attention in newspapers, tourist sites, and scholarly mention; see Appendix C

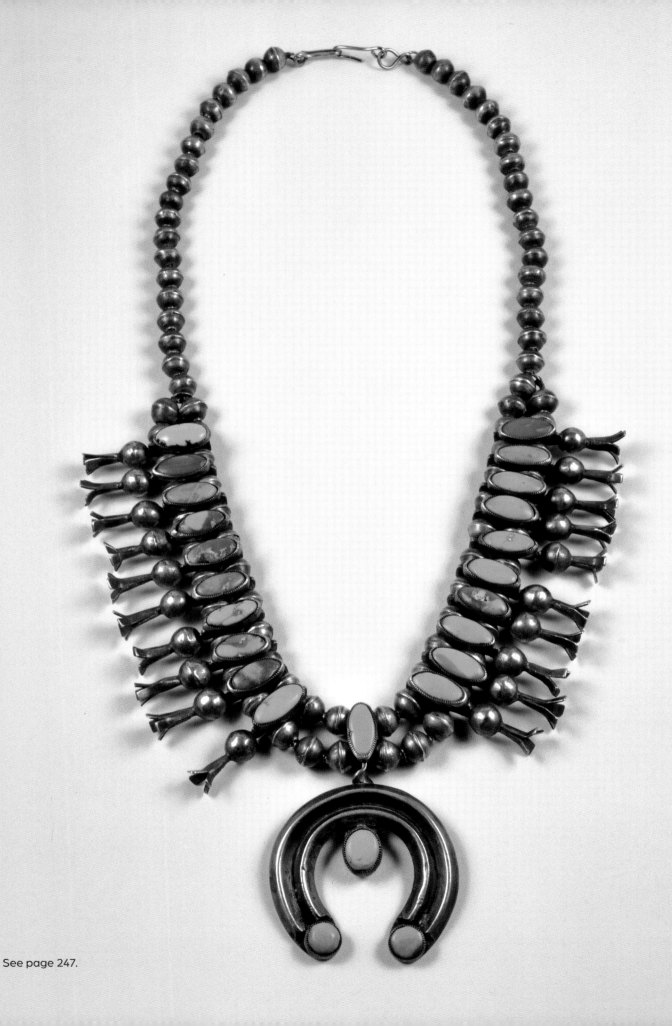

See page 247.

# 1940 to War's End: Patriotic Craft—or Art?

The year 1940 marked seventy years of established Navajo and Pueblo metalwork jewelry production. While the United States warily watched events in Europe—with isolationist voices prevailing for the moment—war and social change were coming, finally bringing the Depression years to an end. The first five years of this dramatic decade were also when the new craft identity first became applied to Southwestern Indian jewelry.

On the surface, however, little seemed to have changed. Patrons of Navajo and Pueblo arts still agitated for governmental protections. Reporting on the pieces exhibited at the annual Gallup Inter–Tribal Ceremonial, an article in the August 17, 1940, *Gallup Independent* stated that "individual Indians showed greater interest in this feature of the Ceremonial than heretofore, but many of their exhibits were entered under the displays of various traders." This remark shows Indian traders still reaping public acclaim instead of the Native makers. Throughout their activities as smiths, school instructors, and demonstrators of fine design, Indigenous artists still largely remained unrecognized as individuals.

# TIMELINE

**1940**   John Adair reports there are 600 active Navajo smiths; 190 of them are women

**1940**   Adair also reports 134 smiths at Zuni; 26 are women

**1940**   Bell Trading begins mechanizing its operations

**1940s**   Charles and Otellie Loloma meet Philip Morton, early advocate of wearable art movement, in New York while enrolled in School for American Craftsmen

**1941**   United States declares war on Japan and Germany after bombing of Pearl Harbor

**1941**   Indian men register for US military draft; Navajo and Hopi men serve as Code Talkers in the Pacific theater: their role is kept secret from public until declassified in 1968

**1941**   Navajo Arts and Crafts Guild is established; Ambrose Roanhorse is first director

**1941**   Museum of Modern Art, New York City, produces exhibition and catalog Indian Arts of the United States; Navajo silversmith Dooley Shorty is featured during exhibition

**1941**   Fred Peshlakai establishes a shop on Olvera Street, Los Angeles, California

**1941**   John Adair estimates 35% of Zuni jewelers make inlay

**1942**   First Navajo Craftsman Show opens at Museum of Northern Arizona

**1943**   IACB stamp program ends, largely because it was difficult to enforce

**1944**   Adair's book *The Navajo and Pueblo Silversmiths* is published by the University of Oklahoma Press

**1945**   Harry P. Mera publishes pamphlets on the Laboratory of Anthropology's collection of *Indian Silverwork of the Southwest*, illustrated with black-and-white photographs

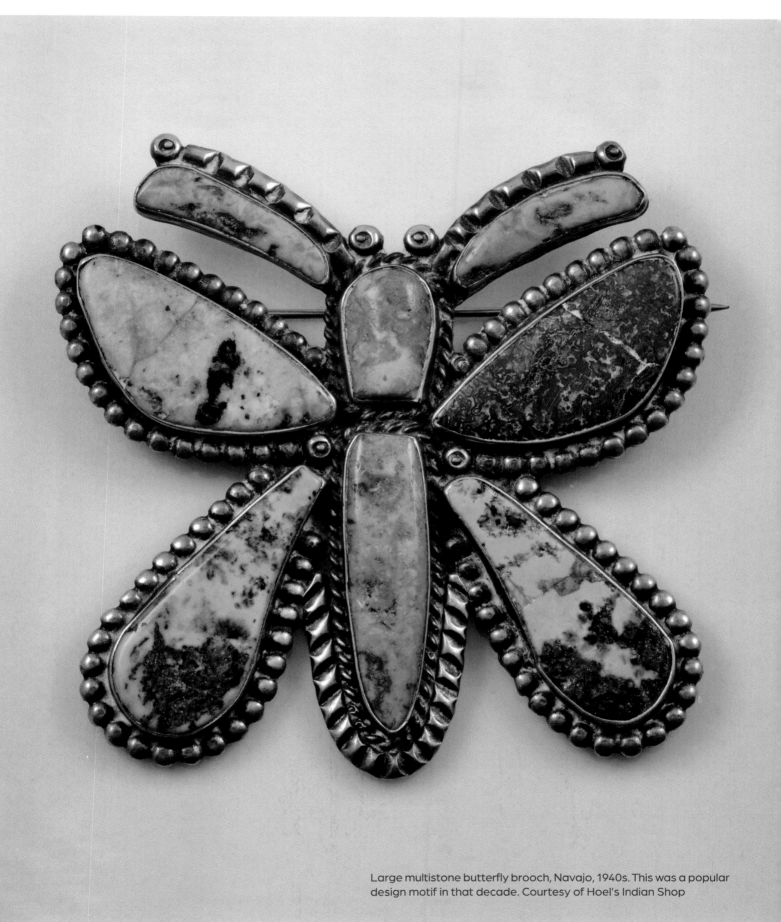

Large multistone butterfly brooch, Navajo, 1940s. This was a popular design motif in that decade. Courtesy of Hoel's Indian Shop

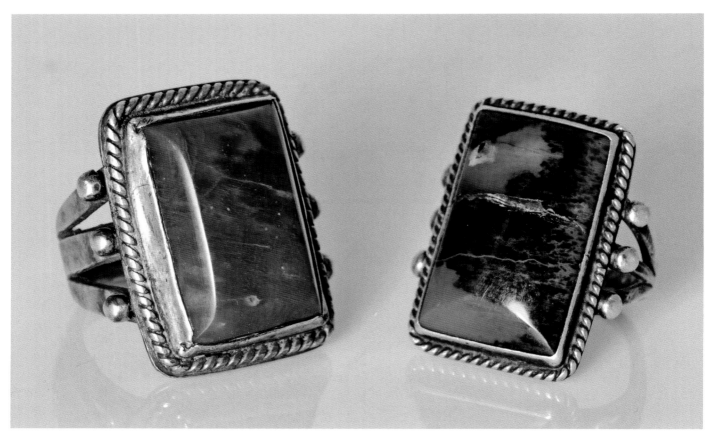

Two rings, petrified wood and agate, 1940s. Courtesy of Eason Eige Collection

The Indian Arts and Crafts Board (IACB) sought better cooperative marketing and related activities to position Indian arts for economic expansion and increased attention. The board chose as its model the European and English arts and crafts movements, where decorative arts workers (including metalworkers) were organized into guilds. The American version emphasized the importance of fine crafts made by hand. The concept of craft guilds seemed tailor-made for the Southwest's Indians. With authentic hand-wrought Native arts under siege from inferior mass-produced goods, advocates felt that Native artists badly needed distinguishing features such as hallmarks and professional vetting.

In 1941, the IACB endorsed the start-up of a Navajo Arts and Crafts Guild (later, Enterprise), and the noted silversmith and educator Ambrose Roanhorse was appointed its first director. He had previously served as head of the short-lived Wingate Guild (1939–40), established to employ skilled Indian school graduates.[1] Similar initiatives were eyed for Zuni, while the Hopi were beginning to organize a guild of their own. To many non-Native promoters, this step toward a craft identity felt like a potentially successful role for Indian smiths and beadmakers if it stimulated a trend toward tribal styles.

That same year, the IACB and a group of influential non-Native arts authorities came together to create a groundbreaking exhibition at the Museum of Modern Art (MoMA) in New York City, which ran from January 22 to April 27, 1941. *Indian Art of the United States* brought new awareness of Southwestern Indian jewelry at a time when all forms of Americana were being boosted, especially since Europe was closed to the usual tourist and scholarly excursions. The IACB zealously exploited New York's status as an influential center for art and fashion trends. The organization arranged to have Indian jewelry sold in the city's major department stores, advertised in regional newspapers, and mentioned in such publications as *Women's Wear Daily* as part of a strategically targeted publicity and retail sales campaign.

Two Navajo smiths, Dooley Shorty and Tom Katenay, were brought in to demonstrate silversmithing during the exhibition.[2] Their appearance was a carefully calculated part of the new patriotic reappraisal of American art forms. *Indian Art of the United States* exposed viewers to a distinctive range of silverwork. Many of the pieces on display illustrated established jewelry forms and styles, including a squash blossom necklace with twelve trefoil beads and a double-barred *naja* pendant, a sandcast bracelet and pin, a concha belt, a *ketoh*, and a twisted-wire bracelet with square-cut turquoise. Zuni inlay pins featuring the Knifewing and Rainbow deities and a mask of the Shalako figure *Saiyatasha* were also featured in the exhibition catalog.

The show's two organizers were influential scholars in their own right; both were more interested in presenting an aesthetic approach to Indian arts instead of the standard

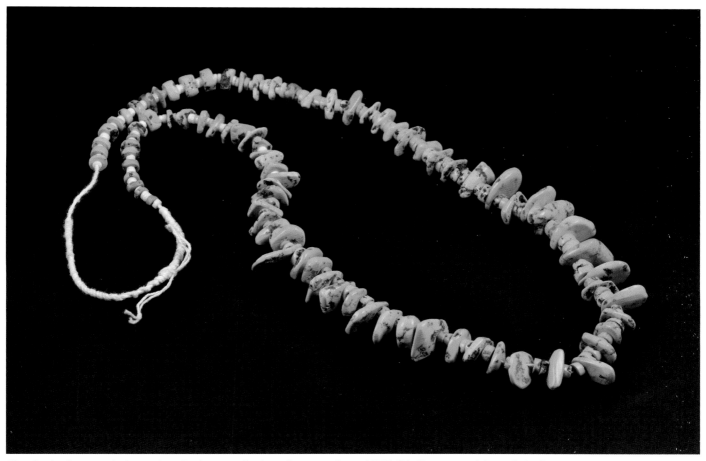

Classic single strand of round and tab turquoise beads on cordage, 1935–50. Courtesy of Joan Caballero

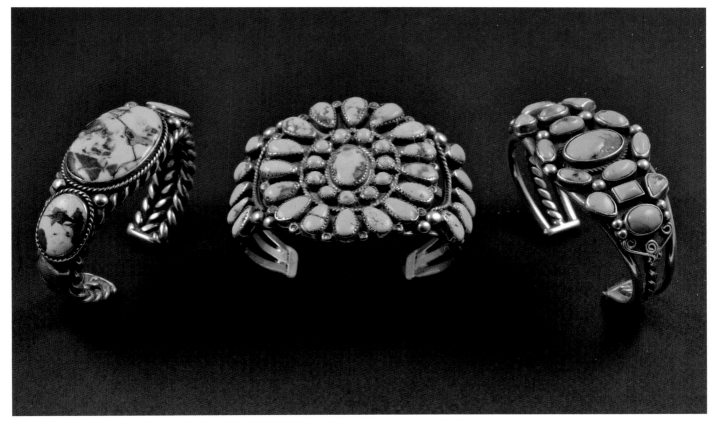

Three fine turquoise bracelets in admired midcentury styles. Courtesy of Joan Caballero

ethnographic evaluation of Native-made objects. Frederic Huntington Douglas (1897–1956) and René d'Harnoncourt (1900–1968) had assembled a display of Native American arts and crafts for the 1939 Golden Gate International Exposition in San Francisco. Douglas was a curator at the Denver Art Museum, and d'Harnoncourt worked at this time for the IACB. Their collaboration was so successful that they were drafted to arrange a larger exhibition at MoMA. One of the comments they made in the catalog about the artistic relevance of Navajo jewelry was remarkably farsighted: "The most striking evidence of the affinity between traditional Indian art and modern art forms can be seen in Navaho [*sic*] silver."[3]

Popular culture, however, was not yet ready to consider Navajo and Pueblo jewelry true art forms. Nevertheless, the exhibition's public reception was significant and positive. Ambrose Roanhorse attended the opening, where he spoke with Eleanor Roosevelt about contemporary silverwork instruction at the Indian schools. The first lady was clearly impressed with what she heard, and her approval of Indian-school training made its way into her "My Day" newspaper column on January 27, 1941. Production increased as a result of this interest, and Sophie Aberle, the superintendent of the United Pueblos Agency, reported in the March 7, 1941, *Phoenix Gazette* that "the Navajos are now having difficulty supplying the demand for silver designs."

The Japanese attack on the Pearl Harbor naval base on December 7, 1941, abruptly brought the country into World War II. Many Navajo and Pueblo men enlisted and served in the armed forces during the conflict; more than 200 enlisted from Zuni Pueblo alone. The US military had deployed Native Americans in World War I, and now they created a special corps of Navajo and Hopi Marines in the Pacific theater. These men (one of whom was Dooley Shorty, along with a number of other silversmiths) were part of a classified communications operation and were known as Code Talkers.

Not everyone who enlisted did so for purely patriotic reasons. As one Code Talker, Wilson Keedah Sr., put it: "I went to war because there were no jobs on the reservation."[4] The Code Talkers' work was dangerous; they used a form of encrypted messages, derived from their own language, that the Japanese were never able to decipher. Keedah and his comrades saw action in key battles at Guadalcanal, Iwo Jima, and Okinawa. Praise and acknowledgment of their contributions arrived much later—their mission would not be declassified until 1968.

The disruptions of war naturally affected the jewelry-making efforts of those not in the armed forces. During the war years, the US War Production Board sought to cut silver supply for nonmilitary use. Indian arts advocates, such as traders, museum professionals (including the Coltons), and the ever-vigilant IACB, argued that Native smiths needed continuing access to silver for pressing economic reasons. Even with this support, silver became difficult to obtain by late 1942, and it remained scarce until the war's end.

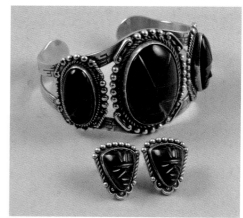

Midcentury Mexican masks carved from onyx, set by a Navajo smith into silver bracelet and earring forms. Courtesy of Elizabeth Simpson

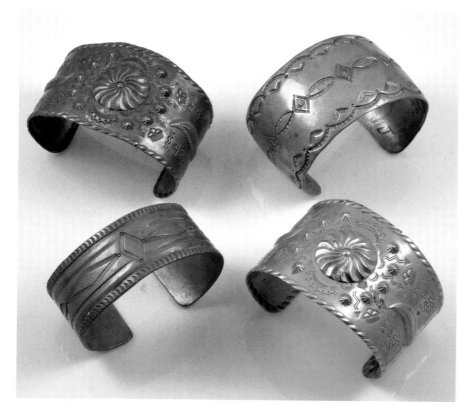

Four wartime lightweight brass, copper, and silver cuffs with lacquer finish for shiny effect. Courtesy of Paul and Valerie Piazza

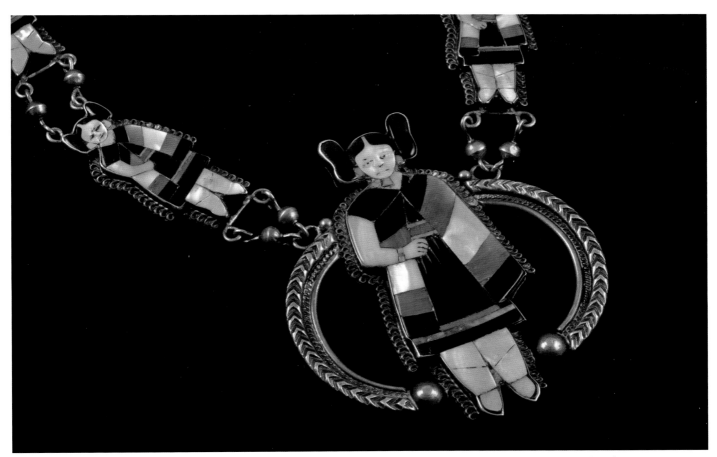

Hopi Maiden design motif necklace by Zuni inlay master Leo Poblano, 1940s. Courtesy of Andrew Muñana Collection

Despite the shortages during the war years, Native jewelers and smiths—many more of them now women—continued to exploit changes in materials and techniques to their advantage. In a 1943 article titled "Navajo Silversmithing Survives," David Neumann noted the Indian jewelry maker's "willingness to adapt his skill to the continually changing requirements of the market and to his changing way of life."[5] Neumann expressed concern about the lack of silver for smiths, speculating that they might be forced to return to using coin silver. Early forms of synthetics, however, soon became available and made their way into jewelry creation.

Jewelry pieces made of copper (among other materials) had been contributed for recycling as part of the war's need for metal. Yet there was still enough copper, regularly used for tourist goods despite an understandable slump in tourism, to be worked by smiths for hand-wrought creations. These items might also be practical, such as ashtrays and boxes.

John Adair's significant research was revealed to the world in 1944 with the publication of *The Navajo and Pueblo Silversmiths*. His work illuminated just how exceptional their Native silverwork had become over the past seventy years. His findings were deeply influential and celebrated American Indian perseverance and achievement. The only quibble with this seminal study was Adair's underappreciation

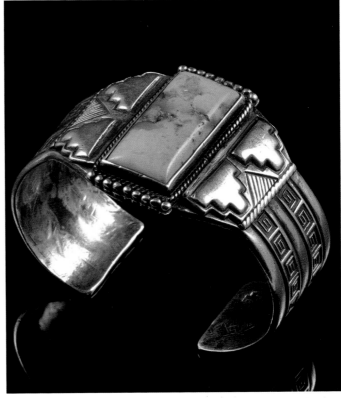

Older-style single-stone bracelet with stamping and appliqué by Paul Saufkie, 1940s. Courtesy of Peter Szego

of Pueblo smiths, found in his statement that only nineteenth-century Pueblo smiths did fine "silver of aesthetic importance" and were either dead or too old to work silver between 1900 and 1940.[6]

Despite the overshadowing effects of World War II, the first half of the 1940s bore witness to a dividing line between older-style jewelry and a growing modernized approach. A hint of the new look can be found in silver bracelets and brooches made under the short-lived IACB official hallmarks program. Many of these silver pieces display strong, clean lines and less ornament. This aesthetic would be manifested later, in the postwar development of the Hopi Silverwork Project, into an active guild and its invention of a tribal overlay style. One of the most important things to come out of the Hopi Guild was a new impetus for creating hallmarks, which spread to all Native jewelers. A few individuals had made hallmarks in the late 1920s into the 1930s, but a significant post–World War II development is how hallmarks finally become a consistent feature used by many jewelry makers.

Even as the marketplace motivated changes in jewelry forms, materials, and design motifs, many Indian arts experts and collectors continued to mourn any departures from traditional practices. Throughout the 1940s, three Santa Fe institutions—the Santa Fe Indian School, The Indian Arts Fund, and the Laboratory of Anthropology—continued programs that urged Native smiths to retain older types of design in their work. This conservative approach was eroded by the rise of named individual artists in the postwar decades.

Writers in local magazines hailed earlier jewelry styles as being most authentic. An article in the December 1941 issue of *Arizona Highways* strongly condemned the effects of tourism on Navajo silverwork.[7] The article noted collectors' preferences for irregularly cut and polished hand-wrought pieces, and the writer admonished buyers to choose only older turquoise stones of a light cerulean blue. Pieces made in the first five years of the 1940s tended to echo contemporaneous tastes for large round beads and bracelet band cuffs having diameters of 1 to 3½ inches. A 1944 Arizona Highways article advised consumers to seek out "marked silver" made from good-quality silver slugs.

The bias in favor of older work helped label pre-1940 jewelry design as "classic," now formally extending this definition by a decade. Such a categorization was part of a nostalgia movement that became evident throughout the 1940s. Phrases like "classic forms" and "classical adornment" were meant to be authoritative tributes to hand-wrought jewelry as a whole. In fact, such labeling was a defensive acknowledgment of coming change. With contemporaneous Navajo and Pueblo jewelry making now designated as craftwork, it became more important than ever to distinguish the superiority of traditional jewelry design over dubious innovations.

Individuals such as Ambrose Roanhorse, Fred Peshlakai, and Mark Chee, among others, could now be praised for their "elegant style" and "classic creations." Adherence to older design standards was the greatest accolade that could be conferred on a silversmith or beadwork jeweler, even

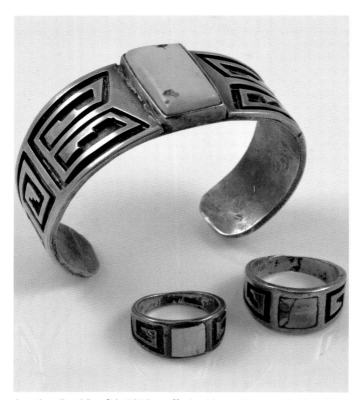

Another Paul Saufkie 1940s cuff, plus his and hers matching rings with early inlay. Courtesy of Laura Anderson

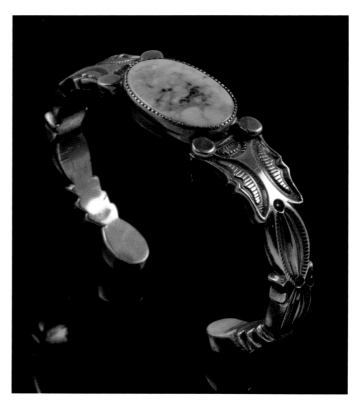

A sophisticated narrow band by Morris Robinson, with turquoise stones on the center and terminals, 1940s. Courtesy of Laura Anderson

though Southwestern Indian silver jewelry making was less than 100 years old and, therefore, not truly "antique." Thanks to years of exceptional work and a persistent groundswell of admirers, Navajo and Pueblo jewelry design firmly and formally acquired classical and traditional status by 1945.

On August 6, 1945, humanity changed forever. Technology had finally produced the ultimate weapon of mass destruction. On that day, an American B-29 bomber deployed for the first time an atomic bomb, dropping it on the city of Hiroshima, Japan. Eighty thousand people died and thousands more perished afterward from radiation poisoning. That this most potent of weapons had been developed and tested in the American Southwest, homeland of the Navajo and Pueblo Indians, was an irony lost on few of the peoples living there. Hopi religious leaders, meeting years afterward, would publicly point to their third prophecy that claimed "a gourd of ashes might one day be thrown from the sky, which could burn the land and boil the oceans."[8]

As Navajo and Pueblo men returned from military service and held sings and other ceremonies to wash away the stain of death and evil, they recognized that their world had also changed forever. While they held their rituals of purification as tradition required, these war veterans understood that their horizons had broadened irrevocably beyond the confines of their homeland. Had they not learned since they left the Bosque Redondo or accepted gifts from President Lincoln for cooperation that their livelihoods depended on managing change brought from the outside? Their cultures were traditional and conservative. Once again, they turned to survivance as a means of retaining the best elements of their original way of life, values, and philosophies.

Non-Natives had historically been slow to give Indigenous peoples the full civil rights they deserved. Native men returning from war were largely unsung heroes. Despite being acknowledged as US citizens, they stepped back into a society in which they still did not fully possess the right to vote in elections that had supposedly been granted to them in 1924.[9] American Indians owned multiple conflicting identities throughout US history, ranging from savages to tourist attractions. In 1945, their rights to citizenship and economic opportunities still could not be taken for granted.

One creative note occurred during 1945–46: Native smiths fashioned a wide assortment of V-shaped "Victory Pins" to show support for the war effort and celebrate the war's end. These items are truly remarkable in their choice of decorative effects. Eagles abound, styles are varied, and these novelty items are both playful and proud. They mark the successful cross-cultural meeting of the abstract and representational, foreshadowing the design motif changes of the next seventy-five years. The pins also indicate the overall social acceptance of Navajo and Pueblo metalwork talent achieved through both unique creation and souvenir design.

Ultimately, the *Indian Art of the United States* exhibition accurately predicted what post-1945 developments would bring. Ethnic arts would move into an era of craft identity. America's Native young people would receive education beyond Indian school training, eventually gaining a college of their own, devoted to intertribal artistic expression. That very artistic expression would give Navajo and Pueblo jewelers a rightful identity as fine artists. All that lay in the future, however. The best was yet to come, but none of it could have been achieved without the historical foundation laid over the first seventy-five years.

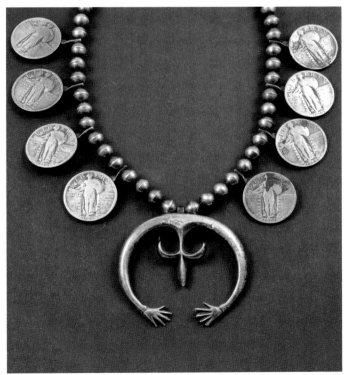

Squash-blossom-style necklaces with coins instead of petals were popular between 1920 and 1950; this 1940s example has coins dated 1927, 1928, and 1930. Author's collection

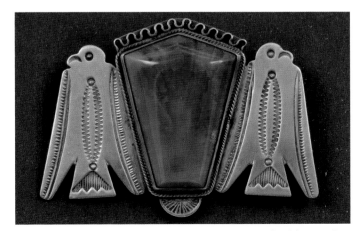

Wartime tourist-era brooch with agate stone and flanking eagles. Author's collection

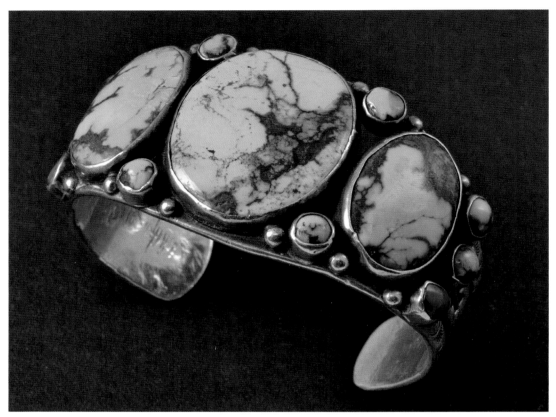

Hopi wide cuff with Bisbee turquoise, 1940s. Courtesy of R. B. Burnham & Co. Collection

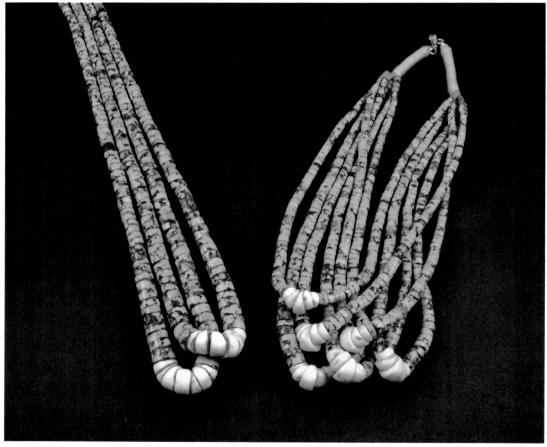

Two sets of Burnham and Persian turquoise heishi necklaces with white clamshell "corn," 1930–50. Courtesy of Joan Caballero

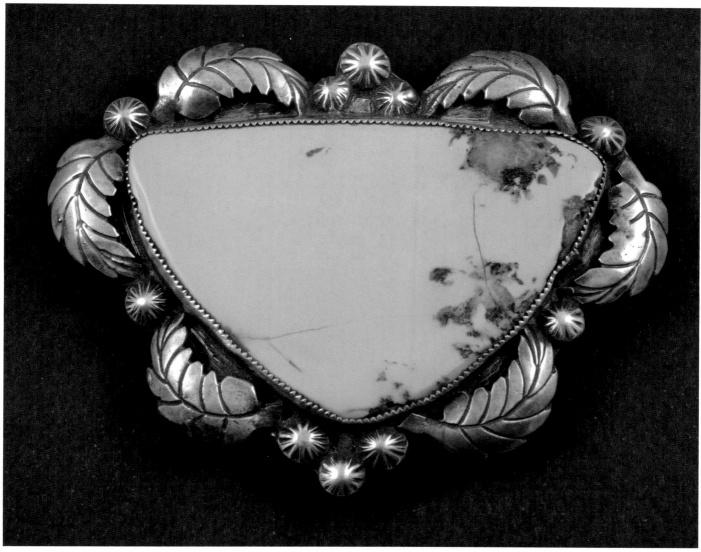

Turquoise brooch with well-carved silver leaves, late 1930s–50s. Courtesy of Joan Caballero

Sew-on with copper loops on all four silver sections, with flattened dome turquoise in the center of a mosaic square, affixed by aluminum adhesive, 1935–50. Courtesy of Joan Caballero

Verso of brooch (*above*), showing safety pin substitute and copper loops

241

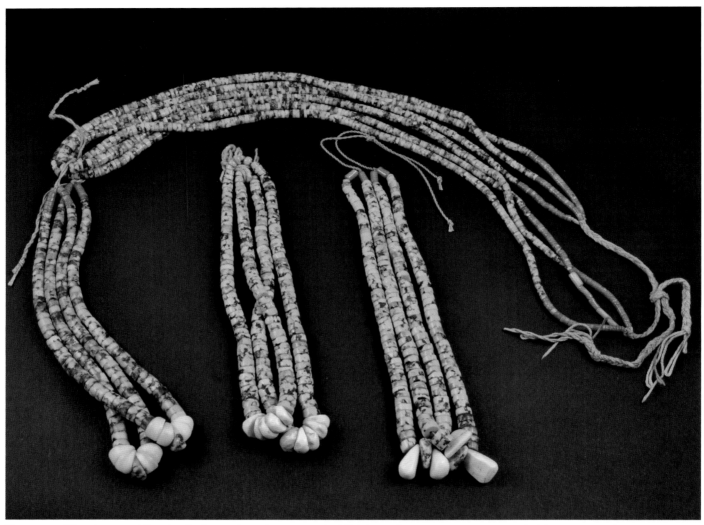

Two sets of Burnham and Persian *jaclas* and one long strand, all finished with red glass beads, 1930–50. Courtesy of Joan Caballero

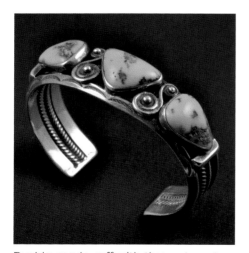

Pueblo-made cuff with three-stone turquoise and fine wire, 1935–55. Courtesy of Joan Caballero

This 1940s bracelet set with onyx center and flanking side wedges has a design that shows Mexican influence. Courtesy of Eason Eige Collection

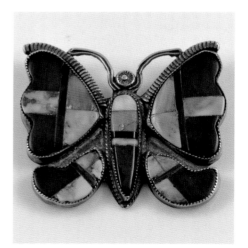

Butterfly with silver inlaid parts, 1940s. Courtesy of Frank Hill Tribal Arts

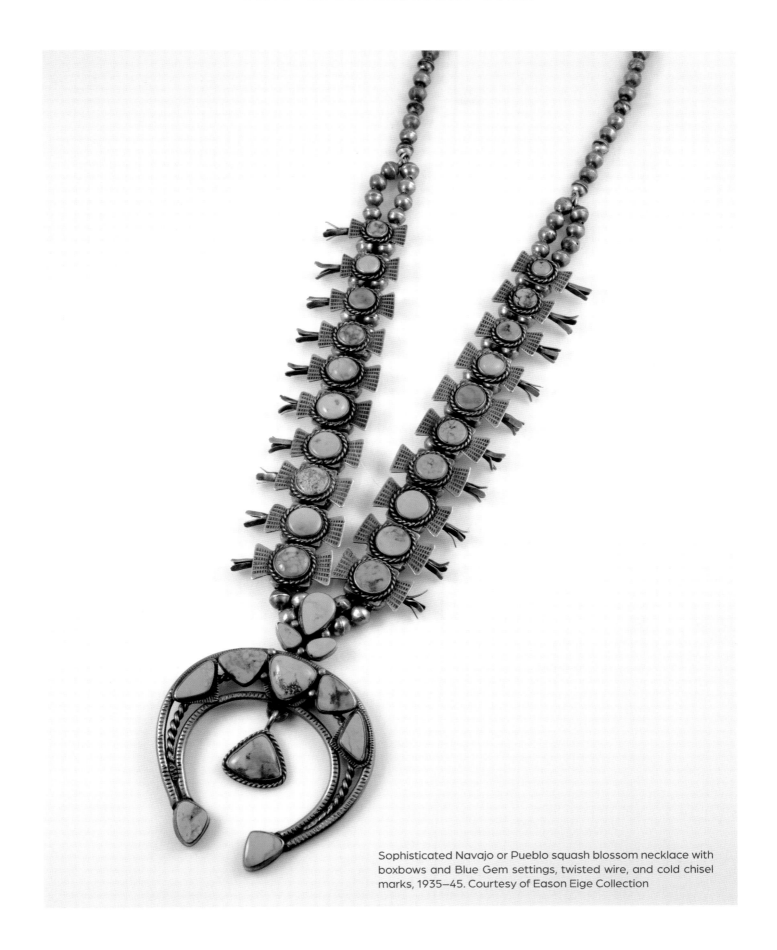

Sophisticated Navajo or Pueblo squash blossom necklace with boxbows and Blue Gem settings, twisted wire, and cold chisel marks, 1935–45. Courtesy of Eason Eige Collection

Early Hopi overlay by master Victor Coochwytewa, 1940s–50s. Courtesy of Michael Haskell Collection

Two Hopi cuffs, made before stipple technique started, 1940s. Courtesy of Michael Haskell Collection

"Midcentury Modern" silver cuff with *HH* hallmark, 1940s. Courtesy of Suzette Jones

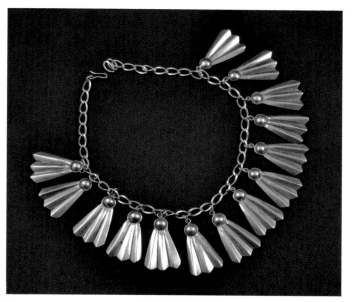

Unusual "Pueblo Deco" type necklace in all silver, 1940s–50s. Courtesy of Suzette Jones

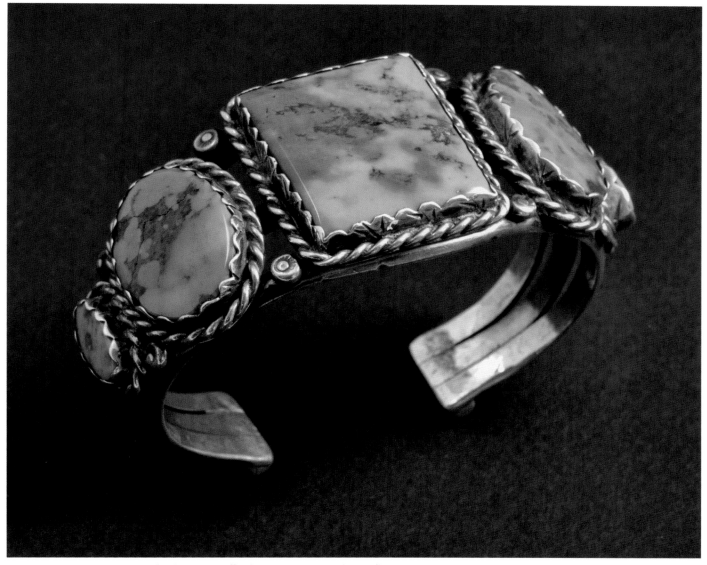

Five-stone Blue Gem turquoise in silver cuff, with stamped bezels, attributed to Roger Skeet, 1940s. Courtesy of Suzette Jones

245

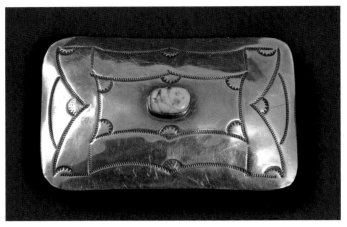

Belt buckle with small stone and spare stamping, 1940s. Courtesy of Suzette Jones

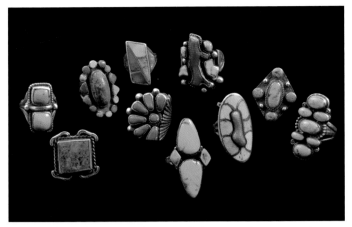

Group of ten rings with characteristic turquoise or coral stone arrangements, 1930s–50s. Courtesy of Suzette Jones

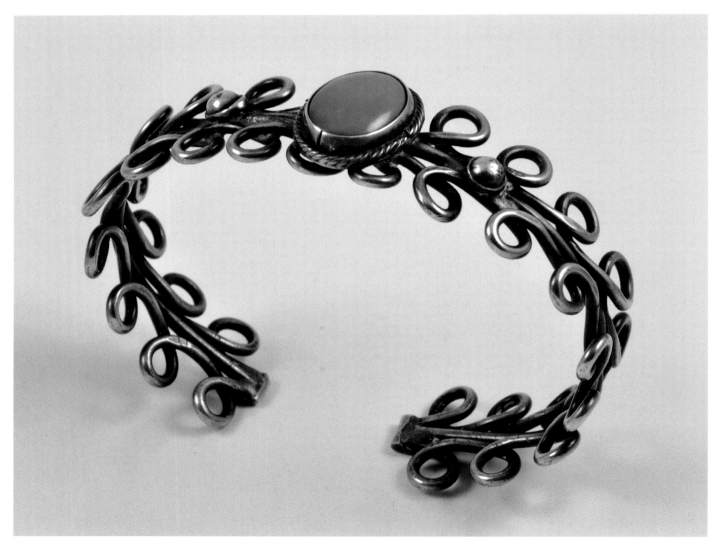

Pueblo twisted-wire bracelet with central green stone. Courtesy of the Hoolie Collection

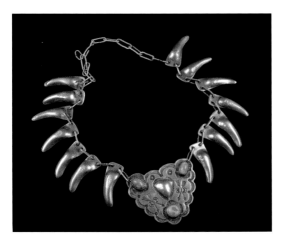

Tourist necklace with silver "bear claws" and stamped crossed arrows, ca. 1940. Courtesy of the Hoolie Collection

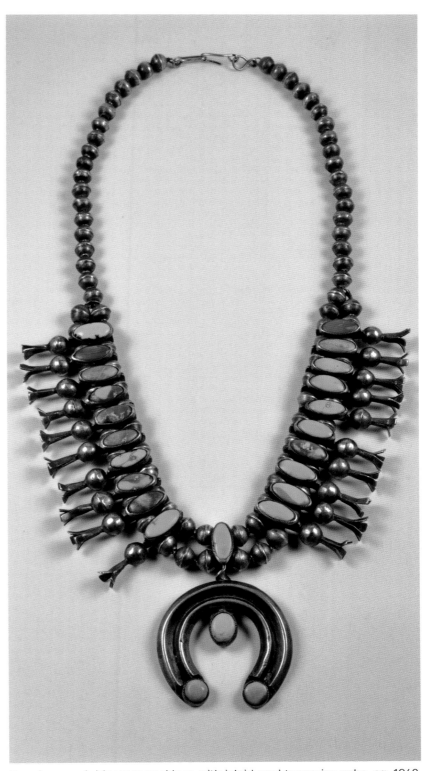

Navajo squash blossom necklace with inlaid oval turquoise cabs, ca. 1940. Courtesy of the Hoolie Collection

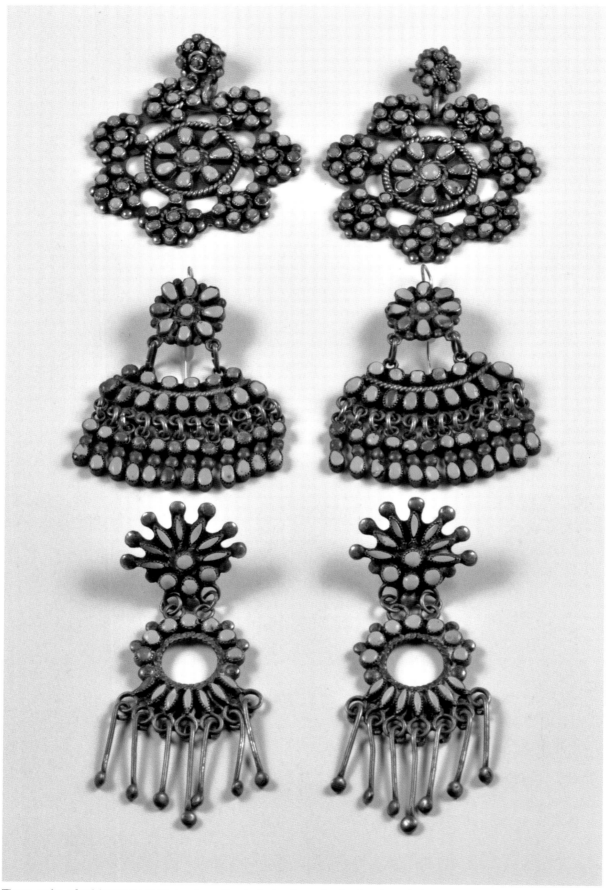

Three pairs of midcentury Zuni earrings: (*top*) cluster in early shadow box; (*middle*) "chandelier" style; (*bottom*) delicate dangles. Courtesy of the Hoolie Collection

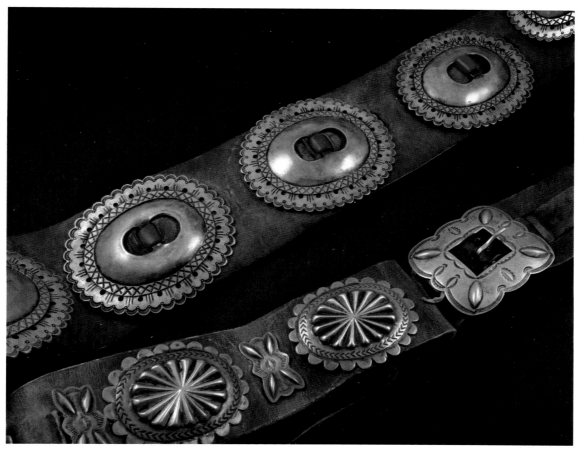

Two 1940s Navajo belts: (*top*) seven large 5-inch plaques; (*bottom*) smaller, 2¾-inch decorative plaques with butterfly spacers, buckle, with repoussé. Courtesy of Bill and Minnie Malone

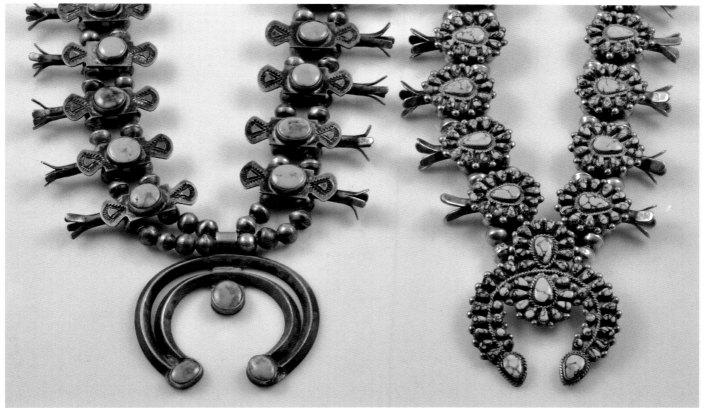

Two 1940s small-scale squash blossom necklaces: (*left*) boxbow, 13 inches; (*right*) cluster, 11 inches. Courtesy of Bill and Minnie Malone

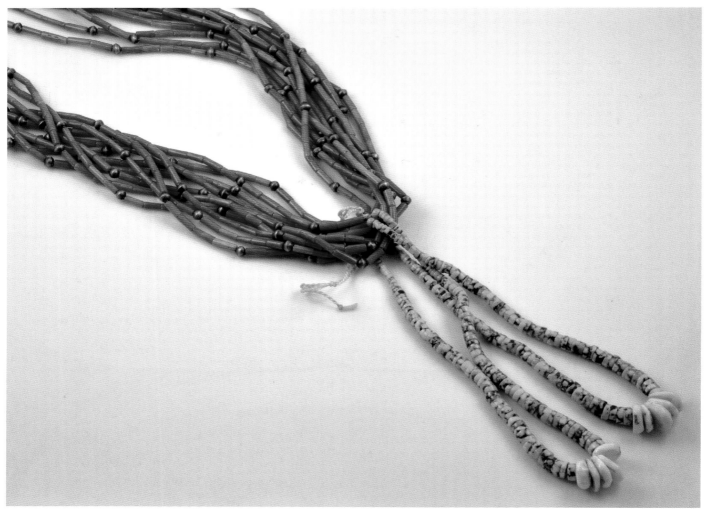

Coral and silver bead ten-strand *heishi* necklace with Bisbee and white corn *jaclas*, 1940s. Courtesy of Bill and Minnie Malone

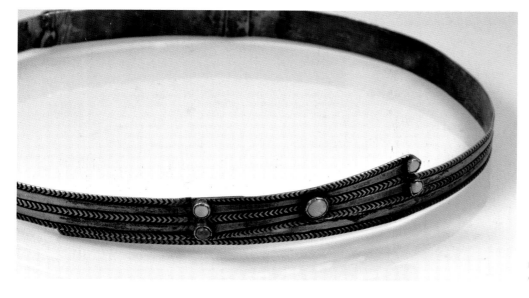

Navajo hatband with small mis-matched cabs turquoise cabs, 1940s. Courtesy of Bill and Minnie Malone

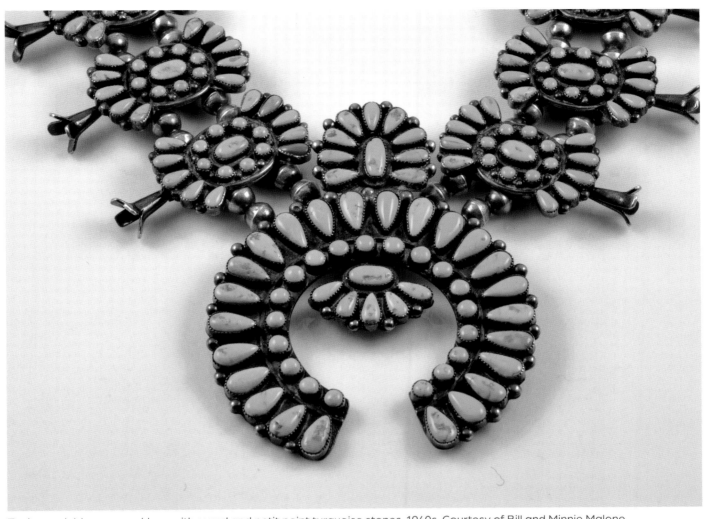

Zuni squash blossom necklace with round and petit point turquoise stones, 1940s. Courtesy of Bill and Minnie Malone

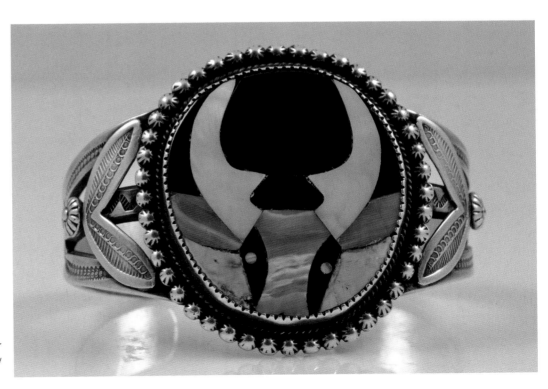

Silver cuff with Zuni inlay steer head, 1940s. Courtesy of Andrew Muñana Collection

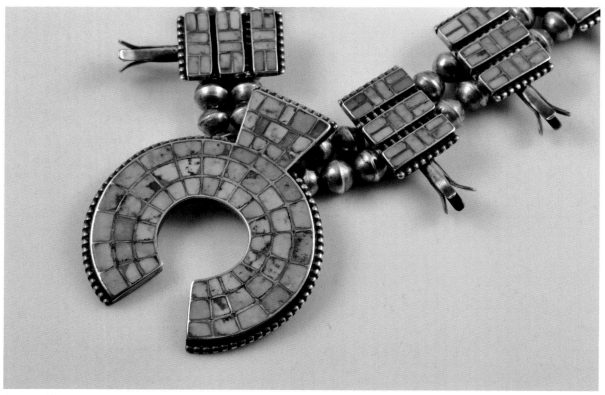

Squash blossom necklace with turquoise channel inlay and unusual rectangular inlay boxbow plates over beads, 1940s. Courtesy of Andrew Muñana Collection

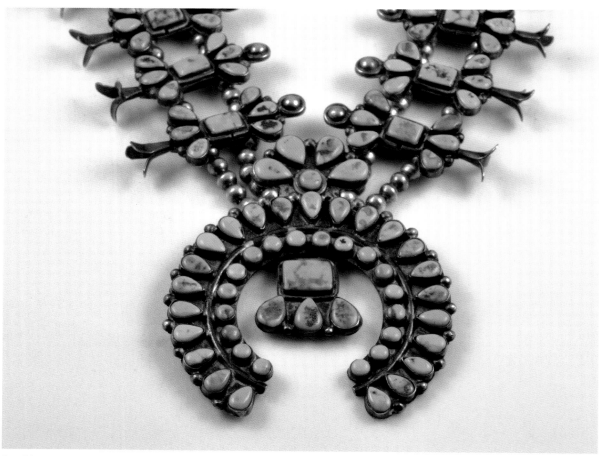

Double-strand squash blossom necklace with Blue Gem turquoise by Della Casa Appa, 1930s–40s. Courtesy of Andrew Muñana Collection

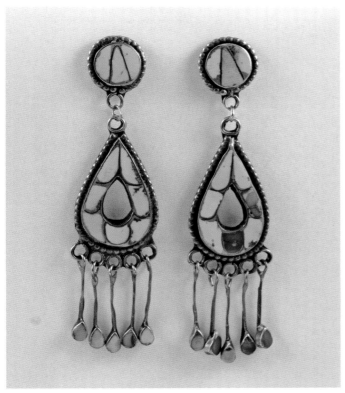

Zuni channel–inlay green stone earrings, 1940s–50s. Private collection

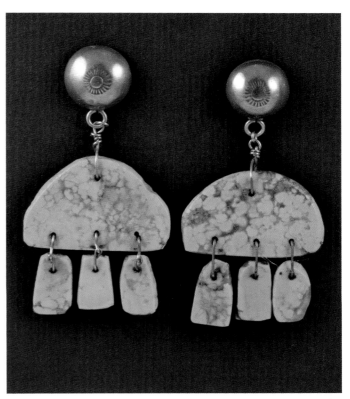

Pueblo rain cloud earrings (an earlier style revived), 1930s–40s. Private collection

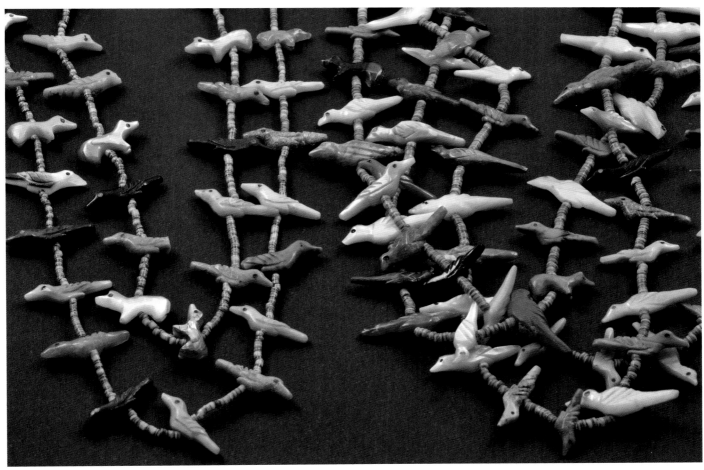

Two multistrand Zuni fetish necklaces by master carver David Tsikewa, early 1940s. Courtesy of Paul and Valerie Piazza

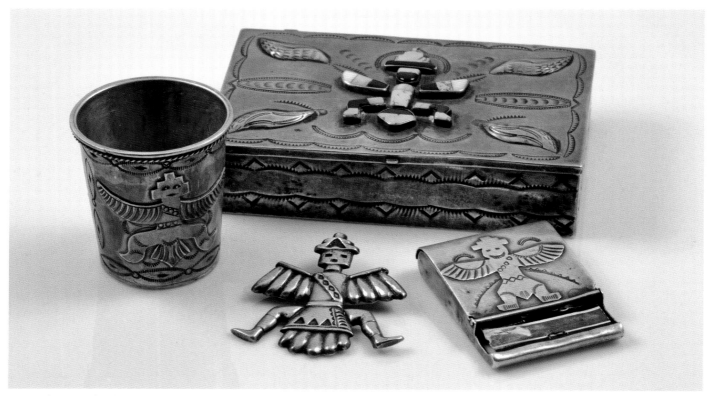

Three silver tourist pieces decorated with Zuni Knifewing design motif, and a pin pendant, 1940s. Courtesy of Paul and Valerie Piazza

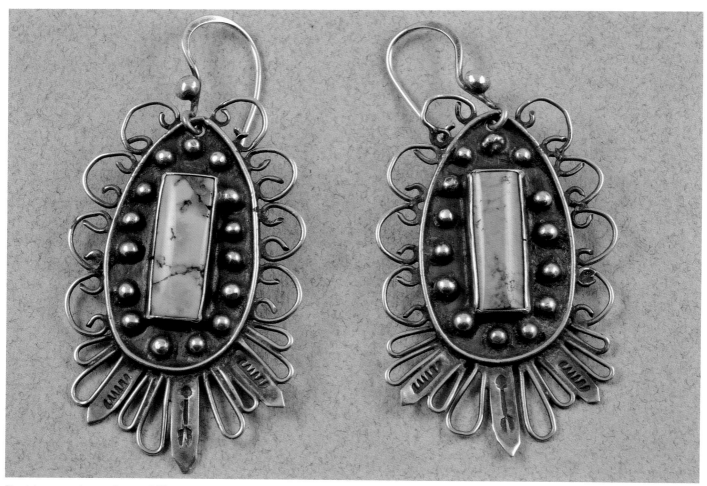

Pueblo green turquoise and filigree earrings, 1940s. Courtesy of Karen Sires

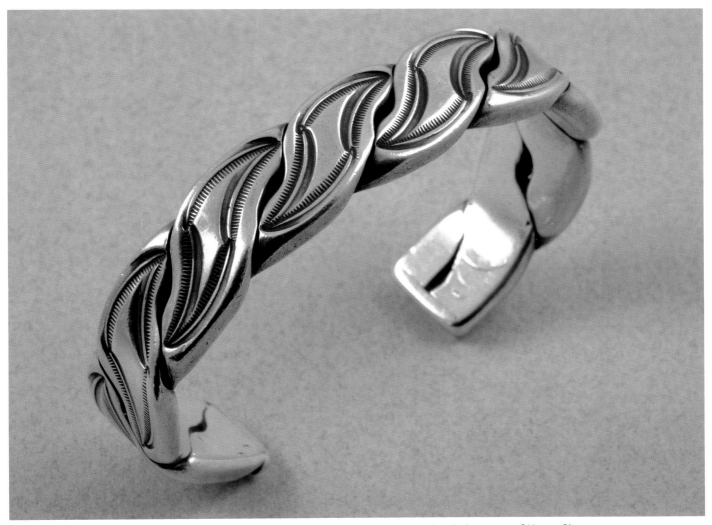

Silver bracelet stamped "U.S. Navajo 2" from the C.G. Wallace trading post, 1938–42. Courtesy of Karen Sires

Verso, showing official stamp

Commercial Santo Domingo tourist necklace from found materials in mosaic pattern, 1940s–50. Courtesy of Karen Sires

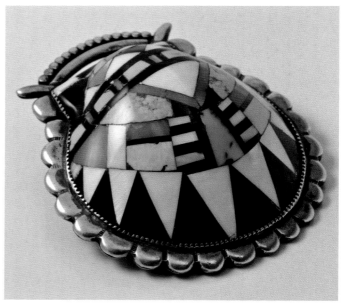

Inlaid shell with silver frame attributed to Teddy Weahkee, 1940s–50s. Courtesy of Karen Sires

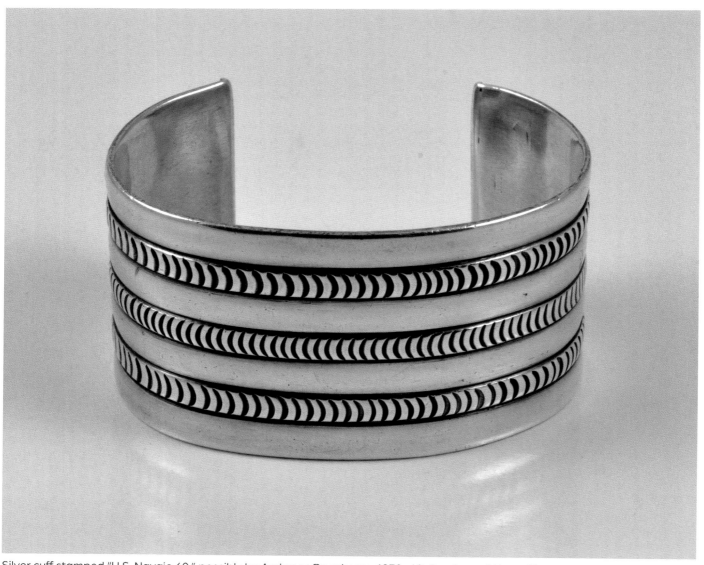

Silver cuff stamped "U.S. Navajo 60," possibly by Ambrose Roanhorse, 1938–42. Courtesy of Karen Sires

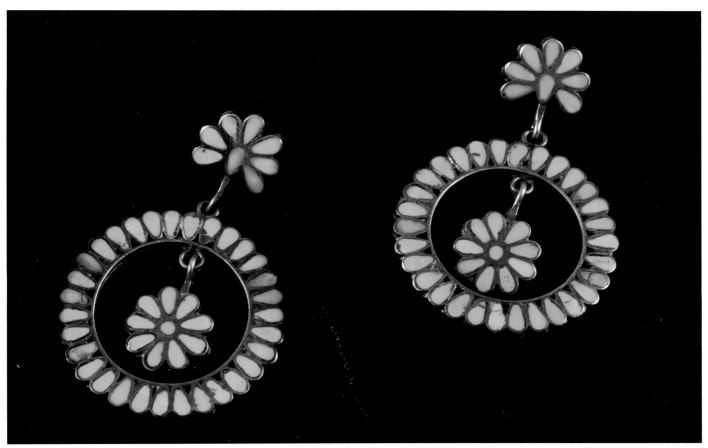

Turquoise earrings by Virgil Dishta, early 1940s. Courtesy of Territorial Indian Arts

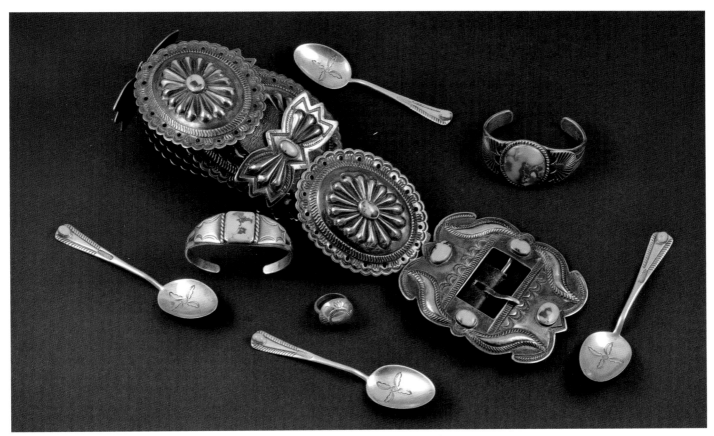

An assortment of jewelry by Austin Wilson, 1930s–50s. Courtesy of White Collection

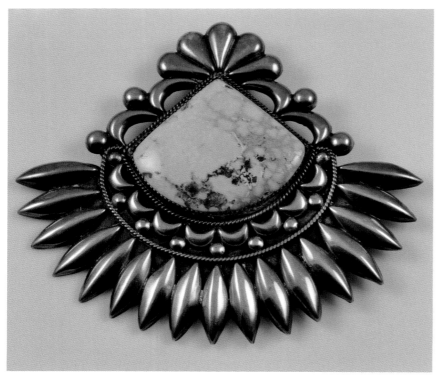

Large turquoise and silver brooch, 1930s–40s. Courtesy of White Collection

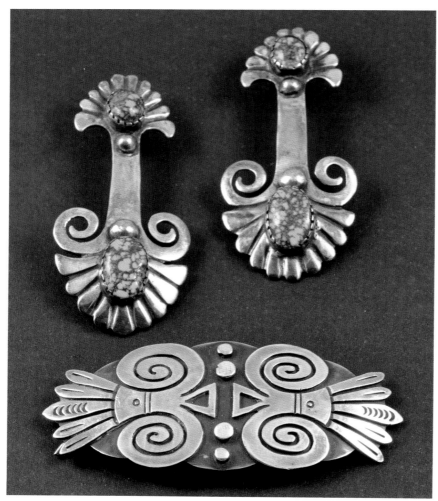

Earrings and barrette by Lewis Lomay, 1940s. Courtesy of White Collection

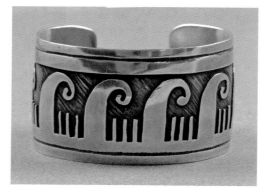

Silver overlay cuff made in Santo Domingo, 1940s. Courtesy of Suzette Jones

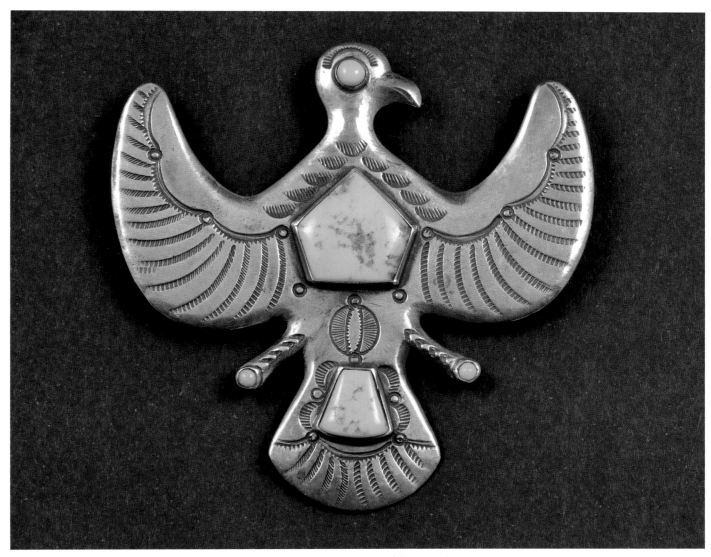

A festive silver and turquoise eagle "Victory Pin," mid–1940s. Courtesy of Suzette Jones

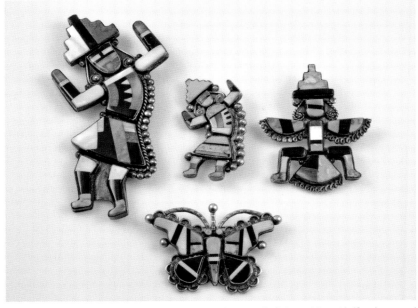

Zuni inlay design motif pin pendants, 1940s: two Rainbow Man, Knifewing, and butterfly. Courtesy of Elizabeth Simpson

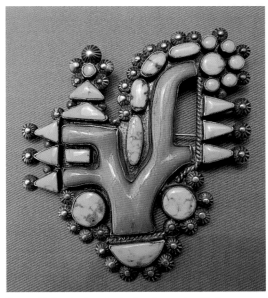

Beautifully abstract–design brooch with turquoise and coral set in silver, 1940s. Photograph courtesy of Karen Sires

259

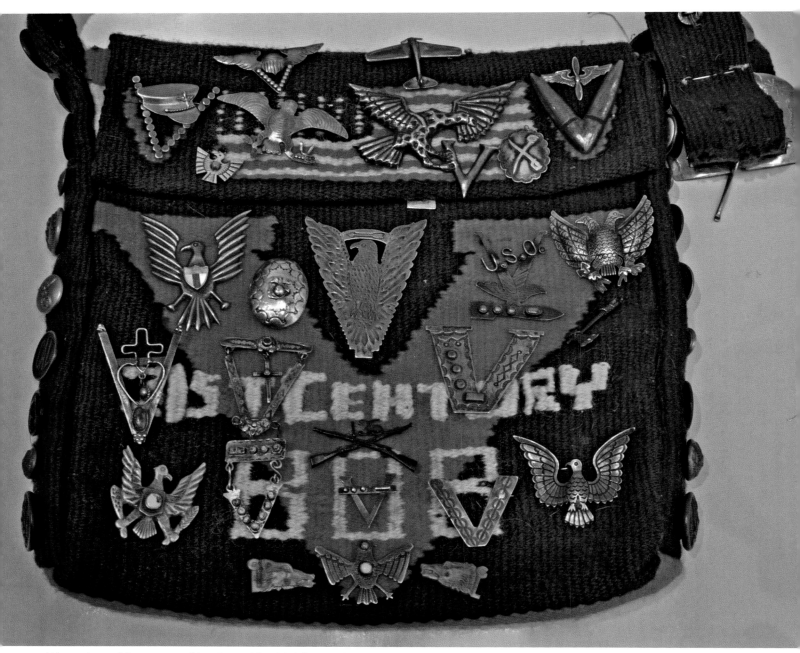

Woven bag with numerous Navajo and Pueblo Victory Pins, 1945–46. Courtesy of Michael Kvietkauskas

"V for Victory" pin. Navajo and Pueblo soldiers returned home at war's end to resume their lives. Many of them were silversmiths. Courtesy of Michael Kvietkauskas

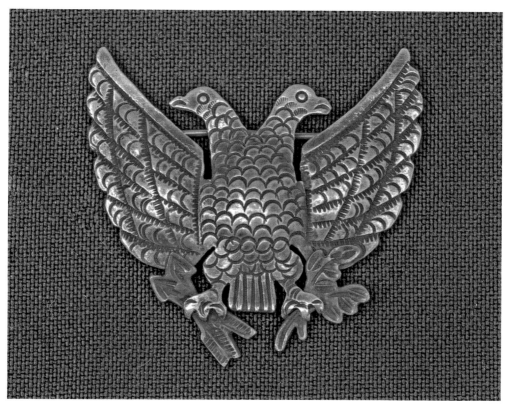

The year 1945 was an important turning point for Navajo and Pueblo jewelry making. In future, for one, design motifs would grow stronger. Courtesy of Michael Kvietkauskas

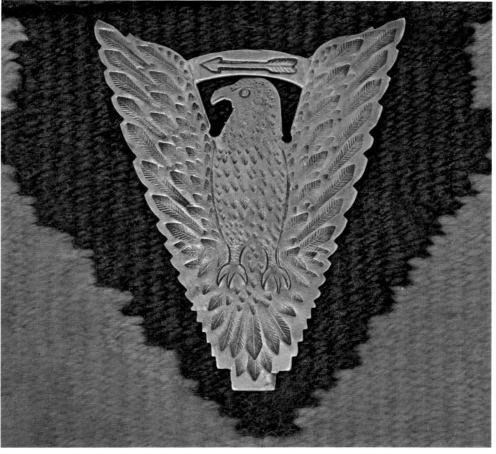

Eagles were already a key Native design motif. Courtesy of Michael Kvietkauskas

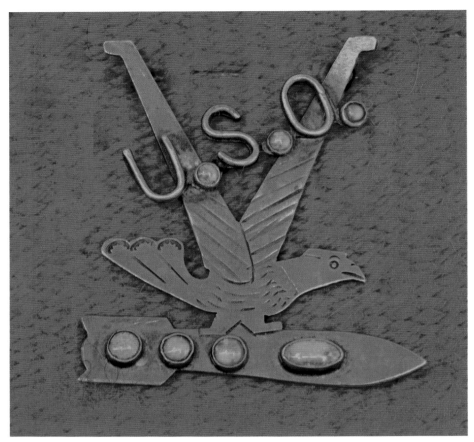

USO Victory pin. From this point on, popular culture would have a place in Native jewelry design. Courtesy of Michael Kvietkauskas

Be Sargent, *Navajo Code Talkers*, 2001. Outdoor mural at 2nd St. and Coal Ave., Gallup, New Mexico. Celebrates the contributions of brave men.

# Key Design Developments in 1940–45

## FORMS

- Pins as brooches take on increased mainstream popular-culture images, even as Native women showed greater interest in wearing them than ever before
- Styles, except for experimental Hopi designs, do not vary much
- More attention is given to useful goods like silver and copper ashtrays, boxes, and accessories (e.g., tie tacks, watch tips and bands, barrettes, money clips, cigarette cases)

## MATERIALS

- These are hard to obtain with the advent of war
- Jewelers repurpose metal, copper wire, and stones due to war rationing
- Some Mexican influences appear, such as use of onyx
- Turquoise and coral stone combinations become popular and continue past 1945

## TECHNIQUES

- Native women step in to create jewelry and metalwork while men are away; women also take employment to do benchwork in curio stores
- Circular and butterfly-shaped stone bracelets are fully realized
- Zuni-style petit point stonework more richly emerges in 1940s, even with turquoise shortages, since turquoise collecting is on the rise

## MOTIFS

- Inlay with figural designs becomes an accepted mode
- Adair reports that butterfly designs were popular at Hopi ca. 1940
- V-shaped Victory Pins, replete with eagles, are made to support the American war effort and celebrate the end of World War II
- Popular birds, steer heads, snakes, and dragonflies appear

## ELEMENTS

- Hierarchy of arrangement; emphasis; scale; proportion; unity; harmony

## NOTABLE MAKERS

- See Appendix C
- A list of names of silversmiths active around 1940 can also be found in Adair's Appendixes and on pages 269–295 of Batkin's reference work

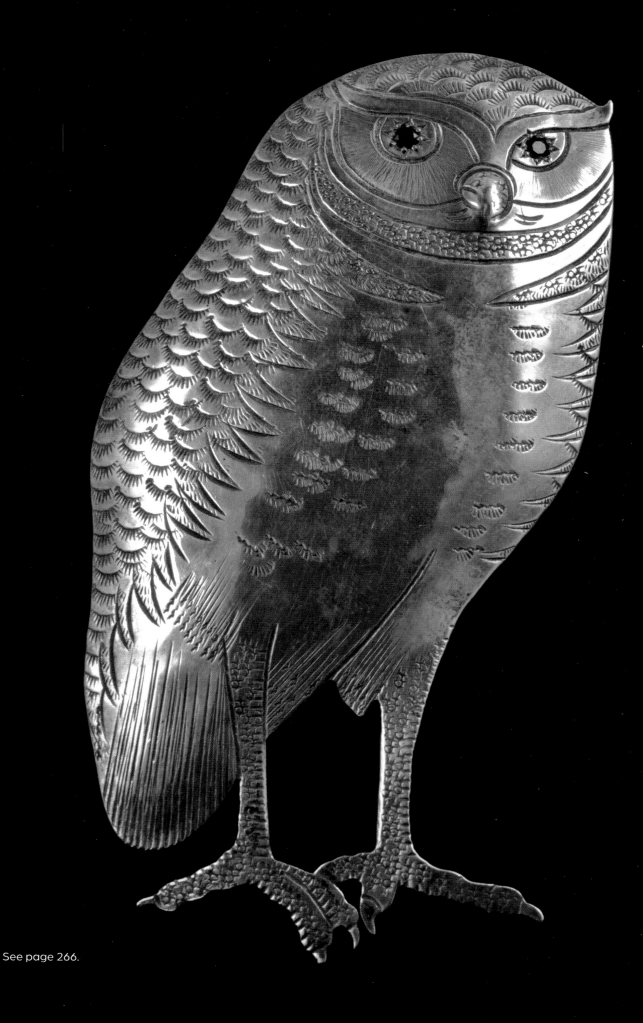

See page 266.

# The View from Midcentury

The history of Native America is a difficult one—peoples dispossessed, displaced, colonial-ized. In response to these hardships, Indians developed strong survival skills. These stories of tribal resistance and perseverance are important contributions to human understanding. In the Southwest, beginning roughly around 1870, Navajo and Pueblo individuals learned to master a craft that was not original to their cultures, while maintaining traditional bead-work and lapidary expertise. Making metalwork jewelry became an essential part of spiritual and economic revival, providing pieces for personal wear and, later, for sale to outsiders.

The making and wearing of jewelry was considered essential to Native cultural sur-vival. Navajo and Pueblo peoples thought silver to be among the "jewels" they revered in their creation stories and songs, since they believed that wearing their silver and stone jewelry signified prosperity and evoked sacred associations. Jewelry held an important place in ceremonies and was worn for everyday purposes as well. Over time, the jewelry made by these Native artisans became the most recognizable American Indian adorn-ment in the world.

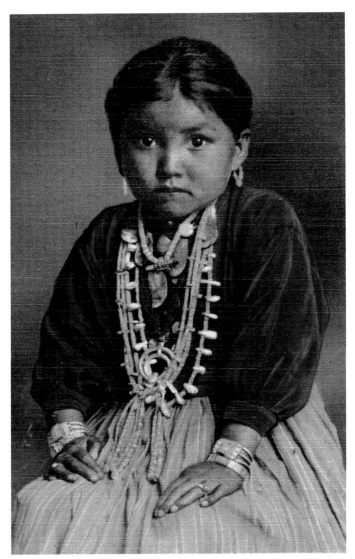

This iconic portrait of a Navajo "Silversmith's Daughter" by an unknown photographer shows how Native children were lovingly draped with jewelry scaled to their size. Private collection

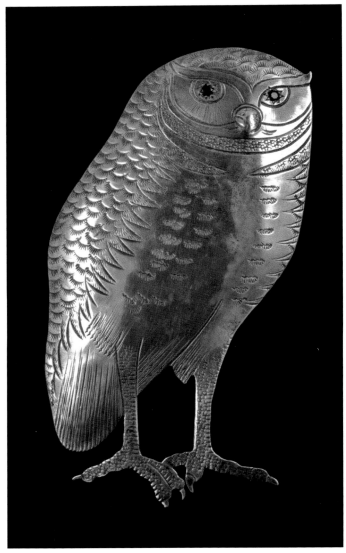

Owl brooch by Awa Tsireh, 1930s–40s. Named individuals' pieces begin to appear more frequently in the mid–20th century, when hallmarks are employed. Courtesy of Karen Sires

Navajos and Pueblos borrowed forms from the cultures around them, including some from the dominant non-Native newcomers to the Southwest. The Native smiths, however, worked with a realistic "adopt, adapt, and discard" set of aesthetic values. Their metalwork adornment ranged from forms with primal appeal to finely finished products displaying coherent, sophisticated design elements. This jewelry was so well established in the marketplace by 1945 that it brought about a growing interest in tribal styles and named artists.

All of this came about because of a dynamic that has been frequently overlooked in written documentation, published literature, and oral history: **Navajo and Pueblo jewelry makers have always been in control of their design.** Non-Natives certainly guided, advised, encouraged, and sometimes even dictated the means of jewelry creation (especially in commercial work), but the resulting combination of tradition, craft, and personal insight was wholly Native in origin.

Using design history as an investigative tool to verify the conclusion stated above, four aspects of unique social development stand out between 1870 and 1945. These developments serve as markers that highlight Native achievement and aesthetic choices, and they can be labeled as

- *construction*
- *design*
- *commercialism*
- *identity*

Each category reveals how remarkable the challenges were and how innovative were the solutions developed by Natives. These markers also illustrate the transition from ethnic adornment to a craft that won widespread Native and non-Native approval.

Over the course of seventy-five years, the *construction* process reveals how making a better product meant being

266

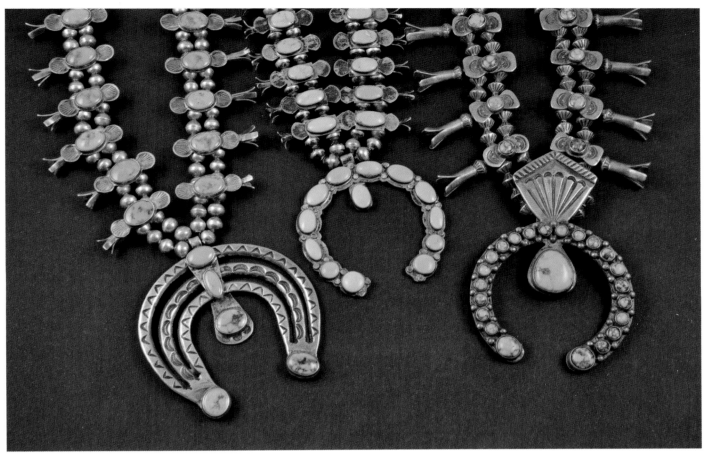

Three distinctive 1940s squash blossom necklaces with boxbows demonstrate how unique designs were the choice of their Native makers. Courtesy of White Collection

open to experimentation and change. *Design* flourished as personal expression enhanced established jewelry forms with unique decorative elements. Native metalsmiths used *commercialism* as a learning experience and a way to improve their productivity. Navajos and Pueblos also permitted non-Native involvement in their jewelry creation while retaining its distinctive *identity*; this feat of cultural accommodation ensured the survival of their cultural character. When examining these four social markers, specific decisions emerge.

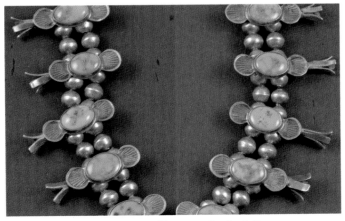

Close-up of boxbows on necklace on the far left

## Construction: Moving Jewelry Creation Forward

Pueblo blacksmiths at Isleta, Acoma, and Zuni were known to have forges for working base metals before 1870. After their return from imprisonment, Navajos took up new roles as blacksmiths, metalsmiths, and, eventually, silversmiths as part of their economic recovery.

Silversmithing in the Southwest may or may not have begun with the Navajos, but they were responsible for its transmission to the Pueblos and other Native peoples in the last quarter of the nineteenth century. Transmission was spread by reciprocal agreements between individuals. Since some Native silversmiths may have been reluctant to share their knowledge for fear of losing income, such agreements usually involved an exchange of commodities, such as livestock, for training in the craft.

Navajo and Pueblo jewelry makers were well versed in handling supply shortages for good turquoise, coral, and even silver. They recycled and repurposed materials as part of their construction process. Santo Domingo made an art of using found materials to create interesting jewelry designs during the Great Depression. A revival of precontact-era Pueblo lapidary techniques such as channel and

mosaic inlay brought fresh opportunities for creativity when added to silverwork. The finesse of these techniques led to uniquely artful and fine-finished jewelry effects by the 1930s and 1940s.

What markers, or social constructs, came from these Natives' construction activities and attitudes?

- Navajo and Pueblo jewelry makers were always willing to take up new and improved tools and technologies.
- They moved forward with learning new construction techniques despite the disapproval of non-Native patrons.
- Critics and patrons often sought to freeze their work into "traditional" modes, but Native artists used older construction when they wished to do so.
- Older techniques, such as rocker engraving and chisel filing, were not lost or abandoned but continued to be implemented when a maker wished to create a specific visual effect.

Such adaptability would serve Navajo and Pueblo jewelers well in the years after 1945. They would have no problems in accepting motorized tools and electrification or in taking up new, nontraditional materials like gold and synthetics. Nor did they hesitate to learn construction techniques that were closer to mainstream practices.

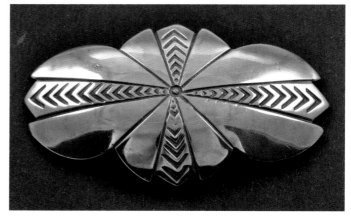

This pin, with its simple, clean silver design, is stamped "Navajo" on the back and may have been done as an Indian school assignment, c. 1940. Author's collection

## Design: Growing by Experimentation

Plains Indian trade ornaments, Spanish filigree, and Anglo Victorian-era jewelry were early cross-cultural influences. Round and crescent shapes from horse headstalls and bridles of Spanish, Mexican, and US soldiers inspired concha plaques and *naja* pendants. Despite the lack of an established tradition, Navajo and Pueblo smiths quickly and assuredly created a precise repertoire of distinctive metalwork-jewelry forms.

Southwestern Native smiths used local volcanic tufa to cast unique openwork bracelets and pendants. Their heft and textured surfaces reveal a primal affinity for the sculptural. Navajo and Pueblo smiths were also adept at making designs for jewelry with alternative (and initially covert) Indigenous spiritual meaning, as in the case of early cross necklaces.

Both peoples first chose decorative patterning and detail that was abstract. Continuous experiments with stamping and detail work made their decoration rich and bold. This development took place shortly before the American public was first exposed to modernist art and design of the early twentieth century. Naturalistic images and a small body of figural design elements made by Native smiths arrived in the second quarter of the twentieth century.

Social markers related to design can be found in specific examples of expanded visual aesthetics:

- Non-Natives attempted to insert themselves into the Native design process, largely by dictating means of improving sales and pleasing non-Native consumers. Navajo and Pueblo jewelry makers followed guidelines when employed by non-Natives but adapted, adopted, and discarded design redirections at will.
- By the 1930s, Navajo and Pueblo jewelry creation possessed an identifiable pattern of uniquely conceived design elements that could be labeled "traditional" and "classic." At the same time, makers also began crafting squash-blossom-style necklaces without using the trefoil

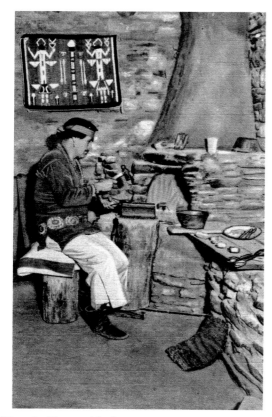

"Navajo Silversmith, Grand Canyon National Park," ca. 1938–40. Private collection

bead for ornamentation on the side, then substituted other types of decorative pieces with self-confidence.

- From the very beginning, Navajo and Pueblo jewelry makers were attuned to personal decorative features that revealed their innate artistry. This was so apparent that prominent non-Native museum professionals readily called their work "art" by the 1940s.
- Even when new initiatives came about, such as the Hopi Silver Project sponsored by the Museum of Northern Arizona in the late 1930s, the actual design impetus would originate from the Native smiths involved in these endeavors.

From the very start of Navajo and Pueblo metalsmithing, jewelry design and decorative effects were built on individual personal vision and communal desire. Students' design ideas were guided and encouraged when working Navajo and Pueblo silversmiths took over teaching jewelry creation in the Indian schools. Makers' abstract and representative design elements multiplied as their world widened.

## Commercialism: Benefits Equal or Outweigh Drawbacks

Although manufactured Indian jewelry offered as inexpensive souvenirs undercut the sales of genuine hand-wrought pieces, such souvenirs could in fact direct consumer attention to better-quality tourist curio jewelry. Commercialism aroused the fear of non-Native patrons that original, pre-industrial Indian design would be cheapened. This dislike of manufactured tourist jewelry brought about a campaign for government and trader oversight and hallmarks on authentic Native-made work. Although the official hallmark programs did not last long, the move to create hallmarks for named individuals proved to be a post-1945 step closer to reaching fine artist status.

Early commercial Indian-made flatware and metalwork showed the makers' ability to express imaginative humor through figural design motifs well before such imagery appeared on hand-wrought adornment. This emergent commercial marketplace also enabled Navajo and Pueblo jewelry forms to become *the* most distinctively identifiable examples of American Indian jewelry in popular culture.

In the long run, commercialism led to product exploitation. Yet, several markers of social change and engagement reveal, once again, that Navajo and Pueblo jewelry making beyond tribal needs brought economic benefits to makers and purveyors:

- Commercialism made sure that Navajo and Pueblo jewelry forms and beads stayed in the public eye, especially when sold as tourist goods.
- Indigenous jewelry makers benefited from commercial work experience by access to wage work and learning new tools and technology.
- When Navajo and Pueblo individuals became entrepreneurs who set up their own businesses, they established a model for others to follow.

Most pre-1945 writers on the subject of Navajo and Pueblo jewelry attached great negativity to commercialism. Nevertheless, Native jewelry makers needed to grow in more modern and more progressive directions—and not be insulted or hindered by cookie-cutter design imperatives or the misguided intentions of non-Native patrons who sought their own vision of what was "Indian."

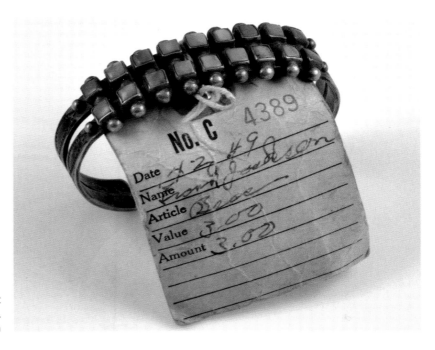

Navajo two-row turquoise and silver bracelet with original pawn ticket from the 1940s. Courtesy of R. B. Burnham & Co. Collection

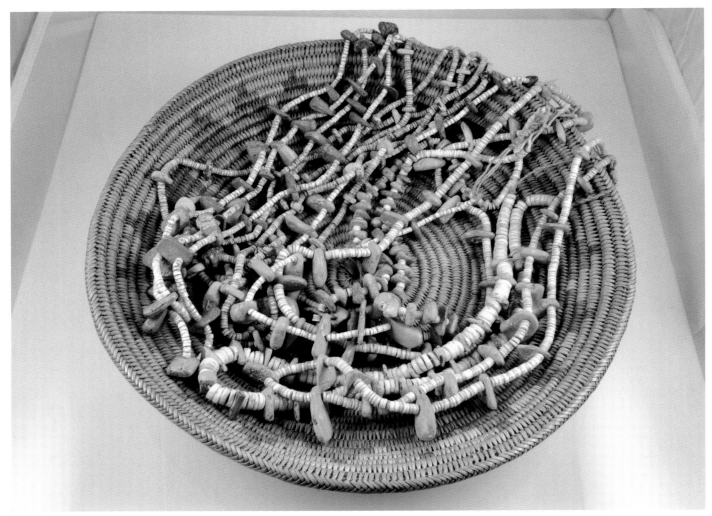

Basket with shell and tab necklaces popular with Navajos, early to mid–1900s. Courtesy of R. B. Burnham & Co. Collection

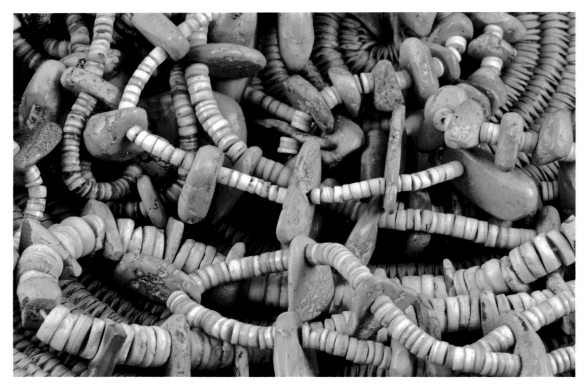

Close–up of beads

## Identity: Creating a Recognizable Talent

Native American identity in the nineteenth century was powerfully negative. After the US government took over its new Western territories, the Indian wars were fought and the Indians inevitably lost. By the last quarter of the nineteenth century, Indian culture was considered thoroughly routed. Many shared the belief of photographer Edward Curtis that Indigenous people would disappear or become wholly assimilated.

Once the West was deemed safe for travel, Indians who were cooperative became integrated into tourism and were presented as demonstrators at selected sites. Here, the Navajos and Pueblos had a great advantage, even more so because of the attractive arts they produced. This meant that many tourists formed their ideas about Indians from the Navajo and Pueblo artisans they met during their travels.

Indian arts shaped non-Native attitudes toward their makers. Several markers, built on social interactions, began to create a distinctive identity—and symbolism—for these two peoples.

- Navajo and Pueblo jewelry forms, such as belts, squash blossom necklaces, and vivid bracelet cuffs, soon became associated with American Indian adornment in general.
- Navajos and Pueblos represented Native peoples in general as arts and jewelry demonstrators at Southwestern tourist sites, scenic national parks, and even world expositions—their pleasant, reserved yet affable manners, "exotic" dress and eye-catching jewelry brought new luster to Indigenous identity.
- Best of all, Navajo and Pueblo jewelry making brought respect to their creators. The iconic nature of their fabrications received accolades as a truly American craft, the new term bestowed by respected experts in the field of American arts.
- Part of this iconic stature came about from the high-quality pairing of silver and turquoise, which won the hearts of collectors in the United States and abroad.
- By the 1930s, Navajo, Pueblo, and other Native jewelry was important enough to be deemed worthy of governmental protections and regulation.

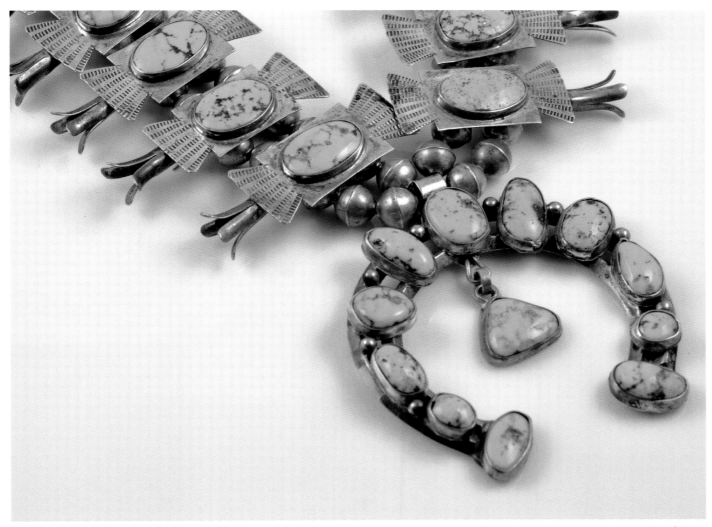

Midcentury turquoise and silver squash blossom necklace shows a taste for decorative effects on boxbow plates. Courtesy of Joan Caballero

Cross-cultural design motif: a silver valentine heart with arrow pin, 1930s. By midcentury certain popular culture symbols were firmly incorporated into Navajo and Pueblo design vocabulary. Courtesy of Joan Caballero

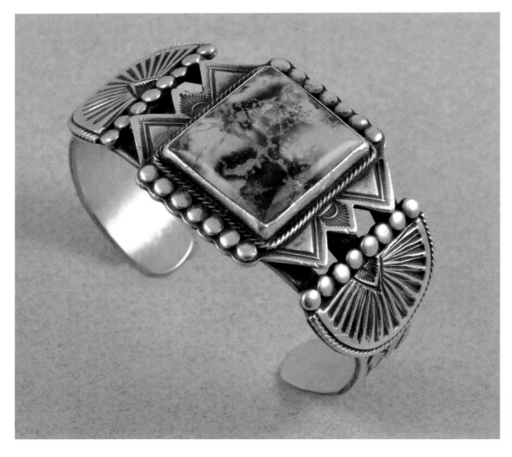

A sophisticated use of silver appliqué elements marks bracelets like this, produced by and after 1945. Courtesy of Eason Eige Collection

None of these positives would have occurred without Native peoples' will for survivance. At the same time, Navajos and Pueblos lived in poverty, struggled against unfair dictates such as enforced school boarding, and battled the daily prejudices of non-Native neighbors and legislators.

Yet they never forgot the Bosque Redondo, stock reductions, and other threats to their self-determination. By the early 1940s, Navajo and Pueblo adornment was considered a valuable form of Americana. These peoples had achieved this stature despite Indigenous artists being held to different standards because of their ethnicity. Non-Native supporters and writers, with the exception of John Adair, denied them opportunities to speak in their own voices. This shortsighted approach meant that knowledge about Navajo and Pueblo jewelry-making motives was filtered through outsider narratives, which led to lost information along with factual errors that have remained unchallenged.

The first seventy-five years of Navajo and Pueblo jewelry creation took place under difficult social conditions.

By 1945, however, their work was well established and ready to be liberated from the ethnographic label of material culture. Indian arts fairs bestowed ribbons and monetary awards to individuals (for the most part), and a number of young, canny jewelers were ready to take their craft to higher levels. The story of the next seventy-five years would still be framed against undeserved social and economic disadvantages, but such raw and ready creativity was taking on a life of its own.

What will Native scholars, currently underrepresented, write about such tenacious creativity in the future? Stories should be told with inclusive perspectives. America's Native peoples are the ultimate survivors, possessing a viewpoint honed by adversity. It's more than likely, therefore, that the "next John Adair" will be someone who has grown up with *hózhó*. In the meantime, we can take pleasure in the first seventy-five years of Navajo and Pueblo jewelry creation. These works teach us how to live and walk in beauty—and not give in to *koyaanisqatsi*.

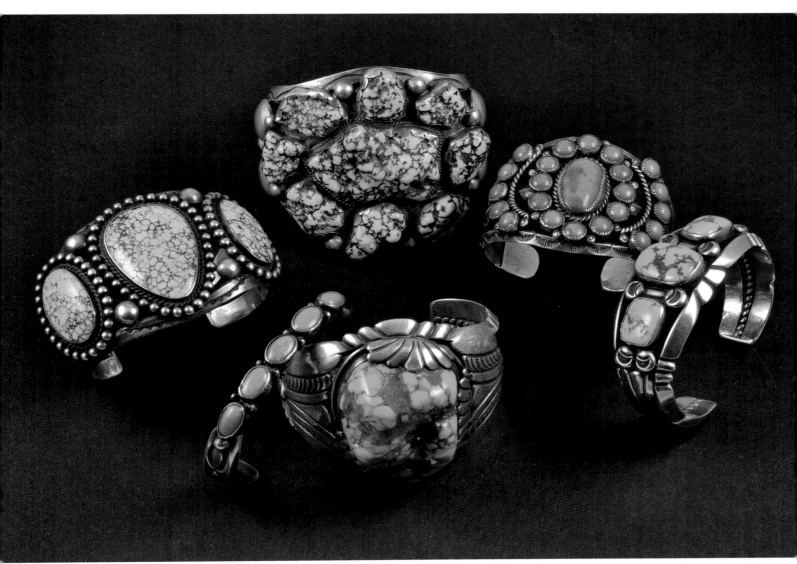

By 1945, both smooth stone and nugget turquoise—along with coral—bracelets fulfill "traditional" and "classic" labels. Courtesy of White Collection

273

Figural design motifs, such as these horse heads, begin to come into their own in the 1930s–40s. Courtesy of Frank Hill Tribal Arts

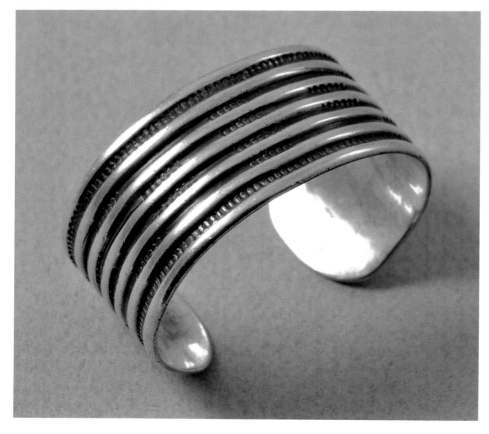

A filed and stamped silver cuff (with "U.S. Navajo 5" stamped on the back) from the Kelsey Trading Post, ca. 1938–42. Courtesy of Frank Hill Tribal Arts

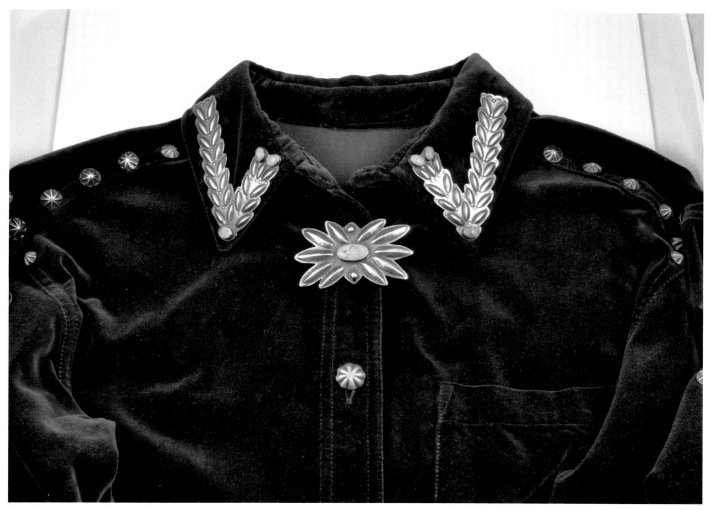

Navajo women revived their interest in silver and turquoise dress pin details in the 1940s. Courtesy of Suzette Jones

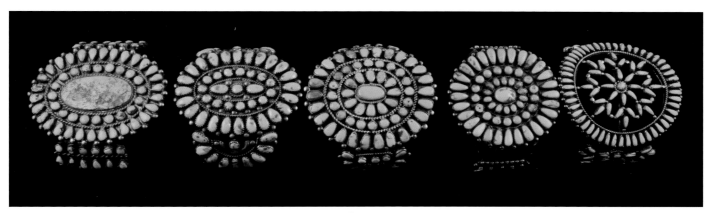

Bar of five classic early cluster bracelets, 1920s–30s. Courtesy of R. B. Burnham & Co. Collection

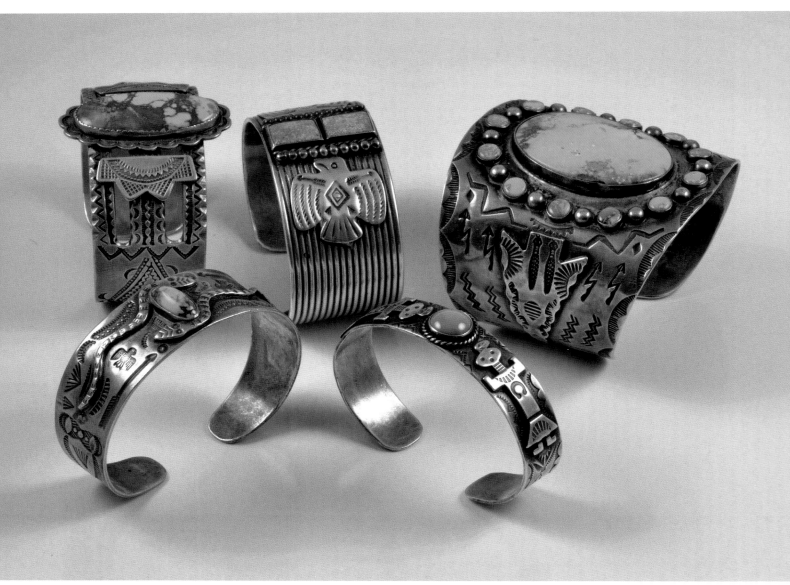

Five commercial tourist cuffs with a proliferation of figural design motifs, 1930s–50s. Courtesy of the Hoolie Collection

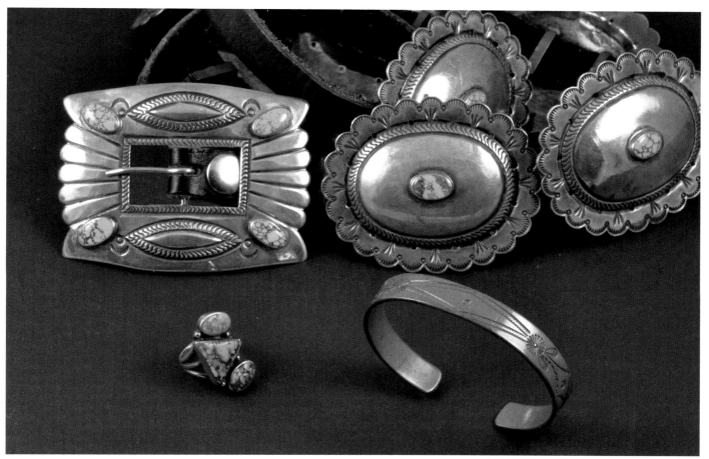

David Taliman concha belt, ring, and copper bracelet illustrate superb technique and personal vision within a "traditional" mode. Courtesy of the White Collection

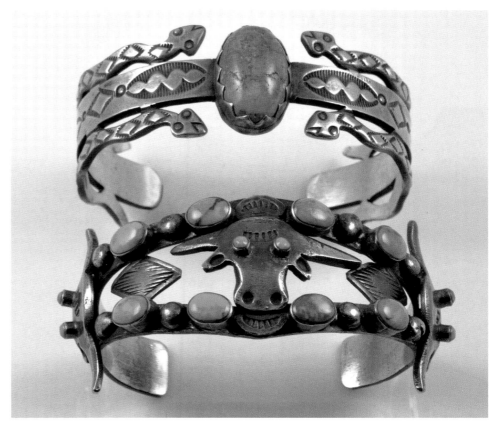

Two cuffs with skillfully integrated figural design motifs and green turquoise stones, 1930s–40s. Private collection

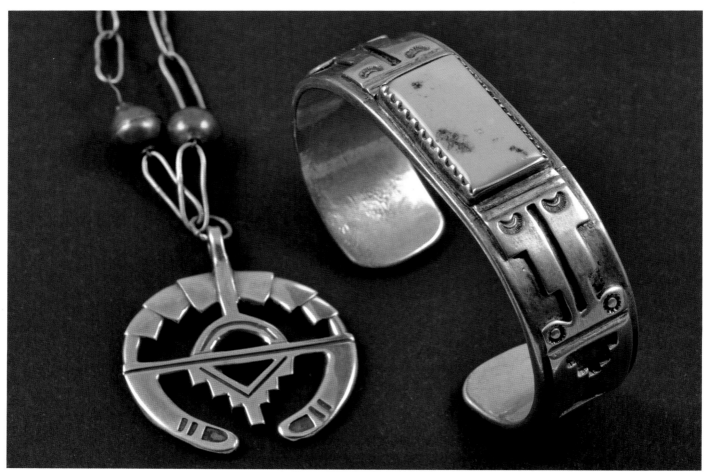

Two pre–1945 creations by Hopi masters: (*left*) pendant by Fred Kabotie; (*right*) bracelet by Paul Saufkie. Courtesy of White Collection

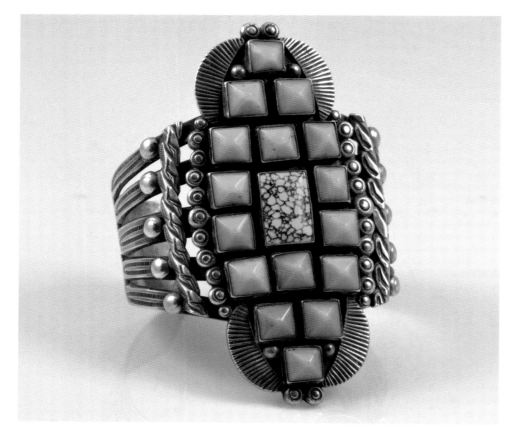

Well-finished big ingot-silver cuff with square-cut coral stones and central turquoise rectangle, 1930s–40s. Private collection

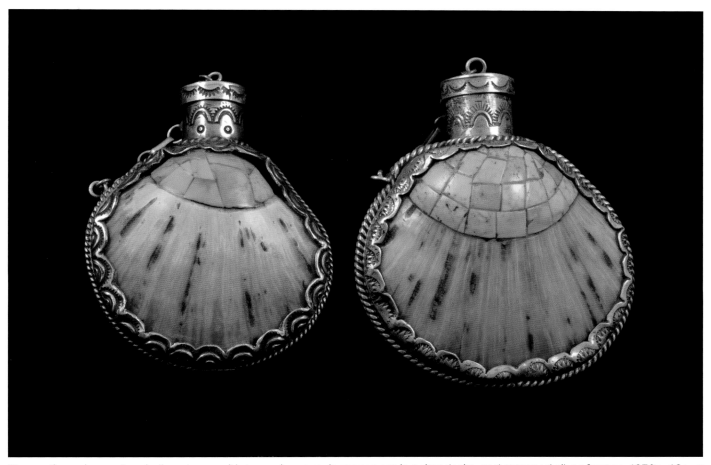

Decorative spiny oyster shell canteens with turquoise mosaic stones set in twisted wire and stamped silver frames, 1930s–40s—a Pueblo–made design. Courtesy of Paul and Valerie Piazza

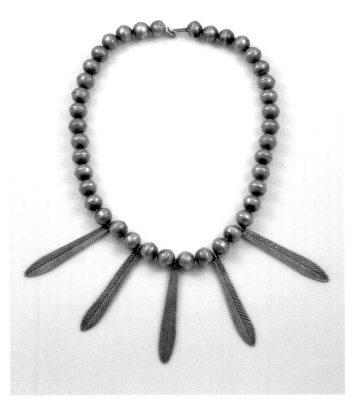

Silver beads with silver feather dangles, 1930s–40s, foretell Navajo and Pueblo jewelry made as fashion pieces in later decades. Courtesy of Paul and Valerie Piazza

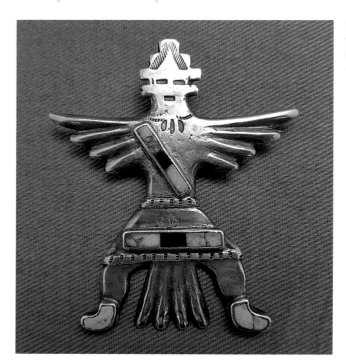

Knifewing pin pendant with turquoise and jet inlay by Juan Dedios, 1930–40. Photograph courtesy of Karen Sires

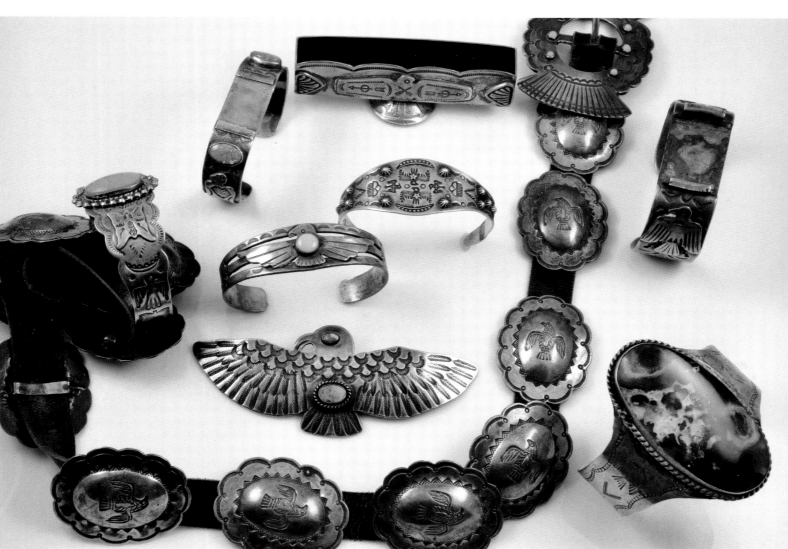

A group of souvenir silver items created at the Garden of the Gods, Colorado, 1940s. Courtesy of Paul and Valerie Piazza

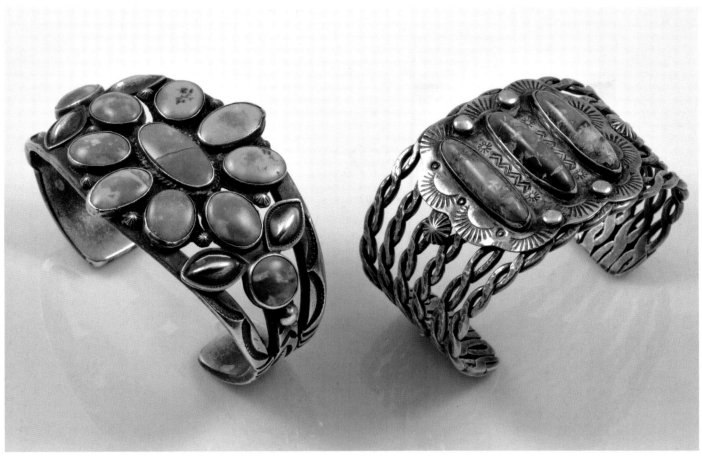

Two silver cuffs: (*left*) sophisticated turquoise cluster; (*right*) stamped plate with lozenge-shaped green turquoise, 1920–40. Courtesy of Paul and Valerie Piazza

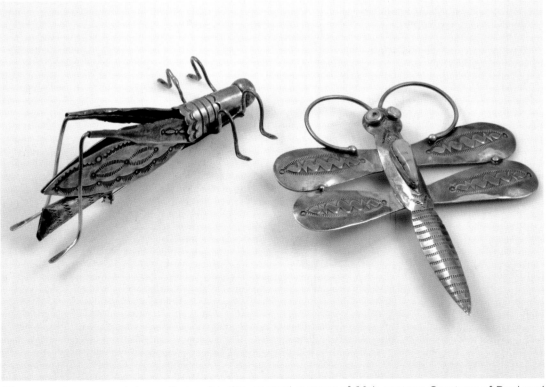

Silver grasshopper and dragonfly tourist pins, second quarter of 20th century. Courtesy of Paul and Valerie Piazza

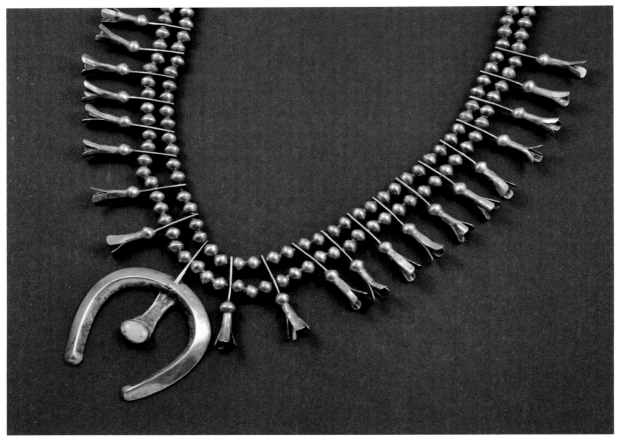

Double-strand bead silver squash blossom necklace with classic petal beads and a midcentury-modern-style cast *naja*. Courtesy of Paul and Valerie Piazza

Fine-finished silver Navajo cuffs with twisted wire, strong stamping, and appliqué abstract design, 1910–40. Courtesy of Elizabeth Simpson

These three circular early earring styles from late 1800s to 1920s will be called "traditional" after 1945. Courtesy of Karen Sires

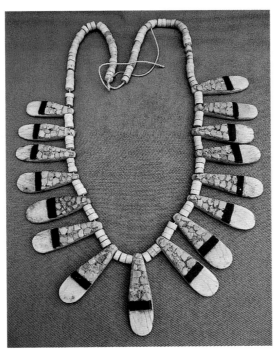

Santo Domingo mosaic tabs on shell necklace, 1930s–40s, is based on an Ancestral Puebloan model. Photograph courtesy of Karen Sires

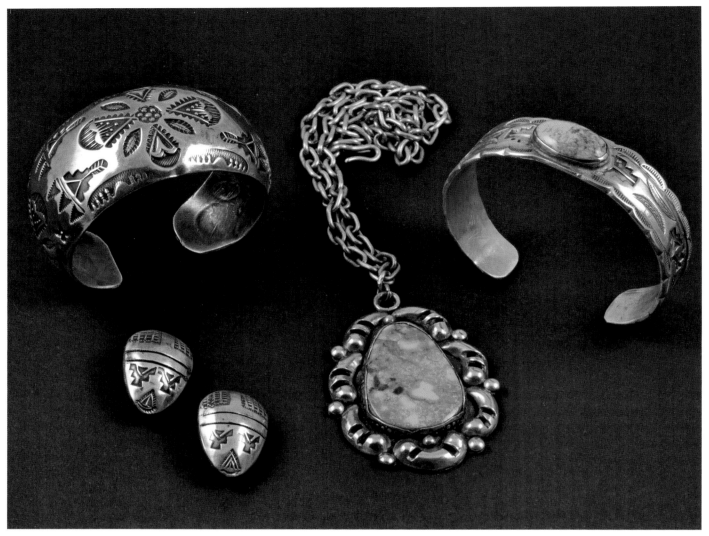

Pre–1945 hallmarked silver pieces by Ralph Tawangyaouma point to future design developments. Courtesy of White Collection

There is a modernist feeling to this ear of corn brooch by Awa Tsireh, 1930s–40s. Photograph courtesy of Karen Sires

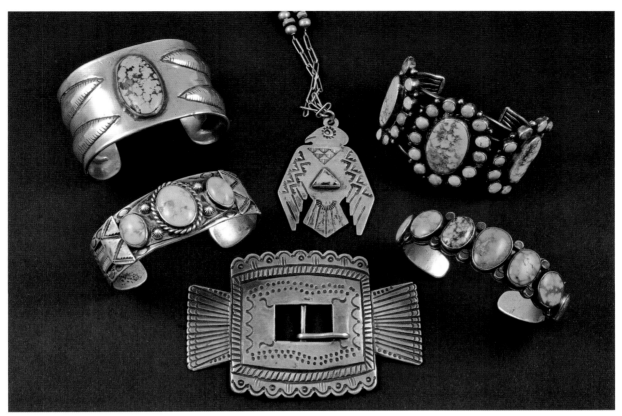

By the 1940s, these works of the 1920s and 1930s will be given "classic" design identity. Courtesy of White Collection

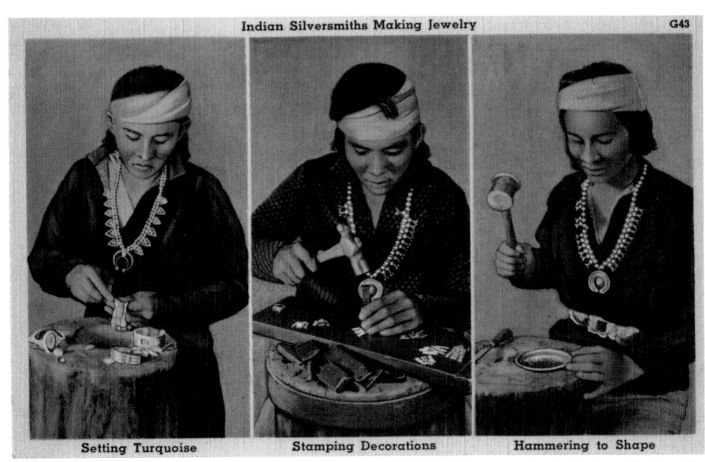

Indian Silversmiths Making Jewelry                                    G43

Setting Turquoise          Stamping Decorations          Hammering to Shape

Postcard of "Indian Silversmiths Making Jewelry" shows that public viewers could sometimes get confused—Navajo and Pueblo smiths both used the same headband wrap when demonstrating and working. Private collection

285

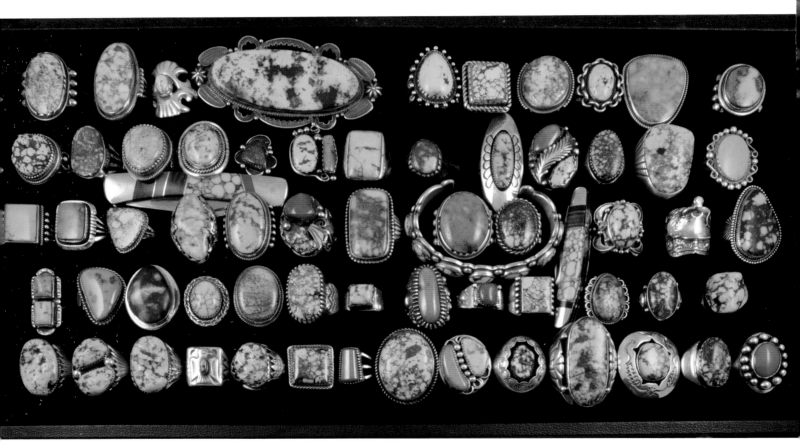

"A trader's 50 years of ring collecting." Courtesy of Bill and Minnie Malone

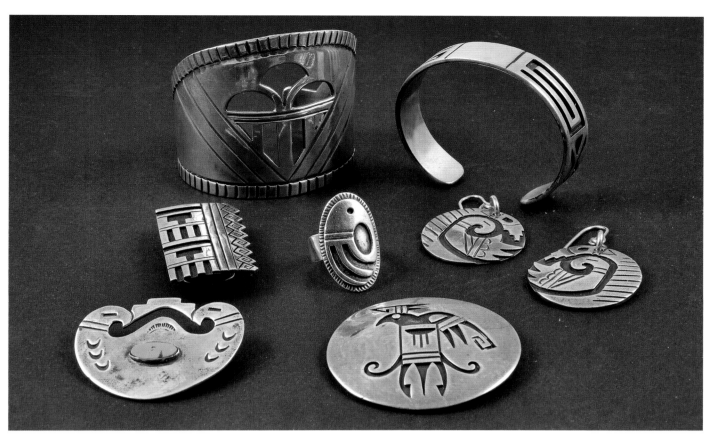

Hopi jewelry will transform in the later 1940s; these pieces are pre–1945: parrot ring by Willie Coin, bird pin by Wallie Sekayumptewa; the others are unsigned. Courtesy of White Collection

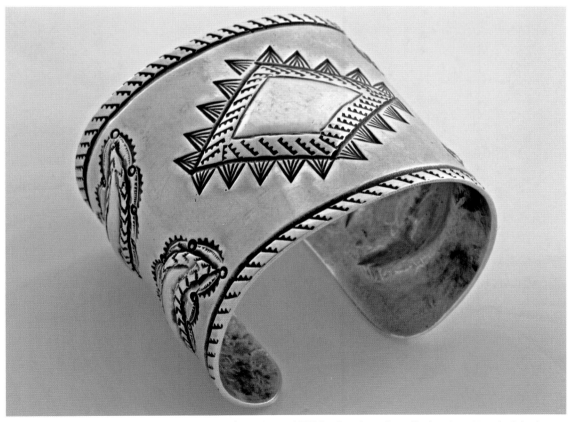

Silver fabricated wide cuff with fine repoussé made ca. 1935 by Santiago Leo Coriz, who attended Ambrose Roanhorse's first silversmithing class at the Santa Fe Indian School. Photograph courtesy of Pat & Kim Messier

287

# Distinctive Design Features That Continue after 1945

## FORMS

- Unique concha ornaments, concha belts; squash blossom and cross necklaces; bowguard plates; cast bracelets, fabricated bracelet cuffs, and thin silver bangles; plain silver and stone-set rings
- Earrings in multiple parts, especially hoops and dangles
- Silver beads that stand alone or are added to traditional Puebloan-style stone beads, especially turquoise

## SHAPES

- Primal shapes—circles, ovals, bands, cylinders, and crescents
- Universal in nature, but also unique, as in the trefoil "squash blossom" bead

## SIZE

- Silver jewelry made to scale for both sexes and children

## TEXTURES

- Unique and rich to touch: hand-drilled stone and shell beads; tufa-cast silver; decorative stamping on silver; appliqué with wire; nugget turquoise

## COLORS

- Meaning differs by cultural group, relating to sacred boundaries, directions, and natural effects
- Most popular are black (onyx or jet), blue and green (turquoise), red (coral), and white (shell)

## CONTRAST / LINE PATTERNING

- Early surface decoration, such as chisel filing, reappears from time to time
- Geometric and organic stamping, abstract and foliate appliqué, round silver "raindrops," repoussé in lozenge shapes, and cast openwork

## DESIGN MOTIFS

- Arrows; birds; butterflies; crosses; dragonflies; seeds and foliate forms; snakes; steer heads; whirling logs; selected figural deities

## MATERIALS

- Integrating regional stones such as agate, petrified wood, and turquoise; white clamshell, olivella shell, and spiny oyster shell, coral and turquoise paired with silver

## RESOURCE CHALLENGES

- Materials shortages; repurposing stone such as drilled turquoise beads; improvised tools including dies and punches; hand-devised stamps for metal

## AESTHETIC CHALLENGES

- Maintaining high-quality balance through symmetry, effective hierarchy of arrangement, unity and harmony, and fine surface finish

## Artist Profile

"Ambrose Roanhorse" from Chester Kahn's *Circle of Light* mural inside the Ellis Tanner trading post in Gallup, New Mexico. Courtesy of the Ellis Tanner Trading Company

## Ambrose Roanhorse
### (1904–1982)

This master silversmith—who is acknowledged by the Navajo Nation, which gave him the honorary title of Beshlakai Natani—has been diminished in modern art historical literature. He and his younger brother Sam (1916–1983), also a silversmith, were born near Fort Wingate, New Mexico, with the last name of Roans, which they changed to Roanhorse in the late 1930s. Ambrose was willing to represent his tribal government when dealing with US government functionaries at the Indian Arts and Crafts Board (IACB) and other non-Native Indian arts advocates.

Roanhorse began learning his craft as a child from his grandfather and father, going on as a young adult to attend Haskell Institute and the University of Utah. He worked for several Indian traders, including Charles Kelsey and C. G. Wallace, and actively entered his work and demonstrated his craft at the Gallup Inter-Tribal Ceremonial. He was appointed silversmith instructor at the Santa Fe Indian School from 1931 to 1939 and taught numerous notable students. Roanhorse was an advocate of older-style Navajo silver, and his pieces are highly finished, clean silver designs with strong lines and spare ornamentation, a style that became prominent in the mid-twentieth century. In fact, his work has been compared to that of Georg Jensen.[1]

Roanhorse maintained strong ties with programs that offered higher visibility to Navajo arts. When the Navajo Arts and Crafts Guild was started in 1940, he served as John Adair's assistant as they implemented IACB standards and hallmarks. He represented the Navajo Nation at the opening of the *Indian Art of the United States* exhibition at the Museum of Modern Art in 1941 and went on to exhibit his work throughout the country. These efforts, along with his influential instruction practices, led to awards in the 1950s from the Palmes Académiques (France) and IACB.

How much more useful would our understanding of Native arts be if we had interviews or other reports about Roanhorse's methods of teaching? His highly modern yet classic Navajo silversmithing design marks a pre-1945 high point. His teaching had an effect on the work of such up-and-coming masters as Kenneth Begay and Lewis Lomay. It is regrettable that so little has been written about his life and accomplishments.

---

1. Octavia Fellin, "Roanhorse," *Indian Life* 38, no. 1 (August 1959): 1.

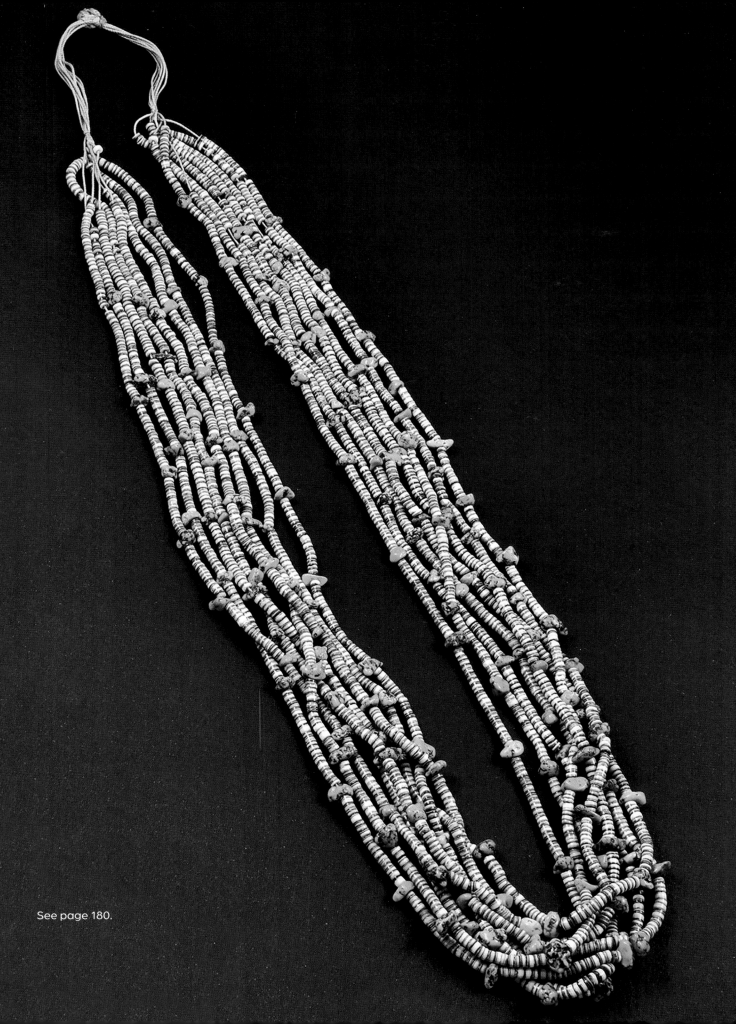

See page 180.

# Appendix A

# Glossary of Key Pre-1945 Techniques and Tools

**appliqué**  A decorative technique in which a cutout design is attached to a piece of metal jewelry by soldering.

**carination**  A shape used on older metal bracelets, consisting of a triangular cross section that comes to a point away from the wrist. This section forms a keeled, or carinated, ridge created by casting the piece in a V-grooved mold.

**casting**  A process for shaping metal by pouring molten metal into a mold that is carved or shaped into a design or form. The mold has a reversed, negative version of the design. Once the metal has cooled, it is removed from the mold, and unneeded pieces are filed or cut away in preparation for finishing. *Tufa casting* is done using a volcanic pumice called tufa; Southwestern Native smiths also learned to sandcast by pouring the molten metal into a vessel filled with firmly packed sand that has been shaped into a design. *Openwork* refers to structural or ornamental openings in decorative patterns on a piece of jewelry.

**coin silver**  The metal of choice through the late nineteenth and early twentieth centuries. Navajo and Pueblo blacksmiths were paid with silver coins; the smiths then hammered the coins or melted them into ingot molds. The use of US coins was banned in 1890, and Mexican pesos were prohibited in 1930. Sometimes the edges from a coin can be seen in an older piece.

**cold chisel**  One of the earliest tools used to decorate cold-metal surfaces by hand; the chisel could chip, cut, or incise a design. Its blade was made of wood or metal, with a sharp edge.

**dies**  Early smiths used hollowed-out metal forms into which they hammered a shape or design. Later specialty forms of these tools were manufactured.

**fabrication**  A process whereby metal jewelry is shaped through various technical means, such as hammering into a form and creating surface decoration through punching, piercing, or adding metal effects.

**filigree**  Probably derived from Spanish colonial silverwork, filigree is fine metal wire, either silver or copper, bent and soldered onto a piece of jewelry for decorative effect.

Original tools for stamping and surface decoration. Courtesy of John C. Hill

**filing**    Files, made by hand before commercial development, were used for making decorative grooves and lines on metal surfaces. Smiths developed their own metal files both before and after the introduction of fine files in the early 1880s. Files exist in shapes that range from round to triangular.

**German silver**    A metal alloy of 60% copper, 20% zinc, and 20% nickel, which is lower in cost than sterling silver. A material popular with Plains tribes. Native smiths often called it "white brass."

**inlay**    In this technique, one of the most prized of the Native Southwest, shell or stone (e.g., turquoise) is glued onto a silver base to form an abstract or realistic design. *Channel inlay* creates recessed silver compartments in which material can be set. *Mosaic inlay* is the process whereby materials, like shell and stone, are arranged onto metal or wood and fitted together without silver outlines or discernable grooves to form a design; this was an Ancestral Puebloan technique.

**overlay**    A technique that involves taking two pieces of silver, cutting out a design on one, and sweat-soldering it onto the lower piece, which is then oxidized for contrast. The top layer is usually highly polished for further contrast, as in Hopi overlay jewelry.

**oxidation**    A process in which silver is blackened or darkened for contrast, usually by treating it with potassium sulfide or liver of sulfur.

**pump drill**  An ancient hand tool used to drill holes in beads for stringing. It has a vertical spindle and a horizontal crosspiece with leather thongs, anchored by a glued pottery or wooden disc, which produces a drilling up-and-down action.

**punches**  Smiths use hammers to strike a punch, a metal tool used to make imprinted or perforated decorative designs on a metal surface. To make a dome-like shape, smiths use a combination of punches with a dapping block or mold.

**raindrops**  Small, rounded balls of melted silver, also called "shots" or "dots," which are soldered onto a surface for decorative effect.

**repoussé**  This technique, which appeared very early in Navajo and Pueblo silversmithing, was used for surface decoration. It involves pushing through or hammering the back of a piece to make a domed, embossed, or raised design, using male and female dies. Native jewelers call the resulting designs "bump ups," and they remain popular today.

**rolling mill**  Rare until available commercially in the 1920s and 1930s, this hand-cranked machine with steel rollers was used to make various thicknesses, or gauges, of sheet metal and wire.

**scratch and rocker engraving**  One of the earliest means of making surface decoration, this process was labor intensive. Rocker engraving was used by Eastern and Plains tribes, but never became popular in the Southwest. By pressing the chisel point of an engraving instrument onto metal and using a rocking motion, a zigzag line can be produced. The early silversmiths used the sharpened edge of a file or awl to create this engraving effect.

**solder**  Silver solder is a metal alloy used to bond two metal surfaces; it is composed of 65% fine silver, 20% copper, and 15% zinc. The process of soldering involves heating the alloy material by using a hot iron to join the two surfaces; metalsmiths use an acid-based flux to enable this method.

**stamping**  A technique for making a relief pattern on metal for design purposes; smiths use a die or punch, which is hammered or punched. Multiple blows create a series of identical patterns. Stamping is one of the most valued surface decoration techniques. The early smiths devised stamps from scrap iron, choosing whatever imagery suited their tastes. These could be abstract or realistic, such as arrows or animals.

**sterling silver**  This alloy has a fineness grade from 0.925 to 0.921, signifying it is 92.5% pure silver and 7.5% copper to 92.1% silver and 7.9% copper. Most Indian silver is made from this combination of materials.

**swedging**  This process began when silversmiths fashioned armbands or bracelets in ridged silver, with grooves on the front and back. This labor-intensive technique first appeared ca. 1880 and requires the use of a swedging block and running chisel.

**wrought**  Any handmade process or fabrication of jewelry that involves hand tools; hand-wrought pieces may be beaten, hammered, or twisted.

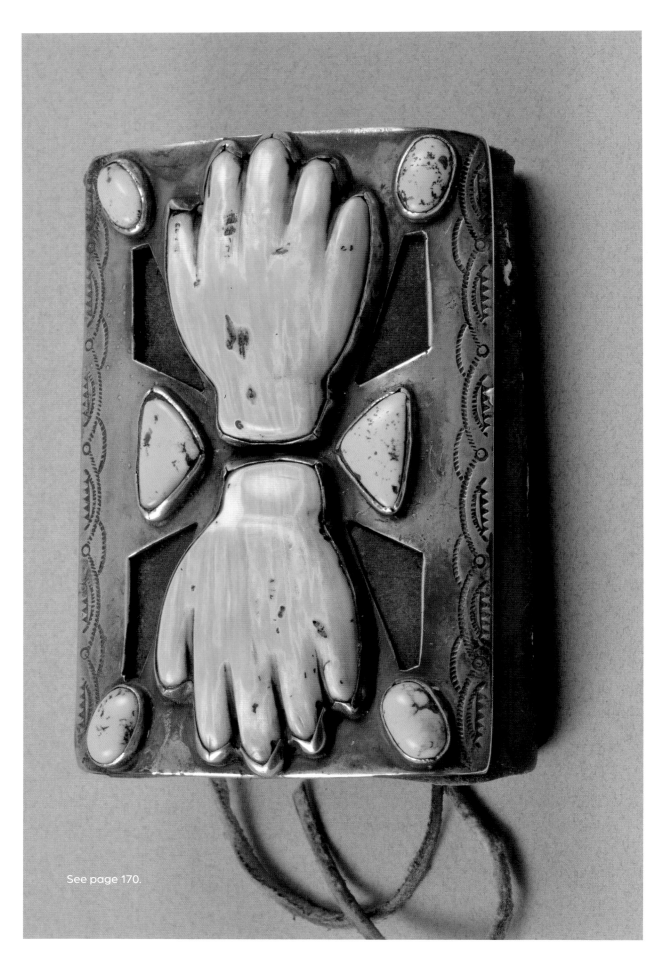

See page 170.

# Appendix B

# Collector Market and Valuation

The study of Navajo and Pueblo jewelry creation between 1870 and 1945 is filled with informational blanks. We know that much of the earliest jewelry has been lost or melted down, and only a small number of these works have made it into museum collections. Those remaining float upon the ever-shifting sea of collecting; such pieces change hands, disappear, and then reappear unexpectedly. Some of the best examples of this early work have emerged from estate sales in areas outside the American Southwest.

Because antique jewelry is finite in number and old in age, well-preserved examples on the market are not inexpensive. Prices have also risen significantly over the last five years. Buyers need to be aware of an insidious black market for all fine Native-made arts, and historical jewelry has been especially targeted for clever imitation. Buyer beware: just because a piece might retain a pawn ticket does not necessarily mean the item is old. To avoid disheartening experiences when buying such items, collectors need to develop an educated and wary eye for the genuine article. This requires backup assistance from ethical, reliable dealers and experts who look out for signs of authenticity, determine provenance, and have a command of what exactly is available in the marketplace.

There are many ways in which silver can be treated to appear older. Features such as coin-silver marks can be faked. Serious collectors invest in learning the properties of metalwork and stonework, the ages and identities of turquoise from regional and foreign mines, and small but telling examples that point to either authentic or duplicitous production. Some of the best dealers, experts, and writers on pre-1945 Native-made jewelry were or are working silversmiths. Knowing how to recognize coin, slug, or sheet silver becomes an important part of learning to be a good collector. Developing relationships with dealers and other collectors is also invaluable, even if this happens only through online groups.

Buying and collecting antique jewelry means getting the most value for your money. The best way to purchase or invest in a quality collection is to learn as much as you can about the objects themselves. One can start with books like this one and the titles listed in the bibliography on page 307. Older publications may be out of print, but some have been reissued, and most can be found for sale in used bookstores and from online vendors.

But the absolutely best means of educating oneself lies in looking at as much older jewelry as possible.

A first step is to visit museums with permanent collections of antique Navajo and Pueblo jewelry on view. The National Museum of the American Indian, part of the Smithsonian Institution, has a digital collection of such holdings that can be seen through its website. Two museums in the Southwest that devote space to permanent displays for educational purposes are the Heard Museum in Phoenix, Arizona, and the Museum of Northern Arizona (MNA) in Flagstaff. The MNA has recently redone its regional cultural arts permanent exhibits with effective input from Native artists. The small but scholarly Amerind Institute in Dragoon, Arizona, also displays relevant historical holdings.

Older Native jewelry can be viewed at the University of New Mexico's Maxwell Museum, and the Albuquerque Museum holds Indian arts and culture exhibitions with regularity. The Wheelwright Museum in Santa Fe is devoted to the study of Navajo arts and holds the papers of the late John Adair. The Museum of Indian Arts and Culture (also in Santa Fe) is a major resource, overseeing the historically significant Laboratory of Anthropology, a place for specialized research. In Taos, the Millicent Rogers Museum offers one of the finest and most comprehensive permanent collection exhibits of pre-1945 Navajo and Pueblo jewelry. The Autry Museum in Los Angeles, California, also exhibits Native arts, and it administers the distinguished Southwest Museum and its fine collection of Indian jewelry as well.

Overall, online museum visual collection resources are still sketchy in terms of development. Much collecting of Navajo and Pueblo jewelry is done online through the popular sales databases. These, however, have their own problems in providing sales of legitimate items through good-quality photographs. The best way to purchase is to handle a pre-1945 piece, noting its heft, shape, and patina. If buying old *heishi*, feeling the beads is essential. Pre-1945 necklaces with beads will most likely have been already restrung or will need restringing before they can be safely worn, and the seller should disclose this information.

Santa Fe, New Mexico, is also the traditional location for popular antique Indian arts markets held in the summer. Attendance at such events will ensure a means of being able to physically handle and examine pieces of jewelry. The more you do this, the more you will learn, along with visiting the galleries of reputable dealers in older antique Indian arts. This last point cannot be overemphasized. There is a lively black market out there, and plenty of people are willing to sell inauthentic, bogus items, made locally or abroad.

Reading, consulting experts, networking with relevant online groups, and viewing as much of this older work as possible are essential. With enough time and effort, items with unexplainable flaws and suspicious elements will become apparent. The kinds of adornment profiled in this book possess historical and aesthetic value. They are also the visual foundation for the fine work to come after 1945.

Collectors of antique Indian jewelry should know that hand-wrought American Indian jewelry is now accepted as fully bona fide fine art. Dealers are well aware of this and establish prices accordingly. No one attempting to collect well should mistake hand-wrought jewelry for less-expensive tourist craftwork or—heaven forbid—manufactured bench-made work. In addition to jewelry for wear, older Native curio flatware and metalwork, especially decorative boxes, have their place in the market.

Antique jewelry may be more fragile than other types of adornment precisely because the materials, whether metals, semiprecious stones, or binders, have not been previously treated. Natural turquoise tends to darken over time, often to a deep green hue. Older shell or natural turquoise jewelry, exposed regularly to urban pollution, can

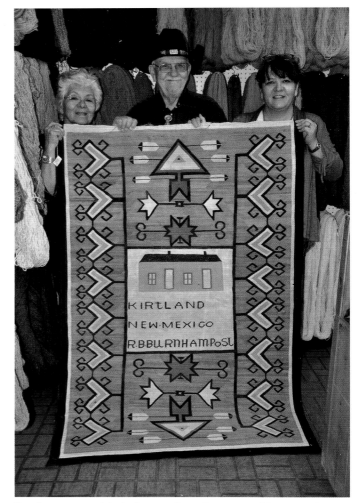

Buy from reputable Indian traders. Courtesy of R. B. Burnham & Co. Collection

Seek out antique Indian arts dealers' shops. Courtesy of John C. Hill

A Maisel's token. Courtesy of John C. Hill

Fake: This cross, sold as ingot silver made ca. 1900, is actually contemporary sheet silver.

develop cracks and pits. Avoid liquid-based cleaners and use polishing cloths. Repair and restoration work should be done by professionals familiar with materials and methods used before 1945.

Since 2022, purchasing a fine authentic piece of pre-1945 jewelry, such as a bracelet or necklace, will invariably run into four or five figures. Smaller pieces will cost much less, but prices for these will depend on their scarcity in the marketplace. Some older jewelry may need repairs, a factor that must be considered when evaluating the purchase price as a whole. Prices that seem surprisingly low should lead the potential buyer to question what they are getting for their money. Even relatively inexpensive small pieces need to be studied carefully—they are among the most likely to be imitated.

At the time of publication, prices for pre-1945 jewelry have been fairly steady, running at determinations of value that seem to be largely followed by most dealers in the field, including those in the Antique Tribal Arts Dealers Association (ATADA). Many pieces remain in circulation, and others come up from time to time as collections are dispersed and

the collector population ages. Authentic nineteenth-century silver necklaces can exceed the $8,000–$10,000 price point, while heishi from that period may cost around $3,000–$5,000. Old bracelets, depending on age, size, and quality, easily run from $2,500 to $8,000 or more. (This estimate reflects pricing as of early 2022. Prices do fluctuate, but sales shows devoted to antique Indian arts reflect the highly competitive nature of collecting.) Genuine hallmarks for known artists, good physical condition, and strong provenance will add significantly to a sale price.

One last word of caution: many sellers, whether onsite or online, may claim that an unsigned piece is by a specific artist based on the item's resemblance to that individual's work or an image in a published guidebook. They do this because most collectors are particularly interested in purchasing a work by one of the well-known and highly respected named artists whose jewelry appears in this and similar publications. Once again, buyer beware! Good provenance and ethical dealing are the best ways to ensure the satisfactory sale of a piece of living history.

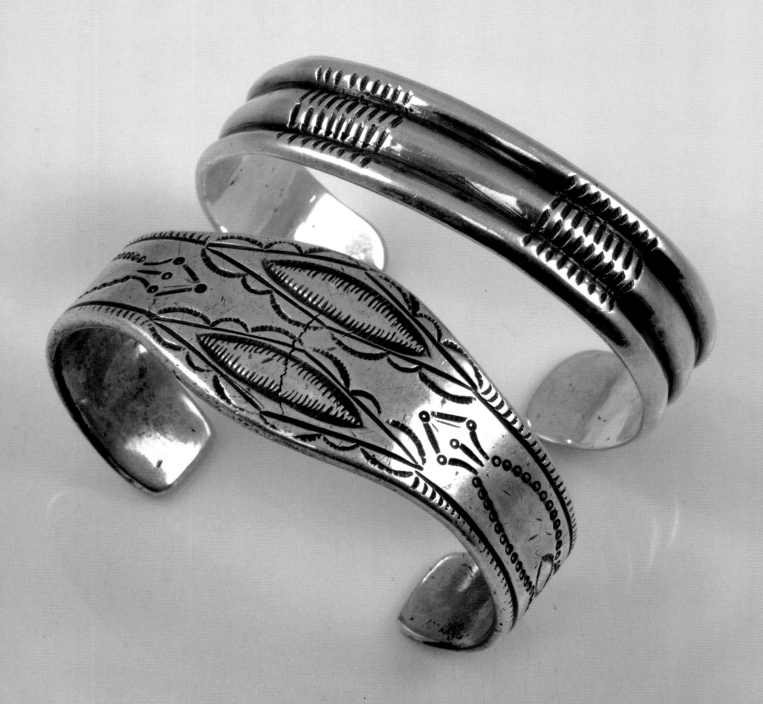

# Appendix C

# Key Smiths and Jewelers Active before 1945

The following pages list silversmiths and turquoise beadmakers and carvers known to have worked before or during the 1940s. Some of these jewelers continued to work after that date, but the list encompasses those who have attained historical and collector interest related to the first seventy-five years of silverwork. Since hallmarks were uncommon before 1945, verifying their work is difficult. In addition, pre-1945 Navajo and Pueblo jewelry has been subject to clever forgery and misrepresentation.

Unfortunately, documentation on many of the earliest individuals is lost; variations in spelling exist among pre-1945 publications. Dates are provided when known and credible. This selected list is intended to show those jewelers whose lives and careers are considered important to Indian arts scholars, collectors, and students of the field; it contains omissions that require future clarification.

## Navajos

Atsidi Chon

Atsidi Sani (ca. 1828–1918)

Atsidi Yazzie

Begay, Kenneth (1913–1977)

Bitsui, Charlie

Blackgoat, Mose

Burnside, Tom

Burnt Whiskers

Chee, James

Chee, Mark (1914–1981)

Da-Pah (1896–1977)

Dodge, Henry Chee (1860–1947)

Etcitty-Tsosie (ca. 1880–1937)

Goodluck, Billy

Goodluck, Hosteen

Houck, Charlie

Hoxie, John

Jones, Wilfred

Lincoln, Ambrose (1917–1989)

Peshlakai, Frank (1903–1966)

Peshlakai, Fred (1896–1972)

Roanhorse, Ambrose (1904–1982)

Shorty, Dooley (1911–2000)

Skeet, Roger (1900–1959)

Slender Maker of Silver (1831–1918)

Taliman, David (1901–1967)

Wilson, Austin (ca. 1901–1976)

Wilson, Ike (1901–1942)

Yellowhair, Chester

## Pueblos

Abeita, Diego (Isleta)

Atencio, Ralph (Santo Domingo)

Churino, Juan Rey (Laguna)

Coin, Willie (Hopi; 1910–1992)

Coriz, Santiago Leo (Santo Domingo; 1913–1997)

Duwakuku (Hopi; ca. 1860s–1956)

Hooee, Daisy (Hopi; 1906–1994)

Jaramillo, Jose (Isleta)

Jenkins, Grant (Hopi; ca. 1903–1933)

Kewanwytewa, Pierce (Hopi)

Lewis, Alvin Concho (Acoma)

Loloma, Charles (1921–1991)

Lomawunu (Hopi; ca. 1880s–1913)

Lomay, Lewis (Hopi; 1913–1996)

Luhan, Juan (Acoma)

Narvasi, Roscoe (Hopi)

Pooyouma, Allen (Hopi; 1922–2014)

Quintana, Joe H. (Cochiti; 1915–1991)

Quintana, Silviano (Cochiti; 1913–2003)

Ramos, Diego (Laguna)

Robinson, Morris (Hopi; 1901–1987)

Romero, Candido (Taos)

Saufkie, Paul (Hopi; ca. 1904–1998)

Sikyatala (Hopi)

Talayumptewa, Washington (Hopi)

Tawahonganiwa (Hopi)

Tawangyawma, Ralph (Hopi; 1894–1972)

Tawanimptewa (Hopi)

Tsireh, Awa (San Ildefonso; 1898–1955)

Vance, Homer (Hopi; ca. 1880–1961)

## Zuni

Balawade

Casa Appa, Della (1889–1963)

Dedios, Juan (1882–1944)

Deyuse, Leekya (1889–1966)

Dishta (1902–1954)

Hatsetsenane (Sneezing Man)

Homer, Lambert, Sr. (1917–1972)

Iule, Horace (1891–1978)

Kallestewa, Mary (1915–1980s)

Keneshde

Kuwishte

Lanyade

Leekity, Robert (John Gordon Leak)

Poblano, Leo (1905–1959)

Simplicio, Dan (1917–1969)

Tsikewa, David (1915–1971)

Tucson, Harold

Vacit, Frank (1915–1999)

Weahkee, Teddy (1900–1965)

Zuni Dick (Tseniheh)

Zunie, Willie

# Endnotes

## CHAPTER 1

1. I pointed out the inadequacy of writing about Southwestern Indian jewelry in my article "Cross-Cultural Controversies in the Design History of Southwestern American Indian Jewellery," *Journal of Design History* (UK) 7, no. 4 (1994): 233–45: "Imprecise information still colours the collective literature, and so there is a clear need for more objective and scholarly treatments. The voices of Native jewellery-makers need to be amplified, while non-Indian 'authorities' look beyond their immediate motivations." Since then, several more published scholarly works have been greatly helpful, but the subject still requires better investigation—and Native perspectives.

2. The term *survivance*, a combination of the concepts of survival and resistance, was defined by Native scholar Gerald Vizenor and appears in a publication he edited, *Survivance: Narratives of Native Presence* (Lincoln: University of Nebraska Press, 2008). Basically, this is a process of ongoing change, meeting acculturation with a "restorative return" to the values of the past that have shaped Native lives. When applied to Indian jewelry design, it indicates that its creators move into the future by transforming the past with a form of collective creative strength.

3. I am deeply appreciative to Indian trader Bruce Burnham for a 2018 conversation. He spoke of the "adopt, adapt, and discard" design motivation, echoing the same descriptive process that other Indian traders had told me about since my research started in the late 1980s. These traders possess a great wealth of knowledge, some of it documented, which may or may not be passed on in the years ahead. The fact that all their stories have not been fully told is a loss to Western history.

4. The cross shape denoted different aspects of the sacred to the Navajo and Pueblo peoples. The incoming Christian Spanish conquerors and the priests who accompanied them saw only one immutable symbol and meaning in this form. Navajo and Pueblo smiths wrought crosses first in base metals and then in silver; various styles of Catholic rosary crosses made their way into the Native smiths' repertoire of adornment. Allison Bird's *Heart of the Dragonfly* (Albuquerque, NM: Avanyu, 1992) shows how subversive Pueblo belief and design could be in the face of oppression.

## CHAPTER 2

1. This misquote comes from misinterpretation of a remark made by Calvin Coolidge, 30th president of the United States, during a speech titled "The Press under a Free Government," before the American Society of Newspaper Editors (January 1925). What he actually said was "the chief business of the American people is business." The main theme of his speech was that Americans were deeply concerned about the country's economy and how they could achieve personal prosperity. Coolidge was likely not thinking about Indians as his audience, but Natives clearly understood that their own prosperity depended on learning how to conduct profitable American-style business. Even Geronimo, the most famous of all captive Indian leaders, quickly learned to sell personal shirt button and photograph souvenirs after his release from imprisonment.

2. This information has been recorded in several sources. For the best summary of Spanish colonial incursions into the Southwest, see John L. Kessell, *Spain in the Southwest: A Narrative History of Colonial New Mexico, Arizona, Texas, and California* (Norman: University of Oklahoma Press, 2003).

3. John Adair, *The Navajo and Pueblo Silversmiths* (Norman: University of Oklahoma Press, 1944), 3.

4. For a fascinating account of the Navajo in captivity, see Lynn Robison Bailey, *Bosque Redondo: The Navajo Internment at Fort Sumner, New Mexico, 1863–1868* (Tucson, AZ: Westernlore, 1998).

5. The federal government had created the Bureau of Indian Affairs in 1824, under the jurisdiction of the US

Department of War. This was the principal agency for handling relations with Indian tribes. In 1849, Congress shifted the BIA to the Department of the Interior. This transfer did little to curb US Army reprisals whenever it was felt that Indigenous peoples were standing in the way of Manifest Destiny.

6. Navajos wore Pueblo-made adornment when they could get it, and both Navajo and Pueblo peoples sought metal ornament when it became available. Illustrations from this period show that both peoples mingled stone, shell, and metal adornments at will.

7. Ned Martin, Jody Martin, and Robert Bauver, *Bridles of the Americas*, vol. 1, *Indian Silver* (Nicasio, CA: Hawk Hill, 2010), 112–19. Bauver's chapters on Indian bridles provide a firsthand analysis of European versus Native American design approaches on headstalls. By the mid- to late 1880s, Indian bridles show individualized decorative efforts while adhering to established headstall and bridle bit forms.

8. Publications on Ancestral Puebloan jewelry making exist, but few discuss what did or didn't survive into the historical era. We know that *heishi* beads were found in precontact-era archeological sites, along with figurines and early mosaic inlay. With these decorative traditions still strong, it should come as no surprise that the first generation of Navajo and Pueblo smiths would combine stone, shell, and metal by the 1870s and 1880s.

9. Adair, *Navajo and Pueblo Silversmiths*, 4.

10. The establishment of the term traditional most certainly applies to precontact-era Pueblo-made adornment, but the term sounds ingenuous when applied to the craft of silversmithing, which began in the late 1860s and developed rapidly over the next two decades.

11. Arthur Woodward, *Navajo Silver: A Brief History of Navajo Silversmithing* (Flagstaff, AZ: Northland, 1971), 85.

12. Experts called the period between 1868 and 1890 a "first phase" for concha belt construction. This and later phases are discussed in Larry Frank and Millard Holbrook II, *Indian Silver Jewelry of the Southwest, 1868–1930* (West Chester, PA: Schiffer, 1990), 7.

13. Ibid., 7–8.

14. Bird's *Heart of the Dragonfly* treats the various styles of crosses made in the Southwest during this period. The double-barred design, often referred to as the Patriarchal cross or Cross of Lorraine, was particularly popular with missionaries and Pueblo faithful alike, since this form also resembled a sacred representation of the Pueblos' sun deity.

15. Native jewelers received recognition from patronage and touristic commercial efforts. The well-heeled Anglo supporters of Indian arts in Santa Fe were proud that their annual Indian fair awarded prizes for best pieces. Winning a ribbon might help a Navajo or Pueblo individual in selling work, but jewelers such as Awa Tsireh and Fred Peshlakai gained wider recognition when they went out on their own prior to 1945.

## CHAPTER 3

1. "First Phase" concha belts were the earliest form, wide and round with diamond-shaped open slots; they were named in recognition of the first decades of jewelry-form creation. In terms of design history, however, the terms *early* or *historic* are more accurate when describing the first thirty years of metalwork overall. Today, such labeling may be more appropriate due to the twenty-first-century acceptance of American Indian jewelry as an art form rather than just a material culture craft.

2. Adair, *Navajo and Pueblo Silversmiths*, 193.

3. Steve Curtis, in his *Navajo Silversmith Fred Peshlakai: His Life & Art* (Atglen, PA: Schiffer, 2014), illuminates the heritage of Slender Maker of Silver's son, explains the complicated Navajo clan system, and illuminates how often talent can repeat over a family's generations.

4. The author favors this quote by Charles Lummis in his *Cañon, Mesa, and Pueblo* (New York: Century, 1925), 169–70: "No Indian of the Southwest knew anything of metals until the Spaniards came; the Pueblos learned silversmithing very promptly. From them the Navajos acquired the art, and beat them at it."

5. Adair, *Navajo and Pueblo Silversmiths*, 173. Adair's book covers Navajo and Zuni silverworking more fully and provides a much shorter analysis of Hopi and Rio Grande metalsmithing transmission.

6. Many examples from this period can be found in the Laboratory of Anthropology in Santa Fe.

7. Cushing repaid his Native hosts by reproducing in a Smithsonian report a drawing of a Zuni altar with a representation of a Knifewing sacred spirit and a curved, stylized figure (soon to be dubbed a "Rainbow Man"), both of which became the earliest graphic fodder for representations of Indian deities.

8. Washington Matthews, "Navajo Silversmiths," in *Second Annual Report from the Bureau of American Ethnology to the Smithsonian Institution, 1880–81* (Washington, DC: Bureau of American Ethnology, 1883), 167–78.

9. Ibid., 168.

10. Ibid., 177: "These Indians are quite fertile in design."

11. Ibid.

12. A man of his times, Matthews was not immune to the casual racism employed by observers of the "Other." His narrative uses the words "savage" and "savages" regularly. This author found regular usage of this term in written, even scholarly, accounts up to 1935.

13. Robert Bauver's "Navajo Bits and Bridles," chapter 5 in Martin et al., *Bridles of the Americas*, 99–136, examines the essential silver ornament that inspired so much early jewelry design at the time.

14. Ibid., 112, 116–17.

15. Clara Lee Tanner, "The Naja," *American Indian Art Magazine* (Spring 1982): 65. Tanner debunks the notion of the *naja* form as solely derived from Spanish silver horse gear and posits that its shape may have come from Ancestral Puebloan pendants made from broken-shell bracelets that resemble crescents, along with pendant loops at the bottom of necklaces.

16. Clara Lee Tanner, "The Squash Blossom," *American Indian Art Magazine* (Summer 1978): 37. Early illustrations from these first decades of creation show most necklaces to be fairly long, whether made of shell or silver.

17. Gary Brockman, *Wearing the Moon: Navajo and Pueblo Silver Buttons* (Middleton, WI: Sky Hill, 2017), 20. This book is a visual delight, offering photographs and images of buttons as they evolved. The author provides a chronological look at how the early dress buttons and sew-ons progressed into more artistically defined ornament over time.

18. Paula A. Baxter, *Southwest Silver Jewelry* (Atglen, PA: Schiffer, 2001), 40–41. One of the men portrayed wears a string of large silver beads with two *najas*! Since the issue of *Century* they appeared in is dated 1882, this shows a fairly early example of Native taste in adornment.

## CHAPTER 4

1. For a useful survey of glass trade beads, see Cloyd Sorensen, "The Enduring Intrigue of the Glass Trade Bead," *Arizona Highways* 47, no. 7 (July 1971): 33. The author notes other commonly used beads, such as "white hearts," and claims that blue, blue green, and white were predominant bead colors in the Southwest. Recently, controversy has arisen over how major a role Lorenzo Hubbell played in the promotion of glass beads, but there is little doubt that the Southwest's Indians used imports from Czechoslovakia and other locales.

2. Tanner, "The Naja," 69. Tanner was among the first writers to point out that Zuni lapidaries used small, differently shaped turquoise stones in a piece of jewelry at this time.

3. Adair, *Navajo and Pueblo Silversmiths*, 172–94.

4. The multiple values for turquoise were given expression in *Turquoise, Water, Sky: Meaning and Beauty in Southwest Native Arts*, an important exhibition and companion volume produced by the Museum of Indian Arts and Culture in 2015.

5. Philip Chambless and Mike Ryan, *The Great American Turquoise Rush, 1890–1910* (Santa Fe, NM: Sunstone, 2016), 39. The Tiffany Company of New York established mine rights that yielded $2 million worth of turquoise between 1892 and 1899 before that vein played out.

6. Chambliss, "Metal of the Moon," 36–37.

7. Frank McNitt, *The Indian Traders* (Norman: University of Oklahoma Press, 1962), 51. This somewhat dated study remains one of the best narratives describing how Indian traders operated in the Southwest.

8. Erica Cottam, *Hubbell Trading Post: Trade, Tourism, and the Navajo Southwest* (Norman: University of Oklahoma Press, 2015), 12, 53.

9. McNitt, *Indian Traders*, 210.

10. Cottam, *Hubbell Trading Post*, 129.

11. Ibid., 138.

12. A question that arises is, Did Native smiths use different-color stones in setting simply because those materials were limited to what they had at hand, or is there a specific meaning behind this variety? Uniform-color turquoise in jewelry was likely a cross-cultural influence. It also helps to remember that Navajo and Pueblo jewelry makers had inconsistent access to good turquoise during the nineteenth century.

13. Adair, *Navajo and Pueblo Silversmiths*, 24, 26.

14. Ibid., 37. The author sees a connection between the new affinity for stamping designs on these bracelets with the trend toward more complicated shapes.

## CHAPTER 5

1. Jonathan Batkin, *The Native American Curio Trade in New Mexico* (Santa Fe, NM: Wheelwright Museum of the American Indian, 2008), 112. The author discusses how learning to make commercial silverwork brought benefits to the Navajo and Pueblo people during the Great Depression. Foremost was that skills acquired in the curio shop aided individuals who would run their own businesses or teach in classrooms.

2. See E. W. Jernigan and Gary Witherspoon, *White Metal Universe: Navajo Silver from the Fred Harvey Collection* (Phoenix, AZ: Heard Museum, 1981).

3. Commercially made Navajo spoons and flatware offer a first look at smiths' abilities to render human and animal designs with humor. These products of the late nineteenth and early twentieth centuries received little attention from writers and experts. Fortunately, Cindra Kline's *Navajo Spoons: Indian Artistry and the Souvenir Trade, 1880s–1940s* (Albuquerque: University of New Mexico Press, 2001) makes a compelling case for the sheer artistry of their designs.

4. Batkin, *Native American Curio Trade*, 179–80. The alarm over mass production was great, dominated by three specific issues: competition with independent smiths and traders, teaching of new techniques in the Indian schools and their appearance in shows, and the false claim of "Indian made" placed on pieces that were partly or entirely machine made.

5. Elizabeth Hutchinson, *The Indian Craze: Primitivism, Modernism, and Transculturation in American Art, 1890–1915* (Durham, NC: Duke University Press, 2009), 3. This book studies the popular-culture trend in America between 1890 and 1915, when Indian arts became suitable consumer goods.

6. Erika Marie Bsumek, *Indian-Made: Navajo Culture in the Marketplace, 1868–1940* (Lawrence: University of Kansas Press, 2008), 108.

7. Ibid., 9–10. The primitivism endorsed by traders and others was based on economic evaluations of Native arts being modernist in aesthetic design.

8. The Taos Society of Artists and patron Mabel Dodge Luhan, among others, were responsible for attracting many artists and writers to New Mexico and northern Arizona. Most of these East Coast visitors came west for health reasons or to vacation. Those who stayed romanticized their Indian subjects but also respected and appreciated Native modes, including jewelry.

9. Hutchinson, *Indian Craze*, 32.

10. Ibid., 113. Although individuals from the Fred Harvey Company, traders, and curio-shop owners were known to give instructions on how jewelry pieces should appear, they made their cases knowing that Native smiths would follow their guidelines but still render designs with some aspect of their "Indianness."

11. Batkin, *Curio Trade*, 112.

12. Tanner, "The Naja," 70–71.

13. Batkin, *Curio Trade*, 117. This particular exposure, on the part of Native demonstrators and the general public alike, greatly bolstered Southwestern Indians as tourist attractions and producers of souvenir goods. One note: most of the silversmiths in the exhibition wore the headkerchief used by Navajo smiths despite their true tribal affiliations.

14. George Frederick Kunz, *Rings for the Finger* (1917; reprint: Garden City, NY: Dover, 1973), 26–27.

## CHAPTER 6

1. The author is still unsure what led her to pronounce in her 2001 publication that Slender Maker of Silver might be Fred Peshlakai's uncle. John Adair was straightforward in his reporting that they were father and son. Steven Curtis's book offers a very careful and extensive examination of Navajo family and kin relationships to confirm that this was so (see p. 29).

2. Adair, *Navajo and Pueblo Silversmiths*, 9.

3. Bsumek, *Indian-Made*, 15.

4. Dorothy K. Washburn, ed., *The Elkus Collection: Southwestern Indian Art* (San Francisco: California Academy of Sciences, 1984). John Adair was the author of the catalog's essay "Navajo and Pueblo Silverwork." His chronology, honed well after the publication of his seminal work, dubbed the period between 1880 and 1910 as "Classic Period," and 1910 to 1945 as the "Period of Early Commercialization." Adair believed that the "Period of Modernization" started after World War II. His definitions were based on the anthropological tracing of Indian social and technological development within the dominant society.

5. The best perspective on the relationship between the Fred Harvey Company and Native American arts comes from a Heard Museum exhibition catalog by Kathleen Howard and Diana Pardue, *Inventing the Southwest: The Fred Harvey Company and Native American Art* (Flagstaff, AZ: Northland, 1996).

6. Real collaborations existed but are hard to confirm, particularly because hallmarks were rare at this time, in addition to a lack of documentation. Some traders, such as C. G. Wallace, would take fine Zuni lapidary work and have it mounted by a Navajo silversmith for economic reasons. This practice endorsed a mistaken belief that Zunis were better lapidaries than silversmiths.

7. Frank Hamilton Cushing's illustration from his Bureau of Ethnology report undoubtedly sparked Wallace's liking for these images. Wallace, a consummate American businessman, was eager to develop a "brand" for Zuni, and in the years ahead the many lapidary examples he commissioned helped drive a collector taste for these figures.

8. The use of the swastika symbol can be found as far back as the Paleolithic era, notably on a bird figurine dated 10,000 BCE. The symbol is found in archeological sites in India dating to 3000 BCE, as well as in later sites in China, Africa, Scandinavia, Britain, and mainland Europe.

9. It's difficult to comprehend where the non-Natives who devised these "Indian Symbols" got their ideas. Some may have arisen through "discussions" with Natives, but most are plainly fanciful, helping to fulfill stereotypes about Indian spirituality.

10. Adair, *Navajo and Pueblo Silversmiths*, 101. His findings indicate that the early independent smiths did in fact control their own designs. A variation on the fourth example of parallel lines sounds rather like the lozenge forms that appeared widespread as surface decoration on silver.

11. Ibid., 103. The anthropologist firmly linked these four particular patterns to Mexican leather stamps. His contempt for phony Indian symbols is evident, but he also admitted that commercial pressures were inevitable and part of Indian arts salesmanship.

12. For more information on the Fred Harvey Company and its buyers, see Howard and Pardue, *Inventing the Southwest*, 24–36.

13. "Old pawn" remains ambiguous to this day. Many establishments use old pawn tickets to help sell pieces that may or may not be older and may possess a questionable identity.

14. John Adair, "Navajo and Pueblo Silverwork," in Washburn, *The Elkus Collection*, 69–75.

15. Potters Maria and Julian Martinez of San Ildefonso and Hopi potter Nampeyo are examples of early Native American celebrities; their families would possess the same luster over the years in terms of artistic creation.

Elle of Ganado, a Navajo weaver, would also garner public recognition. Inevitably, such attention would soon be paid to up-and-coming Navajo and Pueblo jewelry makers; by 1930, many of these notable individuals would be either newly working or youngsters.

16. The second wave of tourism, created by automobile travel on Route 66, helped curio stores sell these affordable souvenirs. Tourist-era jewelry, whether created for the Fred Harvey Company or stores like Maisel's, joined the ranks of popular-culture collectibles by the 1970s.

## CHAPTER 7

1. Batkin, *Curio Trade*, 200.

2. Ibid., 173, 272–93.

3. Patronage from small regional museums in the Southwest did much to encourage Indians to enter their market shows. The first Natives involved in such activities, including having their works judged and receiving awards, must have had to walk a cultural tightrope.

4. Bsumek, *Indian-Made*, 36–38.

5. Margaret Wright, *Hopi Silver: The History and Hallmarks of Hopi Silversmithing* (Flagstaff, AZ: Northland, 1989), 37–47.

6. Jennifer McLerran, *A New Deal for Native Art: Indian Arts and Federal Policy, 1933–1943* (Tucson: University of Arizona Press), 93–99. The IACB is still active today and provides educational materials and policy oversight within the Department of the Interior.

7. Bille Hougart, *Native American and Southwestern Silver Hallmarks*, 4th ed. (Washington, DC: TBR International, 2019). This invaluable guide offers a chronology and description of these short-lived tribal stamps; see pages 16–17.

8. Emily Farnham, "Decorative Design in Indian Jewelry," *Design* 35 (March 1934): 15. Farnham also describes Navajo and Pueblo jewelry makers as "savage smiths."

9. M. Colton, "Hopi Silversmithing—Its Background and Future," *Plateau* (July 1939): 1–2.

10. Ibid., 2.

11. Ibid., 7. One point should be noted: Colton discloses that the museum chose design examples as commissions (orders) to the individuals who participated in the project. These financed incentives were put on display in the museum to form a collection; at the same time, the smiths were encouraged to make their own experimental designs for display.

12. Representations of kachinas/katsinam fit better with the "craft" designation for Indian jewelry that evolved after World War II.

13. Cindra Kline's *Navajo Spoons* deserves much more than a footnote. Her examination of an underrated and often-ignored art form fashioned for curio sale demonstrates just how artistic, even witty, Navajo design could be. The lack of serious attention given to these whimsical creations underscores how much mainstream arts critics have cast decorative arts into the role placed on them in European American art history—as "minor arts." Kline skillfully relates Navajo spoon designs to material culture of the American Southwest.

14. Spratling's workshop is a remarkable example of cross-cultural dynamics at work in the history of Mexican silver jewelry during the 1930s and 1940s. His arrival in Taxco to revive its local silverwork industry was based on reanimating pre-Columbian and traditional designs. When comparing Mexican silver with Southwestern Indian silver jewelry, the design differences are visually conspicuous. Yet, more research is needed on the interrelationships between Mexican jewelry and Native production in the American Southwest.

15. Patania's silver designs were artful and sometimes playful. He was a leading advocate of signed pieces, and he trained such prominent post-1945 figures as the Santo Domingo smith Julian Lovato, who inherited Patania's thunderbird hallmark. Patania's most influential designs were made after 1945.

16. Mera's early-modern silverwork design appraisals became persuasive guiding principles for antique and vintage Indian jewelry experts and collectors.

### CHAPTER 8

1. Margery Bedinger, *Indian Silver: Navajo and Pueblo Jewelers* (Albuquerque: University of New Mexico Press, 1974), 120.

2. Paula A. Baxter, "Navajo and Pueblo Jewelry, 1940–1970: Three Decades of Innovative Design Revisited," *American Indian Art Magazine* 21, no. 4 (Autumn 1996): 36. Discovering the names of the artists involved required checking MoMA's internal records, which incorrectly invert Shorty's full name.

3. Frederic Douglas and René d'Harnoncourt, *Indian Art of the United States* (New York: Museum of Modern Art, 1941), 201.

4. Howard J. Langer, comp. and ed., *American Indian Quotations* (Westport, CT: Greenwood, 1996), 146.

5. David Neumann, "Navajo Silversmithing Survives," *El Palacio* 50, no. 1 (January 1943): 6–8. He was an Indian trader and art dealer who wrote frequently for *El Palacio*; his most significant contribution was a 1933 article that linked Navajo silver dies to Mexican leather punch decoration.

6. Adair, *Navajo and Pueblo Silversmiths*, 172. He later acknowledged his error in judgment to various individuals in the field. Nevertheless, these words did not help the relegation to second place of older Pueblo silverwork by less-critical minds. Charles Loloma would change that misperception completely.

7. Catherine Chambliss, "Metal of the Moon," 35–37. Chambliss's commentary disregards the reality that souvenir design aided Native jewelry popularity. She also discusses creative success solely in terms of Navajo accomplishment while disregarding Pueblo achievement.

8. In 1948, Hopi elders met to vocalize a series of prophecies, later appearing before the United Nations assembly in 1959. They felt that one of these prophecies had come true with the dropping of the atomic bomb, a literal version of the "gourd of ashes" the world witnessed. These warnings were part of a greater campaign to make outsiders understand the need to retain Hopi land boundaries and keep their sovereign rights inviolate.

9. Although Native Americans were technically granted citizenship through the 1924 Snyder Act, their right to cast ballots in elections was fought separately in state courts. Arizona granted them voting rights in 1948. New Mexico gave its Indians this enfranchisement only in 1962, the last state to do so.

# Bibliography

## Navajo and Pueblo Cultural History

Bailey, Garrick, and Roberta Glenn Bailey. *A History of the Navajos: The Reservation Years*. Santa Fe, NM: School of American Research, 1986.

Bailey, Lynn Robison. *Bosque Redondo: The Navajo Internment at Fort Sumner, New Mexico, 1863–1868*. Tucson, AZ: Westernlore, 1998.

Bsumek, Erika Marie. *Indian-Made: Navajo Culture in the Marketplace, 1868–1940*. Lawrence: University of Kansas Press, 2008.

Cajete, Gregory, Tracy Bodnar, and Lauren Black. *A Trail Guide to Aztec Ruins National Monument*. Tucson, AZ: Western National Parks Association, 2013.

Chino, Conroy. *Petroglyphs of the Southwest: A Puebloan Perspective*. Tucson, AZ: Western National Parks Association, 2012.

Dilworth, Leah. *Imagining the Primitive: Representations of Native Americans in the Southwest*. Washington, DC: Smithsonian Institution Press, 1996.

Dozier, Edward P. *The Pueblo Indians of North America*. Long Grove, IL: Waveland, 1983.

Dutton, Bertha. *The Pueblos: Indians of the American Southwest*. Englewood Cliffs, NJ: Prentice-Hall, 1976.

Farella, John R. *The Main Stalk: A Synthesis of Navajo Philosophy*. Tucson: University of Arizona Press, 1990.

Frisbie, Charlotte J., and David P. McAllester, eds. *Navajo Blessingway Singer: The Autobiography of Frank Mitchell, 1881–1967*. Albuquerque: University of New Mexico Press, 1978.

Gibson, Daniel. *Pueblos of the Rio Grande: A Visitor's Guide*. Tucson, AZ: Rio Nuevo, 2001.

Gorman, Zonnie. *The Circle of Light: Contemporary Biographies of Navajo People*. [Gallup, NM]: Circle of Light Navajo Educational Project, 2004.

Iverson, Peter, and Monty Roussel. *Diné: A History of the Navajos*. Albuquerque: University of New Mexico Press, 2002.

Kessell, John L. *Spain in the Southwest: A Narrative History of Colonial New Mexico, Arizona, Texas, and California*. Norman: University of Oklahoma Press, 2003.

Krech, Shepard, II, and Barbara A. Hail, eds. *Collecting Native America: 1870–1960*. Washington, DC: Smithsonian Institution Press, 1999.

McPherson, Robert S. *Both Sides of the Bullpen: Navajo Trade and Posts*. Norman: University of Oklahoma Press, 2017.

———. *Dinéji' Na 'nitin: Navajo Traditional Teachings and History*. Denver: University Press of Colorado, 2012.

Ortiz, Alfonso. *The Tewa World: Space, Time, Being and Becoming in a Pueblo Society*. Chicago: University of Chicago Press, 1969.

Parsons, Elsie Clews. *Pueblo Indian Religion*. 2 vols. Lincoln, University of Nebraska Press, 1939–66.

Rothman, Hal K., ed. *The Culture of Tourism, the Tourism of Culture: Selling the Past to the Present in the American Southwest*. Albuquerque: University of New Mexico Press, 2003.

Sando, Joe S. *The Pueblo Indians*. San Francisco: Indian Historian Press, 1976.

———. *Pueblo Nations: Eight Centuries of Pueblo Indian History*. Santa Fe, NM: Clear Light, 1992.

Schaafsma, Polly, ed. *Kachinas in the Pueblo World*. Salt Lake City: University of Utah Press, 1994 (reprinted in 2000).

Schwarz, Maureen Trudelle. *Molded in the Image of Changing Woman: Navajo Views on the Human Body and Personhood.* Tucson: University of Arizona Press, 1997.

Stephen, A. M. "The Navajo." *American Anthropologist* 6, no. 4 (October 1893): 345–62.

Trimble, Stephen. *The People: Indians of the American Southwest.* Santa Fe, NM: School of American Research, 1993.

Underhill, Ruth M. *Life in the Pueblos.* Santa Fe, NM: Ancient City, 1991.

Waters, Frank. *Book of the Hopi.* New York: Penguin, 1977.

Zah, Peterson, and Peter Iverson. *We Will Secure Our Future: Empowering the Navajo Nation.* Tucson: University of Arizona Press, 2012.

Zolbrod, Paul G. *Diné Bahane': The Navajo Creation Story.* Albuquerque: University of New Mexico Press, 1987.

## Reference Resources

Batkin, Jonathan. *The Native American Curio Trade in New Mexico.* Santa Fe, NM: Wheelwright Museum of the American Indian, 2008.

Baxter, Paula A. *The Encyclopedia of Native American Jewelry.* Phoenix, AZ: Oryx, 2000.

———. *Southwest Silver Jewelry.* Atglen, PA: Schiffer, 2001.

Branson, Oscar T. *Fetishes and Carvings of the Southwest.* Tucson, AZ: Treasure Chest, 1976.

———. *Indian Jewelry Making.* 2 vols. Tucson, AZ: Treasure Chest, 1977.

Chambless, Philip, and Mike Ryan. *The Great American Turquoise Rush, 1890–1910.* Santa Fe, NM: Sunstone, 2016.

Cordwell, Justine M., and Ronald A. Schwarz, eds. *The Fabrics of Culture: The Anthropology of Clothing and Adornment.* New York: Mouton, 1979.

Davis, Mary L., and Greta Packer. *Mexican Jewelry.* Austin: University of Texas Press, 1963.

Dubin, Lois Sherr. *The History of Beads: From 30,000 B.C. to the Present.* Rev. and expanded ed. New York: Abrams, 2009.

———. *North American Indian Jewelry and Adornment: From Prehistory to the Present.* New York: Abrams, 1999.

Garmhausen, Winona. *The History of Indian Arts Education in Santa Fe.* Santa Fe, NM: Sunstone Press, 1988.

Hougart, Bille. *Native American and Southwestern Silver Hallmarks: Silversmiths, Designers, Guilds and Trader.* 4th ed. Washington, DC: TBR International, 2019.

Howard, Kathleen L., and Diana F. Pardue. *Inventing the Southwest: The Fred Harvey Company and Native American Art.* Phoenix, AZ: Heard Museum, 1996.

Kunz, George Frederick. *Rings for the Finger.* Philadelphia: Lippincott, 1917. Reprint: Garden City, NY: Dover, 1973.

Langer, Howard J., comp. and ed. *American Indian Quotations.* Westport, CT: Greenwood, 1996.

Lidchi, Henrietta. *Surviving Desires: Making and Selling Jewelry in the American Southwest.* Norman: University of Oklahoma Press, 2015.

Limerick, Patricia Nelson. *The Legacy of Conquest: The Unbroken Past of the American Southwest.* New York: W. W. Norton, 1987.

Lummis, Charles F. *Mesa, Cañon, and Pueblo.* New York: Century, 1925.

Margolin, Victor. *Design Discourse: History, Theory, Criticism.* Chicago: University of Chicago Press, 1989.

McNitt, Frank. *The Indian Traders.* Norman: University of Oklahoma Press, 1962.

Meloy, Ellen. *The Anthropology of Turquoise: Reflections on Desert, Sea, Stone, and Sky.* New York: Vintage Books, 2002.

Messier, Pat, and Kim Messier. *Garden of the Gods Trading Post.* Charleston, SC: Arcadia, 2019.

———. *Reassessing Hallmarks of Native Southwest Jewelry: Artists, Traders, Guilds and the Government.* Atglen, PA: Schiffer, 2014.

Ortiz, Alfonso, ed. *Handbook of North American Indians*. Vol. 9. Washington, DC: Smithsonian Institute Press, 1979.

Paterek, Josephine. *Encyclopedia of American Indian Costume*. Denver, CO: ABC-Clio, 1994.

Pogue, Joseph E. *The Turquoise. Memoirs of the National Academy of Sciences* 12, no. 2. Washington, DC: National Academy of Sciences, 1915. Reprint: Glorieta, NM: Rio Grande, 1973.

Taggett, Sherry Clay, and Ted Schwarz. *Paintbrushes and Pistols: How the Taos Artists Sold the West*. Santa Fe, NM: John Muir, 1990.

Vizenor, Gerald, ed. *Survivance: Narratives of Native Presence*. Lincoln: University of Nebraska Press, 2008.

White, Richard. *"It's Your Misfortune and None of My Own": A New History of the American West*. Norman: University of Oklahoma Press, 1991.

Wright, Barton. *Hallmarks of the Southwest*. West Chester, PA: Schiffer, 1989.

## Works on or Related to Jewelry

Adair, John. *The Navajo and Pueblo Silversmiths*. Norman: University of Oklahoma Press, 1944.

Arrow Novelty. *Catalogue of Indian Design Silver Jewelry*. New York: Arrow Novelty, 1912, reprinted in 1987.

Bahti, Mark. *Southwestern Indian Designs with Some Explanations*. Tucson, AZ: Treasure Chest, 1995.

Bauver, Robert. *Navajo and Pueblo Earrings, 1850–1945: Collected by Robert V. Gallegos*. Los Ranchos de Albuquerque, NM: Rio Grande, 2007.

Baxter, Paula A. "Cross-Cultural Controversies in the Design of American Indian Jewellery." *Journal of Design History* (UK) 7, no. 4 (Winter 1994): 233–45.

———. "Navajo and Pueblo Jewelry, 1940–1970: Three Decades of Innovative Design Revisited." *American Indian Art Magazine* 21, no. 4 (Autumn 1996): 34–43.

———. "Nineteenth Century Navajo and Pueblo Silver Jewelry." *Magazine Antiques* 153, no. 1 (January 1998): 206–15.

———. *Pueblo Bead Jewelry: Living Design*. Atglen, PA: Schiffer, 2018.

———. *Southwestern Indian Bracelets: The Essential Cuff*. Atglen, PA: Schiffer, 2015.

———. *Southwestern Indian Rings*. Atglen, PA: Schiffer, 2011.

Bedinger, Margery. *Indian Silver: Navajo and Pueblo Jewelers*. Albuquerque: University of New Mexico Press, 1973.

Belknap, William. *Fred Kabotie, Hopi Indian Artist*. Flagstaff, AZ: Northland, 1977.

Bell, Barbara, and Ed Bell. *Zuni: The Art and the People*. 3 vols. Grants, NM: Squaw Bell Traders, 1975–77.

Bird, Allison. *Heart of the Dragonfly*. Albuquerque, NM: Avanyu, 1992.

Bird, Gail, Diana F. Pardue, Maynard White Owl Lavadour, and Yazzie Johnson. *Be Dazzled! Masterworks of Jewelry and Beadwork from the Heard Museum*. Phoenix, AZ: Heard Museum, 2002.

Boylan, Lona Davis. *Spanish Colonial Silver*. Santa Fe: University of New Mexico Press, 1974.

Brockman, Gary. *Wearing the Moon: Navajo and Pueblo Silver Buttons*. Middleton, WI: Sky Hill, 2017.

Brugge, David. "Navajo Ring Bits." *American Indian Art Magazine* 26, no. 4 (2001): 78–87.

Bulow, Ernie. "Mysteries of Zuni Silver: Decoding Adair's List." *ATADA News* 25, no. 1 (Winter 2015): 26–33.

The C. G. Wallace Collection of American Indian Art, November 14, 15, and 16, 1975. New York: Sotheby Parke-Bernet, 1975. Auction sales catalog.

Chambliss, Catherine. "Metal of the Moon." *Arizona Highways* 17 (December 1941): 26–37.

Cirillo, Dexter. *Southwestern Indian Jewelry*. New York: Abbeville, 1992.

Colton, Mary-Russell F. "Hopi Silversmithing—Its Background and Future." *Plateau* 12 (July 1939): 1–7.

Cottam, Erica. *Hubbell Trading Post: Trade, Tourism, and the Navajo Southwest.* Norman: University of Oklahoma Press, 2015.

Curtis, Steven. *Navajo Silversmith Fred Peshlakai: His Life and Art.* Atglen, PA: Schiffer, 2014.

Douglas, Frederic, and René d'Harnoncourt. *Indian Art of the United States.* New York: Museum of Modern Art, 1941. Exhibition catalog.

Ellis, Dorothy Hawley. "The Jewelry Heritage of Santo Domingo." *New Mexico Magazine* 54, no. 4 (April 1976): 10–18, 44–45.

Ezell, Paul. "Shell Work of the Prehistoric Southwest." *Kiva* 3 no. 3 (December 1937): 9–12.

Farnham, Emily. "Decorative Design in Indian Jewelry." *Design* 35 (March 1934): 13–15, 23–24.

Fellin, Octavia. "Roanhorse." *Indian Life* 38, no. 1 (August 1959): 1.

Frank, Larry, and Millard Holbrook. *Indian Silver Jewelry of the Southwest, 1868–1930.* West Chester, PA: Schiffer, 1990.

Harrington, M. R. "Swedged Navaho Bracelets." *Masterkey* 8, no. 6 (November 1934): 183–84.

Hegemann, Elizabeth C. *Navaho Silver.* Leaflets 29. Los Angeles: Southwest Museum, 1962.

Hill, Gertrude. "The Art of the Navajo Silversmith." *Kiva* 11 (February 1937): 17–20.

———. "The Use of Turquoise Among the Navajo." *Kiva* 4, no. 3 (December 1938): 11–13.

Hodge, F. W. "How Old Is Southwestern Indian Silverwork?" *El Palacio* 25 (October 1928): 224–32.

Jeancon, Jean A. *Pueblo Shell Beads and Inlay.* Denver Art Museum Leaflet 30. Denver, CO: Denver Art Museum, 1931.

Jernigan, E. W. *Jewelry of the Prehistoric Southwest.* Santa Fe, NM: School of American Research, 1978.

Jernigan, E. W., Byron Harvey III, and Gary Witherspoon. *White Metal Universe: Navajo Silver from the Fred Harvey Collection.* Phoenix, AZ: Heard Museum, 1981.

Kenagy, Suzanne G. "Made in the Zuni Style." *Masterkey* 61, no. 4 (Winter 1988): 11–20.

Kirk, Ruth Falkenberg. *Southwestern Indian Jewelry.* [Reprinted from *El Palacio*] School of American Research, Papers 38. Santa Fe, NM: School of American Research, 1945.

Kline, Cindra. *Navajo Spoons: Indian Artistry and the Souvenir Trade, 1880s–1940s.* Albuquerque: University of New Mexico Press, 2001.

———. "Turquoise Tenacity: Saving Every Last Bit for Santo Domingo's Mosaic Jewelry." *El Palacio* 120, no. 2 (Summer 2015): 37–41.

Lowry, Joe Dan, and Joe P. Lowry. *Turquoise: The World Story of a Fascinating Gemstone.* Layton, UT: Gibbs Smith, 2010.

Mangum, Richard, and Sherry Mangum. "The Hopi Silver Project of the Museum of Northern Arizona," *Plateau* n.s. 1 (1995).

Martin, Ned, Jody Martin, and Robert Bauver. *Bridles of the Americas.* Vol. 1, *Indian Silver.* Nicasio, CA: Hawk Hill, 2010.

Matthews, Washington. "Navajo Silversmiths." In *Second Annual Report of the Bureau of American Ethnology to the Secretary of the Smithsonian Institution, 1880–1881.* Edited by J. W. Powell, 167–78. Washington DC: Government Printing Office, 1883.

McBrinn, Maxine, and Ross E. Altshuler. *Turquoise, Water, Sky: Meaning and Beauty in Southwest Native Arts.* Santa Fe, NM: Museum of New Mexico Press, 2015.

McLerran, Jennifer. *A New Deal for Native Art: Indian Arts and Federal Policy, 1933–1943.* Tucson: University of Arizona Press, 2009.

Mera, H. P. *Indian Silverwork of the Southwest.* Vol. 1. Tucson, AZ: Dale Stuart King, 1960.

Moore, J. B. *The Catalogues of Fine Navajo Blankets, Rugs, Ceremonial Baskets, Silverware, Jewelry & Curios: Originally Published between 1903 and 1911*. Albuquerque, NM: Avanyu, 1987.

Neumann, David L. *Navajo Silversmithing*. Santa Fe: Museum of New Mexico, 1971.

———. "Navajo Silversmithing Survives." *El Palacio* 50, no. 1 (January 1943): 6.

Orchard, William C. *Beads and Beadwork of the American Indians*. New York: Museum of the American Indian, Heye Foundation, 1975.

Ostler, James, Marian Rodee, and Milford Nahohai. *Zuni: A Village of Silversmiths*. Zuni, NM: A:shiwi, 1996.

Richards, Donald P., and Karen M. Richards. *A Study of Navajo Concha Belts*. Atglen, PA: Schiffer, 2021.

Rosnek, Carl, and Joseph Stacey. *Skystone and Silver: The Collector's Book of Southwest Indian Jewelry*. Englewood Cliffs, NJ: Prentice-Hall, 1976.

Rushing, W. Jackson. *Native American Art and the New York Avant-Garde*. Austin: University of Texas Press, 1995.

Schiffer, Nancy. *Jewelry by Southwest American Indians: Evolving Designs*. West Chester, PA: Schiffer, 1990.

Sei, Toshio. *Knifewing and Rainbow Man in Zuni Jewelry*. Atglen, PA: Schiffer, 2010.

Slaney, Deborah C. *Blue Gem, White Metal: Carvings and Jewelry from the C. G. Wallace Collection*. Phoenix, AZ: Heard Museum, 1998.

———. *Leekya: Master Carver of Zuni Pueblo*. Albuquerque, NM: Albuquerque Museum, 2018.

Sorensen, Cloyd. "The Enduring Intrigue of the Glass Trade Bead." *Arizona Highways* 47, no. 7 (July 1971): 10–37.

Struever, Martha Hopkins. *Loloma: Beauty Is His Name*. Santa Fe, NM: Wheelwright Museum of the American Indian, 2005. Exhibition catalog.

Tanner, Clara Lee. "The Naja." *American Indian Art Magazine* 7 (Spring 1982): 64–71.

———. *Southwest Indian Craft Arts*. Tucson: University of Arizona Press, 1968.

———. "The Squash Blossom." *American Indian Art Magazine* 3 (Summer 1978): 36–43.

Tisdale, Shelby J. *Fine Indian Jewelry of the Southwest: The Millicent Rogers Museum Collection*. Santa Fe: Museum of New Mexico Press, 206.

Torre-Nez, John. *Beesh Łigaii in Balance: The Diane and Sandy Besser Collection of Navajo and Pueblo Silverwork*. 2nd ed. Santa Fe, NM: Museum of Indian Arts & Culture, 2005.

Turnbaugh, William A., and Sarah Turnbaugh. *Indian Jewelry of the American Southwest*. West Chester, PA: Schiffer, 1988.

Underhill, Ruth. *Pueblo Crafts*. Lawrence, KS: Haskell Institute, 1953.

Volk, Robert M. "Barter, Blankets, and Bracelets: The Role of the Trader in the Navajo Textile and Silverwork Industries, 1868–1930." *American Indian Culture and Research Journal* 12, no. 4 (1988): 39–63.

Washburn, Dorothy K. *The Elkus Collection: Southwestern Indian Art*. San Francisco: California Institute of Sciences, 1984.

Woodward, Arthur. *Navajo Silver: A Brief History of Navajo Silversmithing*. Flagstaff, AZ: Northland, 1972.

# Index